CULTURAL HERITAGE OF THE
GREAT WAR IN BRITAIN

Heritage, Culture and Identity

Series Editor: Brian Graham,
School of Environmental Sciences, University of Ulster, UK

Other titles in this series

Cultural Heritage of the Great War in Britain

ROSS J. WILSON
University of Chichester, UK

ASHGATE

Published by
Ashgate Publishing Limited
Wey Court East
Union Road
Farnham
Surrey, GU9 7PT
England

Ashgate Publishing Company
110 Cherry Street
Suite 3-1
Burlington, VT 05401-3818
USA

www.ashgate.com

British Library Cataloguing in Publication Data
A catalogue record for this book is available from the British Library

The Library of Congress has cataloged the printed edition as follows:
Wilson, Ross J., 1981-
Cultural heritage of the Great War in Britain / by Ross Wilson.
 pages cm -- (Heritage, culture and identity)
 Includes bibliographical references and index.
 ISBN 978-1-4094-4573-9 (hardback) -- ISBN 978-1-4094-4574-6 (ebook) --
 ISBN 978-1-4724-0309-4 (ePUB) 1. World War, 1914-1918--Social aspects--
Great Britain.
2. World War, 1914-1918--Great Britain. 3. World War, 1914-1918--Influence. 4.
Popular culture--Great Britain. 5. Collective memory--Great Britain. 6. War memorials--
Great Britain. 7. War and society--Great Britain. I. Title.

 D524.7.G7W55 2013
 940.3'41--dc23

 2013000850

ISBN 9781409445739 (hbk)
ISBN 9781409445746 (ebk –PDF)
ISBN 9781472403094 (ebk – ePUB)

Printed in the United Kingdom by Henry Ling Limited,
at the Dorset Press, Dorchester, DT1 1HD

Contents

List of Figures and Tables

Figures

Tables

Acknowledgements

All books are a product of a network of associations, experiences and ideas. Therefore, I would like to extend my deepest thanks to the individuals who have assisted in bringing this book to publication. Acknowledgements are due to the publishing team at Ashgate, who have been supportive throughout a long process which saw this book develop into its current form. My gratitude to the staff at the British Library, the Brotherton Library at the University of Leeds and the J.B. Morrell Library at the University of York, who patiently provided support and service to me over the years as I developed this project, should also be stated. My special thanks are due to those who have helped me develop my ideas for this work. It is the example of their fine scholarship and teaching which has served as an inspiration to continue my own research. Whilst any faults are entirely my own, any credit should be shared with them. These individuals include, Professor Julian Richards, Dr Dominic Perring, Dr Kate Giles, Dr Jonathan Finch, Dr Geoff Cubitt, Dr John Clay, Dr Kalliopi Fouseki and particularly Dr Emma Waterton who offered her opinions and assistance throughout the creation of this book. I am indebted to Alex Sotheran for permission to use a number of his photographs as well as his criticism and perspective. I would also like to extend my especial thanks to Dr Laurajane Smith, Professor Richard Bessel and Dr Kevin Walsh for their helpful advice and criticism. Finally, I would like to dedicate this work to my family, who have never ceased to support me. Guy, Pippa, Freddie, Arthur, Drew, Mandeep, Bryn and Jill, I am indebted to your kindness and your patience. The majority of this book was written in the United States and my thanks are due to my family there, Steve, Cindy, Ian, Lucy and Edwin. To my parents, Margaret and Roger, who always encouraged and enabled my studies, I cannot thank you enough. To Nancy, this book is for you.

Chapter 1

Introduction

The Great War appears to possess a pre-eminent place across the communities, regions and nations that constitute contemporary Britain. Indeed, it would not be hyperbole to state that this conflict which was fought at the outset of the twentieth century still haunts modern society (see Fussell 1975, Winter 1992). This legacy of the war, of the trenches, the mud, the large-scale death and the sea of apparently endless headstones and monuments on the former battlefields across Europe and the Middle East is still prominent. To speak of the Somme, Passchendaele or Gallipoli, particularly in certain areas and localities within Britain, is to evoke strong feelings of loss, pity, anger and pride. The aftermath of the world's first global conflagration still reaches into the present. As the local memorials in the towns and villages of England, Scotland, Wales and Northern Ireland still stand witness and testify the loss of life in the war; materially and psychologically this is a war that is still lived with (Wilson 2009). However, with the passing of the last veterans of the conflict, the events of 1914–1918 could seem to be receding into the historical distance. Indeed, as the conflict has now slipped from 'living memory' to 'remembered history' one might also expect the Great War to fall from public consciousness (see Dyer 1994). On the contrary, as the anniversaries of the events of the war are still marked and the denouement of the conflict is remembered each November, the war appears to be still significant for individuals, communities and wider society. Despite the passing of the years, the place of the conflict within public life in Britain remains undimmed: this is a war which in many ways has not ended.

This apparently unyielding 'popular memory' of the Great War in Britain is the focus of this book. Through a detailed analysis of the local, regional and national remembrance of the war, the public and private commemoration of the dead and the subtle legacies of language, image and perspective, the 'cultural heritage' of the conflict within contemporary Britain will be detailed. The purpose of this investigation is to assess why the war has remained so significant within society; to detail why the conflict is still called to mind within the 'public consciousness' (after Connerton 1989). As such, this study will approach the issue of heritage and memory as a purposeful denotation and action within a wider socio-political context (after Smith 2004, 2006, Walsh 1992). In essence, remembering, valuing and using the past are activities which are undertaken for a specific purpose. Rather than simplistically assuming that the conflict is remembered because it 'should be', that the scale of death necessitates its remembrance, this analysis takes the stance that these events are remembered because of what it communicates to contemporary society about itself (after Wertsch 2002). In this assessment,

therefore, the cultural heritage of the Great War is identified as it serves to inform, reflect upon and frame experiences for current groups and communities. The events of 1914–1918 are a means of illustrating and motivating issues in the present, to comprehend and explain notions of identity, place and politics. As this analysis will demonstrate, the processes of drawing upon the Great War as an aspect of a shared cultural heritage creates and sustains bonds within communities. Indeed, the First World War remains prominent within contemporary society in Britain because of its ability to be used to relay information to one another and to others. In this manner, this study will assess the entwining of the experience, history, memory and heritage of the Great War.

The Great War: Experience

The summons detailed in Laurence Binyon's (1922: 70) poem, *For the Fallen*, which was written in 1914 before the major loss of life that occurred with the Battle of the Somme or the conflicts that raged around the Flemish city of Ieper, is one that calls for remembrance:

> At the going down of the sun and in the morning
> We will remember them.

The poem is intended to provide instruction for a population, perhaps long removed psychologically or chronologically from the events of 1914–1918, to maintain the memory of the dead. It commands its audience to remember the war, to bear a responsibility to those who gave their lives for their country. Binyon's poem is, therefore, a dedication to the sacrifice for which the nation mourns. In some respects, this invocation provides a frame through which subsequent generations have recalled the war (see Heffernan 1995). This sense of responsibility for remembrance appears to emerge in the post-war era and comes to dominate commemorative ceremonies (see Gregory 1994). The 'burden of memory' and the solemn nature of remembrance could be considered to be borne from the sheer size of fatalities during the war and the subsequent trauma brought to families and communities throughout Britain (see Winter 1986). During the four years of war, the deaths of British Army servicemen and women numbered over 700,000. Over a million individuals from Britain were also wounded during the conflict and in some cases suffered lifelong injuries from the effects of the industrialised war; whether blinded or choked by gas fumes, mutilated by shell fragments, struck sightless or deafened by high explosives or rendered mentally incapacitated from the effects of their wartime service. The sheer size of these figures would themselves appear to validate Binyon's call to remember. However, such an approach has been critiqued as obscuring the historical circumstances in which these deaths and injuries occurred (see Sheffield 2002). Indeed, recent historians have asserted that a lack of historical perspective is largely responsible for what

is critically termed the 'myths and memory' of the war, or perhaps, more kindly, the 'popular perception' of the conflict in Britain (after Bond 2002). Therefore, to place these losses into context in order to assess the popular memory and the cultural heritage of the war, the history of the conflict must be considered.

Whilst some scholars have argued that the United States Civil War (1861–1865) was the first 'modern war', fought with the products of an industrialised society, the Great War can nevertheless be asserted as the first war fought on an international and industrial scale (see Griffith 1994). The conflict encompassed land, sea and air on three continents and drew in millions of men and women to serve the competing national interests of the combatants (Keegan 1998, Strachan 2005). The war which originated in Eastern Europe then spread to Western Europe, Africa, the Americas, Australasia and Asia as the colonial powers of Britain, France and Germany mobilised their empires in the pursuit of victory (Morrow 2004: 8–12). The well-known battlefields of the Western Front in France and Flanders were just one theatre of war alongside the fields of conflict in Salonika (Greece), Mesopotamia (Iraq), the Ottoman Empire (Turkey), East Africa (Tanzania, Rwanda, Burundi) and the Eastern Front (Poland, Bulgaria, Russia, Serbia, Hungary) (see Beckett 2001: 20–25). As the Entente of France, Britain, Russia, Italy, and after 1917 the United States, sought a breakthrough against the Central Powers of Germany, Bulgaria, the Ottoman Empire and Austria-Hungary, vast amounts of manpower and material were expended. In total, approximately 10 million soldiers and civilians died as a result of the war (see Tucker 1998).

As an international conflict, the war brought soldiers and civilians from all over the world into contact with one another (Das 2011; Winegard 2012). As labourers, soldiers and nurses, men and women from Europe, Africa, Asia and the Americas volunteered or were enlisted by nation states and imperial governments to help the war effort (Grundlingh 1987, Guoqi 2005, Howe 2002). This great congregation in and around the battlefields of the Great War has often been highlighted as the origins of nationalism and political autonomy for the dependencies and colonies of the European powers (Thomson 1994, Vance 1998). Forged in the 'crucible of war' this movement for self-determination has ensured that in this respect the conflict's repercussions have been experienced throughout the twentieth century (see Dunn and Fraser 1996). Aiding this movement towards independence was the substantial economic costs of the war for the combatant nations (Wrigley 2000). The high level of borrowing that the Entente Powers engaged in during the war, principally from the United States, alongside the crippling financial penalties inflicted upon Germany after its defeat, ensured that the age of European dominance over the globe began to recede (Silverman 1982). Politically, financially, and as the level of fatalities increased, morally, European hegemony was to be challenged in the post-war world and never again achieve the same level of pre-eminence.

As the battlefields of France, Flanders, the Italian Alps, Eastern Europe, Gallipoli and Salonika testified this was also a conflict which broke new ground in the conditions of warfare (Kramer 2007). As developments in military technology had led to relative stalemate between opposing armies, troops were compelled to

'dig in' (after Henig 1989: 10). Across the war landscape, soldiers constructed a network of trenches, dugouts and tunnels to hold positions and to launch attacks (Ellis 1989: 9). Military officials responded to the changes in warfare by employing policies of attrition. Attacks and raids designed to wear down the enemy's defences, deplete important reserves of morale and result in a greater loss of life than the attacking army were the tactics used by all belligerent nations in the conflict (Ashworth 1980: 5–7). Such policies led to the substantial scale of death in the now well-remembered bloody engagements on the Somme, Passchendaele, Verdun, Vimy Ridge and the Dardanelles Campaign. For example, in the Battle of the Somme, during the first day of attacks on 1 July 1916, the British Army sustained 38,000 fatalities and 19,000 casualties (see Middlebrook 1971). For the Battle of Passchendaele, between July and November 1917, the scale of death has been difficult to assess, such were the conditions of warfare. Most estimates place the number of fatalities as over 225,000 for the British Army and 250,000 for the Germany Army (see Macdonald 1978). Modern warfare had also ensured that many of these deaths were painfully unheroic; bodies were mutilated by shrapnel, disintegrated by high explosives or lost in a sea of mud as artillery bombardments transformed the war landscape (Van Bergen 2009). Another consequence of this stalemate was the frequently appalling conditions of the trench systems in all theatres of war (Saunders 2012). Exposed to the elements, littered with the detritus of war and often the remains of the dead, the 'trenches' possessed a double-edged quality for the soldiers; they protected them from attack but confined them to a narrow strip of space. As the war poet Siegfried Sassoon (1983: 137) remarked in his poem *Memorial Tablet* these battlefields could be reduced to nightmarish visions:

> I died in hell –
> (They called it Passchendaele).

These conditions were experienced by armies which had been raised from a civilian population (Proctor 2010). In Britain, with a small standing army in 1914 and no tradition of compulsory military service, volunteers were marched into military camps at the outset of the war and sent off to serve 'King and Country' (McCartney 2005; Beckett and Simpson 1985). Throughout Britain, local communities and businesses raised 'Pals Battalion', enabling workmates and neighbours to serve together in the armed forces (Simkins 1988). Evidence suggests that these volunteers were enthusiastic and patriotic, desiring to 'see the war' before it ended (Bourne 1989: 30–35, De Groot 1996: 8–12). After the true nature of the war had been made clear as one of bloody deadlock, conscription was introduced in Britain, though not in Ireland, to ensure victory in the field (see Bet-El 1999). Able-bodied men aged 18 to 45 were recruited into service and overwhelmingly accepted their role as soldiers (see Bourke 1996, 1999). Indeed, throughout the war, incidents of disobedience and mutiny within the British Army were infrequent (after Corns and Hughes-Wilson 2002). This absence of indiscipline, perhaps a product of the rigid

enforcement of military law and the oppressive class structure of society as much ~~No~~
as patriotism and devotion to duty, is also surprising when considering the colossal
mobilisation of the British population. In total, over five million individuals served
in the armed forces during wartime. These soldiers, artillerymen, medical staff
and labourers were part of a wider service where women contributed to the war
work. As members of the Queen Mary Auxiliary Army Corps, the Land Army or
charitable organisations such as the Red Cross and the Young Men's Christian
Association, women as well as men assisted in the drive for victory (see War
Office 1922).

During the four years of war, civilian populations from all combatant nations
suffered the privations of war as well as the devastation and bereavement on the
news of the death of a loved one (Beckett 2006, Bilton 2003). In Britain, despite the
Zeppelin Raids that occurred during the early years of the conflict, which terrorised
the East Coast of the country, killing civilians in East Anglia and Yorkshire, the
'cold bite' of war was not as harsh as that experienced in Germany, Belgian, France
and Russia (Darrow 2000, Ziemann 2011). Nevertheless, across Britain, the war
brought political intrusion into daily life, propaganda, rationing and the terrible
threat of bad news delivered from the General Staff by telegraph (see Van Emden
and Humphries 2004). The closed curtains in daytime informed neighbours and
relatives that a father, son or brother had been killed or was 'missing' in action and
presumed dead. Indeed, such was the constitution of the British Army with the
formation of 'Pals Battalions' that entire streets within towns and villages could be
similarly touched by loss after a particularly bloody and costly engagement at the
front (see Moorcroft 1992). Therefore, the war was brought home to civilians, who
were far from being alienated and distant from the events on the battlefield (see
Gregory 2008, Watson 2004). They were as intimately and as closely connected to
the conflict as the soldiers in the trenches.

Britain emerged from this maelstrom of war as a partner in a victorious coalition
with France and the United States as the major contributors (Cohrs 2006). Both
civilian and soldier alike had helped win the war. Despite the horrific condition
of modern warfare, the unprecedented losses that occurred in the major battles
of the conflict and the upheaval of civilian life, victory was achieved (Sheffield
2002). The ability of the country to raise a substantial army, mobilise its resources,
redirect its economy onto a wartime setting and maintain the morale of a civilian
and military population was a remarkable achievement (see Turner 1988).
As if to justify the decisions made by both the military and political hierarchy,
contemporary historians have been at pains to laud the success of Britain's army
and people in securing victory (see Robbins 2005). However, the enormous loss
of life that had been inflicted alongside the horrendous conditions of modern war
that had been endured somewhat marred the victory for an exhausted nation (after
Marwick 1965). As the Armistice was announced in November 1918 and peace
terms with Germany and her allies were discussed in Versailles in January 1919
the war passed from experience into history and memory. In this movement, the
meanings and messages that could be gleaned from the conflict became the object

of debate and contestation (after Todman 2005). Remembering and retelling the Great War began to be an act of interpretation; an action which was suffused with the desires and demands of those who recalled the events of 1914–1918 rather than those who experienced it.

The Great War: Memory

In the post-war era, the process of remembering the Great War in Britain was a highly organised state response to an event of overwhelming magnitude (Gregory 1994, King 1998). Indeed, even as the war was still raging, the British Government was already planning how the commemoration of the dead was to take form (Longworth 1967). Principal in this decision was the insistence that the bodies of soldiers on the battlefields would not be repatriated but would be buried collectively as a symbol of sacrifice and dedication to duty (Bushaway 1992, Heffernan 1995). In the aftermath of the conflict, notable architects and designers were enlisted to construct a memorial landscape across the former battlefields (Stamp 2006). Sir Edwin Lutyens, Herbert Baker and Sir Reginald Blomfield worked to provide the now iconic three elements to the cemeteries of the newly-formed Imperial War Graves Commission (to be changed in 1960 to the Commonwealth War Graves Commission): the Stone of Remembrance, the uniform headstones and the Cross of Sacrifice. On the Western Front, where the British Army had sustained its most terrible losses, large memorials at Thiepval on the Somme and the Menin Gate in Ieper were erected to honour 'the missing'. These monuments, listing the names of the dead whose bodies were never recovered, served as witnesses to the scale of the war and the actions of those who fought in the horrendous battles of the Somme and Passchendaele (see Chapter 3). On the battlefields of Mesopotamia, Salonika, East Africa and the Dardanelles, similar cemeteries were constructed to remember the service of those who had fought in what was a termed by popular and political decree 'the war to end all wars' (Winter 1992, 2006).

As this memorial landscape was constructed so too were monuments and memorials in Britain itself. Central to this process was the building of the Cenotaph in Whitehall (Greenberg 1989). This monument, designed by Sir Edwin Lutyens, was originally constructed as a temporary plaster edifice for the parades of 1919. However its simple form as a tomb for those with no known grave proved incredibly popular with the public, a great number of whom had a family member or friend who was one of the 'missing'. Dedicated to the 'Glorious Dead', the Cenotaph marked a point in the landscape where the bereaved could congregate to mark the death of a loved one. The Cenotaph in Belfast, located at Belfast City Hall, unveiled in 1929, also marked a point of connection for families in the then newly formed Northern Ireland. Similarly, the dedication of the Tomb of the Unknown Warrior in Westminster Abbey in November 1920 provided a place where the grieving families or friends of one

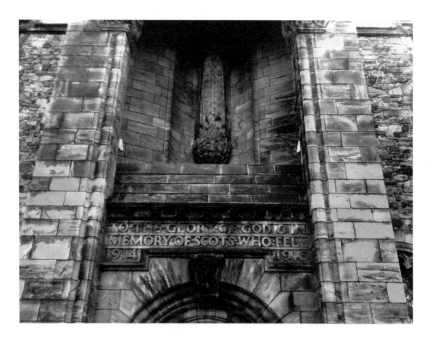

Figure 1.1 Scottish National War Memorial, Edinburgh

of 'the missing' could visit a grave and mourn (see Inglis 1993). The tomb was designed to be both a statement of national honour and a symbol of individual loss. Parents, siblings, relatives and acquaintances could thereby associate with the burial of an unknown individual within a place usually reserved for the monarchs and heroes of the nation. The inscription on the tombstone attested to this emotional link:

> THUS ARE COMMEMORATED THE MANY
> MULTITUDES WHO DURING THE GREAT
> WAR OF 1914 – 1918 GAVE THE MOST THAT
> MAN CAN GIVE LIFE ITSELF

This combination of commemoration and recognition of service is reflected within the major memorials to the war in Britain. The Scottish National War Memorial, dedicated in 1927, marks the deaths and the victories of the Scottish regiments in the Great War (see Macleod 2010) (Figure 1.1). The memorial, with its artistic scenes depicting the front, marks the sacrifice of Scottish soldiers in the war and also formed a place of mourning for the bereaved. The same sentiments are repeated in the Welsh National War Memorial in Cathays Park, Cardiff, dedicated in 1928. Upon the exterior frieze of this neo-classic design, constituting a circular colonnade enclosing a sculptural group featuring bronzes of servicemen is inscribed:

I FEIBION CYMRU A RODDES EU BYWYD DROS EI GWLAD
YN RHYFEL MCMXVIII
[To the sons of Wales who gave their lives for their country in the War 1918]

In Ireland, where the post-war commemoration of the dead was compromised by the campaign for independence, the bitter legacy of the Easter Rising of 1916 and the Anglo-Irish War of 1919-1921, the Irish National War Memorial Gardens were not completed until 1939 (see Johnson 1999, 2003). Designed by Sir Edward Lutyens, the sunken rose garden surrounds an altar-like slab of Irish granite and the site was dedicated to the memory of the 49,000 Irish soldiers who died in the service of the British Army (Leonard 1997).

Alongside the national memorials, in the cities, town and villages that had been touched by the war, local memorials were raised to mark the loss of life and the impact of these deaths on communities in Britain (after Connelly 2002). These memorials ranged from simple plaques, naming the dead to memorial rolls and statues depicting the British 'Tommy' (see Boorman 1988). These war memorials reflected a community's desire to demonstrate its role in a global endeavour and to mark the deaths of local individuals who had died in a 'foreign field'. Indeed, this presence of a memorial provided a place for the bereaved and enabled them to mourn; as the graves of those who were lost in the conflict could be located in France, Belgium, Mesopotamia, Turkey and Greece, such markers proved to be significant points of congregation to honour the dead of a locality (after Gaffney 1998). For example, in the case of the Lancashire town of Clitheroe, public subscription helped fund the purchase of the Norman castle and grounds where a bronze statue of a reverential soldier with bowed head was erected in the 1920s (Figure 1.2). Upon the plinth on which the figure was placed reads the inscription:

ERECTED BY THE INHABITANTS OF CLITHEROE
IN GRATEFUL REMEMBRANCE OF THEIR FELLOW TOWNSMEN
WHO GAVE THEIR LIVES
IN DEFENCE OF THEIR KING AND COUNTRY
IN THE GREAT WAR 1914 – 1918

Local pride, nationalism and private grief were thereby united within these memorials. Similar structures were put in place in the cities, towns and villages elsewhere in England, Scotland, Wales and Northern Ireland. Each of these constructions reflecting the desires of a local community to provide a distinctive point to reflect upon the service of fellow residents for a wider, collective, national effort.

The Great War: Remembering

The memorials, both on the battlefields and across the wider regions within Britain, served to focus commemorative activities and frame the memory of

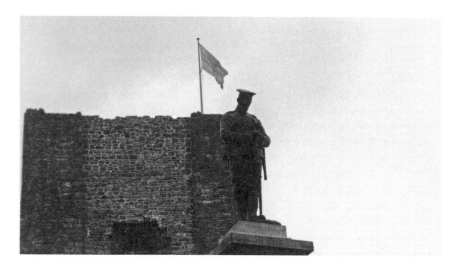

Figure 1.2 Clitheroe War Memorial

the war as one of sacrifice and endeavour. However, in the post-war world fears were also repeatedly stated that the war would be lost from public memory; that a population that had grown up with peace, where the war was a distant memory, would soon forget the loss and devastation of the conflict (see Brittain 1933). Siegfried Sassoon (1926: 18), in his poem *Aftermath*, lambasted what he perceived as the complacency of the general public and the indifference of the government to the memory of the war:

> Have you forgotten yet? …
> Look down, and swear by the slain of the War that you'll never forget.

As a veteran, Sassoon was recalling the experience of the conflict, but remembering the war involved a far more complex set of perspectives. After the Armistice, the war began to be remembered through a diverse array of cultural responses which altered with the shifting interests and objectives within society (after Ashplant et al. 2000: 5). Memoirs, novels and film were published which provided a different lens through which to view the war (Bracco 1993). Sassoon himself published his memoirs, originally under the pseudonym of George Sherston, which joined an ever-increasing genre of 'war literature'. Among veterans such as R.C. Sherriff (1929), whose play *Journey's End* was first performed in 1921 and C.E. Montague (1921) who had earlier penned his account of the war in *Disenchantment*, notable additions to this field included, Richard Aldington's (1929) *Death of a Hero*, Edmund Blunden's (1930) memoir *Undertones of War*, Robert Graves's (1929) *Goodbye To All That*, David Jones's (1937) *In Parenthesis* and Frederic Manning's (1936) *Her Privates We*. Throughout the 1920s and 1930s, the war

was remembered by a new generation through these first-hand accounts of the horror and devastation of the conflict. Such perceptions were substantiated with the translation of Erich Maria Remarque's classic, *All Quiet on the Western Front*, published in 1929, which provided a German perspective on the loss and personal tragedy suffered during wartime.

After the end of the Second World War, a new generation were able to frame the war through the same means of novels and memoirs but also increasingly television and film. The two most notable contributions to the representations of the Great War in the post-war period were the television documentary, *The Great War* (1964) and the Theatre Workshop (1965) production *Oh! What a Lovely War*, first performed in 1963 and later produced for film in 1969. These particular representations are considered to have provided a new outline through which to recall the war (Sorlin 1999). This original depiction focused on the representation of the individual in warfare and the devastating effect of the global conflagration on the perceptions of the ordinary soldier (Danchev 1991). Whilst the novels and memoirs of the immediate post-war period represented the oeuvre of a middle-class officer, these depictions of loss, separation and horrendous conditions appeared to ensure that a voice was given to the ordinary, working-class 'Tommy in the trenches'. Novels of the period, written by authors who had not directly experienced the front line or the home front, also reflected this perspective which provided powerful, albeit fictional, accounts of individuals and their experiences of the Great War (see Harris 1962). Further television serials such as dramas *Days of Hope* (1975) and *The Monocled Mutineer* (1986) also enabled viewers to witness the events of war unfold from the point of view of the 'everyman'. This mode of remembering was later reinforced in the television series *Blackadder Goes Forth* (1989). This acclaimed comedy series featured a small group of soldiers on the Western Front, stationed in a dugout and a small section of trench. The humour of an incompetent General Staff was weighed against the acute pathos of the suffering of the soldiers; a sentiment which was reinforced in the final scenes of the series where the heroes are ordered to go 'over the top' to face what appears to be certain death in a pointless attack.

In the 1990s, the representation of the battlefields altered with a wave of novels and films that focused on the social and psychological effects of the war on the individual (Korte 2001). In Barker's novel *Regeneration* (1991), the main character is shown to be suffering from severe trauma and hospitalised with other 'shell shocked' soldiers away from the front. Shell shock is also a feature of the novel *Birdsong* by Faulks (1993). Similarly, in Harnett's (1999) novel, *Brother to Dragons*, the mental anguish and disturbance caused by the character's participation at the front, haunts the veteran in the post-war world. In these novels, the ordinary soldiers' account of the front lines as a brutal, hellish and violent torment is explored as an examination of the psyche. Issues of gender, sexuality and identity politics are thereby addressed in these works of fiction as contemporary concerns are explored through the war. Indeed, Elton's *The First Casualty* (2005) references homosexual affairs, masculinity, official incompetency, but focuses particularly on

government complicity and cover-ups. In the wake of the 2003 'sexed-up' dossier on Iraq's possession of weapons of mass destruction, the role of authority and the implications of claiming a truth in wartime are explicitly questioned in the novel. Films such as the horror film *Deathwatch* (2002) and the drama *The Trench* (1999) also assess the psychological damage wrought by the war, as soldiers are shown to grapple and suffer from the fear and paranoia of conflict (see Hanna 2009).

Contemporary representations of the battlefields have thereby maintained the stylistic traditions of the post-war memoirs and novels but have inevitably woven elements of current concern into this narrative and imagery (Hanna 2007). Recent television programmes such as documentary *The Trench* (2002), brought the current vogue for 'reality television' to the remembrance of the First World War. This programme organised several 'recruits' from the northern English town of Grimsby to take part in a schedule of 'realistic' training and deployment in a recreated trench in northern France. Whilst the taste and decency of the programme was greatly debated, as it required individual to re-enact a scene of mass-death, it indicates, albeit rather crudely, the desire for the war to be made 'real' for contemporary society. This can also be located with similar television events. Indeed, with the marking of the ninetieth anniversaries of the Armistice, the history documentary programme *Timewatch* (2008) detailed how the hundreds of lives were lost on the final day of the war due to official delays and bureaucracy. The programme then sought to locate descendants of these soldiers who died on Armistice Day 1918, to bring relatives to the graves of forgotten or faintly remembered family members. Such attempts to associate past and present, despite the passage of time, were particular features of this ninetieth anniversary. Indeed, the British Broadcasting Corporation (BBC) icon for the series of programmes broadcast to mark the event consisted of the interlinked numerical figures '1918–2008'.

The novels, memoirs, films and television programmes which have depicted the First World War since the cessation of hostilities have certainly served to remember the events of the conflict for society. Critics also describe how these representations rely on a limited set of images of the conflict to present the Great War to the wider public and thereby remember the conflict in a particular way. Certainly, the popular depictions of the war in the media have overwhelmingly focused on the battlefields of the Western Front and drawn upon the concept of incompetent officers and government ministers, the horrendous condition of the battlefields and the rats, gas, mud and blood of the trenches. These repetitive elements within the cultural output are highly noticeable features (see Bond 2002, Todman 2005). The use and reuse of scenes and motifs in film, television and fiction have enabled some scholars to identify the Great War as a 'topos' – constituted by successive generations of authors and artists who have created a distinct 'fictional' place (see Badsey 2001). It is this construction which has been considered to form the basis of the wider 'cultural memory' of the war in Britain (after Sheffield 2002). In these representations of the Great War on screen and page, it is the particular view of the conflict as a piteous, futile waste of life conducted in

a hellish vision of industrialised warfare which is evoked. To illustrate the strength of this mode of representation, the contemporary work of the Poet Laureate, Carol Ann Duffy (2011a: 16), can be seen to employ these same images; to call to mind the common elements of what is remembered about the Great War, 'men who would drown in mud, be gassed, or shot, or vaporised by falling shells'. Indeed, this use of the imagery of the war can be seen to be a powerful feature of Duffy's (2011b) work, drawing upon the emotional intensity and pity that these scenes of warfare induce. In *Last Post*, Duffy (2011b) imagines the poet being possessed by the power to write the war over, to save the lives of millions from '… that moment shrapnel scythed you to the stinking mud …' (Duffy 2011b: 4). However, the usage of these themes and imagery, the reliance on this 'topos' of the Great War, perhaps emphasises not a lack of imagination on the part of the audience or the authors concerned with detailing the experience of the events of 1914–1918, but perhaps represents a desire from both the creators and the consumers of this media to witness the conflict in this particular manner above others (after Fish 1980).

The Great War: History

These 'common elements' of remembrance have been the object of sustained criticism from revisionist historians who regard the limited and often maudlin or emotive representations of the war in the popular media to be an inaccurate account of the events of the Great War (Bond 2002). Within these analyses, the 'Western Front' or 'Gallipoli', which have frequently been re-imagined through literary accounts, forms an entirely separate arena from the reality of the battlefields of the Dardanelles or northern France and Flanders (after Badsey 2001). Historians have decried the media representations of the war as relying solely upon the post-war memoirs of a disaffected officer class whose wartime experiences did not reflect the attitudes and ideas of the wider body of troops within the British Army (after Beckett 2001). Letters, diaries, memoirs and oral testimonies of veterans recount a plethora of outlooks some of which are positive and enthusiastic for the wartime duties and the victory that was secured (see Carrington 1965). Scholars have highlighted the relatively high morale and commitment of the British soldiers to counter the perception of 'disillusion' in the trenches (Silbey 2005, Watson 2008). Significantly, the Great War is promoted in these accounts as a 'forgotten victory' within Britain (after Sheffield 2002). The image of pity and bleak despair which is thought to be portrayed in the media representations of the war is thereby contrasted with the image of a war whose cessation brought relief and celebration in Britain (see Gregory 1994). Armistice Day in the immediate post-war era was indeed a moment for national celebration, for Officer Balls and reunions of comrades as well as for the mourning of the dead. However, this particular response was replaced in the post-war world as economic recession, growing support for pacifism and fears of European militarism became influential within public life (Todman 2005).

Despite this critique of the 'popular memory' of the war by contemporary historians, the discipline of history itself has contributed to the perceptions of the conflict (Braybon 2003). Since the declaration of the Armistice the historians of the war have provided particular frameworks to consider the experience and impact of the Great War (Grieves 1991, Simkins 1991). In the initial aftermath of the conflict, the official government-sponsored histories provided detailed if not dry accounts of the actions of the British Army in the field (Green 2003: 10). These largely uncritical records listed the events of the war, the loss of life and the cost both in material and manpower to achieve victory (see Edmonds 1922). These testaments were largely substantiated by the publication of the wartime diaries and memoirs of the members of the General Staff in the early 1920s (Haig 1919). Following these initial historical assessments, notable military historians surveyed the field and used the war to critically consider the pursuit of the war (see Liddel ✗ Hart 1928, 1930, 1934). Issues of tactics, deployment, logistics and communication were the objects of these historical enquiries as the manner in which victory was achieved was examined. However, these trends in historiography altered after the events of the Second World War, as shifts in society and thereby the work of historians provided another perspective on the war (Danchev 1991). A wholly critical assessment of British Army policies was provided and a greater focus of the lives of those who experienced the conflict first-hand is clearly discernible in these works (Taylor 1963, Wolff 1959). This trend was emphasised in the 1960s and 1970s as an explosion of interest in oral history ensured that the veterans of the war both from the battlefield and the home front were encouraged to relate their responses to the events of the Great War (Middlebrook 1971). Subsequent developments in social and cultural history have enabled new avenues of enquiry to be explored as the subject of the war has become a part of the canon of academic historical study (Purseigle 2005, Purseigle and Macleod 2004, Jones et al. 2008).

In this way, historical enquiry, whether of a military, social or economic hue, has also provided a framework for the remembrance of the Great War. This is particularly evident in the recent surge of interest in family history, as descendants of servicemen and women have scoured official and private records for details on the life of a relative (Spencer 2008). This endeavour has been greatly facilitated by the digitisation and online accessibility of the records of the Commonwealth War Graves Commission. Recovering or uncovering these histories serves to reconnect a current generation with the past and establishes a strong link between the present and its concerns and this historical event. Before the advent of the 'digital age', organisations such as the Western Front Association, founded in the 1980s, also provided this access to the past. Similarly, the last two decades have seen an upsurge in the research and publication of regional histories of the war, whether the experiences of those on the home front or on the battlefield (see Bilton 1999, 2003). Accounts of the experiences of 'Pals Battalions' or local regiments have been researched and published, largely by local enthusiasts or amateur historians, to perhaps provide a particular locality or region with a relationship to the war or to reaffirm the connections as the veterans of the war pass away.

Despite the capacity for historical study to provide a frame of understanding for the conflict for current society, there is a tendency to largely ignore the assumptions that underlie historians' own field of study whilst highlighting the flaws in the media representations of the war and the limitations of the 'popular remembrance' of the conflict within Britain. These assessments have taken the initiative from the seminal study of Hobsbawm and Ranger (1983) regarding the 'invention of tradition', where the genealogy of cultural practices were considered to highlight the conscious construction and unconscious fabrication of national and cultural narratives. The cherished notions of patriotic identity, pride and practice were shown in this assessment to be myths born out of a modernist project to reaffirm the principles of the nation state. Utilising the principles of this classic study, historians have tracked the development of the 'myths and memory' of the Great War in Britain (Todman 2005). As stated, these studies have highlighted the diversity of responses to the war both within the army and within wider public life. Feelings of pride, grief, sorrow, anger and duty were expressed in the years immediately following the conflict. This complex response to a momentous event with individual, local, national and international repercussions is perhaps best reflected in the erection of the war memorials across the country and the cemeteries and memorials on the battlefields. However, from this plethora of opinion, historians have identified the development of a largely uniform canon which is generally traced back to the work of the war poets, specifically Wilfred Owen and Siegfried Sassoon. The popular readings of these individuals are considered to have framed the Great War as the 'trenches of the Western Front' and the conflict itself as being a 'futile, waste of life', where the stoic soldiers who suffered the privations of war were 'lions led by donkeys'. Certainly, the place of Owen and Sassoon in the memory of the war is undeniable (see Onions 1990). It is their work which is often used as both a form of shorthand for discussing the conflict and as a means of remembering it. For example, Sassoon's (1918: 31), *Suicide in the Trenches*, evokes the tragedy of the war, the brutal, inhuman conditions of the battlefields and the indifference of those who ordered the soldiers to fight:

> Sneak home and pray you'll never know
> The hell where youth and laughter go.

Owen has achieved a far higher status as the soldier poet who died days before the declaration of the Armistice in November 1918 (Stallworthy 1993). His own life is therefore viewed as emblematic of the catastrophic nature and cruelty of the conflict and his verse is saturated with this sense of pathos. The anthemic *Dulce Et Decorum Est* (Owen 1965: 55) is used both to lament the loss of the dead and to castigate society for the sense of patriotism and duty that led young men to such horrific deaths on the field of war:

> Bent double, like old beggars under sacks,
> Knock-kneed, coughing like hags, we cursed through sludge ...

The inclusion of these works in the National Curriculum and their use at Remembrance Day events has reinforced the perception of both Owen and Sassoon as the authentic 'voice' of the war. The establishment of this accepted version of the war has been lamented by historians as they seek to highlight an alternative interpretation of the conflict (Terraine 1980). Whilst the limitations of the war poets to describe the entirety of the Great War is apparent, the search for the 'origins' of the myths and memory of the war is itself highly restricted. As historians have attempted to undermine and challenge the popularly held ideas about the Great War, they have neglected to ask two significant questions regarding the memory of the war in Britain. Firstly, there is an absence of consideration as to why this memory of the conflict has proven to be so pervasive. If the remembrance of the war is so limited, for what reason is it so evocative? A number of scholars have assumed that the ease at which 'media memories' of the past are consumed lies at the root of the issue. However, such an analysis does not account for the similarities in these representations of the war. If the imagery of the war in novels, film and television has taken such a narrow account of the war in their depiction, it affirms a far more active aspect of its audience, that there is an expectation that the war should be portrayed in this fashion (see Wilson 2008a). We can, therefore, consider that with this expectation there is utility; the war is remembered in this way because this memory does something for wider society and the individuals and groups who hold it. Secondly, there has been a tendency to assume the validity of a 'singular national' remembrance of the war in Britain. The terms 'popular memory' and 'national memory' are often employed without critical assessment in examining the manner in which images or ideas of the Great War have become dominant. Both these issues disregard the nature of the construction of memory, heritage and indeed history as a multivocal, contested engagement as well as a local process (after Cubitt 2009, Hodgkin and Radstone 2003, Radstone and Hodgkin 2005, Radstone and Schwartz 2010).

The Great War: Heritage, History and Memory

By examining the 'heritage' of the Great War in Britain the relationship between the history, memory and the act of remembering the conflict will be placed under scrutiny (see Wilson 2008a). The term 'heritage' is one which has become a specialist field of enquiry within academia and also increasingly within the public realm, but it is an expression whose use is problematical (Smith 2006, Smith and Akagawa 2009). Scholars have sought to identify what constitutes heritage, both for analysis and for use in legal and political issues as activists have drawn attention to problems of the preservation and destruction of the material and immaterial environments of cultures, groups and communities (Graham and Howard 2008, Howard 2003). Rather than search for a concrete definition as a guide, it would be more suitable to consider 'heritage' and the denotation of 'heritage' as a verb rather than as a noun, emphasising the active

engagement of the process (after Harvey 2001: 327). For in essence, heritage lies in the action of appellation; naming a place, practice or performance as 'heritage' qualifies it as an object of value and purpose (Dicks 2000a). Heritage constitutes a tool that contemporary society calls upon to establish a connection between past and present (see Sørensen and Carmen 2009). This connection is made to validate, substantiate and to activate present-day concerns (after Hewison 1987, Lowenthal 1985). Therefore, the process by which this action of naming 'heritage' takes place is always conducted within a wider context of social, political and cultural factors (Ashcroft and Graham 2005). As such, heritage has been evoked to legitimise normative attitudes and behaviours, thereby disenfranchising economic, social, ethnic and political groups (see Robertson 2012, Smith et al. 2010). In contrast, dissonant modes of heritage have also been mobilised to re-establish the place of minority groups or ideas within a wider national or cultural collective (Ashworth et al. 2007, Tunbridge and Ashworth 1996). Following these approaches, within this analysis of the heritage of the Great War, the mechanics of remembering will be exposed as groups and communities assert their connection to the past.

Whilst the complex processes that accompany the naming of an object, place or practice as 'heritage' has been assessed, the manner in which it structures perceptions about the past, mobilises ideas about history and provides a framework for contemporary society to engage with an earlier material or immaterial environment has also been of increasing interest to scholars (Ashworth and Graham 2005, Graham et al. 2000). In this work, heritage is a frame through which society understands contemporary issues; to enlighten, illustrate or to emphasise present concerns with past precedents (after Smith 2006). To illustrate this, a basic analogy with the framework of the 'Common Law', used within the legal jurisdictions of most English-speaking countries, would not be inappropriate, as an appeal to 'how things were' and 'how things have been done' renders quite clear both the sentimentality of appealing to the past as time-honoured tradition as well as its potential use to disrupt or judge a complacent or forgetful present (after Macdonald 2009). As a frame through which to view both past and present, heritage serves individuals and communities by placing issues within a comprehensible structure (Benton 2010: 5). Assessing heritage as a frame of reference provides the analyst with the means to examine both the construction and the use of these perspectives on the past (West 2010). The application of these frames does not limit or bound the perception of the past into a particular set of understandings: a trap of nostalgia and romanticism (see Shaw and Chase 1989). It enables the apprehension and communication of the past as a social reality which is expressive of the needs and desires of individuals and communities (Dicks 2000a). It is these drives which proponents of the theory of 'frame analysis' describe as organising the manner in which the world is perceived (see Hallahan 1999, Scheufele 1999). In this theoretical approach, the understanding of the world is never without a preconfigured interpretation; we organise the world perceived 'as' something already comprehended (after

Heidegger 1962: 191). In this manner, the Nietzschean (1968: 267) drives for domination and control are often cited as influential in the construction of perceptual 'frames':

> It is our needs that interpret the world; our drives and theirs, for and against. Every drive is a kind of lust to rule; each one has its perspective that it would like to compel all the other drives to accept as a norm.

In considering how frame analysis can be used within heritage studies, these 'drives' are essential in the construction of the frames in which we consider how past individuals and societies functioned and their relevance in the present (after Howard 2000: 213). These frames are, therefore, the conceptual structures which guide and inform the perception of the past (after Goffman 1974: 10). How the past is perceived or how heritage is understood is dependent upon these frames. As such, the use of referential frames to comprehend and to structure notions of history as well as the present must be considered as an active, responsive process: 'frames are principles of selection, emphasis and presentation composed of little tacit theories about what exists, what happens, and what matters' (Gitlin 1980: 6).

By applying this theory of 'frame analysis' to the field of heritage studies, a greater assessment of both the presentation and the reception of the past can be enabled. For example, an investigation which assessed the frames through which an English country house is perceived could consider its presentation as an architectural contribution or as an icon of national achievement. Conversely, the same country house could be viewed as a symbol of political domination or class oppression through another 'framing' of heritage (see Smith 2009). The construction and use of these different frames are inevitably intertwined with the wider social and political environment (Goffman 1974). Therefore, they are utilised because they provide individuals, communities and societies with a means of perceiving the past that asserts an aspect of themselves which reflects their needs, drives, desires and expectations. Assuming that there is a 'dominant' mode of representation or frame through which heritage is perceived is highly valuable. However, it does not account for why individuals would mobilise such a perception which might be against their own interests or apparent logic. Certainly within a Foucauldian approach, individuals might assume a dominant, normative mode of representation as they are transformed through the operation of power within society thereby becoming the agents of their own domination (Foucault 1980). Yet this analysis is highly limiting and dependent on the perception of individuals as passive automatons (Habermas 1987). Therefore, within this investigation, the application of frame analysis operates on the basis that particular frames are used within society that structure and render the past into a comprehensible format. These frames are used because they do something for those who employ them. In this manner, active agents use 'frames' to create a particular perception of the past and a specific appreciation of the present. This is undertaken to mobilise the past in a way that informs and shapes current concerns of identity and place as well as power.

Consequently, 'remembering' within this context is an active choice by individual, groups, or wider society; a choice which is situated within a nexus of cultural and social issues. Wertsch (2002) considers this nature of agency to be the key basis of study, as remembering is always 'something that we do' (Wertsch 2002: 17). This dynamic attribution of memory is formed through the way in which cultural forms, such as monuments, memorials, novels, films, narratives and images are 'framed' by agents in the act of remembering. These cultural forms, whilst possibly originally intended for a specific narrative regarding the past, provides a means through which alternative, dissonant or affirming narratives are created (Wertsch 2002: 6). The investigation of these frames entails the analysis of the cultural forms that are mobilised within this frame. It also requires an understanding of how such frames are produced by the state or institutions and how they are used by individuals and communities (Wertsch 2002: 6). This creation of frames through which the past is perceived is regarded in this examination as a subtle interplay between agents and cultural forms. This ensures that the analyst is concerned with examining how heritage is framed and perceived, the interplay between the agent and the object they contemplate (Wertsch 2002: 6–7). The value of this approach is that it ensures that heritage and the denotation of heritage is viewed as a dialogue rather than focusing on one party over another. This also argues against the naïve assumption that cultural forms operate to influence and shape memory or define notions of heritage. In this approach we can consider cultural forms such as historical texts, memorials, landscapes, novels, television programmes, films or more intangible legacies of the past such as phrases, images, perspectives or abstract notions of trauma or pride as constituents in the frames that are constructed within society to comprehend the past and view the present.

Outline of the Book

To investigate the frames which form part of the cultural heritage of the Great War and analyse how these outlines reflect and structure contemporary perceptions, the usage of phrases, references, perspectives, metaphors and imagery that relate to the conflict within popular, media, heritage and political discourse will be examined. This 'intangible heritage' of the war forms the medium through which the events of 1914–1918 are considered and maintain a place and value across British society. By perceiving the events of the Great War in this manner particular connections between the past and the present are made, thereby providing a reference point for the war and the demonstrating the utility of the 'heritage' of the conflict. By examining the history, usage and meanings of references to the Great War across a variety of media, including local and national newspapers, historical societies, political publications and manifestos, the heritage sector, popular expressions, blogs and internet chat rooms, an analysis of the frames of reference which structure the remembrance of the war in Britain can be created. This is the 'cultural heritage' of the Great War in Britain, identifiable through the

manner in which the conflict is evoked by individuals, communities and wider society through the 'frames of remembrance'.

The analysis of the cultural heritage of the Great War in Britain poses questions regarding both methods and terms. To use Britain as the focus of analysis is increasingly difficult as devolution and moves for independence have questioned the future of the United Kingdom (see Nairn 1977). To speak of Britain as a cultural and political entity with the assumption of a collective character or imagination is therefore highly dubious in such a fractious environment (see Graham and Howard 2008). Indeed, this is a significant issue in assessing the memory of the Great War across Britain as too often what is regarded as a facet of the 'national' remembrance of the war could be more accurately classified as a 'regional' and specifically a 'home counties' and 'English' association with the conflict (Bond 2002). To avoid such assumptions, which obscure the varied ways in which the Great War is evoked across society, this assessment makes a particular point of the preposition contained within the title of the book. This is a study of the cultural heritage of the Great War *in* Britain. As such, 'Britain' is treated as a geographical entity for the delineation of analysis rather than as the political object of study. This is not to suggest that the cultural heritage of the war is used to construct and maintain national identities and national myths, it is to establish that these myths and identities are not tied to a collective and stable notion of 'Britain'.

The chapters of this book reflect this concern and are arranged thematically to examine various aspects of the 'cultural heritage' of the Great War through assessing the language, imagery and metaphor used in the framing of the remembrance of the conflict. This analysis will detail how the memory of the Great War is mobilised across regions, groups and communities across Britain to comment upon contemporary issues. Therefore, the manner in which the past and present are drawn together will be the subject of study as the construction of frames of reference creates a particular means by which to perceive that past and present. Chapter 2 emphasises this process of the construction and uses of heritage as it examines the modes by which the war is considered within public, political and media discourse. One of the most subtle but important aspects of the cultural heritage of the Great War in Britain is the way in which the war has left a unique legacy as the source of additions to the lexicon of popular English usage. Names, words, songs, phrases as well as metaphor and allusion provide a means of both remembering the conflict but also to frame it in a particular manner in the present. The role of intangible aspects of a culture, such as language and expression, as a significant aspect of cultural heritage and popular memory have been well attested in recent years (see Ruggles and Silverman 2009, Smith and Akagawa 2009). Drawing upon this work and utilising approaches within Critical Discourse Analysis (Fairclough 1995), this chapter examines the employment of expressions which stem from the conflict such as 'over by Christmas', 'in the trenches', or 'over the top', within popular, political and media discourse. By investigating both the historical sources of these expressions and their appearance in the discourses used by contemporary newspapers, online forums, political debates, blogs and

historical groups, the manner in which the Great War is called to mind can be analysed. Popular discourse that references 'the trenches' or 'the Somme' are considered in this chapter to be more than attempts to present a colourful turn of phrase but expressions of political and social importance. Through these frames of representation, ideas about modern war, the role of the state and societal inequalities are communicated. These idioms provide a framework through which the Great War is remembered but also brought to bear on present and future contexts.

Chapter 3 continues this assessment of how the remembrance of the war has been structured by examining how the conflict is accompanied by a particular set of images which serve to frame its remembrance (see Wilson 2010). Indeed, to speak of the Great War in Britain is to immediately evoke an image of devastated landscapes, mud-filled trenches, beleaguered soldiers and mass death represented in the form of memorials or cemeteries. The sepia-toned pictures of soldiers at the front would even appear to reaffirm what is already known about the war. This almost automatic response by which certain images of the conflict are conjured in the present is a significant feature of the cultural heritage of the war. Whether through visual representation or description, these images are drawn upon by historical societies, newspapers, family history networks, heritage sites and online communities to illustrate the war. However, these images carry important social and cultural effects as they constitute a means of 'framing' the war in a particular manner. By examining the history and contemporary usage of these images this chapter will assess how the employment of specific images communicates issues of political, social, regional and national identity. For example, the pictures of the battlefields, of cratered and debris-strewn landscapes, are used to indicate 'man's inhumanity', 'the horrors of war' or the 'horrors of mechanised warfare'. Pictures of the cemeteries of the war are also drawn upon to stress ideas of 'sacrifice', national or imperial endeavour and conversely the incompetence of governments or officials. Similarly, images of downtrodden soldiers or trench-bound units from the 'Pal's Battalions' or from Scottish or Welsh Regiments are mobilised to evoke regional and national identification and empathetic links with the past. Images, therefore, form a rhetorical device to represent the war within contemporary Britain. However, as some images are perceived to be the 'correct' or 'preferred' visualisation of the past, others are closed off or rejected for their depiction of the conflict. Through investigating the use of images of the Great War and the ideas that they are considered to convey, the cultural heritage of the conflict as a system of values and beliefs can be analysed.

Chapter 4 builds upon this use of image by addressing the issue of perspective within cultural heritage: the position from which the past is remembered. The chapter assesses how the 'view from the trenches' has served to construct a particular means by which the memory of the war has been mobilised. The concept of 'the trenches' possess great importance and significance within the cultural heritage of the Great War. References to 'the trenches' abound within popular culture and are used in various contexts to express how opposing opinion divides groups ('entrenched'), how an opinion is derived from first-hand experience

('from the trenches') or how individuals or groups are positioned amidst action and development ('in the trenches'). The usage of the 'the trenches' within these contexts reveal the assumption which is a singular feature of the cultural heritage of the war that to speak 'from the trenches' is to possess a value of truth. Indeed, the 'view from the trenches' denotes a veracity which is rarely open to challenge. This perspective on the past is demonstrative of an imaginative, empathetic or sympathetic connection with the ordinary soldier and it is utilised within local and national politics, popular discourse and the wider media to comment upon contemporary contexts in Britain. Through an examination of the historical development of this connection with 'truth' and 'the trenches' and a consideration of the perspectives provided by the war poets, the employment of this mode of representation will be analysed. The references to 'the trenches' will be assessed as a means of placing the individual or group within both a position of authority whilst implying a status of 'victimhood' (see Alexander 2001: 3–5). However, whilst this discourse is used within political and social contexts in movements for issues such as equality or reform, it does not represent the only means of evoking the perspective of participants in the conflict to critique the present (after Brown 1995: 20). This chapter will address how the Great War remains current within British society by assessing the 'views' from the past as frames which are mobilised for current concerns.

Chapter 5 expands upon this idea of utilising the perspective of the past for present day issues by considering how the 'myths and memory' of the war have been constructed and maintained within groups and communities in society. The popular memory of the Great War in Britain has been undermined for venerating myths of the war and obscuring the historical 'truths'. Historians have criticised representations which reiterate what are regarded as the clichés of the conflict, such as underage soldiers in the trenches, the camaraderie of the 'Christmas Truce' of 1914 or the disillusion suffered by the ordinary ranks before they were sent over the top to face the slaughter of machine gun fire. However, despite the 'debunking' of these myths they remain current with contemporary Britain. Much to the consternation of some historians, these stories of the conflict have proven to be highly persistent. Across newspaper coverage, media representation and the heritage sector the myths and memory of the conflict are rehearsed. The reason for the endurance of these ideas about the past is that they are chosen for what they reflect about contemporary society, rather than their historical accuracy (see Edkins 2003: 5–7). Nevertheless, this lack of historical background does not make these stories any less significant. Therefore, this chapter will identify an array of myths that appear to underlie the cultural heritage of the Great War and assess the way in which they are used to narrate and illuminate issues within modern Britain. These myths and memories form a means of framing the Great War and comprehending its assumed 'message' for contemporary society.

Chapter 6 examines the wider usage of the cultural heritage of the Great War by assessing the manner in which it informs issues of identity, politics and place through museums, memorials and memory. Throughout the towns and cities

across Britain, museums, libraries, galleries, archives and memorials constitute the tangible heritage of the conflict with memorials exhibitions, displays, documents and artefacts. These items and spaces are used and interpreted by the public to place themselves in relation to the history of the conflict. They provide a means of building a perspective or a framework on the past that builds relationships and develops a consciousness of the war. This material heritage of the war, therefore, shapes ideas about identity and place at a local and at a national level. As communities acknowledge their wartime history in regimental museums, memorials to 'Pals Battalions' and exhibitions in libraries and archives, the heritage of the conflict is utilised to present a specific identity for that community. Similarly, recent moves within Scotland and Wales to specifically remember countrymen that served within the British Army also constitutes a means to draw upon the cultural heritage of the Great War to create distinct identities in the present. Alongside this process, memorial activities, commemorative acts and the physical heritage of the war are employed to create specific political and moral identities. The invocation to 'remember' in modern Britain is assessed within this chapter as a process of establishing a sense of self that requires individuals to 'frame' their understanding of the Great War in a particular manner. Therefore, this chapter examines the various types of regional, local, political and moral identities that are established through the physical heritage of the Great War to analyse the frameworks through which the conflict is remembered.

Chapter 7 concludes the book by reviewing the manner in which the cultural heritage of the Great War is mobilised across contemporary Britain. As such, this conclusion will detail how the conflict is used as a means of expressing identity, place and politics. The focus of this analysis will be to highlight how the cultural heritage of the Great War forms a means of expression which has wider implications within society. The cultural heritage of the Great War, when expressed in such sentiments as, 'lions led by donkeys' or 'mud, blood, rats and gas', possesses a critical or dissident perspective upon society, its institutions and its government. However, such frames of reference could also serve to exclude and limit social participation as association with a formative trauma within society could be barred to others (after Eyerman 2001: 7). What is considered within this chapter is the manner in which the cultural heritage of the Great War constitutes an anti-democratic discourse, a necessary critical agenda within a democratic society (Brown 1995, 2001). This function of heritage also affirms the use of 'frames' through which the Great War as an active choice, a reasoned and purposeful act of remembrance which reflects contemporary needs, fears and desires. Through this conclusion, the core theme of this assessment will be reiterated, that the heritage of the Great War is utilised and altered by those who hold it to be significant and that the war serves as a cultural resource to inform, illustrate and contest issues of politics, culture and identity across Britain.

Chapter 2
Slang and Sayings – War Discourse

The reference to the Great War in popular discourse within Britain is substantial. Implicit and explicit allusions are frequently made to the conflict within public life. Despite the passage of time since the Armistice of 1918, it is through language, metaphor and allusion that strong links to the past are made to create and maintain the cultural heritage of the Great War (after Macdonald 1997). The discourses that structure heritage as an aspect of society, revealing the configuration of social, cultural and political power have recently been highlighted by a number of researchers (see Smith 2006, Waterton 2010). These assessments have drawn attention to the ways in which heritage is talked out by various sectors of society indicating the operation of power and control (Ashplant et al. 2000). This mode of analysis utilises the work of Fairclough (1995, 2001) in the field of 'critical discourse analysis' which examines how the usage of language identifies issues of identity, authority and order (van Dijk 1988, 2008). The employment of pronouns, phrases and prepositions by individuals and institutions of authority has been shown to structure society, whilst dissonant ideas are equally expressed in the application of language. Using these analyses, the language, phrases, metaphors and idioms in which the Great War is called to mind can be examined (after Schudson 1992: 150). Therefore, this chapter will examine how the conflict of 1914–1918 is evoked in public spheres across Britain to affirm aspects of politics and identity. It will examine how the usage of language in popular, political and media discourse 'frames' the remembrance of the Great War in particular ways. The conflict forms part of wider social life through these 'frames' as it enables a way of considering the past and its implications for the present. Language, phrases, expressions, metaphors and allusions thereby constitute the cultural heritage of the Great War as they provide a framework through which individuals and communities remember and mobilise the memory of the war for contemporary debate.

The war of 1914–1918 supplied a great many additions to the 'linguistic toolkit' in Britain. Soldier slang, pidgin French and Flemish, popular songs and military terminology became common expressions during the period as a large citizen army shaped wider popular culture (Brophy and Partridge 1931, Gallichan 1939). From the Edwardian music hall number *It's a Long Way to Tipperary*, written before the war but seemingly capturing the public spirit after 1914, to the soldiers' expression of 'San Fairy Ann', a corruption of the French 'Ça ne fait rien' (It does not matter), the legacy of this 'war vernacular' remains highly prominent within communities and wider society (see Wilson 2011). Regardless of the pervasive manner of this discourse, this usage of the 'war vernacular' in particular social and political contexts reveals a significant aspect of the way in which particular 'frames' are constructed to remember the conflict. Employing words, phrases

and terms associated with the war is thereby a means by which individuals and communities utilise the cultural heritage of the conflict to substantiate ideas in the present. Rather than assuming that such usage is an unconscious practice of the wider cultural lexicon, the employment of a distinctive 'war discourse' is regarded here as an active choice where language has been used to affirm a specific memory of the conflict and assert aspects of identity, politics and place (after Waterton and Wilson 2009).

To mention the words or phrases from the war, such as 'the trenches', 'the Western Front', 'Somme', 'Ypres', 'Verdun', 'Gallipoli' or 'Messines' still holds an almost hypnotic element across many communities in Britain. Evoking these names possesses a solemn quality which requires a certain reverence amongst its audience. The naming of these battlefields, where thousands of British troops died, or reference to the atrocious conditions endured by the soldiers in this manner serves as a frame through which the war is remembered. These names are not neutral purveyors of data; they are saturated with an interpretation of the war as a bloody, futile waste of life: a specific remembrance, borne from a specific need to remember (see Wilson 2008a). For example, the process by which the 'Somme' or 'the trenches' have become bywords for death, destruction and solemn pity reflects the way in which succeeding generations have utilised the cultural heritage of the war. Through these references to places, experiences and sayings the Great War has been remembered within a particular frame to judge and to assess the present. By assessing the usage of the 'war discourse', the role of the cultural heritage of the Great War across Britain can be analysed.

In the Trenches, Trench Warfare and Entrenched

The references to 'the trenches' or aspects of 'trench warfare' abound within public discourse within Britain. The terms originally became intimately familiar to the soldiers and the public alike during the years of the First World War as news from the front, direct 'from the trenches' offered solace, security and a source of gossip (see Farrar 1998). The expressions also developed sinister associations, as for returning soldiers and concerned family members 'the trenches' marked the place of death, dismemberment and dislocation from home and a sense of safety (see Das 2005). The modern usage of these terms displays a marked similarity with their wartime origin (see *OED* 2002: 262). Across wider society, individuals and communities use these terms to describe exposure, danger, combative stances and active roles (see Ammer 1989: 235). Denoting a particular context as 'trench warfare' is a significant example of this contemporary convention. Indeed, the descriptor of 'trench warfare' has become a frequent presence in political accounts as it is used to serve as a description of dogged encounters between competing ideologies. In this fashion, former Prime Minister Tony Blair (1997: 74) discussed the 'old Labour party politics' in his bid for election in 1997:

There was fault on both sides, but the atmosphere of trench warfare which so often existed on what was then called "the shop floor" was unacceptable in a modern economy.

Similarly, an article in the political and current affairs magazine, the *New Statesman* (Bright 2008: 10), described a more recent encounter from 2009 within the Labour Party in the same manner:

> In the trench warfare that passes for Labour politics these days, Gordon Brown and his generals have spent the conference season pounding another set of rivals into the dirt.

This usage is not restricted to one side of the political divide, indeed former Prime Minister John Major (1999: 213) makes reference to 'the trenches' in his memoirs as he describes the bruising encounter within his own party in 1992:

> At the end of it, the Maastricht Treaty had been ratified after a year of gruesome trench warfare in the Commons, but only by the narrowest and most nerve-shattering of margins.

To evoke 'trench warfare' is, therefore, a means of illustration, but it relies upon a particular understanding of the war as a grinding, conflict of attrition with little respite and slight returns in the way of production or development. Such a perception is significant as the usage of 'trench warfare' to describe situations other than those of the First World War demonstrates a common and communicable understanding of the expression. In essence, demonstrating the existence of what Stanley Fish (1980) describes as 'interpretative communities'; self-constructing groups within society that maintain particular patterns of understanding and perspective because of a shared agenda or interest (Fish 1980: 15). In this manner, 'trench warfare' is particularly significant within the political sphere for its association with futility and waste. To label a context as 'trench warfare' is to undermine or question its value and its rationale. Therefore, newspaper headlines such as 'Budget 2010: David Cameron prepares for 48-hour trench warfare' (see D'Ancona 2010), which discusses the events leading to the announcements of the government's key economic policies, reveals the assumptions of pointless political barrages and ineffectual volleys of ideological insults. Similarly, the usage of this reference of 'trench warfare to refer to the futility of a situation, is relied upon to describe the wider political sphere within contemporary Britain at a national and at a local level. The author Robert Harris (see Gilbey 2010), discussing his political affiliations described in a newspaper interview how:

> politics now is simply a 'trench warfare of managerialism' ... people, from left and right and doubtless middle, who lament the state of British politics. I used to

> love politics. I can't say I do any more. All the fun has gone out of it. Each side
> is engaged in this trench warfare of managerialism.

Similarly, in 2011 the editorial within the *Belfast Telegraph* (Editor's Viewpoint
2011) lamented how politicians in Ulster were concentrating on personal agendas
rather than motivating the public's interest in the political process:

> Unless we challenge politicians to up their game, give us clear thinking on
> important issues, abandon "trench warfare" this poor state of affairs will
> continue.

This usage of a reference to the Great War enables the user to decry a situation as
a reasonless waste, using the expression as a frame through which to evoke the
remembrance of the war as a futile military engagement. Alongside its appearance
within a political context, its use within a business and a legal sense also follows
a similar pattern as commentators assess how different interest groups are
locked within a debilitating stalemate over a variety of issues. For example, the
attempt to create some form of consensus over the future of public transportation
in Edinburgh was described in exactly these terms; 'Duo aiming to end trench
warfare of capital tramworks' (Dalton 2010). However, despite the prominence of
this reference within the political sector and its critical deployment, this usage of
'trench warfare' appears to carry no direct political comment. Whilst individuals
might be described as engaged in 'trench warfare' within political discourse, this
refers to the proclivities of the individuals themselves rather than the carrying
association with issues of authority and responsibilities. In this way, 'trench
warfare' is a neutral assessment of a situation, one which carries no indignation,
sorrow or action, it reaffirms the perception of the conflict as meaningless but casts
no accusation of blame or accountability.

The apolitical application of the term 'trench warfare' stands in direct contrast
to the politicised usage of 'trench warfare' within wider public discourse. To
evoke or refer to 'trench war' in this manner is to make an explicit political and
social comment as it critically refers to the conditions of the battlefields and the
authorities whom are assumed to have placed soldiers at the front. The reporting
of stories in the national and local newspapers in Britain that relate to the First
World War often refer to the 'grim', 'gruesome' or 'horrific' life in the trenches
and the 'senseless' waste of life by 'incompetent' politicians and military officials.
As such, references to 'trench warfare' carries implicit and explicit criticisms
of contemporary political policies. The brutal experiences of trench warfare are
considered to have irrevocably altered society. Wheatcroft (2001), writing in the
Observer newspaper, regarding plans to recreate the 'trench experience' for a
reality television programme demonstrates this perspective:

> Their fate was certainly sacrificial, and it changed history. But not in the way
> that their commanders and rulers supposed.

This discussion of the trenches and trench warfare to highlight issues in the present day provides its users with a means to frame the remembrance of the conflict in a particular manner. Representations of the trenches or trench warfare provide a means to reflect on current concerns. For example, a revival of the 1921 R.C. Sherriff play, *Journey's End*, which is set in the trenches of the Western Front, in Birmingham in 2011 was reported in the local newspaper as possessing the power to 'speak' to its audience not only of its own time but of theirs (see Jackson 2011):

> The play may have been first staged more than 80 years ago, but its message and understated dramatic power remain fresh and relevant.

Similarly, a display of wartime photographs used in the broadcast of the television documentary *The First World War* (2003) is assessed as linking individuals with those who served in the trenches to enable a comparison with their own lives:

> There are so many things that join us up to that time and to those people, and make us think about what we would do in those circumstances (Anon 2003a, 'Truth and the Trenches', *The Scotsman*).

The reference to 'trench warfare' or to 'trench war' is used to connect past and present as these terms serve as particular frames through which a specific memory of the war is called to mind; a memory that emphasises suffering and pity and mobilises resentment towards those in authority whose predecessors are considered to have prolonged the conflict. For example, the 2006 campaign for compensation by members of the British Army for foot injuries sustained in operations and training exercises was specifically linked in some media outlets to the wounds sustained in 'trench warfare' by British First World War soldiers (see Anon 2009a).

> About 150 soldiers are claiming compensation from the Ministry of Defence for injuries caused by the cold similar to the infamous First World War "trench foot", it was revealed yesterday.

This use of allusions to the First World War and specifically to the 'trenches' or 'trench warfare' serve to heighten emotional and political responses to condemn or criticise military or civilian authorities. This has occurred most notably in the recent wars in Afghanistan and Iraq. Newspaper reports evoked the memory of the Great War and specifically the Western Front in critical pieces which decried the tactics and the progress of these operations. For example, *The Scotsman* reported in January 2007 of the incredulity of troops occupying trenches in Afghanistan; 'Almost 100 years after WWI, British troops have returned to the trenches' (Cumming 2007). Similarly, Michael White (2010), writing in the *Guardian* newspaper in May 2010 evoked the 'bloodier existential conflict' on the Western Front to highlight the deficiencies in the 2003 invasion of Iraq. In this mode of representation, the Great

War was used as a frame to situate an understanding of the war in Afghanistan. Therefore, news reports entitled 'All Quiet on Afghanistan's Western Front' recall more than the state of current operations in the field (North 2005).

The Great War is thereby evoked regularly as a means to describe and illustrate the precarious positions endured by individuals in the present. These references are utilised within a wide range of forums, newspapers, blogs and personal accounts to describe the travails of private citizens, sports stars and politicians alike. In this manner, small businesses are lauded for their efforts 'in the trenches', footballers speak of their teams battling 'in the trenches together' and worried professionals describe their experiences 'in the trenches' in opposition to those 'behind the lines'. Such uses of the 'war discourse' are more than colourful phrases as they call to mind a particular remembrance of the war. To be 'in the trenches' is at once to experience 'reality' or the 'truth' and to draw on this phrase frames the remembrance of the war in a specific manner. Whether this refers to a sporting context, such as a report that concerns local rugby teams; 'sometimes, you have to be in the trenches. At times like this, it's good to see who is going to put their hands up' (Crowson 2011); or its usage within a political activist sphere, 'In the trenches: fighting racism online' (Anon 2012a), discussing the 'trenches' in this manner immediately places the individual in a position of endurance but one of apparently moral value. To speak 'from the trenches' or to tell 'tales from the trenches' imbues the perspective with significance as it denotes experience, hardship, 'battle scars' and noble endurance. To place oneself within the 'trenches' in this fashion is to assume the mantle of heroic victim from which a valuable and apparently 'truthful' account can be derived. The frequency in which the 'trenches' are placed within contemporary discourse, implicitly and explicitly referencing the Great War, demonstrates the place of the conflict as a communicable and understandable format in which to convey meaning and value (after Fish 1980). The usage of 'trench warfare' or 'the trenches' provides a frame with which to recall the Great War, an illustration of how the heritage of the conflict is drawn upon in the present. Whilst its usage within an overt political context is largely apolitical in content, to evoke the 'trenches' within popular and media discourse is to apply a critical political perspective onto issues of authority, power and identity.

Going Over the Top

In the battlefields of the Great War, along the Western Front, Salonika and in Gallipoli, the trench structures provided a degree of safety and security to soldiers during artillery bombardments. To leave the confines of the trenches was to place oneself in a precarious position, open to enemy fire of shells and bullets as well as the confusing and perilous war landscape between the trenches (see Empey 1917). Therefore, orders to go 'over the top' on raids or attacks were treated with fear at the consequences of engaging with the enemy and exhilaration to be part of the

wider war (Wilson 2012: 134–6). Going 'over the top' became a phrase within the army that announced action but which alluded to the dangerous exposure of moving beyond the trench walls. The expression has become a standard feature of many English speaking countries today and it has maintained some of its initial meanings whilst accommodating a particular perspective on the conflict (after Ammer 1989: 177). Indeed, the uses of the expression in a contemporary context are largely confined to two areas; firstly, it denotes a sense of combativeness as one might describe an engagement with a potentially difficult situation; secondly, it describes excessive and even ludicrous behaviour which goes against the expected norms and roles within society (see Siefring 2005: 330). Each of these uses frame the Great War within a mode of remembrance that references loss, folly and endeavour, whilst drawing upon the cultural heritage of the conflict to inform and illustrate the present.

To be ready to go 'over the top' and to steel oneself for the battle ahead is a common expression within political and popular discourse. The cultural heritage of the Great War as a heroic endeavour but perhaps one tinged with tragedy as an ultimately futile pursuit is called to mind with this usage of the expression. In this manner, headlines from political arena, such as 'Armies gather to go over the top on top-up fees' (Hoggart 2003a), or, 'PM goes over the top and survives skirmish in no man's land' (Hoggart 2003b) illustrate the use of the war discourse within a contemporary context. The phrase enables a sense of defensive, embattled and active associations with the subject. Indeed, it associates with a strong responsive posture which highlights the willingness to endure and to expect or acknowledge a potential stalemate or inconclusive victory. For example, headlines which associate the phrase with wider issues, such as 'Going over the top in the climate war' (Pike 2008), emphasise the drudgery of debate and the futility of successive waves of attacks on positions. However, the reference to going 'over the top' is also one which posits a strong moral position upon the individual too. To go 'over the top' evidences a sense of ethics and dedication. In the following example, which references the reforms to the National Health Service in Britain, by the New Labour Government, this usage is clear (Hammond 2003). 'Over the top' and the Great War are explicitly evoked to reinforce an idea of probity and public service:

> So we'll all be going over the top – the Somme once more – in some absurd attempt to fulfil Blair's promise to turn round the NHS by the time of the next election.

The intensification of morality and endurance associated with the phrase 'over the top' is particularly noted when it is used in comparison with more recent conflicts such as the Falklands/Malvinas War (1982), the First Gulf War (1991), and the recent conflicts in Afghanistan (2001) and the Second Gulf War in Iraq (2003). Indeed, using overt references from the Great War to illustrate and expound upon issues concerned with contemporary military ventures heightens the phrase's significance.

For example, during the Falklands/Malvinas War of 1982, the wartime rhetoric of the Conservative Government led by Margaret Thatcher was notable for its tendency towards Edwardian nationalism (Korte 2001). As Samuel (1989) noted, it was the first time since the Battle of the Somme that arch-nationalist poet Henry Newbolt's refrain of 'Play up! Play up! and play the game!' could be evoked without irony. In this context, allusions to 'over the top' can be used to bring recent conflicts into the same frame of remembrance as the Great War. The twentieth anniversary of the Falklands/Malvinas War in 2002 served as an occasion to evoke the sense of pride and nationalism that had been propounded during the original campaign. The excerpt below from an article in the Liverpool newspaper *Daily Post* entitled 'Proud to be British' evidences the echoes of the 1914–1918 war to affirm the significance of the Falklands/Malvinas conflict for the nation:

> You get a very emotional feeling to think that people were giving their all, going over the top not knowing whether they would come home. As we know some of them didn't (Anon 2002a: 16).

Similarly, the Conservative Party Peer Lord Ashcroft (2011) also uses this reference to 'over the top' to honour the war dead of successive generations, symbolically linking current British Army servicemen and women to those who fought in the Great War:

> Whether that person went over the top at the Battle of the Somme, climbed into the cockpit of a Spitfire during the Battle of Britain or was dropped behind enemy lines in an SAS-style operation in the Falklands War, that individual, and many others like them, had to dig deep and show real courage.

However, the Great War can also be evoked to provide a critical perspective on these conflicts. For example, reference to the battlefields of the Western Front illustrates the brutality wrought by modern warfare and the responsibilities of Governments in detailing soldiers to fight in 'foreign fields'. Indeed, one veteran of the Falklands/Malvinas War recalled his experience through the frame of the Great War (see Banks 2012):

> As we prepared to advance, I thought: This is crazy. It's like going over the top in the trenches at the Somme. We're all going to be mown down by machine guns.

The anti-war campaigner and the founder of the Respect political party, George Galloway, also evoked 'the thousands ordered over the top' in his condemnation of the continuation of the war in Afghanistan in June 2011 (Galloway 2011). Therefore, explicit and implicit reference to the experiences of the First World War with the usage of the phrase 'over the top' mobilises both affirming and

dissonant perspectives as it enables access to the very different aspects of the cultural heritage of the Great War.

Interestingly, it is the critical aspect of the phrase 'over the top' or 'going over the top' which has become incorporated into the vernacular within Britain as a means of analysing or curbing the excesses within society. It serves as a way of rebuking the ridiculous. From overbearing administrative functions within institutions, to effusive and self-congratulatory review procedures and the excesses of political life and discourse, accusing another of going 'over the top' acts as a form of social critique. In this manner, the individual or group has been reprimanded for their failings to keep within acceptable social norms. The idiom of 'going over the top' derived from soldiers' wartime experiences of dangerous and potentially fatal endeavour persists as a means to describe an affront to the ordinary sensibilities of society. Observing another in this action arouses fear, suspicion and at times anger too. The utilisation of the expression within society provides a means for the conflict of 1914–1918 to be implicitly evoked and thereby implicated in the usage of the phrase. In this fashion, the assaults on the enemy positions during the conflict, where soldiers went 'over the top', are cast as ludicrous, dangerous and a departure from the accepted moral conduct of everyday life. The expression gains from this association as it casts the subject of censure as comparatively wasteful, excessive and ultimately futile.

However, whilst 'over the top' in vernacular usage bears the moral rejection of the loss of life during the Great War it also possesses the exhilaration described by the soldiers in the trenches as it implies action and a break from the routine. To be 'over the top' is at times regarded as a necessary and liberating act. From fashion, music and the arts, 'over the top' performances and pieces are lauded for their ability to escape the ordinary. These events are challenges to the orthodoxy and therefore attract censure; perhaps mirroring the struggle between the 'accepted' memory of suffering soldiers in the trenches with revisions to this perspective that stress the ways soldiers willingly engaged with their wartime duties (after Bond 2002). That some individuals revel in going 'over the top' poses problems for the norms and routines of society. Nevertheless, despite this empowering aspect, the usage of this popular phrase is largely one which enables a form of social critique, questioning injustice or investigating abuse. Intriguingly, the phrase is often activated to complain of government, police or official over-reaction (e.g. 'Police over the top at climate camp', McVeigh 2009: 15). The complaint of brutality and violence as well as bureaucratic excess is one which specifically draws upon the heritage of the Great War in Britain. It plays upon the memory of the war as one where government and military incompetence and cruelty brought about mass death amongst an armed force which was largely manned by citizens. This is a social remembrance which is mindful of a presumed dereliction of responsibility by officials and authorities. It is this heritage that the expression calls upon, as a reference to the bloody encounters of the battlefields, as it enables a means of reinforcing morally acceptable modes of conduct.

Over by Christmas

The pathos associated with the Great War in Britain is frequently reasserted with the statement that those volunteering with the outbreak of war in August 1914 were under the impression that the military engagement would be brought to a swift conclusion. 'Over by Christmas' has become a phrase synonymous with the war and the irony of its apparently unplanned longevity. Citizen soldiers are perceived to have been buoyed and persuaded by the notion that the war would be a brief adventure. Associating the conclusion of the war with the advent of Christmas festivities serves to heighten this sense of tragedy. Contrary to this view, the employment of the expression at the onset of the conflict was associated with a variety of feelings and not necessarily representative of the '*esprit de corps*' of the 'lost generation' (Halifax 2010). Indeed, the phrase may have even predated the advent of the war itself (Pennell 2012, 225–6). Nevertheless, it is the critical application of 'over by Christmas' which is used within contemporary Britain. The phrase is often employed to cast a critical eye on the policies and initiatives of governments, seemingly connecting one ill-judged action with another. The Great War is thereby brought to bear on the present; the heritage of the Great War as a means of political and social critique within Britain is highly evident in this respect.

The usage of the expression can be located predominantly within the political sphere where its latent criticism of authority can be implied by readers (after Chambers 1984). With the advent of the global recession in 2008, the phrase was re-energised as the actions of governments to stabilise financial markets to enable future growth was frequently couched in terms associated with the perceived poor planning of the military and civilian authorities in the First World War. Reported in the *Daily Mail* in May 2009, the Chancellor of the Exchequer's predictions for economic recovery were placed within this framework of understanding, 'Chancellor Alistair Darling has insisted the recession will be over by Christmas' (Fleming 2009, Pascoe-Watson 2009). The phrase assumes a doubtful, pessimistic tone which casts doubt on the authority and ability of institutions and governments. Similarly, the *Guardian* reported in September 2009 that the Confederation of British Industry (CBI) was also forecasting economic recovery in the same sceptical mode of understanding, 'Recession over by Christmas, says CBI' (Hopkins 2009). The phrase mobilises the distrust for authorities as it associates the gruelling war of 1914–1918 with the assurance of a short-term solution. The negative outlook implied with the expression is accompanied by the expectation or realisation of a long-drawn-out process. This is frequently reflected within the coverage of both sports and politics as football and rugby seasons for poor-performing teams are 'over by Christmas' whilst promises for action by local authorities are also placed within this context.

This usage of the expression as a critical, cynical assessment of the actions of authorities can be observed in the reports of the operations of British troops in the Iraq War (2003–2011) and the war in Afghanistan from 2001. Is this setting, 'over by Christmas' or stating that troops would be 'home by Christmas' provided a

means to understand the contemporary conflicts through the frame of the Great War. This was particularly apparent with the relocation of the Black Watch Regiment during the Iraq War in October 2004 from the British base in southern Iraq to the highly volatile central Iraq region between the cities of Karbala and Fallujah at Camp Dogwood. The Regiment, which had fought in Flanders and France during the Great War, immediately became the object of concern in Parliament, the national press and amongst the wider public. This deployment of soldiers was interpreted by some as a disregard for the safety of those serving their country and was placed within a framework of understanding which was derived from the Great War. In this manner, a bloody war of attrition, seemingly without purpose or end and a negligent government brought the conflict of 1914–1918 to bear on these current events (Wilson 2008). This connection between past and present was pronounced further by the assurances given by former Prime Minister Tony Blair in Parliament that the Black Watch Regiment would be 'home by Christmas': ' … the Black Watch will still be back home by Christmas at the end of their six-month period' (HC Deb, 20 October 2004, c883). This statement served to draw direct comparisons with the events of 1914 to 1918 as national newspapers used the title to cast doubt on the Prime Minister's strategy and aims in the war (see Jones 2004, J. Smith 2004, Tempest 2004). The title of the story which covered the issue in the Scottish newspaper the *Daily Record* evidences this critical usage of the phrase; 'Families pour scorn on Blair's Black Watch vow: I'll only believe my David is home for Christmas when I'm pulling a cracker with him' (see Crerar 2004: 4). The transfer of soldiers to what was regarded as the 'triangle of death' during a period of high fatalities and intense fighting during the Iraq War was frequently associated with the actions of a government that sent soldiers off to the battlefields in August 1914. Peace campaigners, left-leaning intellectuals and opposition politicians all rounded upon the claim that troops would be 'home by Christmas'. Indeed, the socialist newspaper, *Morning Star* reported the story within the frame of understanding derived from the Great War (Bagley 2004):

> A *Stop the War Coalition* spokesman recalled that the notorious phrase home by Christmas had been heard before when troops were sent to war. He added: Last time, it presaged a descent into endless slaughter – and that is what Tony Blair is committing the British troops to today.

Similarly, the *International Marxist Tendency* also reported the story with reference to the events of 1914–1918 (Lyon 2004):

> Blair even announced that the Black Watch would be home before Christmas. This is a pledge that may come back to haunt him, as it did British commanders at the beginning of World War I.

In this manner, the Great War is mobilised as a frame to comprehend and interpret current events as the heritage of the conflict is used as a means of criticising the

actions of present-day authorities. The usage of the 1914–1918 war to demonstrate failings serves to emphasise the utility of the heritage of the First World War as well as its malleability. The events of the conflict fought at the outset of the twentieth century are used to add meaning and value to the contemporary fears and anxieties. For example, the anti-capitalist newspaper, the *Socialist Worker*, covered the redeployment of the Black Watch with direct reference to the war (Anon 2004a: 4):

> James Buchanan, who has two sons in the Black Watch in Iraq, said at a protest later, "The Ministry of Defence says it will bring the boys home for Christmas. That's what they said in 1914. How many will come home in boxes?

This association between the 2004 redeployment of the Black Watch Regiment to Camp Dogwood and the events of the First World War is also explored in the stage play *Black Watch* (Burke 2007). Indeed, in the context of the Iraq and Afghanistan wars, the battlefields of the Great War became a framework through which the policies of government could be examined and unfavourably assessed. The expressions 'over by Christmas' or 'home by Christmas' are drawn upon as damning indictments of leadership as they are shown to be indicators of callous irresponsibility. This sentiment is enacted within the media but also within a wider public sphere:

> Now Tony Blair has said British troops will spend their fourth Christmas in Iraq and probably another four after that – almost double the amount of time their forefathers stayed in the trenches of the Western Front (Harding 2006: 15).

> In April 2003 he pitched some 40,000 British servicemen and women into southern Iraq in the belief that, like the Tommies going to war in August 1914, they would be home by Christmas (Fox 2009: 22).

The phrasing of 'over by Christmas', therefore, carries substantial symbolic effect in its employment as at one moment it forms a critique of official policy but it is also constitutes an alternative perspective. During the recent wars in Iraq and Afghanistan, anti-war sentiment called for the return of troops 'by Christmas', paralleling the consequences of a long, drawn out war of attrition in the world's first industrial conflict (see Roberts 2007). This call for soldiers to be 'home for Christmas' appears as a means to counter and critique the perceived inevitability of prolonged military engagement. The heritage of the Great War in this manner is used to engage and activate popular opinion regarding the nature of conflict both in the past and the present. Using the 1914–1918 war to frame contemporary experience thereby heightens and enhances the claims made by groups regarding the feasibility of military action or the competence of public officials. This usage is not solely restricted to the wars in Afghanistan and Iraq. Indeed, this mobilisation of the heritage of the Great War can be

observed in popular culture from the at least the 1960s onwards. For example, the Jonah Lewie (1980) song *Stop the Cavalry*, featuring the line 'Wish I was at home for Christmas', depicted scenes of the trenches of the Western Front as the song used the politicised lament as an anti-war statement. However, this usage does not negate the appearance of the phrase as a critical medium. This cultural heritage of the Great War within Britain is too often argued away as the vapid consumption of novels, film and television programmes. This neglects the significant ways by which the war is called to mind for use in contemporary debates. The phrase 'over by Christmas' or 'home by Christmas' reflects these issues as it has been called upon to structure the Great War in way that places greater scrutiny on the present.

No Man's Land

During the war of 1914–1918, the deployment of industrialised weaponry, the raising of mass civilian armies and the commitment of not only the combatant European nations but the various colonies, dominions and imperial interests ensured a type of warfare that had not previously been witnessed on the continent (Keegan 1998, Morrow 2004). Military officials schooled in the history of the Napoleonic Wars of large-scale manoeuvres to outflank opponents were confronted with a warfare that relied upon holding territory within defensive positions (Griffith 1994). On the battlefields of France and Flanders, Salonika and Gallipoli, soldiers of the British Army, alongside their allies and enemies, 'dug in'. This process created trench systems, substantial defensive structures which enabled armed forces to occupy ground and launch raids and attacks on the opposing force's positions (Holmes 1999). The construction of these trenches ensured the development of an unoccupied and contested space between the front lines (Leed 1979). This area became highly significant in the lives of the British soldiers on the battlefields as it was a place of both fear and excitement for troops. Attacks, raids and observations missions would be launched into this space which became known by both official designation and the soldiers' own vernacular as 'no man's land' (see Ashworth 1980). The term itself has a far longer history than the war for which it is most associated. 'No man's land', 'no-man's-land' or 'nomansland' originated as a legal definition for disputed ownership of property in the Central Middle Ages and has been variously applied to refer to dangerous, unoccupied or liminal areas since the 14th century (Siefring 1999: 201). However, it is as a moniker to describe the areas between opposing trench lines during the Great War where it has gained its common reference (OED 2002: 183).

Within contemporary usage, to speak of 'being in no man's land' or 'going into no man's land' is to communicate a sense of trepidation, isolation and the unknown. The expression is located within political, media and popular discourse within Britain and represents a significant aspect of the intangible cultural heritage of the Great War. The phrase is largely used to vividly illustrate an unnerving absence of

others. Within the spheres of sport, politics, finance and business and amongst the wider public, 'no man's land' serves to describe separation and loss. Indeed, the usage of the expression is dominant within Britain, for example, 'Postcards from No Man's Land: The desertion of Britain's high street' (Hall 2009), 'Creditors left in no-man's land over bust NHS Foundation Trusts' (Anon 2008a) or 'Fabio Capello will get caught in no-man's-land' (Hansen 2008). It is within the political arena that the expression has been thoroughly utilised as it is drawn upon to describe the politicking and partisanship of government. Politicians of all political hues who face exclusion or desertion from their erstwhile allies are depicted as lost in 'no man's land'; 'Clegg needs to find a way out of No Man's Land' (Murray 2009); 'Blair in no man's land' (Brown 1999). In this context, the phrase emphasises the isolation of no man's land. Indeed, within the professional, political and business world the expression overwhelmingly refers to remoteness and precarious endeavour in a multitude of contexts. For example, the expression could be mobilised in relation to one of Britain's most well-known high street store:

> In some parts of stores, away from M&S's clutch of in-house brands, you end up in a no-man's-land, [with] rows of clothing which don't have an identity (Felsted 2011).

Whilst the term can also be seen in relation to the political manoeuvrings within contemporary Britain:

> Scottish independence referendum: Alex Salmond marches out into political no-man's land (Peterkin 2012: 8).

Finally, such is the power and malleability of the phrase that it can also be drawn upon within a Parliamentary debate on the legal status of assisted suicide:

> My concern, despite the policy, is that we are left in this country in a legal no-man's land (HC Deb, 27 March 2012a, c1407)

Therefore, the pronouncement that an individual or company occupies a legal, political, financial or moral 'no man's land' emphasises the uncertainty of their position. The heritage of the Great War is called upon to embellish and elaborate this situation as it serves as a means of reinforcing a troubled status. However, similar to the employment of 'in the trenches' the usage of the phrase within a political context is largely apolitical; it carries no social judgement or context and whilst implicitly or explicitly calling to mind the Great War it is largely used as a descriptive turn of phrase.

As a colourful expression, 'no man's land' provides a convenient means to describe barren or forgotten areas. Popular novels, guides and articles that do not concern themselves with the war use the term to emphasise an empty, derelict space or an isolated experience (see Callow 2003: 298; McGregor and

Boorman 2004: 194). It also serves as a convenient title for pieces to illustrate the absence of a place or the hazards experienced by individuals in the 'front line' of an occupation (Pinter 1975; Simpson 2009). As an evocative idiom, 'no man's land', therefore, ensures that the Great War can be referenced without explicitly referencing the conflict itself. Using the term in this way enables the communication of a particular understanding of the war, of isolation and danger, to bring to bear issues or experiences in the present, beyond the confines of military experience (after Fish 1980). It mobilises the 'war discourse' in arenas far removed from martial endeavour to portray a pressurised or uncertain position. This usage of the heritage of the Great War enables the experience of conflict to be activated as a means to frame the experiences of the present. Indeed, whilst 'no man's land' is frequently evoked across Britain as a useful, descriptive term, it is also utilised by individuals, groups and communities for overt political purposes as a means to evoke suffering, the dereliction of responsibility and a call for greater social action and solidarity. It is this application of the term which emphasises the dissident aspect of the heritage of the Great War as it is used against prevailing conditions both within Britain and in a wider global context. As a framing device, 'no man's land' is evoked within popular and media discourse to compare the conditions of contemporary conflicts with that of the 1914–1918 war. The Great War is thereby employed as a lens to view and understand modern war; the world's first industrial scale conflict is placed as the example of contemporary conflict *par excellence*. This usage of 'no man's land' draws parallels between the past and present, not just for wars that impact upon British citizens or in which its troops are engaged, but within wider international crises to appeal to a humanitarian need:

No man's land: My trip to a refugee camp in Syria destroyed any hope that the horrors of Iraq might end, or that we are doing enough to help its victims (Garai 2009).

The thought of Conroy and Bouvier spending another night in no-man's-land because of the distrust was grim (Jaber and Amoore 2012).

Stray dogs, abandoned cows … and the rice farmers who refuse to go: The only living things left in Japan's nuclear no-man's land (Anon 2011a).

'No man's land' in this respect is used to communicate a powerful sense of poignancy, requiring the reader to translate the battlefields of the Great War to current concerns (after Korte 2001, Wilson 2009). The expression, therefore, carries a mode of understanding that places contemporary events within a framework constructed through the 1914–1918 war. The 'no man's land' of wartime northern France, Flanders and Gallipoli becomes imposed upon contemporary political crises, human tragedies and natural disasters; the former providing meaning and milieu to the latter. The affecting and sentimental frame

which is constructed through this aspect of the heritage of the Great War is used to engage and activate public opinion.

In a similar way, the expression has also been used within the context of the Iraq and Afghanistan wars. Describing the military engagement of soldiers from the United States, Britain and their allies in 'no man's land' or British soldiers inhabiting and patrolling 'no man's land' in this respect adds an implicit political context. The scale of loss, the prolonged length of the conflict and the public perception of the seemingly futile nature of the Great War ensures that the phrase does more than provide colourful description for reports. Indeed, allusions between the Iraq and Afghanistan campaigns and the First World War were especially common in critical reports of the conflicts fought as part of the 'war on terror':

> Iraq is a Bloody No Man's Land. America has Failed to Win the War. But has it Lost it? (Cockburn 2005).

In this setting, Iraq and Afghanistan are placed into context with the Great War; the 'no man's land' of the battlefields of the 1914–1918 war becomes transposed onto the experiences of contemporary British soldiers and the wider pursuit of the recent conflict. Drawing analogies between the past and the present thereby passes comment and criticism on the conflict. A war fought at the outset of the twentieth century, almost synonymous within cultural life in Britain with wholesale slaughter, futile endeavour, incompetent authorities and utter devastation, is used to illustrate and expound upon a current context. In Iraq and Afghanistan, the British Army and British politicians become 'lost', 'bogged down', 'caught' or 'pinned down' in 'no man's land' as the contemporary actions are placed within an understanding formed through the framework of the cultural heritage of the Great War:

> Horrors of closet civil war played out in no man's land (Steele 2006: 5).

> The traditional notion of victor and vanquished is no more, leaving the army caught in a no man's land between politician and terrorist (Riddell 2006: 32).

These associations carry negative connotations as the expression 'no man's land' serves to call to mind the supposed 'horrors' of the Great War. This sensationalism can be witnessed across both tabloids and broadsheets in Britain as the events of the battlefields of the First World War are used as both figurative and literal comparisons for the recent military activity in Iraq and Afghanistan. Indeed, the landscape of 'no man's land' from the Western Front, Salonika and Gallipoli is recreated in the accounts of soldiers experiencing the more recent conflicts:

> They then marched a kilometre across no-man's land as the battle raged (Hurst 2007: 12).

Days later, Mark had his second escape during a patrol on "Taliban hill" – which overlooks a no-man's land between the area controlled by coalition troops and the zone held by the terrorists' (Lyons 2007).

I ran for my life across No Man's Land. We found cover at a small bridge under the calm direction of Major Richard Parvin. More incoming fire (Lavery 2009).

The usage of the expression carries particular weight as the evocation of the First World War battlefields places these contemporary fields of conflict and those who fight within them into a similar sympathetic frame of reference as the soldiers of the Great War (see Fussell 1975). As the British troops of the 1914–1918 war are considered behind a sentimental veil which emphasises stoicism, heroism and endeavour in the face of atrocious conditions and poor leadership, the experiences of British and international soldiers in contemporary conflicts are placed within similar modes of understanding (see Preston 2003). Reinforcing the place of 'no man's land' within this manner also constructs the actions of troops stationed in Iraq and Afghanistan within an uncritical and favourable remembrance framework. This allusion can be seen to have been drawn upon with the deployment to Afghanistan by Prince Henry of Wales in 2008. This tour of duty by a member of the British Royal Family was abruptly ended after press speculation led to concerns for safety of the royal and those serving with him. However, the reporting of the Prince's service brought an opportunity to 'place' the royal in the context of 'no man's land', in scenes reminiscent of the Great War. The *Daily Mail* newspaper recounted the Prince's service in the battlezones of Afghanistan which was re-visioned as the battlefields of 1914–1918.

Manning a powerful machine gun for the first time, the prince fired round after round across cratered No Man's Land, using only distant puffs of smoke as his target (Hickley 2008).

Similarly, the *Daily Telegraph* reported on the heroic endeavours of the third-in-line to the throne as an adventure in 'no man's land':

Prince Harry immediately claimed a position and, crouching on sandbags and gritting his teeth with concentration, he pumped rounds into no-man's land, aiming at distant puffs of smoke (Anon 2012b).

'It's just no man's land … they poke their heads up and that's it,' he says. Peering through an arch of sandbags over the abandoned farmland, a shredded piece of sack cloth hanging in front provided the only cover for his firing position (Anon 2008b).

The right-wing, conservative leanings of the papers who drew upon this phrasing provide a means of framing the Prince's experiences within the setting of the Great

War. It creates a link to the 'everyman' experience associated with the troops of the 1914–1918 conflict. The service of the grandson of Queen Elizabeth II is thereby rendered into just another 'Tommy in the trenches'; one who shares in the suffering and exhibits the stoicism associated with the troops. In this respect, being 'in no man's land' is a mark of camaraderie with your contemporaries.

Whilst the term is employed within this context to include a member of the British Royal Family, it is also employed as an indicator of a more inclusive demographic. When used to refer to a collective, the term 'no man's land' operates at symbolic level as it denotes a shared experience or suffering. To be in 'no man's land' with others is a mark of solidarity. The usage of the expression in this respect is politically driven as it critiques authorities by placing responsibility for the location of individuals or groups in the exposed, dangerous position of 'no man's land. Individuals are 'left' or 'stranded' in 'no man's land' by officials, local government or the national administration. From education, healthcare provision and housing, the neglect of care is highlighted in the expression:

> Parents left in "no-man's land" at Hertford school expansion decision (Greek 2012).

> The worst outcome for patients would be if the service is left in no-man's-land with current arrangements crumbling, and without workable new arrangements in place … (Mason 2012).

> What this means is we are going to be left in no-man's-land. Our lives are being left in limbo (Rudkin 2011).

The accusatory nature of describing a predicament as a 'no man's land' draws upon the intangible heritage of the Great War as an exercise in futility, perpetuated by incompetent or indifferent officials. This referencing of the culpability of authority is a significant aspect of the term 'no man's land'. Its use in this respect can be seen within the media but also within popular and political discourse. The musician PJ Harvey's (2011) usage of the term in her work *Hanging in the Wire,* which set in the context of the Iraq and Afghanistan wars, provided a critical appraisal of the British establishment who led its citizens into conflict, 'Walker sees the mist rise / Over no man's land'. Similarly, the Merseyside group The Farm (1990) relied upon the appeal to solidarity which is implicated in a shared sense of suffering in their song *All Together Now* which directly references the battlefields of the First World War and the Christmas Truce of 1914:

> All together now
> All together now
> All together now, in no man's land

In this manner, 'no man's land' is reworked as a positive, empowering space, where individuals and groups can reject the controlling elements within society and seek resolutions outside of official channels. This 'class-based' assessment of 'no man's land' provides an examination of social hierarchy within society; a governing elite allowing the wider social groups within society to endure the privations of a field of conflict is implicit within this usage. The heritage of the Great War is thereby mobilised for action and change as 'no man's land' becomes both a critique of official policy and the starting point for a sea-change in ideas and practice. This usage of the term can be observed in the comments made by the politician George Galloway as he attempts to rally supporters to the cause of rejecting mainstream political parties:

> That's why we go over the top into no man's land next week full of hope. And this time we are determined to overrun the enemies' lines (Galloway 2004).

The Scottish Socialist politician John McAllion also mobilises the term to call for cooperation within left-wing politics in Scotland:

> We need to get out of our party political trenches and meet somewhere on the political equivalent of no man's land (McAllion 2007).

'No man's land' is a significant feature of the cultural heritage of the Great War, its place within society across Britain enables a variety of functions, from a simple illustrate device to a complex social and political argument. The evocation of 'no man's land' provides authors and audiences with a means of framing current events and issues within an understanding of the 1914–1918 war (after Chambers 1984, Fish 1980). This mode of discourse is altered to suit the events concerned; whether as a direct analogy for recent conflicts, for politically charged encounters or for seemingly mundane aspects of everyday life, using this term relates issues to a common reference point. This orientation provides nuanced layers of meaning, as 'no man's land' is used to stir strong emotions regarding responsibilities, suffering and the dereliction of duty.

War of Attrition

The perception of the Great War as a 'war of attrition' or of the British military engaged in a 'policy of attrition' is one which has become synonymous with the perception of the incompetent politicians and generals of the conflict (see Robbins 2005). Despite this interpretation, the policy of a 'war of attrition' has a seemingly logical origin, based upon the needs of the British Government and General Staff to conserve military manpower and undermine a larger and better-equipped military unit (French 1988). During the war, in Parliament and within the War Office, the term was used to describe how British troops could best be deployed to support

allies in all theatres of war and to ensure the possibility of a 'break-through' moment (Johnson 1994). However, with the large scale of fatalities that ensued from the Battle of the Somme and Passchendaele (Third Battle of Ypres), the policy of a 'war of attrition' began to acquire the associations of 'butchery and bungling' which are now the widely presumed perception of the British military policy during the Great War (see Laffin 1997). Using the appellation 'war of attrition' or 'policy of attrition' has thereby become part of the wider vernacular within Britain. In this usage, the label of a 'war of attrition' is a derogatory or pessimistic assessment of a policy or situation as it highlights the great cost, in time, effort, money and human lives. The expression has thereby become part of the 'war discourse' as it enables the referencing of the Great War to provide context, embellishment but also to politicise and criticise the present.

The employment of the phrase 'war of attrition' frequently appears to describe sporting and political contexts as the expression's ability to illustrate long-drawn-out engagements on the playing field and in Parliament prove highly useful within the media (see Brooks 2012, 'Cheltenham Festival 2012: this meeting is a war of attrition on many fronts'; Anon 2003b 'War of attrition: Labour's discontents grow as the war against Iraq proceeds'). However, the term is also used for more than short-hand illustration. When contemporary events are couched in the terms of a 'war of attrition' the assessment of a needlessly prolonged, bloody encounter akin to the experiences of the Great War are implicit in the statement. For example, the phrase was used repeatedly across the media to describe the events in Syria during the uprising after 2011:

> The Syrian rebels' war of attrition ... (Weiss 2012).

> In the heartland of the uprising against Bashar al-Assad a grinding war of attrition has now become an unforgiving battle to the death (Chulov 2012).

The usage of the term 'war of attrition' has been especially significant to politicise and to criticise the most recent wars in Afghanistan and Iraq where British troops have been deployed in a long-standing conflict. The expression takes on something of a lament in this context, as the protracted nature of the military operations in the areas became abundantly clear as the wars progressed during the first decade of the twenty-first century. Within the media, political and public sphere describing military, political or civilian experiences in Afghanistan or Iraq as a 'war of attrition' thereby emphasises a perception of the conflict as a bloody, pointless endeavour which has no end in sight:

> The war of attrition in Iraq continued its bloody course yesterday with at least 63 people killed, including a busload of soldiers who died when a roadside bomb exploded in the northern city of Beiji' (Beresford 2006).

They will blunder on, not to a clean defeat but to something far worse, a war of attrition whose poison will spread across a subcontinent (Jenkins 2003).

Placed in the context of official action or inaction the term also constitutes a damning assessment of policy and practice. To be placed in a 'war of attrition' demonstrates quite a predicament; an ill-planned, costly and potentially futile endeavour. In this manner, the expression is often called upon within Britain to describe labour and industrial disputes between business interests or government and trade union representatives. For both sides in this context the phrase carries symbolic weight, seemingly damning the senseless waste of lost work or profit and critiquing the heavy-handed, indifferent position of authority. Within the trade union movement and wider socialist organisations within Britain, denoting a 'war of attrition' with government policy or corporations provides an implicit link with the heritage of the Great War as it characterises a battle between the ordinary individuals, 'us' or the 'rank and file' and the governing elite, invariably detailed as 'them' or the 'brasshats'. This is a highly politicised usage of the 'war discourse':

Local government unions at Southampton City Council have settled into a low-level war of attrition with council bosses after an impressive campaign of creative, rank-and-file-driven industrial action in 2011 failed to prevent the imposition of new contracts (Ward 2012: 11).

... because they are usually unable to mobilise the offensive power of the rank and file, these activists find it hard to act independently of the full-time officials ... they have ... often been worn down by the endless war of attrition waged by the bosses (Callinicos 2006: 14).

To counter this appropriation of the term, striking workers and their organisations are often depicted by conservative sources as engaging in a futile, unrealistic war of attrition. The expression enables the construction of a frame of understanding that illustrates a pointless task undertaken by troublesome elements which necessitates and reaffirms conservative or orthodox policy. In this manner, a 'war of attrition' is not something that is inflicted upon a body of workers by a government or corporation, rather it is characterised as a weapon used against the supposed interests of wider society:

The Public and Commercial Services Union, which represents 270,000 civil servants, is now embroiled in a war of attrition without any hopes of an early end to the deadlock (Anon 2007a).

If more strikes are ordered it will turn into a war of attrition (Murray et al. 2002).

The expression thereby assumes both politically conservative and radical values as it is used to weaken and to promote opposing viewpoints. The significance of this usage is that despite the political differences, both applications of the expression rely upon the heritage of the Great War. Denoting a 'war of attrition' in this manner outlines debates on politics and policy using the events of the 1914–1918 war. As the encounters on the fields of France, Flanders, Gallipoli and Mesopotamia were viewed as part of the 'war of attrition', costing thousands of lives and, on the Western Front and in Turkey particularly, achieving very little, the term has come to be part of a critical 'war discourse' across Britain. Whilst it is used to demonstrate political points of a variety of hues, its appearance within politics and wider society demonstrates the pervasiveness of the cultural heritage of the war. Whilst other terms exist to describe such conditions of deadlock and stalemate, the term 'war of attrition' carries a political, social and emotive intensity through allusion to the Great War.

Shell Shock

In a war fought on an industrial scale, the conflict of 1914–1918 brought an industrial level of death and injury (after Kramer 2007). The tactics of all sides of 'pinning down' the enemy with heavy shell fire and the use of prolonged artillery attacks before advances shaped both the physical terrain of the battlefield and the mental health of the combatants (Bourke 1996, 2000). Those who were exposed to these salvos as well as the tense nature of front-line conditions began to exhibit signs of psychological trauma (Holden 1998). The diagnosis of 'war neuroses' amongst front line troops became common during the conflict as medical practitioners and eventually government ministers recognised the damage caused by military service (see Rivers 1918). The conditions suffered by soldiers were grouped under an all-embracing term of 'shell shock'; a description of both the impairment caused by the experience and its presumed cause of the intense artillery assaults in the front line (Reid 2009). Whilst the assessment of war trauma and combat stress disorders have continued to utilise the term to describe the psychological impact of war on front-line troops, the term has been incorporated into wider usage within Britain beyond the confines of the battlefields of the Great War (Leese 2002).

Suffering from 'shell shock' or diagnosing 'shell-shock' within others has become a heavily utilised idiom within a variety of fields of discourse within communities and groups. Within the sporting arena, it is frequently relied upon to express the desolation experienced by an individual or team which is brought about by a heavy or unexpected defeat. For example, 'Great Britain Men "shell-shocked" by Spain defeat and now face struggle to qualify for Champions Trophy 2012' (Benammar 2012) or 'Caley Thistle Leave Hearts Shell-Shocked' (Ralston 2007). The term is also applied to the political sphere as candidates, seasoned politicians and established governments can be left 'shell-shocked' by unexpected results. For

example, 'Labour leader "shell shocked" by Harrow Council win' (Kirk 2010: 4) or 'A Formby Conservative councillor was said to be "shell-shocked" after being axed by her own party' (Siddle 2010: 5). Despite the proliferation of the term as a vibrant and sensational 'headline-grabber', the expression also operates as part of the 'war discourse' as it contributes to a subtle arrangement of politics and power (after van Dijk 1988).

To state that another is suffering from 'shell shock' is to place that individual within a framework constructed from the heritage of the Great War. This requires a positioning of that individual or group as a 'victim', one who has suffered or has undergone a traumatic experience. A frame of understanding for contemporary contexts is thereby made with the figure of the ordinary soldier of the First World War suffering the excesses of industrialised conflict in the trenches at the behest of indifferent officials. One who is described as afflicted by 'shell shock' is, therefore a pitiable, sympathetic figure. The use of the term forms a means of identifying an individual or group within a modern context and illustrating their position through the cultural heritage of the Great War to portray them as victims of circumstances that are beyond their control. In this usage of the term, a distinct political agenda can be identified as the idiom enables a critique of current structures of authority. For example, in the wake of austerity measures imposed on the public sector by the Coalition Government in Britain after 2010, the expression acquired a particular weight. The opposition Labour Member of Parliament, Andy Burnham (2010) used the phrase to highlight a dereliction of duty on the part of the Prime Minister: 'what changed, Mr Cameron? I think shell-shocked NHS staff deserve an answer'. The Labour Party's critique of these government cuts focused on official responsibility and the accountability which should be owed towards the populace.

The expression 'shell shock' possesses a means to cast a compassionate light on the experiences of individuals and groups. Its use within a political context enables an implicit or explicit suggestion that an injustice has been committed. As a description of a current predicament, 'shell shock' forms a means of exposing the power relations within society; as those described as afflicted by the condition are inevitably placed in this position by another, more dominant group. The relations are in this manner characterised by the 'war discourse', which frames the experience of a group or individual as one which has been abandoned or abused by those in power. Those who perform a public service are often left rendered into 'shell shock' by seemingly neglectful authorities (see Stewart 2012 'Shell-shocked LAs about to get another surprise' or Wyllie 2011 'Teachers shell-shocked at school closure news'). For instance, those who were subjected to the large-scale riots in London in August 2011 were placed in this context:

> To an audience still shell-shocked by the damage to their homes and livelihoods wrought by the riots and failure of policing last August, my theme was the urgent need for the police … to rediscover a service ethos … (Gilbertson 2012: 3).

> By August 11th, a shell-shocked London was picking up the pieces, as were
> Birmingham, Liverpool, Manchester and many other English cities (Anon
> 2011b).

> It was clear from the outset that the population in the affected areas had entered
> a state of shell-shock (Cole 2011: 4).

The term in this respect provides a means of demonstrating a 'victim' status, as
'shell shock' is an expression that denotes a state of affliction which has been
wrought by forces beyond the control of the sufferer. Issues of responsibility are
latent within this usage, as those pained by this condition are granted a status of
innocence whilst another bears the accountability for this situation either directly
or indirectly through a disregard of their obligations. In this manner, the term
forms a very powerful political and social accusation and demonstrates how the
cultural heritage of the Great War is mobilised within contemporary contexts.
This framing of the past to view the present is most directly witnessed in the
usage of 'shell shock' to describe the experiences of contemporary servicemen
and women. During the conflict in Afghanistan and Iraq from 2001 and 2003
respectively, British troops suffering from a variety of post-traumatic stress
disorders were frequently characterised within the popular press as afflicted with
the medically-archaic term 'shell shock'. For example, see Tootal (2009: 15) 'My
friend Tug and the scandal of our shell-shocked soldiers' or (Anon 2010a) 'Shell-
shocked Afghanistan war veteran':

> It is the war illness once referred to as 'shell shock and war neurosis that is
> estimated to blight thousands of troops returning from Afghanistan (Watt and
> Williams 2011).

> These days, the term shell shock is no longer used but the problem of mentally
> damaged ex-soldiers is still with us (Nelson 2009).

'Shell shock' in this manner evokes the compassion associated with the soldiers
of the Great War with current members of the armed forces. Indeed, this can be
observed with both the title and the wider content of *Shell Shock: The Diary of
Tommy Atkins* (Blower 2011), a novel written by a former British Army soldier
concerning the fortunes of a young man who returns back to Britain suffering
post-traumatic stress disorder. The account, written in part to raise money for
veterans' charities, draws strong allusions to the Great War, evoking a sense of pity
for the central character 'Tommy', the traditional moniker of all British soldiers
since the Napoleonic Wars of the late eighteenth century. Such uses of the term
emphasise the connection between past and present. Therefore, by employing
'shell shock' as both a direct description of current conflicts as well as a reference
for historical issues, a wider framework of understanding is created; this draws
upon the 1914–1918 war to illustrate but also to politicise current issues within

society. This 'war discourse' enables the past to be activated to serve present agendas, a defining feature of the cultural heritage of the Great War in Britain.

Barrage

During the periods of stalemate in the trenches, soldiers were subjected to intense artillery fire by the enemy to weaken morale and destroy any trench and dugout positions which may have been developed. These sustained attacks were entirely novel in warfare, as mechanised, high-calibre weapons brought previously unknown damage and devastation to both the war landscape and the bodies of the soldiers at the front (Leed 1979). The intensity of these offensives was particularly disturbing to the troops as they were forced to be entirely passive and seek shelter from the threat of death and dismemberment which was wrought by heavy shelling (Bourke 2000). To describe these attacks and the new method of conducting warfare, both official documents and soldiers themselves referred to the 'barrages' of fire to illustrate the strength and concentration of the artillery and its intended effect of isolating and assailing parts of the front line (Brophy and Partridge 1931: 39). The term, derived from the French noun *barre*, has been reformulated after the war beyond the battlefields to illustrate an attack on a person or institution. Whilst the term is largely drawn upon as a mere illustrative or descriptive assessment, it nevertheless provides a further example of the 'war discourse' that utilises the Great War for purposes of social and political effect.

'Barrage' is used within a variety of contexts within Britain beyond its original military description. It is utilised as a powerful noun or transitive verb to depict quantity and intensity, particularly in association with a process of critical evaluation; therefore, one speaks of a 'barrage of questions' or a 'barrage of criticisms' which are levelled at another. Public figures, celebrities, but particularly politicians, can be subjected to a 'barrage' of criticism for misdemeanours and unpopular decisions. For example, 'Barrage of Criticism For Hewitt' (Anon 2007b), or 'Brown runs into a barrage of criticism from unions' (Milne and Gow 2000: 1). In this fashion, the term has become a means to focus critique upon an individual in the public eye, as to be subjected to a 'barrage' implies that the object of assessment is already 'in the open'. Therefore, the term is mobilised to serve as a means of public censure, a 'barrage' of questions or criticisms is 'fired' against an individual or group that might be considered to be a rogue, errant or obstructive element within society:

> Mr Maude faced a barrage of criticism from fire experts after issuing his advice and Labour MPs last night called on him to resign (Foster 2012: 2).

> From the outright opposition of many health trade unions to a barrage of scepticism and questions that have been thrown up by think-tanks … one might surmise that the health secretary has no friends (Timmins 2011: 5).

In this respect, to be subject to a 'barrage' appears to evidence a healthy, democratic process as it offers a means to emphasise a public condemnation of the actions of those in authority. 'Barrage' serves an intensifying element within public and political discourse, drawing upon a structure which has been derived from the Great War. To describe a 'barrage' of criticism emphasises a scale and concentration that mirrors the military actions undertaken on the battlefields of the First World War. Intriguingly, within a political context, to be subject to such a 'barrage' does not equate with inspiring a degree of public sympathy; such 'barrages' are described as a tool against powerful elements within society. For example, former Prime Minister Tony Blair was described as facing such an onslaught from dissatisfied members of his own party: 'Rebels lay down barrage of criticism' (Ward and Watt 2002). Where the term is associated with a degree of compassion is within the experience of a wider public body, beyond the sphere of celebrities and politicians. In this instance, to be subject to a 'barrage' of criticism or abuse immediately places an individual in the context of victimhood. This usage of 'barrage' as an embellishment also serves to colour and politicise debates particularly those involving the armed forces. For example, 'barrage' is frequently misapplied to describe any encounter with enemy fire, ensuring that accounts of British soldiers in Iraq and Afghanistan suffering a 'barrage' of enemy attacks, heightens the sense of danger within the warzone by placing the conflict in context with that of the Great War (e.g. 'British troops come under missile barrage', Bowcott 2003: 8). As an aspect of the 'war discourse', the term 'barrage' provides a means of censuring and intensifying contemporary contexts through a structure that draws upon the heritage of the Great War.

Blighty

During the war of 1914–1918, cultural aspects of the British Imperial pre-war army became incorporated within civilian life. Language, habits and routines which were the practices of a professional, small army before 1914 acquired wider cultural currency as a large body of citizens were conscripted into military service (de Groot 1996). It is this exposure which brought the term 'Blighty' into public consciousness and usage. The word is derived from the Urdu *vilāyatī*, which refers to 'foreign' and was corrupted into 'Blighty' by British troops to refer to the mother country whilst stationed in the Asian subcontinent in the nineteenth century (Partridge 1966: 50). As the war progressed the term began to increase in popular usage as popular songs such as 'Take me Back to Dear old Blighty' (Scott et al. 1917) were used by both soldiers and the wider public alike. At the front, 'Blighty' became both a sentimental term to describe 'home' whilst also acquiring a violent aspect as wounds (including those which were self-inflicted) which would guarantee leave away from the front and recuperation in Britain were known as 'blighty ones' or a 'blighty' (see Van Bergen 2009: 202). Whilst this brutal aspect of the term has not been wholly preserved in contemporary usage,

what has maintained and magnified beyond its wartime context is the sentimental attachment of Blighty to refer to 'home'. What is strikingly discernible in this romantic usage is a conservative element that appeals to a narrow, nationalistic sense of 'Britain' (see Low and McArthur 2011). This imagined sense of belonging, whilst drawing on the 'shared experience' of the Great War, is frequently used to mobilise an exclusory identity, a particularly problematic concept across an increasingly fragmented and multicultural Britain.

In its contemporary usage, 'Blighty' is employed as a means of expressing attachment and place and to differentiate 'here' from 'over there'. Such usages refer to Britain's power and prestige but also to idealised visions of 'home'. For example, 'Dear old Blighty's truly world class' (Reece 2009: 22) or 'Why Blighty breeds a better class of bounder' (Pelling 2012). In this manner, 'Blighty' assumes a jocular, patriotic reference which enables and promotes a collective identity through a means of common reference:

> As if the idea of a summer staycation in Blighty hasn't been discredited enough
> by the soggy old weather, those of our countrymen unwise enough to linger
> anywhere in the vicinity of these sceptered isles in early September are going to
> get a nasty shock (Burchill 2010: 25).

Referring to the nation as 'Blighty' assumes a shorthand for stressing a sense of belonging. Individuals associate with the term and it serves as a means of identification. This can be seen in the uses of the expression in contemporary journalism; 'Back in Blighty, the pedalo hero who fooled the French' (Martin 2007) and 'Diary of returning expat: back in Blighty' (Pickles 2011). The wartime connotations of the term provide a means of stressing a shared history, endurance and suffering which provides a context for expressing national identity. 'Blighty' thereby assumes both the sentimental attachments of home, as in the expression 'dear old Blighty' whilst providing a pugnacious defence of character confirmed in the turn of phrase 'best of Blighty'. However, whilst providing a basis for a group of people to identify, the term is restricted in its usage and seemingly its referents. 'Blighty' assumes a particularly English connotation in its application. The term is noticeably more prominent within media, political and public discourse in England than in Scotland, Wales and Northern Ireland (see Green 2006: 126). Within these nations, the term 'Blighty' possesses connotations of identity that does not find contemporary relevance in the context of devolution and independence (after Nairn 1977, Perryman 2009). The expression appears to signal a means of asserting a 'British' identity that relies on the supposition of equating 'English' with 'British'. 'Blighty' as an idea therefore reinforces an increasingly difficult concept of political union between the home nations (see Perryman 2008). Whilst the term is problematised elsewhere, within England, 'Blighty' still possesses a degree of cultural capital. Indeed, the term is used unhesitatingly within a commercial setting for tea shops, antique stores and boutiques, all of which provide sentimental, nostalgic products and visions of 'Britain' (after Lowenthal 1985,

1989). The term is also frequently relied upon within an expatriate community, who mobilise upon the term to frame the experiences of their country of origin. As a catch-all reference to Britain, 'Blighty' was the name given to the blog operated by *The Economist* to report on issues pertinent to the nation:

> On this blog, our correspondents ponder political, cultural, business and scientific developments in Britain, the spiritual and geographical home of The Economist (Blighty Blog 2012).

This usage appears to reinforce the idea of a unified country without referring to 'England' or 'Britain'. It is perhaps of no surprise that the television channel UKTV rebranded its name as 'Blighty' in 2009 as a means of promoting its content as 'British'. Indeed, the channel states unequivocally:

> Blighty unashamedly celebrates all that is great, unique and inspirational about Britain today (Blighty 2012).

The term 'Blighty' constitutes a conformist element within the 'war discourse'; whereas the expressions and terms that comprise the cultural heritage of the Great War demonstrate a potential for political and social dissonance, 'Blighty' is mobilised to offer a means of reaffirming established political and social norms. It is, therefore, mobilised by right-leaning elements across society and the term is infrequently used beyond the conservative, English press and public discourse.

Militarised Expressions: At the Front, Behind the Lines, Brass Hats, the Dugout and the Bunker

The process of war in France, Flanders, Gallipoli, Mesopotamia and Salonika transformed and militarised a pre-war civilian landscape (Gibson 2001, 2003). Farms, villages, towns, factories and even empty land all became appropriated for military use. Surveyed, occupied, renamed and reinforced, a martial identity was imposed upon the terrain. Weapons, material and military architecture also reshaped these areas, as the industrialised warfare reformed what had previously been largely pastoral or agricultural regions (Wilson 2011). In some instances, the legacy of this transformation can still be evidenced today. For example, across the regions of northern France, Picardie, Somme, Pas-de-Calais, as well as western Flanders, trench lines, shell craters, fragments of material, the human remains of 'the missing' as well as dugouts and unexploded ordinances are regularly uncovered (see Saunders 2001, 2002, 2007). This is demonstrative of an entirely novel type of warfare that engulfed the world at the turn of the twentieth century (Kramer 2007). As a new means of conducting conflict, this process also brought terms and expressions within wider usage as civilian conscript armies

experienced military service (see Booth 1996). Whilst expressions and terms may have held long usage within the military, the impact of the war on combatants and non-combatants alike brought a greater familiarity with specialised terms (after Brophy and Partridge 1931). Within Britain, this lexicon of new terms was incorporated into wider public usage which reflected the soldiers' experience of the war. As soldiers wrote home regarding their lives of the front lines, in the trenches, dugouts and bunkers as well as behind the lines in the towns and villages of France and Flanders, this industrialised warfare became incorporated into the phrases and expressions of the wider populace (after Donald 2008). Their continued usage within British public life marks a significant feature of the cultural heritage of the Great War as this intangible legacy provides vivid social and political commentary.

Within contemporary society, 'at the front' or 'in the front lines' is used to describe the position of individuals and groups directly engaged in action or initiatives. The term distinguishes those who experience issues 'first-hand' and is related in this manner to the expression of 'in the trenches'. Those who are 'in the front lines' are thereby assumed to be more knowledgeable, more beneficial by virtue of their location and able to provide some form of 'truthful' perspective. In Britain, the term is regularly applied to those within the public sector who occupy public service roles. These 'front line services' or the 'front line sector' are thereby framed by the heritage of the Great War as their position, their deployment and their circumstances provides analogies to the conflict of 1914–1918. To speak of 'cutbacks', 'reductions' or to question the 'conditions' of front line staff calls into context the role of troops on the battlefields of the First World War. For example, in the wake of austerity measures in Britain after 2010, the impact on 'front line' public sector workers could be directly read into the context of the war of 1914–1918 (e.g. Carter 2010 'Fewer staff, wards shut, services cut. Protecting frontline NHS, ConDem-style'). In this manner, the 'front line' becomes highly politicised; political philosophies which criticise those at the 'front' clash with opinions which seek to protect 'front line' workers:

> Of course, teachers, nurses and other front-line workers in the public sector do hugely valuable jobs. But these people have become by far the most formidable, unionised and muscular interest group in the country (Hastings 2011: 28).

> Nursing leaders accuse the government of breaking promises to protect frontline staff from £20billion of NHS spending cuts (Radnedge 2011).

Socialist and left-leaning sentiment predominantly sides with those 'at the front' whilst conservative elements criticise the 'waste of labour' that the front line services are considered to represent. In the context of severe cutbacks and government restrictions in public spending after the 2008 recession, the cultural heritage of the Great War was drawn upon by proponents of the left to criticise government measures which 'failed', 'let-down', 'abandoned' and 'lied' to front

line workers. Implicit and explicit connections could therefore be made between the soldiers in the trenches of the First World War, at the front lines in the battlefields, with those providing staff members occupying public service roles at the 'front line' of the welfare state.

The framing of these debates with the heritage of the 1914–1918 war is mirrored in the way in which those operating 'behind the lines' has become a derogatory remark aimed at those who considered to be far removed from the action 'at the front'. Politicians and political leaders who are believed to occupy 'safe' areas 'behind the lines' are ridiculed and shown to be out of touch with the events at 'the front'. The disparaging term 'brass hats', itself derived from the Great War as a term to describe high-ranking officers, is also evoked in this context. 'Brass hats' who work away from the 'front lines' emphasises both a physical and social separation, as a distinctly class-based agenda is mobilised through a context provided by the Great War (see Routledge 2011, 'Brass hats enlist in David Cameron's army'). The failures of a government who are perceived to be indifferent or removed from public experience or 'front line' issues can therefore be couched in the experiences of the Great War:

> In reality, it smacks of the hide-bound failure to consider the possibility of being wrong that exemplified the World War I brass-hats who ordered hundreds of thousands of infantrymen to march to their deaths, with fixed bayonets against machine guns and mustard gas (Anon 2007c).

This social and political discourse is also apparent in the application of the terms 'dug-out' and 'bunker', both of which refer to the militarised landscapes of the battlefields of the First World War but are also used to emphasise separation and distance within contemporary society. Those ensconced in the safety of a 'dug-out' or a bunker are deemed to be avoiding confrontation and action. For example, 'Number 10 gets into full-blown bunker-mentality mode' (Martin 2012) or 'Hunkered in the Bunker: High oil prices and the euro's woes threaten to burst Labour's economic bubble' (Warner 2000). Politicians who flee to the sanctuary of 'the bunker' are not provided with the same degree of sympathy or compassion which is bestowed upon those 'in the trenches'. Indeed, the 'bunker mentality' is one of ridicule and contempt. In a piece entitled, 'News from the PM's Bunker', published in the socialist newspaper, the *Morning Star* (Anon 2011c), this theme is explicitly stated:

> An embattled leader besieged in his bunker. Cronyism and abuse of power. Government flunkies raking in thousands and suppressing growing discontent among the nation's youth. Mass unemployment.

An avoidance of engagement and action, the 'political bunker' appears as a symptomatic of a distant, elitist authority that are not willing to consider alternative propositions which might not have such deleterious effects:

[Prime Minister] David Cameron was accused of a "bunker mentality" after groups representing health staff who oppose the reforms were excluded from the talks (Grice 2012: 5).

A Labour insider who has worked in both Downing Street and Millbank yesterday attempted to dispel the idea that Mr Blair had fallen into the trap of listening only to a few trusted people. The idea that he is stuck in the bunker is untrue, he said (MacAskill and White 2000: 21).

The 'bunker' is, therefore, the recourse for the 'bombarded' elite, or the 'brass hats', who instead of facing a 'barrage of criticism' take sanctuary away from the 'front lines'. Through this militarised language, through allusion, metaphor and analogy, though direct and implicit reference, the cultural heritage of the Great War is called upon to structure and arrange how contemporary contexts are perceived. The use of these terms provides not just a means of mere illustration. Indeed, the employment of the 'front lines', 'behind the lines', 'dugouts' and 'bunkers' ensures a wider understanding of current issues which are outlined by the experiences of the 1914–1918 war. These expressions are utilised within political, media and social discourse to affect and to introduce elements of power, control and resistance. The imposition of names, expressions and terms from the militarised landscapes of the First World War not only ensures that the conflict continues to serve as a cultural reference point but also as a framework of understanding. The cultural heritage of the Great War is thereby a device to think with and in terms of, rather than as a set of intensifying adjectives and nouns to colour political and social debates.

Conclusions

It is through the 'war discourse' that the Great War still occupies a firm place across communities and societies within Britain. To speak of 'being in the trenches', 'exposed in no man's land', 'suffering from shell shock', 'going over the top' or that 'it'll all be over by Christmas' is to evoke the cultural heritage of the First World War. These references do not operate as clichéd expressions, devoid of rhyme or reason, carrying no 'cultural baggage' with their utterance. These phrases are highly active; they mobilise emotion, politics and social agendas to place the present in the context of the past. Indeed, on a basic level, the extent to which the 1914–1918 war frames and structures contemporary perceptions can be identified with how the conflict colours wider understandings of contemporary military engagements. A criticism levelled at the 'popular memory' of the Great War by modern military historians has been the extent to which the experience of the war is taken as the example of contemporary conflict *par excellence*. In this respect, every military engagement, despite advances in tactics and technology, is viewed through the lens of the war fought at the outset of the twentieth century. The war poets, Siegfried Sassoon and Wilfred Owen, as well as the popular depictions

1989?

of the conflict in novels, plays and films from *Oh! What a Lovely War* (Theatre Workshop 1965), *Blackadder Goes Forth* (BBC 1994) and *Regeneration* (Barker 1991) have contributed to the perception of the Great War as *the* war to illustrate all wars. However, such usage of the 1914–1918 conflict to explain and illustrate could be considered an inevitable result of the first mass exposure of military life to civilian culture (after Mosse 1990). It is through the Great War that a lexicon of military terms and definition came to be used within wider society and their usage to describe current conflicts, such as the 'bombardment of troops' in Iraq or Afghanistan is perhaps therefore inevitable. Nevertheless, rather than assuming that these terms are employed unknowingly, in a vapid utilisation of language, the 'war discourse' evidences a far more nuanced approach. Phrases, expressions and terms are employed not because they are convenient platitudes or established sayings; aspects of the 'war discourse' are drawn upon because they have political resonance, social effect and cultural weight to provide a direct commentary and critique on contemporary issues at all levels within society.

This is the intangible heritage of the Great War, located in the phrases and expressions which developed during the conflict and have subsequently been used by wider society. This usage continues because these terms and sayings possess relevance and power. For instance, stating how an individual or group is 'lost in no man's land' or 'battling in the trenches' immediately places the subject within a context of sympathy and pity. This association is drawn upon from the mundane aspects of everyday life to the operations of the military in recent conflicts:

> A losing battle in the trenches – Residents have no control over construction work on their doorsteps (Spackman 1994).

> Afghanistan battle like First World War: British, Afghan and coalition forces battled the Taliban at close quarters, knee-deep in mud, over Christmas in fierce trench battles reminiscent of the First World War, it has emerged (Anon 2009b).

The 'war discourse' is used here to describe the ethereal legacy of the Great War. Despite the monuments and memorials which spread across the villages, towns and cities in the home nations as well as on the former battlefields of the conflict, which were constructed to ensure that 'we will remember', it is this intangible heritage that keeps the memory of war current. This is not to suggest that the remembrance of the conflict is fixed, indeed the application of the 'war discourse' to the Afghanistan and Iraq conflicts demonstrates the malleability of the cultural heritage of the Great War. What is significant about the 'war discourse' is not necessarily the subjects to which it is applied to frame and structure perceptions, but the political and social agenda it provides to these subjects. The 'war discourse' is used to illustrate, expound and identify current issues of concern with the 1914–1918 war through the experience, historical or remembered, of the soldiers of the conflict. Whilst the heritage of the Great War can thereby be utilised for both dissident and conservative appeals, it is the

radical aspect of the 'war discourse' which is most noticeable. The appeals to question the nature of authority, demand responsibility and the emphasis on a shared experience of suffering emphasises how the legacy of the conflict today is located within a social and political critique.

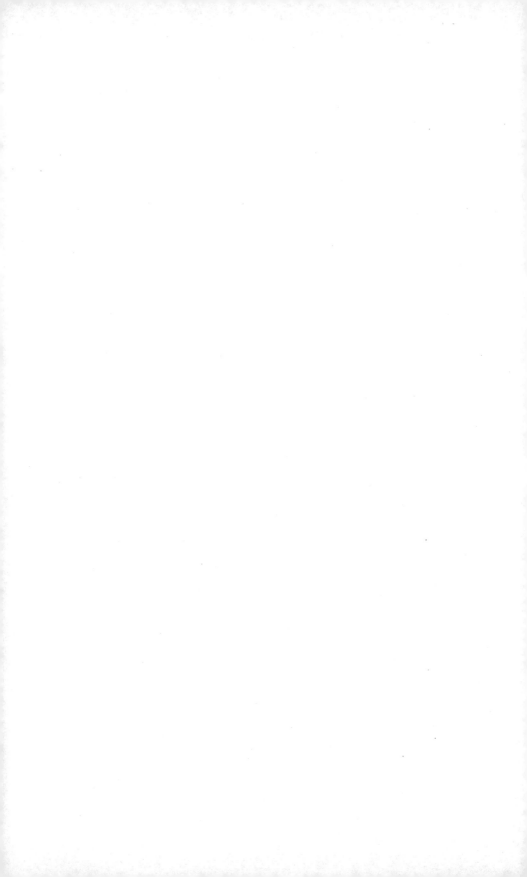

Chapter 3
Framing the Past – Imagery and the Great War

The visual representations of the Great War in Britain have been extensive (Sternberg 2002). Across a variety of media, from even before the Armistice of 1918, the war had been seen and imagined in Britain through images (Sorlin 1999). From film, television, newspapers, novels and comics, these representations of the war provided a means of framing, accessing and understanding the conflict (after Hanna 2009, Todman 2005). These images and this means of remembering the conflict are becoming of increasing concern and interest to scholars as the war has now passed from 'living memory' with the deaths of the remaining veterans (Williams 2009). Suffering soldiers, desolated battlefields and the memorial landscape appear to dominate the vision of the First World War (see Dyer 1994). These images constitute a significant aspect of the cultural heritage of the Great War as they frame the remembrance and perception of the conflict. They thereby form a means of focusing attention on contemporary political and social issues through the framework of the war of 1914–1918 (after Wilson 2007, 2008a). This is accomplished by the pervasive nature of the images of the conflict; whether it is through direct visual representation or by textual description of images, these representations are drawn upon by historical societies, newspapers, family history networks, heritage sites and online communities to illustrate the war. By examining the history and contemporary usage of these images this chapter will assess how the employment of specific images communicates issues of politics, society and identity across modern Britain. The ability of images and the imagination to frame the war for use in shaping and informing contemporary debate is demonstrated in the dominance of a number of 'preferred visions' of the conflict (see Hynes 1991). Indeed, whilst some images are perceived to be the 'correct' or 'proper' visualisation of the past, others are closed off or rejected for their depiction of the conflict (after Chambers 1984: 5). Through investigating the use of images of the Great War and the ideas that they are used to convey, the cultural heritage of the conflict as a system of framing values and beliefs can be analysed.

The visual elements of heritage have recently come to the fore as scholars have addressed the way in which images frame and structure the perception of the past (Russell 2006, Waterton and Watson 2011). Indeed, visualisations of heritage form perhaps the most accessible and engaging means through which an understanding and interpretation of 'the past' is filtered and selected (Waterton 2009, Watson and Waterton 2010). Therefore, issues of power, domination and resistance are brought into consideration as the promotion of a vision or visions of the past above

others could serve to exclude, repress or stigmatise sections of society (after Littler and Naidoo 2005). This follows on from the work conducted within the wider field of visual anthropology and representation studies which have highlighted how images and the place of representational schemata within society constitute evidence of shared cultures, values and norms (Banks and Morphy 1999). This is the significant aspect of visuality: its communicative ability (Pink 2006). For an image to be useful, meaningful and effectual within society, it must contain elements which can be deciphered, understood and contextualised by the wider part of that social group (after Barthes 1984). This process can be witnessed with the way in which the First World War is remembered. Within the context of the Great War, across communities, nations and regions in Britain a set of preferred images are relied upon to convey the 'proper' or 'preferred' understanding of the conflict (see Sternberg 2002). This constitutes the visual counterpart to the 'war discourse'; as just as the language of the Great War is used to express current social and political issues, the representations of the First World War provide specific 'frames' through which the past is used to understand and picture the present.

The manner in which images structure the remembrance of the Great War and interpret its heritage for contemporary concerns can be observed in the relatively sparse variety of images that called upon. Despite the fact that the war encompassed both military and civilian lives, that it impacted upon those in the front line as well as those on the home front, that it involved men, women and children from across the world as colonies, dominions and dependencies were drawn into the conflict, it is three images particularly that serve to shape and focus the heritage of the Great War across Britain (see Badsey 2009). These three consist of the soldier in the trenches, almost invariably on the Western Front in France and Flanders, the desolate and devastated battlefields and no man's land and the post-war memorial landscape, the cemeteries and memorials which are scattered across the former fields of conflict (see Arthur 2007, Macdonald and Seaton 1991). It is these images which dominate the remembrance of the First World War and their deployment within specific contexts evidences how the heritage of the conflict is used within contemporary society.

These limited 'visions' of the conflict are quite striking. Commentators have noted that the mere mention of the Great War, 1914–1918 or the First World War appears to almost automatically conjure the trenches, no man's land and the rows upon rows of headstones in the memorial cemeteries (see Dyer 1994, Sheffield 2002, Todman 2005). The dominance of these particular images has been lamented by historians who seek to revise what they define as the myopic and highly limiting 'popular memory' of the conflict (Bond 2002). These revisions critique the overpowering nature of these visions of the war and lay the blame for their dominance on the media representation of the events of 1914–1918 (Badsey 2001). These 'media-ted' images are highlighted as focusing on specific details, emphasising the limited experience of a few and assuming it to be representative of the experience of the wider majority (Hanna 2007, Todman 2002). Similarly, the focus on the battlefield and the soldiers in the trenches has also been critiqued

for its androcentrism in a war that was experienced by both men and women both at the front, immediately behind the lines and at home (Watson 2004). This limited image is in direct contrast to how the war was 'imagined' at the time (see Grayzel 1999). Indeed, the work of women during the war was frequently represented by both the government and wider media during the conflict itself as directly comparable to the work of the soldiers in the trenches (Watson 1997; 2000; 2002). The dominance of the image of the trenches is observed to be a post-war phenomenon, brought about by the cultural and social emphasis on seeing the war 'first-hand' (see Higonnet 1993, Higonnet et al. 1987). Whilst accurate in the highlighting of the repression and exclusion of alternative views, these assessments do rely on the assumption that images are vapidly consumed by their audiences and neglect the question of why particular representations find favour over others. This selection is not merely an acceptance of dominant 'media-ted' images. Rather, the dominance of particular images of the conflict occurs because they are used to represent, question and reaffirm issues of power, politics and identity across Britain.

The Soldier in the Trenches

The image of the British soldier, stoically enduring the privations and dangers of the industrial scale war in the trenches of the Western Front has become emblematic of the Great War for communities across Britain (Wilson 2010). This picture of the war was certainly current during the conflict. The vision of the 'Tommy in the trenches' was a stalwart of wartime propaganda, print media and advertising as the martial experiences of front line troops were used to promote the war effort and maintain morale both at home and in the field (Buitenhuis 1992, Messinger 1992). Since the Armistice, memoirs, novels, film and later television programmes have also drawn upon this image as the experience of the ordinary infantryman undergoing the experience of the mud, blood, gas and rats of the trench system in France and Belgium particularly has become a literary topos (from the ancient Greek τόπος, meaning place) and part of an identifiable canon of 'war books' in its own right (see Brophy 1929, Falls 1930). However, the usage of this image, whether through visual or textual description, is not evidence of the persistent nature of cliché. It is demonstrative of the utility of this particular aspect of the heritage of the Great War. Imagining, remembering and framing the history of the conflict of 1914–1918 through the outline of the 'Tommy in the trenches' possesses social and political resonance in contemporary Britain.

The evocative power of this visualisation of the war can be witnessed in the contemporary campaign to pardon soldiers executed by the British Army during the Great War. The 'Shot at Dawn' Campaign, begun in the early 1990s, fought for the dismissal of guilty verdicts for over three hundred British, Irish and Commonwealth military personnel who were executed for offenses committed whilst serving during the war of 1914–1918 (see Putkowski and Sykes 1989).

The campaign attracted widespread support from the political elements on the left as well as substantial public interest. However, it is also encountered criticism from right-leaning political elements for a perceived 'leftist' or 'Marxist' political bias (see Hughes-Wilson 2006). What is distinct about the campaign is that it relied upon a specific image of the ordinary, working-class solider in the trenches suffering from the mental and physical anguish caused by their experience of the war. Indeed, this image was regularly repeated in the popular press in the coverage of the issue:

> A volunteer aged 19, McCracken had reacted badly to the news that his mother had died. He had just returned to the frontline from hospital when he stepped out of the trenches. He was shot for desertion (Chrisafis 2004: 4).

> He had volunteered to do the double watch to help a sick pal, but Frank himself was suffering from trench fever, starved of sleep and dazed by shellfire. A young officer accused him of sleeping on duty and arrested him. At a 10-minute field court martial he was sentenced to be executed by firing squad (Anon 2011c).

> Many of those killed are now believed to have been suffering from post-traumatic stress disorder after enduring months of heavy bombardment in the trenches (Neil 2005: 8)

The effect of this mobilisation of the image of the soldier in the trenches provided a significant affect for the campaign for the pardon of executed soldiers. Although in 1998, during the ninetieth anniversary of the Armistice, the then Armed Forces Minister, Dr. John Reid, refused to grant posthumous pardon, he did stress the need to acknowledge the status of soldiers in the trenches as 'victims' of a 'cataclysmic and ghastly war' (HC Deb, 24 July 1998, c1373). The image of the suffering, victimised soldier in the trenches was thereby reinforced and provided with official sanction. Whilst the appeal was also refused again in 2002, the campaign finally achieved success in 2006 with all soldiers executed for military offences during the Great War pardoned by the British Government with the passing of the *Pardon for Soldiers of the Great War Bill* (2006). The appeal of the image of the ordinary soldier facing the maelstrom of war in the trenches was at the centre of this debate and its prominence can be observed in the questions raised in the Irish, Scottish and British Parliaments which accompanied this issue. In Westminster, during a discussion of the issue in January 2006, the arguments were loaded with the imagery of the war and specifically that of 'the trenches'. For example, Don Touhig (Labour Party) as Parliamentary Under-Secretary of State for Defence stated:

> ... anyone who has studied the records and eye-witness accounts, heard or read the poetry, looked at the photographs or talked to those who survived the trenches, will realise that some places came as close to hell on earth as anyone

could possibly imagine, and that it was an awful experience for those involved (HC Deb, 18 January 2006a, c258WH).

This echoed previous discussions on this topic in the British Parliament which emphasised 'the trauma of the trenches' and the 'horror' of the front lines (see HC Deb, 9 May 1996, c469). The imagery of victimhood in the trenches of the Western Front was reiterated in these debates as Members of Parliament utilised the visual appeal of the neglected and abused ordinary soldier at the front. The Liberal Democrat Politician Mike Hancock referred to soldiers 'as victims':

> ... the majority of them were volunteers. These men were in danger day in and
> day out, week in and week out, for years in some instances (HC Deb, 24 July
> 1998, 1379).

This evocation of suffering in the trenches was also noticeable in its employment in Parliament at Westminster for its capacity to stress wider concepts of nationality. In this way a shared history of suffering as 'Britons' formed the basis of reiterating the necessity of political union in the face of increasing moves towards greater devolution of powers and even independence in Wales, Scotland and to a lesser extent Northern Ireland (after Novick 2001). Within the political discourse at Westminster concerning the issue, even since its introduction as a topic of debate in the 1990s, the 'sacrifice' of soldiers in the trenches has been framed as a fundamentally 'British' history (see HC Deb, 9 May 1996, c470). In 1998, responding to a question posed by the then Member for Parliament (North Antrim), the Democratic Unionist, the Reverend Iain Paisley, the Armed Forces Minister reiterated the experience of soldiers from Northern Ireland as part of the wider 'British' experience of suffering in the trenches. The shared sense of victimhood was thereby significant as a part of a presumed 'British' identity:

> The loyalty they showed to the United Kingdom throughout that period should
> not and will not be forgotten. I am sure that it is at the back of our minds as we
> deal with contemporary developments, and that it occasionally comes to the
> forefront of our minds when we consider the role of Ulster and the north of
> Ireland within the United Kingdom (HC Deb, 24 July 1998, c1385).

Throughout the Parliamentary debates in Westminster on this issue, the description of the suffering 'Tommy' has been accompanied by an evident employment of inclusive pronouns (after van Dijk 1991: 20). The image of the soldier in the trenches is in this way recognised so that the history is significant for 'us', that it is 'our' history and that 'we' should remember and value it. Representing the British Government, Don Touhig (Labour Party), reminded Parliament in November 2006 that:

> ... this week, we will remember our war dead. I hope that, as a country, we can at
> long last find it in our hearts to pardon and pay our respects to all the young men

who lost their lives on the foreign battle fields of the First World War. Whether they were shot by the enemy or by their own side, all were victims of a terrible and bloody war (HC Deb, 7 November 2006b, c775).

The location of contemporary identity with the soldier in the trenches is a powerful device, as the image of the suffering, victim of the conflict provides a means of identification across Britain. Affirming the soldiers in the trenches as 'British' and their experiences at the front as 'our' heritage assumes especial pertinence in the context of the potential 'break-up' of Britain (after Nairn 1977). The media coverage of the issue was also accompanied by a reiteration of national endeavour as the soldiers were significantly detailed as 'British' (see 'The war over pity: Why the deserters have been forgiven' (Anon 2006a: 23), 'Executed WW1 soldiers to be given pardons' (Norton-Taylor 2006a: 5)). The widespread description within the media of these men who were executed as 'British' soldiers is highly significant (see Hickley 2006). As whilst the pardoning of executed soldiers was couched in terms of 'Britain', for sections of the media and politicians in Westminster, the image of the soldiers enduring the horrors of combat has been equally important in stressing other identities across Britain. Indeed, the initiation of an enquiry in 2004 by the Irish Government into Irish soldiers, who fought in the British Army during the Great War and who were executed for military offences, brought the usage of this image of the trenches to the fore. As the British Government considered an appeal for pardons for these men from the Irish Government, the way in which the vision of the soldiers in the trenches enabled other identities was quite apparent. In opposition to the 'British' national press, regional and national media outlets within Britain portrayed the vision of the solders in the trenches in particular ways beyond the notion of 'Britain'. For example, the news that the British Government were considering the issuance of pardons for Irish soldiers brought greater focus for other identities within contemporary Britain within the media. A report in the *Scotland on Sunday* newspaper reflected this difference:

> The British government is preparing to grant official pardons to Irish soldiers executed for desertion during the First World War, while refusing to clear the names of hundreds of Scots, English and Welsh troops who suffered the same fate (Brady 2004a: 12).

In this manner, the image of the soldiers in the trenches is reclaimed not as 'British' but as representative of a wider array of identities that constitute contemporary Britain. These soldiers are reclaimed or adopted and then valued as representative of a particular 'imagined community (after Anderson 1983). Indeed, this process can be observed in the debates within the Irish Parliament after the pardoning of the Irish soldiers who had been executed or 'shot in the trenches' as it was also phrased (see 'Pardon plea for Irish volunteers shot in trenches', Chrisafis 2004). In 2006, the debate in the Seanad Éireann (the Senate) of the Oireachtas (National

Parliament) of Ireland focused on what has been a historically 'difficult' subject of Irish men fighting for Britain in the Great War (see Dungan 1995, 1997). However, this political obstacle was overcome in stressing how 'Irish soldiers' in the British Army were suffering 'victims' of the war. Dermot Ahern of the Irish republican party Fianna Fáil, Minister for Foreign Affairs reflected this issue with a statement to the Seanad Éireann in 2006:

> ... it would be equally misguided not to try to imagine the conditions in which these volunteers found themselves — the situations in which some were charged and executed for cowardice or deserting their post, without any proper recognition of medical conditions like shell-shock or the appalling pressures soldiers on the front faced on a daily basis (Seanad Éireann, 28 March 2006, v183).

The 'awful events in the trenches' were evoked in this debate in the Seanad Éireann which focused on the experiences of Irish men in the Great War and the need to acknowledge their contribution whilst also incorporating the thirty-six Irish men who were executed during the 1914–1918 conflict into the wider scheme of remembrance. In this way, all these soldiers were valued as 'Irish' and as fellow-sufferers of the conflagration by drawing on a seemingly shared 'vision' of the war of soldiers as victims in the trenches. The independent politician Joseph O'Toole drew upon this image within the debate:

> Members will recall the pictorial record of the First World War from which one saw the trenches with the rats, the dirt, the bodies and body parts and the countryside wrecked (Seanad Éireann, 28 March 2006, v183).

The debate demonstrates a significant feature of this image of the war; the identification of the Great War as that of the infantryman huddled in the trenches, exposed to the artillery, machine gun fire and atrocious conditions which has enabled a sense of collective identity despite the religious, political and national divisions that have marked relations between Ireland, Northern Ireland and Britain. Indeed, the vision of troops in the trenches was considered in the debate to ensure a 'shared future on this island' and that the soldiers in the trenches should be remembered as 'Irish' not as 'British':

> It is the intent of the Government that this is not how he or any of the Irishmen who fought in the First World War should be remembered and it is our intention, therefore, to honour their memory. As in the case of those "shot at dawn", it is our objective to recover their memory from the dishonour that was done to them 90 years ago. It is an act of national solidarity with those of our countrymen who volunteered to fight in a truly terrible war and with the always complex and often tragic experiences of previous generations as a whole (Seanad Éireann, 28 March 2006, v183).

This process of the location of identity within the image of the solider in the trenches is significant as it is also evident within communities, regions and nations in Britain. Attaching oneself to this vision of the past provides a means of anchoring notions of character and a 'sense of self' for various different groups. In Scotland, the issue of providing pardons for soldiers was debated in the newly-formed Scottish Parliament in 1999 and the issue became a point in which to distinguish a 'Scottish' identity separate from notions of 'Britain'. The debate on the issue was also used to demonstrate a significant political issue for the new authority as whilst the Scottish Parliament voted in favour of the pardons for executed soldiers, the elected assembly was unable to pass laws on military matters and had to cede to Westminster. Despite this limitation, debates within the Scottish Parliament also focused on the image of the soldier in the trenches to further the campaign for pardons. The Scottish Labour Politician, Elaine Murray, urged members of the Holyrood assembly to reflect on the image of the suffering troops:

> Let us remember the conditions under which the private soldier at the western front existed. It was a pointless, static conflict over strips of earth, which achieved nothing other than the slaughter of millions of young men from both sides. The soldiers were condemned to existence in hell—floundering in mud in the winter, baking in the summer, rats and parasites their constant companions, never knowing whether today's sunrise would be their last, without respite, week after week, month after month, year after ghastly year (SP OR, 11 November 1999, S1M-223).

However, within these debates the focus of attention with the usage of pronouns such as 'our' and 'we' was towards Scotland in particular rather than Britain as a whole (see Allardyce 1999: 6; Mulford 1999: 9). The Scottish Labour, Patricia Godman demonstrated this tendency with her statement regarding the powers the institution had to force its will on the matter:

> Matters relating to the armed forces are reserved to Westminster. Nevertheless, it is fitting that this Parliament should speak out on behalf of the Scottish soldiers who were executed following courts martial conducted by officers who never gave the accused a fair hearing (SP OR, 11 November 1999, S1M-223).

Similarly, for this debate and within later coverage of the pardons, the national and local press within Scotland mobilised the same image of the soldier in the trenches as 'Scottish' as opposed to 'British'.

> Dozens of Scottish soldiers who were shot for cowardice or desertion during the First World War are finally set to win pardons (Anon 2006b: 4).

The Scottish Parliament is to pardon 39 Scots soldiers shot for cowardice and desertion during World War I. MSPs are expected to back a motion calling for them to be cleared and their reputations restored. The Scots were among 307 British troops shot by firing squad during the conflict (Alba 1999: 12).

Corresponding sentiments were expressed within some sections of the media coverage of the issue in Northern Ireland. Within the province, issues of Irish, British and Ulster identities were negotiated with the pardons for executed soldiers as the image of the soldier in the trenches was observed to be significant for the identities of various groups and communities (after Graham and Shirlow 2002). In this matter, expressing sympathy for the suffering 'Irishmen' in the trenches from 'Belfast, Londonderry, Dublin and Cork' who served in the conflict and who were executed reflects both historical and contemporary issues of identity within Northern Ireland (see Starrett 2000). In 2004, the nationalist Social and Democratic Labour Party Lord Mayor of Belfast Martin Morgan campaigned for the pardon as a cross-border, anti-sectarian issue (see Fitzgerald 2004). Indeed, with the passing of the Good Friday Agreement in 1997, the image of the victimised soldiers in the trenches appeared to offer the possibility of uniting behind common frames of reference. As those from the province executed during the 1914–1918 conflict included the Shankill Road teenager James Crozier as well as Peter Sands from the Falls Road, both areas which had suffered during 'The Troubles' (1963–1985), the potential of the unifying image of common suffering in the trenches was evident in the political and media discourses which stressed both the 'Irish' and 'Ulster' identities of the individuals (see Douglas 2006). In a similar manner, the campaign for pardons in Wales also drew upon this visualisation of the past as specifically 'Welsh' troops in the front line were emphasised within the media reports (see 'A pardon, 90 years on', Rogers 2006: 6). The image of the Welsh soldier, suffering in the trenches of the Western Front in northern France and Flanders, therefore provides a means of promoting alternative identities beyond normative, hegemonic structures.

Within England, rather than an image of an 'English' 'Tommy' in the trenches and whilst national media reiterated a discourse of 'British' soldiers, local media coverage of the pardons issued to executed soldiers focused on a regional connection. This was particularly strong within the northern counties of England, which drew connections with arguments from Ireland that suggested that execution rates of soldiers from particular regions across Britain were disproportionally higher. For example, the Yorkshire newspaper, the *Bradford Telegraph and Argus* reported the issue as a 'local' concern:

Eighty-seven soldiers from the 306 which includes Commonwealth countries, were from the North of England, 27 from Yorkshire regiments (Anon 2002b: 11).

Similarly, the Tyne and Wear newspaper, *The Journal*, also highlighted the higher level of executions of 'northern' soldiers.

... grant pardons to 306 soldiers from the UK killed by firing squads, including
87 soldiers from the North of England (Anon 2004b: 5).

Areas in the North of England, and to a lesser extent in the Midlands, were
thereby able to promote a regional identity through the association with the
image of victimised soldiers serving in the trenches. Local media coverage of the
issue focused on the regional identities of those who had been executed and the
'harrowing experience' of the trenches for both these 'victims' and their 'pals'
from the same city, town or county (see 'North boy soldier shooting revealed',
Diffley 2004: 7). Honouring the memory of those executed became a means of
stressing attachment and place. Soldiers who were executed after enduring the
'stresses of the trenches' were described as occupying particular relevance for a
locality. For example:

> Midland relatives of a soldier shot for cowardice during the First World War
> (Cowan 2006: 15).

> Three soldiers from Carlisle's Border regiment have been granted posthumous
> pardons (Brenan 2006: 4)

> A Winnington solider executed for cowardice during the First World War is set
> to receive a posthumous pardon (Kandel 2006: 5).

In June 2009, Bolton Town Council in the north west of England became one
of the first authorities to independently elect to have the name of James Smith,
executed for military misconduct in 1917, to be placed on the town's Roll of
Honour (Bolton Council 2009). The listing of the soldier's name on the official
memorial marked an identification with this 'victim' as a 'hero' of the town:

> More than 90 years after he was shot as a deserter, town hall bosses have now
> agreed to add him to the list of Bolton heroes sacrificed in the conflict (Qureshi
> 2009: 8).

The issue of pardons for executed soldiers of the First World War therefore highlights
a significant factor in the cultural heritage of the Great War. The appropriation
of the image of the soldier in the trenches for means of expressing and detailing
contemporary identities emphasises how the war of 1914–1918 is used to frame
current concerns (after Edkins 2003: 72). As nations, communities and regions
across Britain reaffirm, renegotiate and debate their place and role, the Great War
and the image of the troops in the trenches serves as a means to focus and mobilise
these identities. The ability to connect with these historical figures appears to
grant communities and groups in the present with a means to state the value and
significance of their identities in the present (see Brown 2001). Describing the
soldiers in the trenches, suffering the full onslaught of industrialised war, who then

falls victim to an uncaring centralised governing elite, provides an affirmation of the distinctive character and qualities of a particular place of origin. It also enables a distinction between a region and a wider national identity (after Dicks 2000a: 5). Within the context of the heritage of the Great War, this process frames broader issues on responsibility and duty as a distinct social and political discourse is drawn upon with the image of the suffering soldier in the trenches. For example, see the following article in the north east newspaper, the *Northern Echo*, 'My uncle was shot at dawn for simply following orders' (Anon 2006c: 7). In this way, particular regions can highlight their association with historic suffering whilst demonstrating the culpability of national organisations in the guise of the government or the army.

Therefore, this dissident aspect of the image of the ordinary 'Tommy' beleaguered by the incompetency of officials as well as the ravages of conflict is also enacted to affirm a social and political identity beyond national and ethnic boundaries. Indeed, the visual appeal of the soldier in the trenches is used to frame class-based identities across Britain. The vision of the trenches has been used to exemplify class divisions, as the put-upon working class soldier suffers the privations of the conflict as upper-class officers based in safe areas behind the lines organise attacks that result in large numbers of fatalities. This image of the trenches has proven to be a powerful and evocative symbol and it is regularly drawn upon by left-leaning politicians, the media and within wider public discourse to assert dissent and disapproval of hierarchical systems and practices of government. The suffering of the soldiers is thereby blamed on a ruling elite and becomes a powerful structuring device in which to frame contemporary identities regarding class, power and democracy. Within the debates regarding the pardons for executed soldiers as well as the broader representations of the Great War, this image of the 'Tommy' is evident:

> What happened was horrendous. It was upper-class generals showing their macho-ness. These were just poor kids, some as young as 16 or 17, who were scared out of their wits. What happened was totally unjustified (Bushe 2002: 23).

> Those who tried them at courts martial were products of the British public school and university system imbued with the values of their class and military culture. These upper and middle-class officers passed judgment on the lower orders just as they did in magistrates' courts at home (Speller 2010).

In this visualisation of the past, the British Generals and officers, the latter occasionally referred to with their wartime derivative as 'red tabs' or 'brasshats', and the British/English upper-classes, occasionally referred to as the 'toffs' are seen as those who inflicted this suffering on the working-class soldier in the trenches. The campaign for pardons for executed soldiers during the Great War served to focus this class-based image of the conflict. Indeed, whilst left-leaning elements championed the cause as an example of 'class oppression' in the early twentieth century, right-wing or conservative elements were critiqued for a

seemingly obstinate refusal to acknowledge the 'victims' of the war. For example, within Parliament at Westminster, the cause attracted the ire of Labour politicians who used the heritage of the 1914–1918 conflict to evoke the negligence of the upper-classes and the heroic suffering of the ordinary soldier. For example, in 1996 with regard to the pardon of executed soldiers, the Scottish Labour politician Norman Godman, reminded his fellow Parliamentarians of:

> … the actions of the appallingly arrogant officers who sent deeply traumatised young men to their deaths … (HC Deb, 9 May 1996, c472).

In the same debate, the Labour politician Tony Banks, used the issue of pardons to criticise the 'elite' who had sent working class soldiers to their deaths:

> A few yards from here, there is an equestrian statue of Lord Haig, who was one of those who sent millions of young men to their deaths, often needlessly. Such people were honoured for what they did, yet they are the sort of people who should be arraigned before the High Court of Parliament, even today (HC Deb, 9 May 1996, c472).

The campaign for pardons often evoked this image of the callous general, officer and even the 'selfish politicians' as the cause of the death and danger of the soldiers in the trenches (see HC Deb, 24 July 1998, 1379). This was evidenced in the media responses to the perceived indifference expressed by conservative elements across Britain to the historical plight of the troops. Indeed, during a Parliamentary debate in 1996, Conservative Members of Parliament were rebuked for the description of the executions as a necessary step *'pour encourager les autres'* (HC Deb, 9 May 1996, c470). Whilst the debate in Parliament over this issue in 1998 was supported by members of the then Labour Government, it was widely reported in the media that 'traditional' elements within the Ministry of Defence were against the issuing of pardons and advised against the policy (see 'Civil servants block pardons for First World War deserters', Bevans 1998: 12). The image of upper-class or official indifference to the suffering soldier was restated in the reports that the Conservative Party leadership was also blocking the passing of the legislation needed to enact the pardons in 2006 ('Tory blow to campaign for war pardons', Brady 2006):

> (Conservative Party Leader David Cameron) risks outraging campaigners and much of the country if he orders Tory MPs to oppose government proposals to clear the names of 306 soldiers executed for desertion, cowardice and insubordination (Brady 2006: 8).

In this instance, with the image of the soldiers in the trenches, the heritage of the Great War is evoked to substantiate and support a dissonant, political identity based upon class politics. This appeal to radical sentiment can be located across national and regional boundaries in Britain as a common response to picturing the

1914–1918 war. Public and online media forums discussing the issue of pardoning soldiers reasserted this image of the First World War:

> Ironically, the officers (upper classes) of the day who lost it were sent back to blighty to some convalescent home. These men weren't shot for cowardice, they were murdered to set an example to their peers (Don Kiddick 2006, *Sheffield Forum*).

> How right you are, unfortunately in time of war it tends to be (mainly) the poorer classes who go to War. The rich and middle class, tended to stay at home or in their well paying job. Sorta (sic) like the slaves going to war to protect the interests of the Politican (sic) and the Business man – it is not the Man in the street who declares war (Bloomfield 2006, *Belfast Forum*).

> What historians who continue to defend the executions fail to mention is that the British Army of 1914 to 1918 was waging a class war of its own against anyone it saw as inferior or of weak character (Macintyre 2004: 8).

This visualisation of the conflict has been used to mobilise critical perspectives as the identification with this example of historical suffering and the negligence of officials frames concerns for both the past and the present. Noticeably, it was conservative elements within society that challenged the issuing of pardons as a political measure (see 'Haig's son opposes First World War pardons', Richard Norton-Taylor 2006b: 8). Former Conservative Member of Parliament Matthew Parris (2006) also condemned the issuance of pardons as it shifted the sense of blame to those who stood in judgement of the condemned soldiers. In this manner, class lines were distinctively marked as the contemporary 'political capital' drawn from the 1914–1918 conflict was evident in the debates surrounding the soldiers in the trenches.

Beyond the issue of pardons for executed soldiers, the use of this radical outline drawn from the cultural heritage of the Great War can be observed with the death of Harry Patch in 2009, the last 'Tommy' to serve in the trenches of the Western Front with the British Army. This moment enabled the reiteration of this specific 'framing' of the image of troops in the trenches to draw upon the heritage of the First World War. For example, it was utilised by the Labour Member of Parliament Jeremy Corbin to highlight government policy in Iraq and Afghanistan in his column for the British-based socialist newspaper, the *Morning Star*:

> Perhaps our schools should be teaching children about the life of working-class young men like Patch who were sent off by self-aggrandising and ignorant politicians to die for what they claim was a noble cause (Corbin 2009).

Similarly, the *Guardian* newspaper's Editorial on the death of Harry Patch outlined the current conflicts fought by the British Army with that of the service of those

who fought in the trenches, thereby highlighting the contrast between 'the nature of individual sacrifice on the one hand and the conduct and purpose of war on the other' (Editorial 2009). Employing the heritage of the Great War to frame debates regarding class politics provides a means of organising and focusing politically dissident identities. In this manner, the image of the soldier in the trenches serves as an important point to mobilise opinions and attitudes as it evokes issues of responsibility, ethics and equality. Summoning this particular visualisation of the First World War thereby places contemporary and historical issues within the same bracket of understanding. Evoking the oppression of the working classes, the excesses of the elite and the abuse of power through a framework provided by the Great War heightens and strengthens opposing arguments. For example, in 2008 Baron Oakeshott, the Liberal Democrat Peer, evoked this visual imagery of the Western Front in his criticism of the pensions provided to politicians at Westminster, stating that:

> ... they look like the first world war generals ... sipping fine wines in a chateau well behind the front line, while privates in the trenches get their pensions shot to pieces (quoted in Anon 2008c).

The image of the suffering soldier in the trenches therefore constitutes a significant aspect of the Great War heritage in Britain. It enables a means of identification both politically and socially as the recognition of the 'horrors' of the trenches provides an example of historical anguish around which groups and communities can coalesce (see Brown 2001). This affirms a wider trend within western societies which seeks to affirm the role of the 'victim' within history as a figure to whom one should identify with and laud (see Novick 2001). To associate with victimhood is to access a vantage point from which one can launch claims for political, social and cultural recognition for this perceived historical injustice. The heritage of the Great War in Britain provides groups and communities with this powerful position as the image of the soldier in the trenches frames a sense of 'victimhood'. Evoking this powerful visualisation of the 1914–1918 conflict outlines a sense of injustice and inequality which mobilises opinion and enables the construction of non-conformist identities and attitudes in the present.

In recent years, the image of the soldier in the trenches has also been used to encompass the multicultural history within Britain as images of soldiers of African, Caribbean and Indian heritage fighting and labouring at the front have been used to promote subaltern histories (see Das 2011). A prominent example would be the case of Walter Tull (1888–1918), a professional footballer before the war, who was of British and African Caribbean heritage, and served in the British Army despite the official regulations prohibiting non-European combatants. Tull, who was killed in action in France in 1918 and is one of 'the missing', has been drawn upon to provide another image of the soldier in the trenches beyond the dominant vision of 'white, working class Tommies' (see Vasili 1996). Honoured with a memorial garden in Northampton in 1999, where Tull played for the local football team, his

service in the trenches of the Western Front has been offered as another means of affirming African Caribbean identity within Britain. Significantly, the cultural heritage of the Great War which is 'discovered' in this instance has been used to promote a 'Black British' identity within educational and political discourse:

> It reminds everyone that black Britons have been contributing to our society for many years (Black History for Schools 2001).

> As the first black infantryman in the British Army, and my home team's first black player, I'm proud of Walter Tull's contribution to his country (David Lammy (MP) quoted in Northamptonshire Black History Association 2007: 5).

The image of the soldier in the trenches expanded in this manner performs the same function of providing a point of identification and acknowledgement.

Such is the central place of this image of the 'trenches' as a point of origin for various identities that any attempt, perceived or intended, to undermine or to alter this visualisation of the past challenges the construction of these 'senses of self'. Indeed, the furore caused by the BBC television reality programme *The Trench* (2002), which offered the opportunity for a contemporary generation to experience 'life at the front', stems in part from the necessity for this historical experience to remain beyond the ken of the modern era (see Hanna 2007). The suffering of the soldiers in the trenches is, therefore, frequently referred to within political, media and public discourse as 'unknowable' or 'unimaginable' (see Harris 2002, Lawson 2002). The image of the trenches and the soldiers who inhabited them are sacrosanct because of this quality and their experience as 'victims' is affirmed through this process. Whilst assessing this visualisation of the past as a significant factor in the formation of identities within Britain has received relatively little assessment, it is an issue that has long been acknowledged elsewhere. The trenches as a 'locus' of identity has often been cited in discussions of the growth of national character in post-1918 Australia, Canada and New Zealand (see Hoffenberg 2001, Thomson 1994). The image of soldiers serving in the trenches is frequently asserted as the 'crucible of identity' for these nations (after Vance 1998). In the aftermath of the Great War and to this day, for these former colonial dependencies of Britain, the 'sacrifice' of the soldiers in the 1914–1918 war is used to validate and to distinguish an identity which is distinct from the 'mother country' (see Adam-Smith 1978, Laffin 1959). In a similar fashion, the identification with the image of troops suffering the privations and traumas of conflict also constitutes a means of building identities and establishing attitudes across the various social and political groups within Britain.

The Battlefields and No Man's Land

The result of the industrialised warfare across the Western Front and to an extent in Gallipoli and Salonika, where British and Commonwealth troops also fought

'in the trenches', was a battlefield which had been deeply scarred by battle (see Eksteins 1989, Saunders 2001). As dugouts, trenches and support lines were built, the latter zigzagging across former agricultural land, and intensive artillery bombardments of opposing positions were launched, a unique war landscape was created (Wilson 2008b). As the war progressed, the conflict shaped the battlefields into a 'strange hell' (Gurney 1996: 214), revealed in the depiction of the landscape of shattered trees and shell holes painted by the war artist Paul Nash (1889–1946) in works such as *Oppy Wood* (1917) or *We are Making a New World* (1918). Such was the distinction formed with this 'new world' that artists, authors and poets frequently referred to the conflict zone in their work as the conditions wrought by war utterly transformed the environment (see Gough 1993, 2010a). Whilst areas in some relatively peaceful sections of the front could appear untouched by war, with animals and plants inhabiting the space which had been divided by the conflict, sections which had witnessed heavy fighting would be littered with the detritus of combat (Winter 1995: 68–9). Heavily cratered landscapes, the material of war strewn across a sea of mud and the remains of the dead in close proximity to the living have become the dominant vision of the Great War in Britain (see Corrigan 2003, Dyer 1994). To mention the battlefields of the Western Front, the Somme, Passchendaele, Vimy Ridge and to a lesser extent the arena of war in the Dardanelles, is to immediately conjure images of desolate, broken wastelands which have been ravaged by intense conflict. In many respects, the First World War across Britain is remembered as this 'mud and blood' image of the Western Front (Bond 2002). However, whilst this perspective of the war has been critiqued by some as indicative of an influential media shaping popular conceptions, this image of the war is retained because of what it communicates to groups and communities in the present (after Smith 2006: 180). Therefore, the battlefields and no man's land form powerful and meaningful visual frames through which contemporary issues are structured and comprehended (after Swindler 1995).

This utilisation of the battlefields of the Great War can be observed in the way in which they serve as the basis of identification for various political and public groups (after Ashworth et al. 2007). This is perhaps most notable in the evocation of the image of the war zone in the remembrance of the Christmas Truce of 1914 (see Brown and Seaton 1984). In this manner, the war-torn landscape of the Western Front is used to frame the moment when British and German troops in certain areas of the front line in France halted hostilities in unofficial truces during Christmas Eve and Christmas Day 1914 (Weintraub 2002). Whilst the truce has been represented in various media since the conclusion of the war, the remembrance of the war as the image of soldiers greeting one another and fraternising in no man's land serves as an important point of recognition for groups (Ekstein 1989: 97). By drawing on this image, the heritage of the Great War is utilised to state a 'sense of place' (see Ashworth and Graham 2005: 3–5, Waterton and Smith 2009: 293). The historical battlefields are thereby imbued with values and meanings in the present, as contemporary groups construct

the Western Front as an imagined 'place'; an area which shapes attitudes and identities (Cosgrove 1993, Tuan 1977). The Christmas Truce of 1914 which occurred on the shattered and broken war landscape of France and Flanders constitutes one example of this structuring of a 'locale' (see Feld and Basso 1996). References to the truce on the fields of conflict enable the communication of a shared vision of the events which further defines this 'sense of place'. This creation of 'place' forms a central part in the utilisation of the heritage of the Great War as part of a dissident identity.

Across the political, media and public discourse regarding the Christmas Truce, the significant aspect of this image of the soldiers' impromptu armistice is its mobilisation for peace movements and political solidarity (see Rifkin 2009: 12). This sentiment is also evident in the cultural representations of the battlefields. For example, the sight of soldiers meeting one another across no man's land is evoked in the imagery of the popular songs that take these events as their subject. The Irish folk singer Cormac McConnell's *Christmas 1915, A Silent Night*, draws explicit reference to the sense of unity across boundaries which are frequently asserted in depictions of the Christmas Truce; 'All brothers hand in hand … Though the captains and the kings build no man's land' (see Lynch 1997). The English folk singer Mike Harding (1977) also used the image of the battlefields as a place of working-class camaraderie between British and German troops in *Christmas 1914*:

> Then from both sides men came running, crossing into no man's land.
> Through the barbed wire, mud and shell-holes, shyly stood there shaking hands.

The blasted landscape of the Western Front and the Christmas Truce were also notably used for the backdrop in the music video of Paul McCartney's (1983) *Pipes of Peace*. These cultural responses are reflective of the uses made of this image by groups and communities in Britain as a means to encourage and activate political and social issues.

The visualisation of the war as the truce in the battlefields of no man's land provides a frame through which current left-leaning identities can be comprehended (see Leggewie 2008). Indeed, the Christmas ceasefire is used to emphasise the solidarity amongst 'ordinary' individuals in the face of national or capitalist aggressors. Writing in a left-wing newspaper, the historian Neil Faulkner (2008) drew attention to the popular revulsion and class anger amongst the troops that contributed to the truce where 'opposing soldiers had fraternised'. Similarly, the anti-war politician, George Galloway (2008), also used the image of the truce to call for action by current populations to demand change from the leaders. Directly framing the contemporary operations of the British Army with the heritage of the Great War in this way enables the communication of a distinct political identity as 'citizen soldiers' are remembered as those who:

> … crossed no man's land, embraced one another … and did not want to continue
> the slaughter (Galloway 2008).

The anti-authoritarian sentiment is directly expressed within the image of the conflict as the vision of solidarity amongst the soldiers of opposing nations is viewed as exposing the 'old lie' of government and military connivance in prolonging the war (see Weintraub 2002). Online forums for popular genealogical or historical studies can also reiterate this vision of December 1914 and 'Christmas in the trenches' as a victory for the ordinary 'Tommy' against the elites of the General Staff and the British Government. For example:

> It was good to see the human spirit prevailed amongst all sides at the front, the sharing and fraternity. All was well until the higher echelons of command got to hear about the effect of the ceasefire, whereby their wrath ensured a return to hostilities (RootsChat 2007).

This image of the ceasefire also provides an outline for regional and national identification within Britain as the association with soldiers from particular areas serves as a means of differentiation from collective, hegemonic identities (see 'Remember Scots serving abroad this Christmas', Crawford 2011). However, the main visualisation of the war as the Christmas Truce activates a means of evoking left-wing and anti-war politics. Indeed, the Peace Pledge Union (PPU), the oldest pacifist campaign group in Britain, founded in the 1930s in the wake of the Great War, uses the 1914 ceasefire in their educational material to demonstrate the capacity for individuals to renounce violence and emphasising the spirit of humankind over adversity (PPU 2012a). The image of this event in no man's land is thereby enshrined as the example above all others of human endeavour amidst the carnage of war. The testimonies of the last few remaining veterans of the truce were used in this manner to stress the abhorrence of the conflict but also wars since the Armistice. In 2005, the last remaining soldier to have witnessed the truce, Alfred Anderson, passed away. The recollections of this serviceman were mobilised within sections of the media to condemn the continuation of war in the present:

> But throughout his long life, the events of the First World War – especially at Christmas time – have haunted him. And as one of the few remaining survivors of the "war to end all wars", he remains saddened by the bloodshed of modern day conflicts (Anon 2005a: 12).

The image of troops meeting on the battlefields is thereby evoked to demonstrate a common cause amongst opposing troops but it also used to conform to a wider understanding and marking of the festive period:

> The meeting of British and German troops on No Man's Land to exchange festive greetings and gifts on the first Christmas of the Great War is still seen as a shining episode of shared humanity from among the bloody chapters of World War One (Anon 2009c: 8).

Therefore, as this image is evoked as an example of humanity set against the backdrop of industrialised war, it has become a heavily sentimentalised vision of the past which has somewhat diluted the ability of this event to activate political and social issues. The Christmas Truce of 1914 has been transformed into part of a wider 'Yuletide Canon', evidenced by its habitual evocation within the media across Britain at Christmas time (see Niland 2011 'The Amazing Truce: Christmas in the trenches' or Simpson (2007) 'Truce in the trenches: let's meet for cigars'). This 'inert' use of the heritage of the Great War has been lamented by activists seeking to frame contemporary abuses of power through the perceived image of working class solidarity represented by the ceasefire in December 1914. Robert Griffith, of the Communist Party of Britain, writing in the socialist newspaper, the *Morning Star*, critiqued the immobile nature of this heritage and its instruction to school pupils:

> Compulsory when surveying the Great War will be an admiring – and yet sombre – mention of the Christmas truce and football games in the no man's land between the trenches. This shows how our common decency underlay the carnage which produced a corpse every 17 seconds for more than four years (Griffith 2005).

The inclusion of the image of the Christmas Truce of 1914 within hegemonic structures such as the national curriculum certainly demonstrates the manner in which this aspect of the heritage of the Great War has been drawn upon for divergent agendas. This usage of the image of the truce is evidenced by its evocation in 2011 as the background for a youth football tournament between teams from England, Belgium, France and Germany. Termed the 'Christmas Truce Tournament', the event was used to mark the ceasefire in 1914, when German and British soldiers reportedly played a football match in no man's land, and was sponsored by the major football leagues from the participating nations. The objective of the competition was stated as 'education', to inform the young football players of the service and sacrifice of all soldiers in the Great War. The Director of the Youth Academy at Manchester United, Brian McClair reaffirmed this image with the purpose of the tournament:

> When we visited No Man's Land and the boys got out a ball and played, that was, well, wow. There's a connection between football and a terrible part of history. And there's sadness. These boys now have a direct connection, every one of them is experiencing something new, something they'll never forget (quoted in Walker 2011: 11).

The visualisation of the Christmas Truce was thereby activated as a 'lesson from history', a situation which is affirmed with the use of the events of December 1914 within primary and secondary education in the United Kingdom (after Jenkins 1999: 1–3). Indeed, in 2009 plans emerged to build a football stadium near the

battlefields in Belgium to honour the Christmas Truce as an example and a message for current generations. Provisionally named the 'Flanders Peace Field and Truce Stadium', the stadium is designed to promote peace and cooperation across the world using the image of the impromptu football matches conducted in no man's land during the ceasefires of 1914. This clichéd assessment of a 'lesson' from the past might be criticised for passively framing this particular aspect of the heritage of the Great War and thereby veiling the image of British and German troops on the battlefields with a sentimentality that removes a sense of political and social action. However, the emotive appeal of this vision of the conflict does serve as a significant motivating factor within wider public discourse (Erskine 2008: 220). Emphasising the poignancy in representations of the truce serves to elevate the event into a higher status as a 'miracle' or as 'unbelievable' or 'amazing' act (see 'The Christmas Miracle', Anon 2008d: 19; 'The amazing football truce', Anon 2011e: 9). In this respect, the soldiers and the battlefields they inhabited in this image are reconfirmed in their status as 'victims'. Therefore, the vision of the Christmas Truce, of opposing troops shaking hands across no man's land, serves to frame the Great War as an experience where individuals suffered unimaginable horrors and the Western Front itself as a 'landscape of martyrdom'; a distinct 'place' where meanings and values are experienced, learned and enacted (see Gough 2010b).

This frame of reference, of the sacrifice and suffering of soldiers in the Great War is also replicated in one of the most dominating images of the conflict, the battlefields themselves. The Somme, Passchendaele, Arras, Gallipoli, Vimy Ridge are recalled as debris-strewn, highly dangerous, heavily-cratered, desolate lands which have been ruined by the processes of industrialised war. This 'mud, blood, rats and gas' image of the battlefields has been lamented by revisionist historians who highlight the varied conditions along the Western Front particularly as well as on other fields of conflict. However, it is the 'charnel house' image of the battlefields, the otherworldly landscape inhabited by the living and the dead which is frequently asserted within media representations of the conflict (see Wilson 2008a). This focus on the 'horror' of the battlefields is relayed through the depictions of the black-and-white or sepia-tinted visions of the front lines provided through websites, museum exhibitions and historical interest groups (see Whitmarsh 2001). It is the latter which have done much to ensure the continued reverence for the battlefields after the passing of the veterans of the campaigns. In Britain, the Western Front Association, founded in 1980, the Gallipoli Association, founded in 1969, and the Somme Association, founded in 1991, all attend to a vision of 'preserving' the memory of the battlefields of the Great War. The heritage they promote is one which honours the soldiers who fought and died on the fields of conflict; but it is the image of the 'hell' of the front lines which dominates political, media and public perceptions.

The portrayal of the battlefields as 'unimaginable', 'hellish' and 'horrific' has a considerable degree of cultural value across Britain (Wilson 2008a). Images of the muddy, rain-filled shell-holes across the war landscape that demonstrate

the senselessness and carnage of the war are dominant in the presentation of the conflict (after Hanna 2007, Williams 2008). Acknowledging the Somme, Gallipoli or Passchendaele as these nightmarish visions is a process that takes place within various spheres of influence in society. The anniversaries of these major battles provide opportunities for reiterating these perspectives. For example, an early day motion passed in Westminster on the anniversary of the first day of the Battle of the Somme in 1995 utilised this perception of the conflict:

> That this House remembers that 1st July was the 80th anniversary of the Battle
> of The Somme in which there were 60,000 British casualties, of whom 20,000
> were killed on the first day of the battle, which became a metaphor for futile and
> indiscriminate slaughter (HC, 1 July 1995, EDM 1077).

This motion, signed by 64 Members of Parliament, reflects the image of the battlefields as a horrendous waste as the particular 'place' of the fields of conflict of the Great War possesses an evocative power within Britain. Similar assertions can be located in the discussions of the battlefields within the Scottish Parliament, the Welsh Assembly and the Northern Ireland Assembly. Within a debate regarding the marking of the 90th anniversary of the Battle of Passchendaele (1917), Members of the Scottish Parliament considered the role of specifically Scottish troops in the conflagration, but it was the particular image of the battlefields that dominated proceedings as the 'treacherous conditions' of the war landscape near the Flemish town of Ieper were classed as 'unknowable' or 'unimaginable' (SP OR, 31 January 2007, S2M-5290). During this debate, members of the Holyrood assembly reiterated the scenes of devastation of the battlefields. Donald Gorrie (Central Scotland) described Passchendaele as the epitome of Armageddon:

> ... it was the worst war. The conditions under which men fought day after day
> on both sides were quite incomprehensible to the ordinary person ... (SP OR, 31
> January 2007, S2M-5290).

Similarly, Euan Robson (Roxburgh and Berwickshire) visualised the horrendous conditions faced by troops during the battle:

> The profound memory of those who survived was perhaps less of enemy fire
> than it was of mud. Many men lost their lives simply by falling into large mud
> pools and were never seen again (SP OR, 31 January 2007, S2M-5290).

Such evocations of desolate imagery can also be located within the representations of the Great War within the Northern Ireland Assembly, during debates regarding the proposed relocation of war graves in France in January 2002. Members of the Legislative Assembly (MLA) drew upon the well-established vision of the battlefields as a bleak, strange 'hell'. During this debate, Steven Agnew (North Down) made a point of reiterating the 'horror' of the war landscape:

The soldiers wore heavy packs on their backs and the ground in that area had been churned up through the ravages of war. As a result, those soldiers, weakened by war, underfed and undernourished, sank to their knees in the mud and fell to the ground face down. Many of them drowned in a sea of mud (NIA OR, 22 January 2002, 27–01).

Further debates within the Northern Ireland Assembly regarding anniversaries and the commemoration of the First World War in the province after the Good Friday Agreement also employed the imagery of the 'loss and the slaughter' of the 'charnel houses' of the battlefields (see NIA OR, 22 November 2010, 101122). This vision of the battlefields as 'gothic nightmare' of dead bodies, shells and mud is also replicated across the wider media (see Ellis 1989: 5, Hynes 1998: 83). Mention of Passchendaele or the Somme within the media across Britain is almost automatically accompanied by an intense description of the 'hellish' scenes. For example:

Because of the nightmarish conditions in which it was fought, Passchendaele was the closest any battle has ever come to an Old Testament description of hell (Farndale 2007).

Through film, television and novels the depiction of the battlefields, predominantly the Western Front but also Gallipoli, as a tragic wasteland has become an accepted trope and almost a cliché (Sheffield 2002). From *Blackadder Goes Forth* (1989) to the battlefield scenes of *Downton Abbey* (2011) and from Graves's *Goodbye to All That* (1929) to Barker's *Regeneration* (1991) this distinct image of the battlefields can be discerned. The framing of the Great War as the ravaged war landscape is evident in the media coverage of the contemporary archaeological excavations in the former warzone (see Price 2008). Archaeologists from across Europe have been working in France and Flanders for over two decades and their discoveries on the battlefields have been extensively covered by the national media in Britain (see Saunders 2002, 2007, Brown 2007). What is intriguing in this reporting is that these excavations of human remains, buried structures and the material of the war are not described as a shocking confrontation with a conflict which has now passed beyond living memory. Rather, the trench lines, corrugated iron supports, the dugouts and the bodies of 'the missing' reaffirm an expectation of how the war should be imagined; even down to the remnants of mud, clinging to the objects as they are retrieved from the earth (see Wilson 2007). For example, the reporting of an excavated trench in 2003 served to fulfil expectations rather than challenge presumptions in some sections of the media:

At first glance, the mournful, featureless and mud-brown archaeological dig, just northeast of Ypres (Ieper) in Belgium, could itself be a Great War battlefield (Lichfield 2003: 12).

Indeed, the images of the excavations demonstrate what is already seemingly known about the war, a desolate, futile, mud-ridden exercise that needlessly cost

thousands of lives ('Ninety years on, victims of a futile massacre exhumed from the mud', Kennedy 2008: 5). The dominance of this image does not result from a cliché or a vapidly consumed media-influenced depiction, rather its dominance in the representation of the war emphasises the way the heritage of the Great War is activated to frame current concerns. This is achieved by framing the battlefields of the First World War as 'hell' as it provides further evidence of the suffering of the soldier and their status as 'victims' of the war. This site of trauma serves as a source of social and political critique (after Žižek 2002: 272). Depicting this war-torn arena of conflict promotes the experience of the soldier and the 'unimaginable' or 'unknowable' horrors of the battlefields as a tragic-heroic figure with which groups and communities can associate with in the present (after Alexander 2001, Eyerman 2001). This is the feature of the heritage of the Great War in Britain of the battlefields acting as a place of 'cultural trauma'. This trauma acts to focus identity and build social, political and moral bonds within a community:

> Cultural trauma occurs when members of a collectivity feel they have been subjected to a horrendous event that leaves indelible marks upon their group consciousness, marking their memories forever and changing their future identity in fundamental and irrevocable ways (Alexander 2001: 1).

Stating association to a place or period of trauma provides a means for individuals to share a relationship to the past, a point of identification where communities can state a shared system of values, attitudes and beliefs (Antze and Lambek 1996). This framing also provides a means of promoting political and social issues as the relation to historical suffering is observed to ensure a degree of prominence for those identifying with that trauma (see Neal 1998).

The image of the desolation of the battlefields of the Great War thereby becomes politically loaded across Britain as it serves to frame particular agendas and concerns. Overwhelmingly, the image of the battlefields as a futile slaughter has been draw upon by left-leaning elements within Britain. Indeed, out of the 64 Members of Parliament who signed the early day motion to commemorate the Battle of the Somme in 1995, 54 were affiliated to the Labour Party (HC, 1 July 1995, EDM 1077). In this manner, the image of the battlefields is mobilised to affirm issues of class oppression and the inadequacy of a governing elite. For example, in 2011, Labour Member of Parliament, Michael Meacher (Oldham East and Royton), used the image of the war landscape to criticise Government policies: 'Like the Somme, it's not just the brutality of Osborne's budget, it's the futility' (Meacher 2011). The evocation of the image of the barren, war-torn fields of the Somme or of Passchendaele as a visual shorthand for official incompetence or indifference towards the majority provides a strong social critique within Britain. This visualisation frames current complaints over government policies or official administration that is perceived to be costly or damaging; 'Like Haig on the Somme, we'll bleed to death in Afghanistan' (Hitchens 2008: 24); 'Surely Somme mistake as battle-weary troops hold their

ground' (White 2001). Issues of blame, responsibility and victimhood are considered here as dissonant political identities are formed through the frame of the 'mass slaughter at the battles of the Somme and the Passchendaele' (see Basketter 2010: 5). The image of working class soldiers led to the 'slaughter of the Somme' by an elite section of society dominates popular perceptions of the conflict. Whilst these frames structure opinion and attitudes in the present, they are key components in the creation of radical political identities as the 'brutality' and 'slaughter' of the battlefields motivates collective appeals for working class and socialist solidarity within Britain and internationally:

> So these few privileged men, the British officer class, risked the lives of thousands upon thousands … as the British soldiers walked into no man's land to confront the German trenches, they were shot down by machine guns (Robson 2005).

> Passchendaele … the wettest summer and autumn in memory turned the battlefield into a swamp. Men, animals and equipment were swallowed into the mud. The dead became stepping stones for the living. The continuation of the battle was simple slaughter (Trudell 1997: 67).

Whilst this vision of the battlefields motivates political identities, it also forms the basis of national and regional identities within Britain. The 'sense of place' that is evoked through the outline of the Somme battlefields is also drawn upon by contemporary groups and communities within Northern Ireland to stress identification and association (see Graham 2004). The associations between 'Ulster' and 'Unionist' identities and the Battle of the Somme has been historically attested as Protestant Ulster, fearing the imposition of Home Rule from Dublin, categorised the battlefields as the scene of the 'blood sacrifice' for Britain in the immediate aftermath of the conflict (see Hennessey 1998: 198–200). The 36th (Ulster) Division, composed of members of the Loyalist Ulster Volunteer Force, who fought at the Somme, occupies a hallowed place within Unionist identity. However, the complex uses of the image of the battlefields across the province demonstrate the varied ways in which identification and notions of victimhood are negotiated (after Graham and Shirlow 2002). The association of the Battle of the Somme with Ulster Unionists certainly remains strong. Indeed, the connection between the shattered battlefields and the service of Loyalists is frequently evoked within politics and sections of the Unionist-leaning media:

> Although it is true that a generation was cut down in the mud, it is also true that those young men were among the most gallant of our sons and that their bravery is forever enshrined in the hearts of many … (NIA OR, 22 November 2010, 101122).

> The courage displayed by the 36th (Ulster) Division in the battle of the Somme is almost as historic as the event itself (Lucy 2011: 8).

In this respect, Unionist and Loyalist identity within Northern Ireland is intrinsically linked to the battlefields of the Somme as a 'sense of place'. The image of the fields of conflict where Ulster soldiers 'sacrificed' their lives for King and Country is also evoked through the murals that adorn Unionist areas of Belfast and Derry/ Londonderry in particular (Jarman 1997, Rolston 1991). These murals depict the 'sons of Ulster' on the battlefield of the Somme and frame the contemporary Unionist cause within the heritage of the Great War. For example, the Newtownards Road mural painted in 1997 consists of the 36th Division marching over the battlefields; the mural on the Rathcoole Estate, Newtownabbey, County Antrim, also depicts the Ulster Volunteer Force as part of the 36th Division emerging from the muddy war landscape of the Somme; and the mural at Canmore Street, off Shankill Road, Belfast, entitled 'Over the top at the Somme' painted in 2002, also illustrates a cratered, muddy landscape where members of the Ulster Volunteer Force advance on enemy lines. Intriguingly, the imagery of the battlefields is not evoked in a sense of 'victimhood' and 'suffering', but as a place of heroism and sacrifice. The Somme remains as a desolate wasteland in this rendering, but rather than an imagined space of pity the landscape of the battlefields is an arena which evokes a distinct identity for contemporary Unionists; an identification which recognises endeavour, achievement and attachment within the context of the battlefields as a site of trauma. In this manner, attachment to this trauma is used to mark a community and individuals as belonging. The Unionist politician Ian Paisley Jr. reflected upon this trauma in an interview in 1997:

> I think nationality is based a lot on emotion and is based a lot on a person's natural identity and affinity. People can change, but the reality is that the vast majority of people in Northern Ireland were born British, see themselves as British, have a British heritage, have grandparents who died at the Somme so they could remain British. They are, therefore, extremely loyal to their interpretation of what Britain is and what it means to them … (quoted in White McAuley 1999: 57).

The visual frame of the Somme is used in this manner to stress a long line of continuation from the Ulster Volunteer Force to the present day concerns of the Unionists. However, the dominance of the vision of the battlefields of the Great War over Loyalist identity within the province has been critically examined through various media (see McGuinness's (1985) play, *Observe the Sons of Ulster Marching Towards the Somme*). The image of the Somme has also been used within sections of the Loyalist community to promote dialogue and cohesion within Northern Ireland (see Brown 2007). This is best represented with the work of the Somme Association which formed in large part to preserve the memory of the 36th (Ulster) Division but also the 16th (Irish) Division and the 10th (Irish) Division who all saw service on the Somme. In this initiative, the battlefields are perceived to form a shared site of sacrifice for communities both within Northern Ireland and the Republic of Ireland. This sense of cross-community engagement

through the image of the battlefields is replicated in the regional branches of the 'Friends' network of the Somme Association in Northern Ireland. For example, the South Belfast Friends of the Somme Association clearly state this intention:

> ... although the South Belfast Friends of the Somme Association and this website follows the story of a largely Protestant Division of men, formed out of the old Ulster Volunteer Force, it is also our intention to commemorate all the Irishmen who gave so much in a war that they found difficult to understand (South Belfast Friends of the Somme Association 2012)

Indeed, the vision of the battlefields of the Somme does not exist as a singular source of 'Unionist' identity within Northern Ireland. As politics and society have altered within the province over the last two decades, the image of the battlefields has been mobilised to construct wider cross-border, anti-sectarian and nationalist identities. These frames of reference are constructed through the heritage of the Great War (see Robinson 2010). For example, in 2008 the laying of a wreath on 1 July to commemorate the first day of the battle by the Sinn Féin Mayor of Belfast, Tom Hartley, was done to acknowledge all 'victims' of the war (see Sinn Féin 2008). In fact, within the last decade, Republican and Nationalist communities have also drawn upon the image of the battlefields to reaffirm 'Irish' identities (Grayson 2010). However, the construction of these associations differs substantially from the Unionist connections to the Somme as it employs the notion of 'victimhood' and 'suffering' that exists elsewhere within communities in Britain. Within Republican sentiment, the image of the battlefields and the Somme in particular is evoked to highlight the indifference or hostility of the British authorities to Ireland and its people (see 'Maskey plans to honour Somme victims', Breen 2002: 13). This is certainly most clearly defined within Nationalist 'Third Way' sentiment that advocates complete independence from Britain as well as from Ireland:

> We should remember proudly the sacrifice of the Somme but we must remember that the Volunteers were of no use to Ulster lying dead on a foreign battlefield. Ulsterfolk today must resist getting entangled in Britain's foreign wars. Ulster must be independent and neutral. Let's fight only for the defence of our own Motherland – Ulster! (Ulster Nation 2007).

It is not only within Northern Ireland that the image of the battlefields constitutes such an important part of national and local identity. In the Lancashire town of Bury the battlefields of Gallipoli form an integral part of local identification. The town, the home of the Lancashire Fusiliers, who suffered substantial losses on the first day of action with the landing on Gallipoli on the 25 April 1915, commemorates the event every year with 'Gallipoli Day' (see Moorhouse 1992). The event, which sees marches and parades through the town, is significant in the identity of local residents. However, it is the image of the bloody battlefields

where soldiers suffered the torments of industrialised conflict that is significant in the town's remembrance:

> Thousands of soldiers were wounded or suffered terribly in the diseased riddled trenches (Morgan 2007: 5).

> A devastating proportion of Bury's youth was wiped out in the bloodshed (Anon 2004c: 6).

Whilst the town's 'proud military heritage' is honoured with these parades, the remembrance of the 'suffering' of both the soldiers and their families on the home front is discernible. Within this acknowledgement of the 'victims' and their plight the association with the events of the 1914–1918 war is made distinct. The frame of reference provided by the heritage of the Great War serves to reinforce aspects of identity and 'place' in the present. To bear witness to the horrific experiences of soldiers on the battlefields of the First World War elevates this identity as it associates with and draws political and social capital from this historic suffering. Identities are thereby made distinct because of this connection (see Mallinson 2005: 3):

> Lieutenant Colonel Mike Glover, Regimental Secretary (Lancashire) of the Fusiliers, said: This 90th anniversary is important not just for Lancashire's fusiliers to remember heroic deeds and fallen soldiers, but also for the people of Bury and Lancashire to rediscover part of their family heritage and to reflect upon the fact that great events always depend upon the contribution of ordinary people (Anon 2005b: 5).

Connecting to the suffering on the battlefields thereby becomes the defining aspect of these identities. Indeed, the notion that a particular region suffered proportionally greater fatalities on the battlefields also contributes to a distinctive sense of place and self within communities across Britain. For example, 20 miles away from Bury is the industrial town of Burnley, whose local history project on the Great War claims that the town suffered a 'disproportionate amount of casualties compared to many other towns and cities in Great Britain' (Gill 2006). The extent of the suffering experienced in the First World War and the associations with that suffering in the present provides emphasis and acknowledgement for contemporary identities. In Scotland, this issue has been explored as political elements within the nation campaign for independence. The greater numbers of fatalities suffered by Scottish Regiments during the conflict has been historically attested but it also forms an important point for rallying support for nationalists (see Devine 2007: 309). Within the political and media discourse in Scotland, the suffering of soldiers on the battlefields of the Somme and Passchendaele have been used to highlight or to evidence the need for separation from Westminster and to affirm a distinctly Scottish identity as opposed to British. This point was

He provides evidence for the 2nd statement but not the 1st (not even the quote from the SNP)

particularly evident in the debates to mark the 90th anniversary of the Battle of Passchendaele in 2007 in the Scottish Parliament. The debate focused on the possible construction of a monument to Scottish servicemen on the battlefields. Dr Jean Turner (Independent, Strathkelvin and Bearsden) stated the significance of the 'sacrifice' of 'Scottish' soldiers in the desolate hell of the battlefields:

> We are talking about remembering the sacrifice of Scottish soldiers. Many of those men lie in unmarked graves in Flanders field. We could walk along the front line on the western front and every six paces, we could be walking on the body of an unknown soldier (SP OR, 31 January 2007, S2M-590).

Des McNulty (Labour, Clydebank and Milngavie) also stated the distinction of Scottish troops in this site of trauma as a means of establishing a unique identity:

> Our soldiers fought alongside soldiers from other parts of the United Kingdom, the Commonwealth, France and the USA to defend our traditions, values and way of life (SP OR, 31 January 2007, S2M-590).

The sacrifice of Scottish soldiers on the battlefields is thereby recognised as significant for Scottish values and Scottish character. The association with this frame of cultural trauma provides a means for members of that group to state solidarity and association (after Neal 1998: 12). Eventually, a monument was erected on Passchendaele in 2007 and supported by funds from the Scottish Parliament. The design of the monument, a Celtic Cross, could be considered a highly significant choice in the context of contemporary Scottish politics. However, the unveiling of the cross, draped in the Scottish national flag, the Saltire for its dedication, reiterated the vision of Scottish troops undergoing the torment of battle as significant for Scottish identity. The Scottish National Party representative, Linda Fabiani (MSP, East Kilbride) stated this sentiment at the opening ceremony (Scottish Government 2007):

> We are very proud of the brave men and women who gave their lives in defence of their country. I hope that this monument will be visited by many people, young and old, as they come to reflect on the history of Passchendaele and commemorate all the Scottish soldiers who played such an important part in the Great War.

As debates over the future of Scotland in the political union of Britain have developed since devolution of power in 1997, the vision of Scotland's soldiers suffering on the battlefields of the Great War have been mobilised to frame contemporary issues of identity through a regard for victimhood and responsibility:

> So, autumn 2014 will find a referendum on Scottish independence 100 years after this epoch-defining battle which killed thousands of Scots with a knock-on

effect of the depopulation of Scotland. Voting to ensure that my kids or grandkids or even great grandkids are never sent like lambs to the slaughter for a monarch or a crusading Westminster zealot will be one of the considerations I think on before voting Yes to Scottish Independence (MacLachlan 2012).

The image of the battlefields and of the suffering of soldiers within the fields of conflict provides an important means of mobilising social and political sentiments in the present (after Alexander 2001: 5). In effect, the battlefields of 1914–1918 act as frames which structure and outline contemporary issues of identity and place. To identify with this example of historical suffering is to substantiate an identity through the power that the status of 'victim' holds within contemporary society (after Novick 2001: 122). Throughout Britain, differing groups and communities harness this image of suffering on the desolate battlefields to reaffirm a distinct 'sense of self'. This enables an evocation of an association which is separate from other dominating narratives and agendas. Historians and commentators who identify this usage of the heritage of the Great War as historically inaccurate or self-serving, fail to identify how these perceptions of the past attain a degree of historical 'truth' for the communities who honour them because of their function for those communities (after Samuel 1989).

However, as the suffering of soldiers provides a means for framing distinctions in association and identity, the vision of the 'sacrifice' and 'slaughter' on the battlefields of the Somme and Passchendaele is also evoked to extol exclusive and discriminatory identities. For example, the far-right British National Party (BNP) regularly calls to mind the battlefields of 1914–1918 in their promotional literature to demonstrate the significance and the need to protect an ethnically uniform 'British' identity. The 'blood-soaked mud of the Somme' in this respect becomes a vision through which demands can be made for representation, rights and distinctive identities (BNP 2012). To counter these assertions, the image of soldiers of African and Asian heritage on the battlefields from Britain as well as across the former overseas territories and possessions of the British Empire has been used within some sections of the liberal media to promote a more inclusive history of 'shared suffering' (see 'West Indians who shared trench hell' (Bright 2002: 17) or 'Images rescued from dump reveal black British "Tommy" at the Somme' (Lichfield 2009: 8)). However, historical studies have shown how the experiences of those who were deemed racially or socially 'inferior' were indeed significantly worse with higher rates of punishment and execution for minor offences (after Oram 1998). Despite this inequality, the image of individuals from varying ethnic backgrounds on the battlefields has been mobilised within official discourse to promote inclusive identities. In 2002, the Ministry of Defence used the image of the diverse composition of the armed forces in the First World War in their educational programme, *We Were There*. The initiative stated the shared image of suffering and service on the battlefields as a reflection of Britain's contemporary diversity:

Well over 1 million men from parts of the Empire that are now linked with
the UK's minority ethnic communities served in the First World War. In some
theatres of war, they provided a vital proportion of our fighting strength. Over
100,000 of them died or were wounded (Ministry of Defence 2002).

This process demonstrates the varied uses to which the image of the battlefields
has been used within society to frame current issues and concerns. Whilst the
vision of the broken, ravaged war landscape has been observed as significant in the
development of identities within former Commonwealth and Dominion nations after
the Armistice, the similar processes of identification and association in communities
and groups has been a relatively neglected subject within Britain (see Wilson 2007).
Rather than constituting one homogenous image of war around which a sense of
national identity has coalesced; the vision of the battlefields is used within Britain to
frame and structure various regional, national and political identities both as a means
of dissonant politics and as a means of establishing uniformity.

The Poppy and the Memorial Landscape

In the representations of the Great War, two of the most powerful images of the
conflict has been the poppy as well as the extensive cemeteries and monuments
to the dead that are scattered across the former battlefields in France, Flanders,
Gallipoli, Salonika and Mesopotamia. Indeed, this memorial landscape, which
was constructed in the immediate aftermath of the conflict, still possesses a
powerful resonance for contemporary society within Britain (Bushaway 1992,
Heffernan 1995). Its initial creation evidences a specific frame of reference for
the remembrance of the war, as the war cemeteries and monuments formed
visual cues for evoking the dedication and service to 'King and Country' (Morris
1997). The architects, Sir Edwin Lutyens (1869–1944), Sir Herbert Baker
(1862–1946) and Sir Reginald Blomfield (1856–1942), who worked with the
then Imperial War Graves Commission (IWGC, after 1960 the Commonwealth
War Graves Commission, CWGC), headed by Sir Fabian Ware (1869–1949) and
advised by Sir Frederic Kenyon (1863–1952) of the British Museum designed
a commemorative form to mark the 'glorious dead' of the British Empire
(Longworth 1967). Uniform headstones, emphasising the collective spirit of the
army and large monumental complexes such as those at Thiepval, the Menin
Gate and Tyne Cot in France and Flanders, the Helles Memorial or the Lone
Pine Memorial in Gallipoli or the Doiran Memorial in Greece were created to
evoke the martial fortitude and dedication to the cause within the armed forces
and commemorate the dead and 'the missing' (see Figure 3.1). The cemeteries
were to be 'a memorial of those lost in the war such as never had been dreamt
of before', providing an 'expression of the idea of sacrifice and heroic death
for a great cause' (Blomfield 1932: 176). These memorials were intended to
perpetually maintain the memory of this sacrifice. For example, the Menin Gate

Figure 3.1 Poppies placed on the Menin Gate, Ieper, 2002

in the Flemish town of Ieper, with its stately arches reminiscent of the great cathedrals, bears the epitaph, 'To the armies of the British Empire who stood here from 1914 to 1918 and to those of their dead who have no known grave'. Indeed, with regard to the Western Front, Sir Edward Lutyens remarked that through the memorial landscape, 'all men in all times may read and know the reason why these stones are so placed throughout France' (Lutyens 1917: Letter to Fabian Ware). In effect, these monuments were designed to frame the memory of the war as the ultimate sacrifice for God, King and Empire. Sir Winston Churchill (1974: 2994) emphasised this capacity of the memorial architecture to move and record the endeavour of the troops in a speech delivered to Parliament in 1920:

> Even if our language, our institutions, and our Empire all have faded from the memory of man, these great stones will still preserve the memory of the remote past and will undoubtedly excite the wonder and reverence of a future age.

The image of the cemeteries and memorials of the Great War has become a central aspect of the heritage of the 1914–1918 conflict (see Stamp 2006). The scenes of

peaceful graveyards and vast monuments to the dead have been used to structure both the remembrance of the war itself and reflect upon contemporary concerns (after Winter 1992). This is most notable in the post-war political and media representation of the memorial landscape as an embolic of national pride and reflection as well as the need for peace between nations.

In terms of using the war cemeteries to frame national consciousness, the war cemeteries have been critically examined for their ideological basis (see Bushaway 1992). This work has focused on the manner in which the CWGC attempted to make manifest the words of the war poet Rupert Brooke (1887–1915) and create a 'corner of a foreign field. That is forever England' (Brooke 1920: 111). In this manner, the cemeteries and monuments were loaded with symbolism which stressed a particular vision of British identity focusing on patriotism, dedication and valour (Heffernan 1995). These values were reaffirmed in the interwar years as guidebooks and information leaflets representing the image of the memorial landscape for those wishing to tour the sites of the battlefields proliferated in the period after the Armistice (Lloyd 1998). Visitors, tourists and 'pilgrims' came to the sites of mourning as bereaved relatives, respectful comrades or merely as interested parties and were able to see these commemorations within this framework. Authors in the post-war period would depict the cemeteries as a 'sacred space' or a 'holy altar' for the British people (Taylor 1928: 27). After 1927, visitors were assured that no trip would be complete without witnessing the Last Post played at the Menin Gate to honour the British 'missing' of Passchendaele (*The Times* 1928: 36–8). The vision of the memorial landscape during the inter-war years was thereby reaffirmed as one which held purpose and meaning for 'Britain' and the 'British'. Therefore, the image of the cemeteries and memorials were evoked as 'sacred' and nationally significant areas which were imbued with the qualities of the nation (Hutchison 1935: 2):

> The knowledge that we defeated our enemies in the Great War 1914–1918 and that our success was the outcome of intense effort throughout the British Empire may ... be calculated to stir up feelings of pride within the hearts of all patriotic British people (Pulteney 1925: 61).

Interestingly, the manner in which the touring books and guides to the region represent the cemeteries and monuments as emblematic of 'Britain' remains largely unchanged. In the contemporary guidebooks, readers can still see the areas of the Somme and Ieper described as 'important to the British race' and visits to the memorial landscape defined as a 'spiritual pilgrimage' (Cave 1996, Spagnoly 1999, Spagnoly and Smith 1995, Stedman 1995). Similarly, walking through the cemeteries is considered to be treading upon 'hallowed terrain' for the nation, whilst visitors are described as 'pilgrims' who have come to 'pay homage on the altar of remembrance' (Freeman 1999; Horsfall and Cave 1995; Oldham 1998). Contemporary tour groups offering to guide visitors around the sites of 'pilgrimage' on the Western Front or Gallipoli restate the sense of 'national significance' that the war cemeteries maintain:

The battles on the Western Front, fought by the men of Britain and the Commonwealth in the Great War 1914–1918, have an important place in our heritage … So much suffering and sacrifice, such bravery and endurance in horrific conditions (they) have left us a legacy of which we can be proud (Holt's Tours 2012).

This is representative of how the vision of the memorial landscape is evoked as symbolic and significant for the wider national community (see Iles 2008, 2011, Winter 2012). Indeed, within political discourse, the image of the cemeteries stands for ardent patriotism as those who committed the 'ultimate sacrifice' for their country are honoured. Lord Astor of Hever (Conservative Party Peer) demonstrated this sentiment in his speech of 2011 in the House of Lords during a debate on the shape of the hundredth anniversaries of the conflict:

It is hugely important that we continue to remember the sacrifices made in the Great War. I agree with my noble friend that our children, and their children, need to be taught how the freedoms they take for granted were won, and at such heavy cost. The Government commend any initiative to maintain a memorial that honoured those who made the ultimate sacrifice for this country (HL Deb, 22 March 2011, c595).

Such 'national' visions of the commemorative landscape are a feature of the political discourse across Britain. For example, the Conservative Member of Parliament, James Clappison (Hertsmere), spoke of this aspect of the cemeteries in 2000:

The cemeteries are beautifully kept and a fitting memorial to the brave men who lie in them. The cemeteries mean a great deal to many people in this country; they should matter to us all (HC Deb, 22 October 2000, c487).

Indeed, in 2002 these sentiments were strongly expressed in Westminster as plans by the French Government to build an airport in the Paris basin, threatened a number of First World War cemeteries with possible relocation. In Parliamentary debates the cemeteries were described as important for 'our country' to honour those 'who made the ultimate sacrifice for us all' (HC Deb, 14 January 2002, c7). In this manner, the image of the cemeteries provides verification of the values and idealism of the nation and the 'sacrifices' made to maintain these aspects of national identity. Speaking in the House of Lords in 2008, Lord Dear, stated that the cemeteries demonstrate 'British' values:

Evidence of that will be found in our war cemeteries in northern France … and many other places across the world, all of which bear stark testimony to the price that this nation has been prepared to pay in confronting those who exercise arbitrary power, unfettered by considerations of natural and legal justice (HL Deb, 8 July 2008, c657).

Figure 3.2 38th (Welsh) Division Memorial, Mametz Wood, France

In effect, the memorial landscape as an aspect of the cultural heritage of the Great War acts as a frame itself as it shapes and informs the contemporary vision of the conflict (see Iles 2011). Indeed, it still performs its original purpose of outlining the war as a vision of 'national' sacrifice. However, as the imagined community of 'Britain', which is purported to be represented within these cemeteries and memorials, is increasingly problematised within contemporary identity politics, other forms of identities are constructed through the memorial landscape both in its original form and with the addition of new commemorative schema. Whilst the graveyards and monuments to the dead were initially envisaged within the frame of a hegemonic 'British' identity, the recent erection of specific memorials to soldiers from Scotland and Wales on the symbolic former battlefields of France and Flanders has formed new visions of the battlefields. In 2007, the aforementioned 'Celtic-inspired' monument to Scottish soldiers who died during Passchendaele, or the Third Battle of Ypres (Ieper), was erected at the Frezenberg Ridge. This was preceded in 1987, by a sculpture of a Welsh Dragon tearing at barbed wire, which was erected near Mametz Wood in the Somme Valley in memory of the 38th (Welsh) Division, a unit which was comprised largely of Welshmen from the Royal Welsh Fusiliers and the South Wales Borders (Figure 3.2).

These additions to the memorial landscape challenge the framing of the war as a national 'British' sacrifice through the postwar commemorative architecture. This is most evident in the opening of the Island of Ireland Peace Park in 1998 at Mesen (Messines) in Flanders. The memorial, inaugurated by the then Irish

Figure 3.3 Island of Ireland Peace Park, Messines, France

President Mary McAleese and Queen Elizabeth II, consists of an Irish round tower and accompanying park which houses memorial stones, was constructed to remember all the soldiers from Ireland who fought in the First World War (see Graham et al. 2000: 36) (Figure 3.3). Intriguingly, the image of sacrifice and the sacredness of the former fields of conflict were evoked to affirm these identities. For example, the Peace Park uses the concept of 'sacrifice' to frame identification with a conciliatory identity across the various communities within the island of Ireland. The park's dedication reads:

> As Protestants and Catholics, we apologise for the terrible deeds we have done to each other and ask forgiveness. From this sacred shrine of remembrance, where soldiers of all nationalities, creeds and political allegiances were united in death, we appeal to all people in Ireland to help build a peaceful and tolerant society.

Indeed, in the opening ceremony President McAleese made reference to the 'victims' of the war and the 'sacrifices' they had made for contemporary society.

The vision of Irish soldiers from the north and the south buried and commemorated 'side by side' has been evoked to cement the peace process and reconciliation (see Coulter 2012). In effect, the memorial landscape is once again mobilised as an outline for current concerns. The image of the memorial landscape is thereby used to frame alternative identities within the wider structures of remembrance that demonstrates the symbolic 'sense of place' which evokes the 'sacrifices' made for the nation or nations.

The image of the cemeteries and memorials serving as symbolic social and political capital and framing present-day desires and concerns, is also evidenced in the manner in which the vision of the graveyards of the battlefields of the Somme, Passchendaele or Gallipoli and the memorials to the dead and 'the missing' are used to structure arguments for peace, the 'folly of war' and the need to 'learn the lessons' of the past. However, this usage of the vision of the memorial landscape is not a modern phenomenon. In the aftermath of the conflagration, during the interwar years, the image of the cemeteries and memorials was frequently used to demonstrate the need for harmony and reconciliation. These processes can be observed as early as 1922, during King George V's pilgrimage to the sites of mourning where he spoke of the memorials serving as an advocate of peace (see Fox 1922). This pronouncement reflected a growing trend within the then Imperial War Graves Commission to promote the sites of mourning as representative of a desire to avoid war and demonstrative of a lasting testament against future conflict (see Ware 1937: 61). The image of the vast cemeteries for the dead was, therefore, mobilised to serve as a proponent of amity. The memorial landscape in France, Flanders and elsewhere as a peaceful, reflective, contemplative space where one could gain knowledge of the cost of war became prominent (see Morris 1997). This recognition became increasingly prominent in the years after the Second World War which had once again divided Europe and seemingly provided the basis of a future, possibly nuclear conflict. George Coppard (2003, 145), a machine-gunner in the war, described his return in 1973 in his memoir, stating his difficulty in relating his memories of his former comrades with the headstones, but nevertheless feeling a 'spiritual link' in the cemeteries and realising the 'futility' of war. Elliot (1964, 3) another British veteran of the conflict, described his own pilgrimage fifty years after the war had ended and heralded the sites as demonstrating the need for peace within the modern world. The 'row upon row' of the cemeteries and the 'name upon name' of the memorials were thereby framed as emphasising the responsibility of current generations to avoid future conflicts.

This outlining of the war through the vision of the memorial landscape as a 'lesson from history' and the importance of peace is reaffirmed through political, media and public discourse. Politicians of all political persuasions frequently evoke the cemeteries as indicative of the responsibilities of leaders to avoid war. This usage became increasingly prominent after the launching of military action in Afghanistan in 2001 and Iraq in 2003. In 2002, during a debate in the Northern Ireland Assembly, the Unionist politician, Dr Ian Adamson used the memorial landscape to frame these concerns:

Every 1 July we go ... to visit Thiepval and the great memorial by Sir Edward
Lutyens ... On that day we commemorate the sacrifice of our loved ones who
died for freedom. We do not seek to glorify war; rather we seek to see that it does
not happen again (NIA OR, 22 January 2002, 27–01)

Such use of the commemorative scheme to call to account the actions of present-
day governments is shown in the speech delivered to the Scottish Parliament in
2007 by the Scottish Nationalist politician, Alasdair Morgan (South of Scotland):

I recommend a visit to one of the First World War cemeteries to any politician who
thinks that he or she might ever be in charge of their country's troops, because
I hope that their visit would make them think long and hard about the nature,
purpose and consequences of war. I never leave any of those places without
having an overwhelming sense of the futility and waste of what happened during
those five years (SP OR, 31 January 2007, 28862)

The image of the war cemeteries as a form of instruction, to learn from the
lessons of history, to promote peace and understanding is thereby a predominant
and potentially dissonant means of framing the heritage of the Great War. This
particular framing of the commemorative landscape is especially evident in the
prominence of this vision of the battlefield memorials in secondary education
within Britain. Trips to France and Flanders, to see the battlefields, memorials and
cemeteries of the 1914–1918 war are regarded as highly informative experiences
for students to reflect on the 'lessons of the war' (see DeMarco and Radway 1995).
The memorial landscape, therefore, is mobilised to use the war as a frame to
understand the loss of life and destruction wrought by all forms of conflict (Figure
3.4). Visits by schoolchildren to the cemeteries and memorials are accorded with
the opportunity for 'learning experiences':

This allowed students to see not only the battle sites of the Somme and the
Ypres Salient, but also the tragic and arguably unnecessary losses seen all too
powerfully in the many cemeteries (Friends School, Saffron Walden 2012).

Over the road, our first cemetery. Immaculate lawns and flower beds, row upon
row of white gravestones. Many have no names, no unit badges: just the simple
inscription, "known unto God". A visitors' book records today's reactions: "Our
third visit, and still it's awesome"; "Speechless"; or "Why?" (Croall 1997: 9).

The memorials and cemeteries serve as a means to see the contemporary world
and respond to its challenges as the image of the commemorations is deemed to
be significant for 'every British schoolchild' (see McManus 2011). The 'lessons'
from history, of the importance of peace and the price paid for that peace is a
significant part of this usage of the heritage of the Great War and one which is
supported within the wider media:

Figure 3.4 Headstone of an unknown soldier of the Great War

> You cannot go … and see the cemeteries and come away untouched. Something
> very terrible happened here, and very moving too. It's right that everybody, but
> especially the young, should come and see, and pay their respects (quoted in
> Sweeney 1999: 8).

Similarly, tours of the battlefields for adults are also couched in similar terms as the vision of 'seas of headstones' are used to understand the cost, waste and 'folly' of war whilst also providing a means to understand contemporary contexts. In this manner, the image of this 'sacrifice' of life during the war for peace can become a point of critical reflection. Contemplating the current engagements and decisions by governments through the frame of the memorial landscape provides a means of drawing attention to issues of 'victimhood' and 'responsibility'. The cemeteries and memorials, commemorating the vast loss of life during the conflict, serve as frames to demonstrate critical, oppositional points in the present:

> … we ended the tour listening to The Last Post under the Menen (sic) Gate. In London, Lord Butler's report on Iraq dominated the headlines. Naturally, we wondered about the value of the ultimate sacrifice (Bower 2004: 13).

The memorial landscape is used as a visual representation of 'the old lie', indicating the failure of governments, their culpability and their neglect of a duty of care to protect and serve the wider body politic. The cemeteries and memorials to the dead of the Great War become frames through which the 'folly' of Great War is exposed alongside the social and political issues that plague current generations:

> Having studied the awful events of the war during the day, watching the evening performance of the Last Post in Ypres moves them in a way that the Cenotaph or Albert Hall ceremonies never do. No army bands, no marching soldiers, no flag waving, no "old Lies" (Barrett 1993: 7).

What was considered as the material testament to the 'sacrifice' of the soldiers for their nation or for peace is framed in this way as evidence of government connivance in the suffering of 'victims'. For example, Robert Fisk's (2009a) article which draws parallels between Iraq, Afghanistan and the Great War was entitled, 'In Ypres I suddenly realised what this war has been about'. The official 'framing' of the war is thereby manipulated to convey an alternative vision of the battlefield cemeteries and monuments. This particular aspect of the heritage of the Great War in Britain serves both as a means of framing collective appeals of remembrance and 'sacrifice' but also as a means of evoking political sentiments regarding the actions and responsibilities of governments and officials. Whilst the framing of the memorial landscape as a statement of peace and reconciliation is devoid of issues of 'victimhood' and responsibility and therefore could be regarded as operating inertly as a call to remember for the sake of remembering; the dissident outline provided by the cemeteries makes direct political and social associations between the past and the present.

In a similar fashion, the image of the poppy as a framing device for the remembrance of the Great War in the present has also been problematised (see Iles 2008). The poppy has been part of the marking of Armistice Day (alternatively named Remembrance Day and Poppy Day) on November 11th in Britain since

the early 1920s and constitutes an iconic part of the heritage of the Great War. Its origins, inspired by the John McCrae poem *In Flanders Fields* written in 1915, as a means of raising money for injured and disabled veterans of the conflict by the Royal British Legion and the Haig Fund have been thoroughly examined (see Newall 1976). McCrae's poem provided a poignant, evocative image of the former battlefields and cemeteries, littered with poppies evoking the blood, the sacrifice and the deaths of thousands on the Western Front:

> We shall not sleep, though poppies grow
> In Flanders fields (McCrae 1919: 3).

After the ending of the Second World War in 1945 and the subsequent involvement of British troops in theatres of war around the globe, the poppy has been used as a device to remember all of those who have fought and died whilst in the service of their country. However, its intimate association with the Great War and the battlefields of the Western Front particularly have ensured its enduring appeal within wider British society as the scale of death and the image of 'suffering' soldiers of the First World War heighten the emotive power of the poppy. This association also contributes to divergent frames of reference for the poppy through which groups and communities view both the past and the present.

As a symbol of sacrifice and dedication, the poppy outlines all military service in the British Army within a wider association with the soldiers of the Great War. This provides a frame of reference in which to view both current and historical conflicts as the endeavour of the armed forces is considered within the same manner as the official memorial scheme as a 'sacrifice' for the nation but also to maintain peace and 'our' values. The emotional appeal of the cemeteries and memorials to the dead, which are adorned with wreaths of poppies, provides a powerful reference to the commemorations. The past and the present are therefore viewed, figuratively speaking, through these wreaths, as a direct line of continuity of service and endeavour from the Somme in 1916 to Helmand in 2006 is drawn through the image of the poppy:

> Now that there are no living survivors left from Flanders fields, we have a generation of young people who will need to make sense for themselves of the significance of what happened in 1914–1918 and what it really means to wear a poppy (Priory 2011: 17).

> The poppy is part of our history. But it is, more importantly, about the needs of today (Hattersley 2010: 21)

> We all wear our poppies, as a public acknowledgement of that debt, respect and thanks. We wear them with pride in our country and for those who have given their lives (HC Deb, 9 November 2011a, c539).

Figure 3.5 **Poppy-shaped floral display to mark Armistice Day, Astley Park, Chorley, 2011**

As the use of the pronouns 'we' and 'our' might indicate in these extracts, the poppy therefore also frames the history of the Great War as a British sacrifice, an integral part of 'British' identity. As a frame of reference, the poppy serves as a means of unifying the wider collective within society behind a common point of appeal (see Figure 3.3). The outrage and shock which is detailed by tabloid newspapers with the absence of poppies on television presenters, sports stars and

celebrities is representative of a perceived affront to the nation and its history (see Callan and Murray 2011: 19). Therefore, regardless of political opinion and the morality of current military engagements, the poppy is used to mobilise a reference to the Great War and thereby affirm a wider national 'British' character. This can be observed in the protest provoked by the decision taken by the Fédération Internationale de Football Association (FIFA) to stop the 'home nations' wearing embroidered poppies on football shirts in November 2011 and by the extremist group 'Muslims Against Crusaders' who burned poppies on Remembrance Day, November 2010. Intriguingly, the reporting of the burning of poppies was referenced as being enacted by 'Muslims' despite the protestors being born and/or educated in Britain. For example, see 'Poppy-burning Muslims plan new "Hell for Heroes" demonstration on November 11' (Anon 2011f), or 'Muslim protesters burn poppy at Armistice Day silence for war dead' (Smith 2010: 3). The image of the poppy as a symbol of British 'sacrifice' in the Great War and its appeal to a 'national character' is most prominently contested within Northern Ireland. Within the province, Unionist elements have long used the poppy to evoke association with Britain, whilst Nationalists have rejected the symbol as demonstrative of the imposition of British rule in Ireland (after Brown and MacGinty 2003). The divisive nature of the symbol and its evocation of identity and place within Britain can also be seen in the protest led by the 'Green Brigade' in November 2010, a group of ultras (a fanatical fan group), who follow the Celtic Football Club. With its historical ties to Irish immigrants in Scotland, Celtic had courted controversy with a decision to wear an embroidered poppy on their football shirts. The Green Brigade criticised this 'British' and 'militaristic' symbol by holding placards during a home game with Aberdeen that read 'Your deeds would shame all the devils in hell. Ireland Iraq Afghanistan. No bloodstained poppy on our hoops'.

As an image that frames the 'sacrifice' of the war dead as part of a national 'British' narrative of endeavour and pride, the poppy therefore also serves to frame contrary perspectives that reject the honour of the 'ultimate sacrifice' that it assumes to represent. In this way, the poppy becomes a frame for dissonant opinions regarding nationalism, political posturing and anti-war beliefs. The poppy evokes the mass-death of the Great War and serves as a means of outlining issues of responsibility and blame:

> Not all of them bled willingly, for king and country; some of them simply bled because they had been seriously injured, because their leaders deemed it appropriate for them to die in pain and terror. A million paper flowers, rooted in the dark earth of this country's frantic military self-fashioning, will never be enough to mop up the carnage (Penny 2010).

> … I shall feel revulsion at the sight of our political leaders posturing on Sunday. For they are today's version of those Great War generals, the "donkeys" who sat back in their chateaux while dispatching young lions to their deaths (O'Neill 2011: 19).

There is everything right about remembering the dead who die in futile wars. There is everything wrong about using the past dead to justify current wars (German 2011).

The poppy therefore becomes a frame through which campaigners can raise concerns regarding official culpability and hypocrisy as the heritage of the Great War is mobilised to further political and social aims in the present. In these circumstances, the poppy, whilst rejected as an official icon, nevertheless still outlines a particular vision of the 1914–1918 conflict, as a futile, bloody massacre led by an uncaring or even hostile ruling elite (see Steel 2009). Whilst the white poppy has often been selected by pacifist and anti-war campaigners since the 1920s, the red poppy provides a means of outlining a powerful, symbolic image of the conflict. Indeed, it was through the image of the poppy in 2010 that former soldiers of the British Army appealed to the public to reject the political machinations of successive British Governments which had led to the involvement of troops in conflicts across the world:

The public are being urged to wear a poppy in support of "Our Heroes". There is nothing heroic about being blown up in a vehicle. There is nothing heroic about being shot in an ambush and there is nothing heroic about fighting in an unnecessary conflict (Griffin et al. 2010).

As part of the heritage of the Great War, the poppy serves to frame quite often contradictory images of the conflict and its meanings for current society. Whilst the heed to remember the sacrifices of the war dead accompanies the poppy, this image of the conflict also provides a powerful means of evoking radical and dissident politics across Britain.

Conclusions

The visual heritage of the Great War is utilised to provide frames and outlines to understand historical and contemporary issues across communities and groups within Britain. The image of the soldiers in the trenches, the battlefields and the war cemeteries are mobilised to provide context and meaning for wider concerns. This aspect of the cultural heritage of the war is significant as it structures a range of points regarding identity politics as associations and links are developed and sustained with the imagery of the world's first global conflagration. Indeed, the Great War forms a cultural resource for current society as groups draw on visions of the war to evidence difference and attachment (after Alexander 2001). For example, social identities are formed through the visualisation of the suffering 'Tommy' on the battlefields as the association with historical examples of victimhood enables groups to establish and negotiate issues of power and place in the present (Brown 2001, Neal 1989). This reveals how the frames provided by

the heritage of the 1914–1918 conflict ensure that points of official negligence and sacrifice are included into present-day discourses regarding the construction of a sense of self. Recognising the suffering of soldiers from a particular community, region or nation provides an image through which identification and attachment can be established. In this respect, the battlefield, trenches and no man's land of the Great War constitutes a distinct 'sense of place' for various aspects of society within Britain.

As such, the war landscape provides a locale from which values, identities and associations can be drawn, reaffirmed and reimagined. Whilst the battlefields and the trenches provide frames of reference through which political and social affiliation is established, the memorial landscape and the poppy can be seen to provide 'official' frames through which the war is evoked. Whilst these particular visions provide particular ways in which to view the 'ultimate sacrifice' of soldiers to defend the nation, its values or to secure peace for the world, these frames also operate to provide dissonant visions of the war which consider issues of belonging, victimhood and the actions of government. This use of the heritage of the Great War to promote political and social issues within Britain has remained largely neglected despite the well-documented, recognised and continued interest in the war within the public, academia and the wider media (see Bond 2002). Although the images of the battlefields, the soldiers and the cemeteries have been assessed in the construction of identities within Australia, Canada, New Zealand and more recently India, the notion that contemporary groups and communities within Britain utilise the imagery of the Great War to construct associations and links has not featured highly as an area of research. However, an assessment of how visions of the conflict are used to frame perceptions of both the past and the present reveals how these images of the war are mobilised within current society. Indeed, the evocation of the Great War through its imagery provides a powerful social and political tool for groups who seek to promote alternative, discordant and non-conformist identities.

Chapter 4
Views from the Trenches – Perspectives on the Great War

The cultural heritage of the Great War has provided a range of frames, both verbal and visual, through which the past has been harnessed to outline, structure and contextualise the present (after Howard 2003: 213). Referencing the First World War through these frames of orientation provides individuals, groups and societies with a means of highlighting and demonstrating current social and political issues through the 1914–1918 conflict. Alongside these modes of associating and utilising the heritage of the Great War a further means of accessing the cultural resources is obtained through the ways in which contemporary communities place themselves in relation to the past; the perspectives they use towards the First World War (after Schofield and Szymanski 2011). Whilst the uses of narrative and genre have recently been of concern for both historians and cultural heritage managers in the representation of history to the public, the perspectives offered to view the past are a relatively underrepresented field of study (see de Groot 2009: 5–7). Within this approach, the viewpoint or vantage through which individuals imagine, perceive, experience or represent history and heritage is significant for the moral, social, political and cultural values that it creates (after McManamon 1999). At a very basic level this can be observed in the recent trend within the cultural heritage sector in Britain to encourage visitors to experience and understand 'elite' sites such as country houses from the perspective of the servant or kitchen maid as a means to appreciate the wider social experience of the place (after Smith 2006: 120). Beyond this simplistic example of the expansion of the social dimension, there exists a wide array of perspectives that can be used to frame historical events for contemporary society (see Fentress and Wickham 1992). Consuming history as activists, participants, victims, witnesses, observers, collaborators or even as oppressors ensures that historical events impact, affirm or shape identities in present-day communities (see Tyson 2008). Therefore, analysing the perspectives taken on the past, examining the manner in which history, heritage or memory is consumed, provides a means of assessing how the past is utilised and mobilised within the present (Arnold et al. 1998, Lowenthal 1998).

In the context of the First World War within Britain, two distinct modes of perceiving the past can be discernible, each of which provides a particular effect on how the 1914–1918 conflict is used to frame contemporary issues. The first of these perspectives is that of the participant; the soldier/victim of the trenches who constitutes such a significant part of the cultural heritage of the Great War (see Korte 2001). Viewing this historical event through the viewpoint of the 'Tommy'

in the trenches ensures a considerable degree of cultural, social and political power within contemporary society. Indeed, the concept of 'the trenches' possess great significance within the cultural heritage of the Great War (see Wilson 2008a). As previously discussed in Chapter 2, references to 'the trenches' abound within popular culture and are used in various contexts to express how opposing opinion divides groups ('entrenched'), how an opinion is derived from first-hand experience ('from the trenches') or how individuals or groups are positioned amidst action and development ('in the trenches') (see Ammer 1989: 147). The usage of 'the trenches' within these contexts reveal the assumption within the British cultural heritage of the war that to speak 'from the trenches' is to possess a singular truth (see Graham 1984). Indeed, the 'view from the trenches' denotes a veracity which is rarely open to challenge. This perspective on the past is demonstrative of an imaginative, empathetic or sympathetic connection with the ordinary soldier and it is utilised within local and national politics, popular discourse and the wider media to comment upon contemporary contexts in Britain. The references to 'the trenches' will be assessed within this chapter as a means of placing the individual or group within both a position of authority whilst implying a status of 'victimhood' (after Alexander 2001).

However, whilst this perspective of 'the trenches', through which the Great War is framed and understood, is used within political and social contexts in movements for issues such as equality or reform, it does not represent the only means of evoking perspectives on the conflict to critique the present. The second mode of perceiving the 1914–1918 war which provides a particular ethical and political perspective is that of the witness (see Gouriévidis 2010, Macdonald 2009, Wright 1985). Rather than operating as a first-hand account, this perspective behoves upon contemporary society to acknowledge the past. After the Armistice of 1918, successive generations within Britain have drawn upon the witness perspective to maintain the memory of those who died and also to 'testify' in the present as to its relevance and its meaning (see Gregory 1994). This particular mode of accessing and viewing the events of the Great War is especially interesting as it can be seen to have emerged and developed in response to the mass-death, grief and trauma caused by the world's first war which was fought on an industrial scale (see Kramer 1997). Through the memorial architecture, ceremonies of remembrance and accounts of the conflict, subsequent generations have been instructed to bear witness to the events of the Great War and to maintain the dedication contained in Laurence Binyon's glorification of the dead in *For the Fallen*: 'we will remember' (after King 1998). As a witness, individuals, groups and communities are required to attend to the memory of the event, to bear the responsibility of calling forth this memory in society and to demonstrate its significance (see Booth 2006: 15–16). However, although the role of the witness to the war has been maintained since the cessation of hostilities, the interpretations of witnesses has altered with the changes within wider society (after Hirsch and Spitzer 2009). Regardless of the differing conclusions, this perspective on the past presents a distinct

moral and ethical agenda as it calls upon an audience to take responsibility that evidence will be shared, recognised and that 'justice' will be performed (see Bernard-Donals and Glejzer 2003). To act as a witness ensures that knowledge is maintained and reiterated for an end purpose. As witnesses to the events of the Great War, contemporary groups can affirm certain 'truths' about the conflict as the perspective of the witness provides an 'honourable imperative' to attest (after LaCapra 1998: 77). Analysing these two perspectives on the past, of the witness and the participant, emphasises how the cultural heritage of the First World War is mobilised and remains current across various aspects of British society.

The View from the Trenches

The personal, first-hand accounts of the Great War in France, Flanders, Italy, Gallipoli and Salonika, that detail the experiences of soldiers from all social backgrounds have been catalogued and recounted in a variety of memoirs, oral histories and archive collections since the 1960s (see Macdonald 1978, 1980, 1983, 1987, 1998). These primary sources have also provided the basis for a plethora of novels, films, memoirs, artistic works and television programmes (see Howard and Stokes 1996, Parfitt 1988). Even before the signing of the Armistice in November 1918, the battlefields had begun to be represented through reportage, film footage, official accounts as well as the letters home from the soldiers (Reeves 1983, 1986, 1997, 1999). It is this 'human' and everyday experience of the war which has attracted the most attention within wider society in Britain from the end of the war to the present day (after Bond 2002, Simkins 1991). Whilst military historians and post-war British Government reports inevitably focused on the wide-scale effects of the conflict, after the cessation of hostilities the individual experiences of the war were used to bring a personal, accessible description of a conflagration that appeared to subsume those who fought as the colossal scale of military operations and the mass-death wrought by the war could seem to obscure the individual (see Brophy 1929).

The evocative power of the soldiers' 'views from the trenches' has, therefore, ensured that this specific manner of focalisation has been used to represent the 'ordinary' experience of service within the British Army during the Great War (see Sternberg 2002). This perception has been reinforced with the publication of memoirs during the interwar years in the 1920s and 1930s as well as the development of oral history in the decades following the end of the Second World War which increased as the veterans of the Great War passed away (see Middlebrook 1971). Whilst the accounts of individuals provides varied experiences of the war, detailing the range of emotions and feelings that the conflict inspired, the mode of the 'view from the trenches' is overwhelming mobilised within Britain to represent very specific perceptions of the Great War (Bergonzi 1965, 1999). In this manner, the 'view from the trenches' is one which is used to denote

suffering and victimisation (Wilson 2008a). To call upon the experiences of those who fought in the battlefields of the First World War is to frame historical and contemporary issues within this context of this sense of trauma and 'victimhood' (after Alexander 2001: 5). Personal accounts of the war, the experiences of 'the trenches', present individuals, groups and communities within Britain with a means of expressing social and political opinions, dissenting ideas and critiques of power and authority. This constitutes a significant aspect of the cultural heritage of the Great War, as this perspective is drawn upon to provide a frame through which current contexts can be conceived and communicated.

This usage of the 'views from the trenches' is most notable in the ways in which the works of the 'war poets', a number of literary figures who served in the British Army during the conflict, are evoked by interest groups across Britain (see Silkin 1996). The work of individuals such as Wilfred Owen (1893–1918), Siegfried Sassoon (1888–1967), Hedd Wyn (1887–1917), Robert Graves (1895–1985), Edward Thomas (1878–1917), Charles Sorley (1895–1917), Ivor Gurney (1890–1937) and Isaac Rosenberg (1890–1918) occupy a revered place within the wider canon of English literature (Featherstone 1995, Gardner 1964). These 'soldier poets' are frequently heralded as the 'voice' of the ordinary infantryman, expressing the 'true' experience of the combatant in the field (J.M. Wilson 2007). Whilst the literary merits of these individuals have been critically assessed and the ability of this small group of men to reflect the experience of a much wider group has been thoroughly questioned, the 'war poets', with Wilfred Owen and Siegfried Sassoon in particular, have been valorised within popular culture across society within Britain (see Stallworthy 1993). Overwhelmingly, these poets focus on the horrors of the conflict, the terrors of the trenches and the suffering of the soldiers on the battlefields (after Winn 2008). These sentiments were certainly not the sole response to the war and there were competing visions which were offered through works by individuals such as Julian Grenfell (1888–1918) and Rupert Brooke (1887–1915) that evoked a sense of pride, nationalism and endeavour in the war:

> And only joy of battle takes
> Him by the throat, and makes him blind ... (Grenfell 1917: 166–7)

However, it is the poetry of Owen, Sassoon and others which is considered to be the 'truth' of the war with its focus on the torment of the troops and their status as the victims of the conflict (see Graham 1984). Indeed, Owen (1965: 178) frequently states in his writing that he was motivated by the desire that the truth of the experiences of the soldiers should be told; he would state in a letter home in 1918, that 'I came out in order to help these boys – directly by leading them as well as an officer can; indirectly, by watching their sufferings that I may speak of them as well as a pleader can'. Such intent to represent the 'truth' of war was also expressed by Sassoon in his famous protest against the continuation of the war in June 1917, *A Soldier's Declaration*:

I believe that by taking this action I am helping to destroy the system of deception … which prevents people from facing the truth and demanding some guarantee that the torture of humanity shall not be prolonged unnecessarily (Sassoon 1937: 481).

These ideas of revealing the truth are also represented in the wider work of Sassoon. This 'truth' reveals the suffering of soldiers, the incompetency of officials and the barbarity of war. Indeed, the poem *The General* appears to encapsulate the sentiment behind these representations:

He's a cheery old card, grunted Harry to Jack,
As they slogged up to Arras with rifle and pack.
But he did for them both by his plan of attack (Sassoon 1983: 58).

Though this is v. atypical of S's poetry

Indeed, this assumed quality of verisimilitude in the war poetry is reflected in Owen's own observations that his poetry is the 'truth of the war' (Graham 1984: 5). This distinction is significant as the claim of truthfulness is an important element within the cultural heritage of the conflict. Rather than the work of the war poets constituting an important aspect of the legacy of the Great War through their literary quality, these works form part of a wider aspect of the cultural heritage of the Great War where to quote from the 'view of the trenches' is to speak the 'truth' of the 1914–1918 conflict and to emphasise the suffering and victimisation of the soldiers. It is this affirmation of the status of soldiers as victims of the conflict which is used within current contexts to stress political and social concerns (after Alexander 2001, Neal 1998).

The war poets are evoked within a contemporary political context to outline a variety of objectives in the present through the association of the suffering soldier in the trenches and the culpability of authority figures. What is mobilised in this aspect of the heritage of the Great War is not necessarily the powerful, emotive verse of the soldier poets, but the perspective they provide; of the 'truthful' account of the trenches. In this respect, the work of Owen and Sassoon is mobilised by dissonant and left-wing elements within Britain to express opposing viewpoints to the perceived injustice of conservative, traditional positions. For example, in 2012 the Labour Member of Parliament, Paul Flynn (Newport West), used the work of Siegfried Sassoon to critique the British Government's involvement in military operations in Afghanistan:

I believe that, as parliamentarians, we are going to be accused, as they were accused by Siegfried Sassoon in 1917 with his declaration against war. He said that the war was being continued by those who had the power to end it. The only reason we continue to send our soldiers to Afghanistan now is to help politicians and military leaders to spin a fantasy ending to the war that will reflect well on them, at the cost of lives and more of our soldiers (HC Deb, 17 April 2012b, c1).

The usage of these literary figures and their work to demonstrate specific current political aims is evident in the early day motion forwarded in Westminster in March 1993 to commemorate the centenary of the birth of Wilfred Owen. The motion, which declared Owen to be the 'consummate poet of the horror and futility of war' was signed by 77 parliamentarians, of which 75 were Labour politicians (HC Deb, 15 March 1993, EDM 1618). The war poets are mobilised because of the perspective they provide to speak 'from the trenches' which constructs a significant aspect of the cultural heritage of the Great War by expressing dissident politics or a critical social agenda. Quotations from Owen or Sassoon therefore provide a means of framing current contexts within an understanding of the suffering of the soldier and the indifference or irresponsibility or authority. Indeed, the Labour politician Denis MacShane (Member of Parliament, Rotherham) used these evocations of the 'view from the trenches' in May 2010 in an analytical assessment of the military policy during the conflict in Afghanistan:

> I have for several years sat and listened to the tributes to the dead and fallen, weeping internally, as many Members have. I think again and again of a poem of Siegfried Sassoon, which I have altered slightly: "Good-morning; good-morning!" the General said When we met him last week on our way to the line. Now the soldiers he smiled at are most of 'em dead" (HC Deb, 26 May 2010a, c174).

Similarly, the Scottish Socialist Party politician, Carolyn Leckie (Member of Scottish Parliament, Central) described Owen and Sassoon in a session of the Scottish Parliament in May 2005 on current veterans' affairs as illuminating the understanding of conflict and making a sacrifice to inform current generations of the horrors of war. The war poets provided a context from which Leckie was able to advocate a general left-wing assessment of all warfare:

> I pay tribute to millions of working-class men and women – not to Governments, war ministries or the arms industry or to the imperialism, greed and brutal ideologies that cause wars (SP OR, 12 May 2005, S2M 2794).

The evocation of the war poets is not limited to the affairs of the army within Britain as the work of these poets frames wider issues of responsibility and official authority within society. Indeed, politicians are able to draw upon the perspective to express broader dissatisfaction with official procedure. For example, in 2010 Declan O'Loan (North Antrim) of the Social Democratic and Labour Party used the work of Wilfred Owen to criticise the effectiveness of the work of the Northern Ireland Assembly:

> Two lines of poetry by Wilfred Owen have kept recurring to me all afternoon: O what made fatuous sunbeams toil. To break earth's sleep at all? Those words

were written amid the carnage and mayhem of the First World War, and it is almost sacrilegious to quote them in relation to the more minor mayhem that is going on around us. Nonetheless, they kept recurring to me because they seemed appropriate (NIA OR, 25 January 2010, 01–25).

The war poets are thereby used to critique and to elevate opinion, by framing contemporary contexts with these works, the individual can call those in power to account, not merely through the damning verse, but because of their status as those who revealed the 'truth' of the war and the suffering of the ordinary 'Tommy' in the trenches. It is this examination of power and its legitimate usage which also offers politicians of various hues to call upon this perspective to activate particular campaigns for justice and recognition. This is not just restricted to left-leaning sentiments within the political sphere. Indeed, those from the right of British politics can also evoke the war poets for a presumed lapse in authority. In such a fashion, the Conservative Member of Parliament, Andrew Robathan (South Leicester) was able to mobilise the anti-authoritarian sentiments expressed by Siegfried Sassoon to critique aspects of the peace process in Northern Ireland before the Good Friday Agreement of 1997:

> Siegfried Sassoon wrote a poem entitled *Aftermath*. It stated: Have you forgotten yet? I say to Opposition Members who are considering voting against these measures – have they forgotten the Baltic exchange, Canary wharf, the mortars at Heathrow and other outrages? Has anyone been caught? I fear not, but at least we give the security forces all possible assistance (HC Deb, 14 March 1996, c1156).

The fluidity of this perspective of the 'view from the trenches' is derived from the critical outlook it provides of a questioning of authority, power and decision-making. However, despite the proclivity of this appeal to all political stances, it is predominantly within the left, through socialist and pacifist organisations in the main, where this manner of framing contemporary concerns through the perspective of the 'trenches' has been most apparent. Therefore, the war poets can be considered as 'culturally useful' as they form a means to engage with this viewpoint, to figuratively reconstruct 'the trenches' in the present to provide a means to outline an understanding of the present. In this mode, the soldier poets' works offer an exemplum, so that the First World War is seen as a 'comparison and an illustration of the uselessness of war' (see Corbyn 2012). The critical appeal of the perspective provided by the soldier poets is thereby drawn upon to demonstrate values and associations for political causes. The position of the war poets as providing the 'truth' of the war from the position of the trenches becomes a means of exercising contemporary concerns through this framework. For example, the communist writer and academic Jim Riordan, used the poetry of Sassoon to critique the home-coming parades of troops from Afghanistan in 2009:

> Perhaps it was my quotation from World War I survivor Siegfried Sassoon that
> sullied the jingoistic glorification of war: You smug-faced crowds with kindling
> eye/Who cheer when soldier lads march by/Sneak home and pray you'll never
> know/The hell where youth and laughter go (Riordan 2009).

Similarly, the work of Sassoon and its critical stance on the Great War, the suffering
of soldiers and the vainglorious actions of the army and government, has been
used to outline the 'illegal' operations in Iraq:

> First World War poet Siegfried Sassoon's family came from Basra. You smug-
> faced crowds with kindling eye/Who cheer when soldier lads march by/Sneak
> home and pray you'll never know/The hell where youth and laughter go, wrote
> Sassoon in *Suicide in the Trenches*. Words that ring fresh today (Arbuthnot 2008).

Indeed, in the context of the Iraq War from 2003 and the Afghanistan War from
2001, the war poets are regularly used to as a frame of reference to understand and
to assess the current role of the British Government and the British Army:

> The poems of Siegfried Sassoon and Wilfred Owen are as relevant today as they
> were then (Miller 2008).

The work of Wilfred Owen is specifically mobilised in this manner with poems
such as *Anthem for Doomed Youth* directly prefacing or framing arguments across
the media within all political spectrums concerning government or official neglect.
For example, *Anthem for Doomed Youth* formed the central argument against the
continuation of the Afghanistan War for the anti-war politician George Galloway
in June 2011 (Galloway 2011a). However, this usage of framing current agendas
through the work of the war poets is not limited to the left-wing press. The deaths
of British combatants in Iraq and Afghanistan are placed within this context to
accuse authorities of irresponsibility and stress the 'victimisation' of those serving
their country:

> Helmand province is not the Somme, but Wilfred Owen's lament for squandered
> life has seemed, back in the UK, to echo down the years. What candles may be
> held to speed them all?/Not in the hands of boys but in their eyes/Shall shine the
> holy glimmers of goodbyes. (Riddell 2009a: 21).

Owen's (1965: 55) poem, *Anthem for Doomed Youth*, evoking the waste and
sacrifice of a generation through the line 'What passing bells for those who die
as cattle?', also provides a means of passing comments on official bodies or
government organisations for the apparent laxity in the provision of security
and a future for the younger members of society. Therefore, within the media
the poem is frequently evoked in newspaper titles which draw attention to this
situation. For example, see 'Anthem from Doomed Youth' (Hanretty 2011,

Monaghan 2009: 19, Mroz 2009: 15). In this respect, the frames provided by this particular work enable contemporary audiences to utilise the heritage of the Great War to understand current issues (after Fish 1980: 18). The poem, *Anthem for Doomed Youth* is also used within a broader political context as an anti-war poem or to mobilise anti-pacifist sentiments. For example, the Peace Pledge Union uses the verse to promote their vision of anti-violence and conscientious objection to conflict:

> Is *Anthem for Doomed Youth* a poem only for the time it was written, or does it still have something to say? What sort of 'anthems' might we write for the 'doomed youth' who are killing and being killed in the world today? (Peace Pledge Union 2012).

The lines from this particular verse are thereby enacted to pass judgement and assess the actions of officials and administrators. Within the popular media, the poem provides a subtle frame of reference to critique government policies. These frames operate by situating audience responses through the context of an understanding of the Great War. The heritage of the 1914–1918 conflict is thereby demonstrated as one which enables dissenting or critical perspectives to be mobilised. The 'view from the trenches' is exercised through pieces such as *Anthem for Doomed Youth* as it appears to expose the hypocrisy, irresponsibility and culpability of authority. The usage of quotations from these the canon of war poetry evokes a particular means of accessing and understanding the present. For instance, writing in the *Daily Mail* in 2010, McKay drew upon Owen's poem to attack government plans to relocate the ceremonies associated with the repatriation of solders' remains from Afghanistan and Iraq away from the public and therefore potentially critical site of the village of Wootton Bassett, Wiltshire, which was on the route for the transportation of the bodies of the dead:

> Young people who knew this might happen coming back to be buried by their families and friends. And bugles calling for them in sad shires, to paraphrase Wilfred Owen's World War One poem, *Anthem for Doomed Youth* (McKay 2010).

Similarly, the same line is used to frame the village of Wootton Bassett within the context of the First World War as bereaved families, local residents and others sought to mark this procession of the bodies of those killed on active service. Owen's words provide a means of reflection and to supply an implicit or explicit questioning of authority regarding the deaths of soldiers:

> How apt that seems now as young soldiers return from Afghanistan in coffins and "bugles call for them from sad shires" (Austin 2008: 8).

> Watching this week's vaunted big push in Afghanistan has been infuriating beyond belief, not least because of the latest procession of soldiers' coffins,

driven in the rain through sad shires, valuable and irreplaceable lives honourably
lost in a rotten cause (Hitchens 2010: 21).

Using the war poets in this manner ensures that the present circumstances are
observed in the context of the events of the First World War. This usage of the
heritage of the conflict is further demonstrated in the appearance of lines, verses
and phrases from soldier poets such as Owen and Sassoon in the church services
of all denominations, which are held to commemorate the dead of current conflicts
or to provide 'lessons' or examples for Remembrance Sunday which is held in
Britain on the nearest Sunday to Armistice Day, 11 November. In these acts of
Christian worship, the war poetry of the Great War acts as an instructional frame
akin to that of scripture. In this manner, *Anthem for Doomed Youth* or Sassoon's
The General serve the purpose of providing illumination and a challenging agenda
for a congregation as they are mobilised to outline current concerns. The critical
riposte towards authority which is activated through the frames provided by the
war poets also serves to connect past and present issues. For example, Canon
Eric Woods, in his Harvest Festival Sermon at Sherborne Abbey in September
2008, explicitly framed his instructions for the congregation on peace and 'shared
humanity' through the war poetry of Wilfred Owen. In this sermon, Canon
Woods instructed the attendants to remember the abuses of power committed by
governments:

> To satisfy the whims and the pride of politicians, the rural communities of
> England have in every generation sacrificed the flower of their manhood to die
> on foreign fields, with bugles calling for them from sad shires (Woods 2008).

Similarly, in the Sermon for Remembrance Sunday, preached by The Very
Reverend Michael Sadgrove at Durham Cathedral in November 2006, the same
poem by Owen, 'Anthem for Doomed Youth', was used to evoke a sense of
universality during a time when British servicemen and women were fighting in
Iraq and Afghanistan:

> What passing bells for those who die like cattle? Wrote ... soldier-poet Wilfred
> Owen – not to insult his fellow soldiers whom he loved dearly, but to point out
> that when slaughter is relentless and indiscriminate, we need to give even more
> value to each individual, recognise the humanity of each as someone's parent,
> someone's child, someone's sibling, colleague and friend (Sadgrove 2006).

The perspective of the 'view from the trenches' is in this instance a means of
establishing other, potentially dissonant and dissident standpoints on the present.
The war poets are referenced to provide a framework of understanding and to
question current issues across British society. Church services and sermons draw
upon Owen and Sassoon to connect to issues of suffering and victimisation as the
soldiers poets are considered to relay 'the intense and prolonged grief' of both those

who served and those who experienced bereavement, as the Reverend Charles Mitchell-Innes stated in his Remembrance Sunday address in Salisbury Cathedral (Mitchell-Innes 2011). In this critical context, *Anthem for Doomed Youth* forms an indictment against a society who may forget the 'lessons' of the past, as the works of Wilfred Owen are used to outline the present using the perspective of the war poet. The Reverend Nicholas Roderick Holtam called upon this framework and a line contained in the verse during the Remembrance Day Sermon at St. Martin-in-the-Field, London:

> There is no celebration of death here, just the knowledge of the pain it causes, the grief of those who remember and wait "and each slow dusk a drawing down of blinds" (Holtam 2008).

Whilst the revenant status of the war poets across British society has been noted by a number of commentators, its usage to frame experiences, to outline issues and to clarify debates in the present has been strangely neglected by scholars (see Fussell 1975). A great deal of study has been conducted on the ability of the poetry of the Great War to shape and alter contemporary perceptions of the 1914–1918 conflict and thereby reduce it to the limited set of experiences of a well-educated, officer-class (see Bond 2002). However, what is evidenced by a study of how the war poets work is conducted is an active engagement with the cultural heritage of the Great War through the perspective that these works provide. The verses of Sassoon, Owen, Gurney or Rosenburg do not form monolithic entities that structure subsequent understanding, rather they are engaged with by agents to structure and understand the present. Indeed, this is further demonstrated in the usage of *Anthem for Doomed Youth* to begin the memorial service at Halifax Minster for the six members of the Yorkshire Regiment, the 3rd Battalion, The Duke of Wellington Regiment, who were killed in Afghanistan in March 2012:

> This poem was written by Wilfred Owen, the great First World War poet, and is entitled *Anthem for Doomed Youth*, a reminder of how young some of the victims of war often turn out to be (Barber 2012).

The perspective of the war poets is significant in this regard because the 'view from the trenches' appears to provide contemporary audiences with the 'truth' of the war: the experiences of those who suffered. In this way the work of the war poets possesses a great degree of cultural capital, as references and allusions serve to cast a frame through which groups, communities and wider society across Britain view events both at home and abroad. These frames provide a particular function by ensuring an explicit or implicit rebuke of authority. By placing current events within the framework of the poetry of the Great War a significant aspect of the heritage of the conflict is evoked; its dissonance. The heritage of the Great War in Britain serves as a medium of critical social and political commentary and the vaunted place of the war poets as the 'voice' of the ordinary soldier reflects this process.

Whilst Owen's work *Anthem for Doomed Youth* appears to provide sustenance for framing issues of responsibility, sacrifice and suffering, perhaps the piece which most demonstrates how the work of the war poets is called upon to effect issues across society in Britain is Owen's *Dulce Et Decorum Est*. This piece, with its vivid descriptions of the horror of war in its depiction of soldiers 'bent double like old beggars under sacks' and its broadside against those who callously and negligently promote 'the old lie' of patriotism and duty which sends thousands to their deaths, has achieved a hallowed place for groups and communities (see Owen 1965: 55). Its usage as a quotation or as a reference enables a poignant and powerful critique of authority, as its perspective from 'the trenches' is mobilised to challenge those in government and demand acknowledgement of responsibility. As such, the poem is used by politicians, the media, interest groups and the wider public alike to stress contemporary social and political agendas through the frame of the Great War. For example, its usage within political discourse is frequently accompanied by an attack on government and their dereliction of duty. In this manner, the Labour Member of Parliament for Liverpool Walton, Peter Kilfoyle, used the poem to express dissent against plans by the government to reduce spending on the military in 2005 which was considered to place lives at risk:

> The immortal lines of Wilfred Owen's greatest poem come to mind: The old Lie: Dulce et decorum est Pro patria mori. No one wants to see the modern soldier reduced to the condition of soldiers in the First World War (HC Deb, 17 November 2005, c1157).

The reference forces an appreciation of contemporary contexts within a frame provided by the vivid imagery of the poem's perspective from 'the trenches'. The heritage of the Great War is thereby evoked as issues of sacrifice, victimhood and responsibility are mobilised to draw attention to the present. The broad appeal of this frame ensures its malleability, as it is drawn upon for diverse causes within the modern political sphere. Indeed, the Social Democratic and Labour Party Member of Parliament for Newry and Armagh, Seamus Mallon, employed the poem to highlight the problem of sectarian violence within Northern Ireland:

> In this context, I turn to another British poet – Wilfred Owen – who in one of his poems challenged the great lie: Dulce et decorum est pro patria mori – It is a good and noble thing to die for one's country. I also challenge that thesis. No one on the island of Ireland or outside it has any right or mandate from the Irish people to say that they are killing in the name of the Irish people (HC Deb, 19 February 1996, c99).

This broader application of the framework constructed through the poem is also evidenced in its earlier use by the Labour Member of Parliament Kevin McNamara (Hull North) to argue against the involvement of the British Government in the manufacture or use of chemical weapons:

As Wilfred Owen said: If you could hear, at every jolt, the blood come gargling from the froth-corrupted lungs, obscene as cancer, bitter as the cud. It is for that reason that ... we will not, under any circumstances, accept binary chemical weapons in this country ... (HC Deb, 1 July 1986, c868).

Dulce Et Decorum Est is used in these circumstances as a rallying cry, an ironic indictment of the abuse of power and neglect of responsibility. This usage is also apparent across the wider media of varying political stances as references to the 'old lie' serves as convenient forms of short-hand for official short-sightedness or incompetence. For example, see 'Army redundancies are the result of politicians trying to peddle the lie that you can do more with less' (Mallinson 2012: 19), or, 'As the world protests against war, we hear again the lies of old (Pilger 2003: 12). The application of the poem and its place as a medium of dissonance can also be observed in the consternation which was provoked by the usage of the verse by figures of authority. In an interview in 2011, the Conservative Prime Minister David Cameron caused bemusement and a degree of outrage when he selected the poem as his favourite verse for its 'eye-opening' qualities. Media coverage of this selection focused on the 'unusual choice' of an 'anti-war' poem whilst British troops were serving in Iraq and Afghanistan (see Thomas 2010). Comments left on the message boards which accompanied the reporting of the story focused on the incredulity of the Prime Minister in not understanding the 'obvious' message of the poem and its indictment against war. Indeed, within some left-wing and socialist quarters this selection was considered to be an affront to the British people from a 'warmonger' (see Anon 2010b). Indeed, such are the uses of the poem for advocating dissenting views that the concept of a member of the 'authority' sharing the 'view from the trenches' was considered to be an irreconcilable position:

Of course, there's every chance Mr Cameron really has gone through what so many of us experience when we read Wilfred Owen's poem for the first time: we follow those words down the page, those dark, queasy words, and we trudge along the trench and we keep on walking right into the story of the Great War and the story of Owen himself (M. Smith 2010: 21).

The trench conditions described in the poem emphasise the sense of suffering and victimhood which is drawn upon as a frame through which the 'old lie' is exposed in the present; by referencing the poem or lines of verse, the perspective from 'the trenches' is used to critique and to undermine. This is not the result of some singular quality of the poem which has structured all subsequent interpretations of the conflict and definitively described those who fought within it; rather, it is derived from how the poem has been utilised as a frame of reference by individuals and groups. For example, the status of the poem as denunciation was also drawn upon by the artist Schoony in February 2011 on the 'Plinth of Peace' opposite the Houses of Parliament. Constructed in January 2011, the Plinth served as a medium of anti-war sentiment for artists. Schoony, an artist skilled in specialist

effects, provided a display called *Boy Soldiers*, which depicted three adolescent figures in military garb with the words 'Dulce et Decorum Est' stencilled over the artwork in blood-red paint (Schoony 2011). Whilst drawing attention to the young age of soldiers killed in action, its position facing Westminster also drew attention to those who are deemed culpable for these deaths. This application of the poem is symptomatic of its wider employment within public discourse across Britain. This usage can also be located in the online Great War Forum, which discusses the conflict, its significance and its relevance for today. Individuals on this forum refer to the qualities of the verse and its ability to comment upon or 'teach' contemporary society:

> (The old lie) ... was memorably savaged by Wilfred Owen in *Dulce et Decorum Est* (Great War Forum 2006)

> I too abhor the fact that young people are today fighting in places like Iraq and Afghanistan and those who are still preaching "dulce et decorum est", but my compassion and admiration is solely for the poor devils caught up in this abomination, not the abomination itself (The Great War Forum 2007a).

> Among the many lessons taught us by the Great War; one is surely best summed up by Owen's *Dulce et Decorum est* (Great War Forum 2009).

The heritage of the Great War should not therefore be solely considered to be the literary inheritance of Owen, Sassoon or Rosenberg; it is not located in the wealth of poetry, nor the wider literature and art which was inspired by the war. Rather, it can be observed in the manner in which these pieces are used by contemporary audiences. The poetry of the soldier poets, emphasising the suffering and victimisation of the combatants on the field of battle, is employed by politicians and within the media for particular effect as it serves to censure the powerful and state the responsibilities of authorities towards the body politic. It is the perspective of the 'view from the trenches' which is mobilised within Britain to challenge perceived injustices and the misuse of authority. The 'truth' of the war is exposed within the work of the war poetry; this idea of truth is then used to outline current fears and desires.

The Witnesses of the War

The First World War appears to hold a peculiar place within communities across Britain; its mention still evokes strong emotions and ideas about both the war itself and about wider issues of power, authority and conflict (see Wilson 2007, 2008a, 2009). This seemingly enduring fascination for the conflict has perplexed scholars who have sought to find meaning in the ways in which modern media has structured the understanding of the conflict as a tragedy; a piteous waste of

life (see Todman 2005). This interpretation rests upon the premise that individuals and groups vapidly consume representations of the conflict on film, television programmes and novels to create these fictions as historical fact (after Bond 2002). However, this assumption disregards the ways in which those remembering the Great War in this manner utilise this process in the present; that the heritage of the conflict performs a function for contemporary society (after Smith 2006). The assessment that 'media-ted' images dominate the understanding of the conflict also bars an examination as to how contemporary society places itself in relation to this event, the perspectives that are taken on the past. How the Great War is viewed, therefore, the 'frames' through which events are understood, becomes as important as the subject that is considered itself (after Booth 1996). Whilst the contemporary popular perspectives on the 1914–1918 conflict have been characterised as sentimental, romanticised, ironic or even macabre they have predominantly been understood as inactive (see Corrigan 2003; Sheffield 2002, Terraine 1980). Contrary to these assessments, a distinctive standpoint or perspective can be identified with relation to the way in which communities in Britain consider the Great War as witnesses. From the development of commemorative schemes after the Armistice, succeeding generations have been called upon to 'witness' the war; to ensure that 'we will remember'. As witnesses, contemporary society is placed within a specific moral, ethical, social and political role which provides a particular framework for understanding the war and its relevance in the present (after Bal et al. 1999, Connerton 1989, Sturken 1997).

In the immediate aftermath of the conflict, the construction of national and local war memorials to commemorate the dead focused the grief, bereavement and shock of the population and required individuals to serve as the bearers of the events of the war (see King 1998). From the Tomb of the Unknown Warrior at Westminster to the Cenotaph in Whitehall and the plethora of monuments, tablets and statues in the cities, towns and villages across Britain a range of sites and commemorative activities every Armistice Day served to create a sense of duty in the remembrance of the dead (see Gregory 1994) (Figure 4.1). This notion of obligation was reinforced with the inclusion of the names of the dead on the memorials and monuments both in Britain and on the former fields of conflict (see Laquer 1994). With the listing of the 'name upon name' of those killed during the war, the memorials explicitly evidenced the scale of death and implicitly its impact upon those who had experienced loss (after Winter 1992). As features of the urban and rural landscape, these structures were associated with the Armistice Day parades and were the focus of the two minutes' silence, enacted in 1919, during the interwar years (see Connelly 2002). Such activities reinforced the concept of the responsibility of remembrance. In effect, the commemorative scheme demanded that individuals bear witness to the dead and their sacrifice (after Heffernan 1995). Indeed, the reflective period of silence was intended as a means to ensure that good witnesses to the events were created. George V's instructions to his subjects issued in November 1919 were indicative of this sentiment:

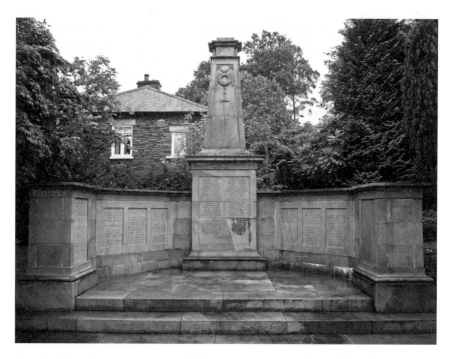

Figure 4.1 Post-war memorial listing the town's fallen soldiers in Windermere, Cumbria

... it is my desire and hope that at the hour when the Armistice came into force, the eleventh hour of the eleventh day of the eleventh month, there may be, for the brief space of two minutes, a complete suspension of all our normal activities. During that time ... all sound, and all locomotives should cease, so that, in perfect stillness, the thoughts of everyone may be concentrated on reverent remembrance of the Glorious Dead (George V 1919: 1).

The remembrance scheme thereby framed the commemorative activities as one where the individual was required to serve as a witness; one who observes and honours that observation of the efforts and effects of the conflict. This position of the witness is deeply inscribed into Judeo-Christian culture as one who maintains ideas and beliefs despite the passage of time or the forces of persecution (Ricoeur 2004: 264–5). As a witness, one is also required to attest this knowledge and belief, to testify as to the veracity of their principles: 'what is called to memory calls one to responsibility (Derrida 1989: xi). This stance of the witness was officially encouraged through not only the local war memorials but also the memorial landscape on the former battlefields of the conflict. For instance, interwar Prime Minister Stanley Baldwin (1867–1947) described the war as the nation's 'great trial' and the cemeteries and monuments as 'evidence' through which future

generations would 'testify' as to the sacrifices made by Britain (Baldwin 1928: 3). Fabian Ware (1928, 1937) also expressed similar sentiments, describing the lists of names on such monuments as the Menin Gate as offering a 'lasting testament' to the dead. Through the memorials and ceremonies, this position of 'witnessing' the First World War was affirmed within communities in Britain. This perspective on the past has been preserved through the same commemorative scheme and constitutes a significant part of the cultural heritage of the Great War.

This mode of placing oneself as the witness to the events of the war can certainly be observed in the contemporary guidebooks which highlight the 'observances' which must be made such as watching the Last Post played at the Menin Gate in Ieper or visiting the Thiepval Memorial or Tyne Cot Cemetery (see Spagnoly and Smith 1995). The discourse of witnessing, testaments, trials and testifying are still terms which mark the remembrance of the 1914–1918 conflict across Britain (see Marshall 2004). This part of the cultural heritage of the world's first global conflagration in Britain is significant, as it provides a framework through which individuals, groups and communities consider themselves in relation to the Great War. Being a witness connotes a particular moral, social and political obligation as those who observe are required to bear the burden of this action and to ultimately testify as to those events (after Booth 1996: 16). Issues of responsibility, duty and justice therefore constitute the role of the witness. However, although the act of 'witnessing' the war has remained a significant part of the cultural heritage of the conflict, the testaments derived from this action have altered. As studies of witness accounts have demonstrated, those who bear witness do not necessarily provide consistent descriptions (see C. Winter 2012). As such, whilst those who visit the memorial landscape, participate in ceremonies on Remembrance Sunday, observe the two minute silence or wear a remembrance poppy can be said to be witnessing, this action has not brought a uniform perception of the war lasting from the Armistice to the present day. Those who do bear witness can and do observe the events differently; the 'truth' of the war is recreated with the perspective of the 'witness'.

Analysts of the 'popular memory' of the war within Britain have drawn attention to the ways in which perceptions of the conflict have been swayed with the altering desires and anxieties facing society with each generation. This is often accompanied by the belief that such alterations are evidence of the 'dilution' of the 'truth' of the conflict (Bond 2002). This interpretation masks the purpose and intent behind the perspective of the 'witness'. To bear witness to the Great War provides a means to exercise a standpoint which demonstrates a moral and social position in the present. As 'witnesses' to the war during the 1920s and 1930s could testify in an era of militarisation to the dangers of conflict and the dehumanisation of war, the observers of the 1960s and 1970s could bear witness in the Cold War era to the ease through which destruction could be visited upon societies and civilisation could seemingly tear itself apart (after Todman 2005: 168). By placing oneself with regard to these past events in the framework of a witness, individuals construct and enact a particular identity which alters their relationship to both the

past and the present (after Brown 2001, Neal 1989). With regard to the Great War within contemporary Britain, 'witnessing' the conflict has formed an association with the events of 1914–1918 that emphasises the suffering and victimisation of soldiers. To bear witness to the war, therefore, requires those in the present to testify to the torment of the troops. This testament is constituted in a variety of guises, most notably in the invocation 'to remember', but this action of witnessing possesses significant ramifications for identity, place and politics within Britain.

To serve as a witness denotes an important moral and ethical character as well as signifying attachment to a sense of identity and belonging. Indeed, to act as a witness to the events of the Great War provides a means of establishing local, regional and social senses of self. With regard to national attachment, the process of witnessing is used to reaffirm aspects of collective recognition within the political and media sphere of a 'British' identity. The appeal that 'we will remember' signifies the importance of the pronoun in commemoration as the shared appeal demonstrates common values and ideals. This is reflected in the oft-quoted statement that those who died did so for the freedoms that are enjoyed within society today. Such sentiments can be identified in the official speeches and statements made in November 2009, which was the first Remembrance Day after the death of the last serviceman of the British Army who fought in the Great War. For example, the then Prime Minister Gordon Brown used the occasion to emphasise the 'national' endeavour and sacrifice which needed to be observed:

> Today is the first Armistice Day we have commemorated since the last surviving members of our armed forces who fought in the First World War passed from our midst. The whole House will want to pay our tribute to them and our tribute to the succeeding generations of our men and women who have paid the full price for our freedom (HC Deb, 11 November 2009, c240).

Similar assertions were made by the Archbishop of Canterbury, Rowan Williams, in his Remembrance Day Sermon which was delivered at Westminster Abbey on 11 November 2009:

> The generation that has passed walked forward with vision and bravery and held together the bonds of our society, our continent, our Commonwealth through a terrible century. May we learn the lessons they learned; and God save us from learning them in the way they had to (Williams 2009).

Such sentiments of collective observation were reiterated within the wider media which also reaffirmed both the 'national' character and the moral imperative in witnessing the Great War. Within these reports, associations were made as to the necessity of inclusion of all members of society within this act of observation. For example, see 'Silence falls on Armistice Day' (Erwin 2009: 2) or 'Armistice Day: the Queen and Duke of Edinburgh lead tributes to fallen soldiers' (Leach 2009). To be a witness to these events is to attach oneself to a particular sense of self:

Most of Britain fell silent for two minutes at 11am in the nation's Armistice Day tribute, made even more poignant by a special service to honour the passing of the final three servicemen of the First World War generation living in the UK (Meikle 2009: 3)

This sense of 'national' observance on Armistice Day was again mobilised by the then Prime Minister Gordon Brown in 2006 with a speech to the politically left-leaning Fabian Society as a means of re-affirming or re-imagining a 'British' identity in the face of Scottish and Welsh devolution and campaigns for independence as well as the political developments within Northern Ireland. In this guise, 'witnessing' becomes a celebration of national character as the common values and ideals of people across Britain are stressed in the remembrance of the war dead:

Perhaps Armistice Day and Remembrance Sunday are the nearest we have come to a British day that is – in every corner of our country – commemorative, unifying, and an expression of British ideas of standing firm in the world in the name of liberty responsibility and fairness? (Brown 2006: 262).

Indeed, not to partake of this act of witnessing identifies groups or communities within Britain as 'others'; those who do not observe this sacrifice or appear to refuse to acknowledge this act are marked as 'disruptive' or 'dissonant'. Indeed, such is the place of this act of witnessing within society that the right-wing British National Party launched a 'Protect the Poppy' campaign in November 2011 to preserve a 'national' observance in the face of anti-war protests by Islamic groups and to prevent an 'insult to our bravest and our best' (BNP 2011). Similarly, in 2011 a number of members of the extremist group, the English Defence League, were arrested in advance of a planned attack on the anti-capitalist 'Occupy' camp protesting against the London Stock Exchange outside of St Paul's Cathedral before Armistice Day. Whilst the act of witnessing associated with Armistice Day constitutes a means of expressing affiliation to a 'British' identity and values as the shared act of reflection forms part of a communal attachment to an 'imagined community' (after Anderson 1983), the same process of witnessing also possesses a means of demonstrating other aspects of identity that exist within Britain. To bear witness to the dead of the conflict forms a means of stressing and differentiating identity across the various groups and communities within Britain. As such, regional and national identities are elevated through the association with the dead of the conflict. Witnessing the sacrifice of those of the past with whom one identifies with or claims attachment to, promotes and distinguishes that identity in the present (after Brown 2001). In this respect, witnessing the dead as 'Scottish', 'Welsh', 'Irish', as 'Ulstermen' or as 'Northerners' enables contemporary groups to testify to the suffering and victimisation of 'fellow-others' (after Levinas 1998: 15). Therefore, Armistice Day commemorations can evoke a particular view of the war which is focused on specifically witnessing 'our' dead. In this manner,

proposals such as that forwarded by the Scottish National Party politician for Cunninghame North, Kenneth Gibson in 2008 that the Scottish Parliament observe and testify to 'Scotland's heavy sacrifice in that appalling conflict', reveals the potential of witnessing the past for contemporary agendas (SP OR, 4 November 2008, S3M-2810). The act of witnessing therefore affirms attachment and place as the observance of the 1914–1918 conflict enables groups and communities to mobilise social and political agendas. Similarly, in Scotland, media coverage of the Armistice Day commemorations demonstrates how witnesses are called upon to bear specific visions of the past:

> Scotland fell silent yesterday as people came together to remember those who gave their lives for their country (Ward 2011: 3).

> Scotland fell silent today in memory of those who gave their lives for their country as events were held to mark Armistice Day (Anon 2011g: 4).

Witnessing is, therefore, not a passive act, devoid of motivation or meaning. Through bearing witness to the past, individuals, groups and communities stake a claim to a place in the present (see Alexander 2001: 5, Brown 2002, 8). As Scottish politicians and media witness the events of the Great War as a sacrifice and suffering of specifically Scottish soldiers an alternative identity is forged for those witnessing Armistice Day. Observing a particular set of the victimised soldiers of the battlefields of the Great War becomes a means of stressing distinction and difference. Bearing witness to these deaths thereby reinforces a sense of identity and belonging (after Ashworth and Graham 2005, Schofield and Szymanski 2011). A similar process can be noted in certain regions within England, where distinctions made in the observance of the sacrifice of the war dead alludes to a distinct sense of self beyond that of hegemonic notions of a 'British' identity. For example, see 'North East falls silent for Armistice Day' (Anon 2010c: 3) or 'Tyneside falls silent for Remembrance Sunday' (Nichol 2011: 3). Certainly, the act of witnessing in the case of Northern Ireland is particularly politically loaded, as to bear witness to the Great War forms highly prominent associations with contemporary contexts (see Graham and Shirlow 2002). As the observance of the deaths of those from the Ulster Volunteer Force, who signed-up for service in the 36th (Ulster Division) at the outbreak of war, has become such an integral focus point for Unionist identity, witnessing the war creates specific identities in the present within the province (Graham 2004). Armistice Day within Northern Ireland has been observed as a moment to reaffirm the ties that bind Ulster Unionist identity as one with a British identity. Witnessing the sacrifice of the dead creates a specific way of viewing and presenting a sense of self. Indeed, the paramilitary group the Ulster Defence Association announced their commitment to the peace process in Northern Ireland on 11 November 2007 by stating their association with a British identity and calling upon the sacrifices of the First World War as a testament to this association:

Our members have from 1893 went forward and paid the ultimate sacrifice and gave their lives in the defence and freedom of small nations on Flanders fields at the Somme during the First World War ... (Ulster Defence Association 2007).

Such is the role of this act of observance within Northern Ireland for Unionist identity that witnessing has become both a point of contention but also a means of potential reconciliation. In 2010, Margaret Ritchie, of the Nationalist-focused Social Democratic and Labour Party, became the first leader of the political party to wear a poppy on Armistice Day as a common ground of remembrance was sought within the province. A collective act of witnessing sacrifice has therefore been forwarded as a means of building cross-community identity within Northern Ireland (after Walker 2000, 2007).

Whilst national, regional and local identity is consolidated with the role of witnessing, the role of observance also provides individuals and communities with a means of forming political and moral identities and values in the present (after Neal 1989: 5). This ability to comment on current issues is derived from the perspective of the witness; as to serve as an observer to the war requires a testimony of that observation. In this manner, those who witness the war are called upon to state a moral or ethical standpoint on the conflict. Whilst the criticism of the 'popular memory' of the Great War in Britain has focused on the assumption of the 'blood, mud and gas' version of the hostilities, this fails to recognise that such a testimony is a distinctly moral judgement on both the past and the present. Such testimonies are perhaps an inevitable product of the witness perspective, as from this vantage members of society are called upon to attest to the sacrifices made; to be a witness requires the individual to bear the 'truth' and nothing but the truth. Therefore, it can be considered that the 'truth' is a fluid concept that serves contemporary agendas rather than historical accuracy; the truth, following Rorty's (1980: 10) pragmatic assertion, is only 'what it is better for us to believe'. In this guise, to witness the war, the sacrifice and the dead, places those witnesses within a framework which assesses the responsibility of authority, the place of justice and the nature of victimisation.

As evidence of this active role of the witness, the manner in which the events of the Great War are observed across the political spectrum can be assessed. Within a left-wing context, the act of bearing witness to the conflict serves as the basis on which a testimony can be derived of anti-militarism, anti-authoritarianism and anti-nationalist agenda. To witness the Great War in this respect is to bear out not just a tragic loss of life but to accuse others of an abuse of power:

The sight of politicians, the royal family and various other members of the nation's ruling class laying wreaths at the cenotaph to commemorate the deaths and slaughter of the untold thousands of working class men, used as cannon fodder to maintain the class privileges which they and theirs enjoy, is truly an act of sickening hypocrisy to behold (Wight 2010).

As such, to observe the events of the Great War to acknowledge the deaths of the conflict is to bear out a testimony which affirms the irresponsibility of the politicians who wage war and send soldiers to fight:

> The best way to remember the dead of past wars is to keep campaigning until all the troops are out of Iraq and Afghanistan (German 2009).

The role of the witness in these assessments is significant; witnesses do not testify that the Great War was a horrendous slaughter brought about by competing national and imperial interests because of a skewed perspective brought about by misrepresentations of the conflict on film, television and historical fiction. Rather, the perspective of the witness enables an active and 'tactical' choice to be made not, as it might be criticised, one borne out of a vapid consumption of mass media products. As such, the observation derived from witnessing the events of 1914–1918 that the conflict was a war of 'imperialist slaughter' provides a basis for a distinct political identity. Just as witnessing the war forms a significant part of national and regional affiliation as 'British' or 'Scottish', the act of witnessing forms an association with a recognisable political identity which stresses dissonance and left-wing politics:

> After all, if there is one thing everyone knows about World War I, after all, it is that old quote about 'lions led by donkeys' - the combination of hubris and incompetence that saw whole regiments of young men marching almost defenceless down the barrels of then-new machine guns. The carnage of the Somme, even by the standards of the bourgeoisie, was largely avoidable (Turley 2011: 12).

The recourse to 'everyone knows' is significant in this respect as it operates as a means of inclusion into this dissident identity to state similar values and ideals. Such sentiments are not only limited to the socialist press but can be observed in the wider media as well. For example, the philosopher A.C. Grayling, writing in *The Guardian* in 2001, stated that 'everyone knows that the First World War – the source of Remembrance Day – should not have happened' (Grayling 2001: 21). To 'witness' the Great War in this respect requires individuals and groups to testify to the conflict as a condemnation of the political elite, as a dereliction of duty for the care of citizens and as a wholesale abuse of the democratic process. With this critique derived from the role of the witness, a political identity is expressed through the action of testifying the existence of these issues as both in the present and of the present (after Brown 2001: 122). Therefore, bearing out that the conflict of 1914–1918 was one of 'slaughter' which was visited upon societies by their own government's negligence, enables testaments to be made that this situation is still occurring:

> In 1918 politicians told us it was a war to end all wars. It turned out to be an empty piece of rhetoric – just like (Prime Minister) Cameron's latest piece of political bombast (Anon 2011h: 24).

What hypocrisy, then, to glorify the victims of past conflicts, to repeat the reassuring clichés, as we send our young men and women to their deaths. Again, for what? (O'Neill 2009: 21).

We still dispatch young men and women to their deaths by the thousand. Pragmatist, not pacifist, we brush away the lessons of 1914–18. At the going down of the sun, we will remember? Perhaps. Yet then night falls: and, all too easily, we forget (Preston 2011: 15).

The basis of this identity is a focus on the suffering and sacrifice of the ordinary soldier and their mistreatment at the hands of a negligent government and military elite. Whilst this forms a point of association for dissonant political viewpoints as it questions the role and nature of authority as well as current policies, it also constitutes a significant aspect of a moral or ethical identity (after Gergen 2005). This mode of identification is highly significant and distinct from the national or political identities that are derived from the act of witnessing the Great War as it comprises a humanitarian appeal which does not necessarily attach itself to a particular agenda. In this process, the witnesses to the conflict place emphasis on the common suffering of the soldiers of the war to emphasise values and associations that cross beyond political or national boundaries. The evocation 'we will remember them', derived from Laurence Binyon's (1922) *For the Fallen* takes on especial significance in this act of observation as a moral and ethical duty in remembrance is stressed. Indeed, within such an approach political or religious connections are considered to be ill-suited or in 'bad-taste' as the dead, the sacrifice and the suffering are observed. This is certainly reflected in the speech of Terry Sanderson, leader of the National Secular Society, to the Scottish Parliament in May 2012 where he demanded that remembrance of the war should be 'inclusive' across Britain and not dependent on official or 'Christian' observance (Sanderson 2012). A removal of these associations places greater emphasis on the observance of the torment of troops.

This increased focus on the anguish soldiers experienced in the conflict can be identified in the growing emphasis placed on the perception of soldiers in the Great War as victims of 'shell shock' or suffering from the as then yet-to-be identified 'post traumatic stress disorder' (see Leese 2002). Whilst the inclusion of this psychological condition in contemporary historical novels such as Barker's (1991) *Regeneration* has been assessed, it possesses contemporary relevance as it reflects a wider means of witnessing the conflict through its capacity to heighten the sense of the victimisation of the troops (see Korte 2001; Wilson 2008a). Afflicted by an unrecognised condition and beset by the atrocious conditions in the trenches, the 'victim' status of the soldiers of the Great War is confirmed in this manner (Holden 1998). As the effects of modern warfare have become of increasing interest as soldiers return from campaigns in Iraq and Afghanistan, their predecessors who fought in the Great War have been used as a comparison and as a frame of reference. Indeed, the official advice offered by the National Health

Service in England and Wales for soldiers suffering post-traumatic stress disorders draws upon the experience of the Great War stating its initial diagnosis in those who had seen service in the 'harrowing conditions' in the trenches (NHS 2008). Official publications within the health services field also repeat this association to demonstrate common sympathy with the plight of others:

> Post-traumatic stress disorder is not new. Many soldiers shot for cowardice in the First World War are thought to have suffered from the condition (Beckford-Ball 2009: 5).

Indeed, the Christmas Appeal run by the *Daily Telegraph* newspaper in 2008 used this perspective of the witness to suffering to ask potential donors for support in helping recent victims of post-traumatic stress disorder:

> During the First World War, a PTSD sufferer would have been placed against a wall and shot because it was believed that this condition was brought on by weakness of character (McNab 2008: 18).

To witness the suffering of troops thereby casts the individual in the present as more than just a dispassionate observer but one who is compelled to testify that this anguish occurred, that it should be recognised and that it should be avoided in the future (after Booth 1996: 15). Indeed, this moral identity formed through the witnessing of the Great War can be observed in the well-documented campaign to pardon soldiers executed by the British Army during the conflict (see Putkowski and Sykes 1989). It can also be detailed in the work of the veterans' charity organisation *Help for Heroes*, who state their work in raising money for veterans of Britain's conflict is 'non-political' and 'non-critical' (Help for Heroes 2012). However, the group draws upon the moral identity of the witness to promote its fundraising activities as well as making direct links with the Great War through such events as a sponsored walk of the battlefields of France and Flanders. Indeed, the charity pop single released to aid the organisation in November 2009 contained a chorus which recalled Binyon's *For the Fallen*: 'We will remember them, give thanks and honour them' (United Artists 2009).

Finally, this moral identity, which is constructed through the witness perspective, is also evident in the online public forums which invite debate and personal accounts of individual or family research into the history of the Great War. Within these websites the invocation 'we will remember them' is repeatedly used as a response or as a topic heading as it serves as a commitment or affirmation of the suffering and sacrifice of the soldiers of the Great War:

> 91 years ago today – We will remember them (Great War Forum 2008).

> Been Reading this Topic with a Great Sense of Sadness and Pride … WE WILL REMEMBER THEM! (Great War Forum 2007b).

Therefore, the construction of a moral identity in relation to the Great War through the perspective of the witness provides a means of demonstrating attachment and exercising a shared set of values (after Neal 1989: 7). However, it can be considered that stating an intention that 'we will remember' in an ethical context is not necessarily an apolitical commitment. Witnessing in this respect enables a conservative element to assert itself within the heritage of the Great War, to preserve the remembrance of the sacrifices made by soldiers in the service of their country. The resolve not to challenge the *status quo* so that 'we will remember them' is therefore evident within aspects of the mainstream political discourse within contemporary Britain. In speeches to mark Remembrance Sunday, Armistice Day or to discuss aspects of the military, 'witnessing' enables an affirmation of common ideals and norms. For example, the Conservative politician and Member of Parliament for Beckenham, Bob Stewart, called upon the declaration of witnessing to sustain financial support for the Armed Forces:

> When the names of the casualties are read out in this House, we always say,
> We will remember them. That places on us a requirement to remember them by
> looking after their wives, children and husbands for the rest of their lives (HC
> Deb, 10 January 2011b, c106).

Similarly, *The Sun* newspaper also used the call to witness and remember whilst drawing links between the First World War and the present day conflicts to promote the support of the then current servicemen and women in Iraq and Afghanistan (Starkey and Wheeler 2007: 4). Witnessing the dead of the war in this process operates to nullify any question of dissent or opposition to current situations. A direct line of continuity is drawn from the sacrifice of those in the Great War to those serving in contemporary conflicts. This is also the way in which the veterans' charity, the Royal British Legion, serves to portray the Great War as it styles itself as the 'custodian of remembrance'. The Legion's call that 'we will remember them' therefore constructs a moral identity through this act of witnessing whilst preserving conservative appeals to support 'our troops':

> The Royal British Legion was formed in 1921 to support the veterans of the
> Great War. But since then, Britain has been involved in many other wars and
> fields of Service, creating a continuous supply of Service men and women, and
> their families, who need our assistance (Royal British Legion 2012).

This uninterrupted thread of service and sacrifice is affirmed through campaigns to support 'our boys' as the events of the First World War are considered alongside the recent campaigns in Iraq and Afghanistan. Indeed, in 2001 after the initial period of success of troops in Afghanistan, *The Sun* newspaper emphasised this assocation with three linked articles containing an interview with a veteran of the Great War exhorting the need to continue current operations, an excerpt on how Serbian 'terrorists' started the 1914–1918 war and the then Prime Minister Tony

Blair's pride to wear a poppy 'as our boys and girls get set to fight in the new war on terror' (see Lister 2001: 7). Quite apart from the claim to be devoid of political meaning, this mode of witnessing removes the place of the Great War as a vehicle of dissonant politics. Indeed, any attempt at utilising the 1914–1918 conflict to draw attention to current issues is derisively critiqued as an attempt at 'politicising' the act of witnessing. Therefore, bearing witness to the events of the First World War still impacts upon the political and social landscape across Britain; the observation of the sacrifice and the suffering of soldiers serve a variety of purposes as it creates and affirms notions of identity and place. Whilst the act of witnessing has resulted in individuals, groups and communities looking upon the conflict and testifying to alternative visions, the framework provided by the witness perspective enables such a process to occur. The position of a witness is in this manner one of the key aspects of the heritage of the conflict within Britain, it serves to mobilise, engage or to reaffirm elements of the past within the present.

Conclusions

The perspectives taken on the Great War in Britain demonstrate key features of the cultural heritage of the conflict. Both the 'view from the trenches', as communicated by the soldier poets, and the 'witness' perspective, which developed through the official memorial schemes, provide contemporary groups and individuals with a means to frame current concerns and agendas within the context of the First World War. With regard to the 'view from the trenches', too often critics of the 'popular memory' have derided the prominence of the work of Owen and Sassoon in both educating a new generation about the war and in influencing the 'lay person's' understanding of the conflict. The implicit suggestion here is that the popular reception of the war poets' work is drawn more from convenience and ignorance than a knowing usage of the words and phrases from these verses. By assessing how such poems as *Dulce Et Decorum Est* or *Anthem for Doomed Youth* are used within the political, media and public discourses as a means to outline and illustrate, the perspective of the 'view from the trenches' can be assessed. This usage stems from an understanding that this perspective represents the 'truth' of the war. The perspective of the 'view from the trenches' is evoked because of this quality, as it serves to emphasise and validate various claims for attention and recognition in the present. Therefore, this viewpoint, derived from the soldier poets, is a significant part of the cultural heritage of the Great War in Britain as it serves as a vehicle of critique and dissonance. It is through the perspective of the 'view from the trenches' that contemporary individuals and communities can assess and assail positions of power and authority across Britain. The perspective is a corrective device on the perceived abuse or neglect of the responsibility of the state towards the wider body politic.

The same issue informs the usage of the 'witness' perspective within Britain. Although official commemorative schemes exhorted post-war society to bear witness

to the events of the 1914–1918 conflict, this mode of framing and understanding the conflict has been altered and shifted with societal changes since the Armistice. Whereas once, this act of witnessing was intended to enable a nation to come together and testify as to the sacrifices made for 'King and Country', witnessing the deaths and suffering of the troops is now used to form and consolidate dissonant or anti-authoritarian identities. Indeed, being a witness to the Great War has provided a powerful means of establishing identities for contemporary groups and communities. The formation of left-wing and national and regional identities through this viewpoint evidences the capacity of this perspective to mobilise and activate communities and individuals. This is not to suggest that witnessing has become a wholly subversive action. Indeed, witnessing the sacrifice of the Great War still inculcates conservative, traditional allegiances towards a hegemonic British identity. This can be noted in the insistence within mainstream political discourse that the war dead represent 'our' values and 'our' shared ideals.

This 'imagined community' is also reified and violently defended against perceived threats by right-wing elements as groups such as the British National Party or the English Defence League. However, in this guise of a witness the aims and objectives of the left and right of the political spectrum are joined in the utilisation of the heritage of the Great War to further a critical agenda of contemporary politics to highlight the failings of the state (after Brown 2001). Indeed, on the death of the last few remaining veterans of the conflict in Britain during 2009, opposing elements of the political spectrum sought to appoint themselves as 'reliable witnesses' to the war and the presumed 'message' of the veterans. In an article in the socialist daily newspaper, the *Morning Star*, the anti-war stance taken by the last veteran Harry Patch to remind others of the brutality of the war was declared to be his legacy (see Donovan 2009). Conversely, members of the British National Party posted a tribute online to the veterans declaring that it was only this political party that mourned the passing of Harry Patch and Henry Allingham and that they would continue their support for 'Britain's troops' (BNP 2009). To be a witness to the events of the Great War is, therefore, a privileged position and a role which enables a critical voice to emerge. This witness perspective and the 'view from the trenches' are important parts of the heritage of the Great War as they provide a means for contemporary groups to realign and establish themselves through the frames which are drawn from the conflict.

Chapter 5
Myths of the War – Imagining the Great War

The popular memory of the First World War across Britain is often derided by critics as dominated by 'myths', fabrications, or pseudo-history which ignores or obscures the historical 'truths' of the conflict (see Corrigan 2003). These myths are considered to structure the remembrance of the war creating a myopic, biased and highly inaccurate perspective of the events of 1914–1918 (see Badsey 2002). A great deal of scholarship has been undertaken to demonstrate the post-war origins of many of these perceptions; thereby demonstrating the ahistorical nature of the Great War's remembrance within communities and groups across Britain (Bond 2002). This determination to uncover the 'inventions of tradition' regarding the world's first industrialised conflict has been highly proficient in demonstrating how popular ideas about the war have been perpetuated through fiction, film and television (Todman 2005). However, in the rush to remove this much maligned 'anti-historical' mode of remembering the war, scholars have neglected why these myths have remained current. Indeed, despite the proliferation of analyses which illustrate the creation of the customs and beliefs regarding the conflict, these 'myths' are still drawn upon (after Sheffield 2002: 12). Such an insistence on apparently inaccurate assessments of the war is not born out of ignorance or the vapid consumption of media products but on the utility of these myths (Wilson 2008a). The reasons for the presence and durability of the 'myths and memory' of the conflict is because they are functional to the groups, communities and the individuals who use them. Whether for social, cultural or political concern, the myths of the war provide society with a frame through which to construct and align present concerns with the events of the Great War. The myths of war are used as outlines by which assessments and affiliations can be stated. These myths of the conflict are, therefore, an integral feature of the cultural heritage of the Great War in Britain; they form part of the intangible legacy which demonstrates how the past is used to outline issues in the present.

Examining how myths and memory frame and structure the understanding of contemporary environments has been a subject of study for anthropologists, psychologists and historians alike (see Lévi-Strauss 1978, Segal 1999). Whilst the subjects of concern differ widely, what is consistent in these assessments is that these myths perform a function within society; they are used to demonstrate ideas, ideals and identity to others and to the self. Indeed, this place of myths within communities was highlighted by the work of the anthropologist Claude Lévi-Strauss (1978) who identified an underlying structure within mythologies. Within this assessment, myths were demonstrated to be functional aspects of a society enabling a resolution of contradictions and rendering problematic and

troublesome issues accessible and understandable. Such an approach borrowed substantially from the psychological study of myth through the work of Sigmund Freud (1939) and Carl Gustav Jung (1964). Both Freud and Jung assessed mythologies across cultures not as irrational aspects of culture but as judicious means of communication and reconciliation. The utility of myths is thereby restated within several assessments as groups are shown to use myths as an important device in framing understanding within a particular context. Historians have also assessed the nature and function of myth within society, as nations, ethnic groups and communities are shown to rely on mythical aspects of their past to understand their origins, their development and their future (see McNeill 1986). Indeed, the groundbreaking work on memory studies conducted by Pierre Nora (1984) and Yosef Yerushalmi (1982) drew attention to the role of myths and memory within the consciousness of a community or wider society. In such circumstances, myths should not be considered as a fabrication of the past or as ahistorical. Myths are reflective of desires and anxieties within society and, therefore, represent a means of examining how the past is brought to bear on the present.

Within Britain, the function of historical myths has been extensively examined by Raphael Samuel (1989, 1994) who sought to establish the place and meaning of the mythologized past across various groups and communities. Samuel also addressed how historical myths function as a means of addressing social, cultural and political concerns (Samuel 1994). This approach is especially significant in assessing the myths and memory of the First World War in Britain as these perceptions provide a distinct frame through which historical and current concerns are connected. Rather than dismiss the myths of the war as erroneous, within this chapter the mythologies that structure the remembrance of the conflict will be shown to be tactically and specifically drawn upon to illustrate issues and identities (Wilson 2007, 2008a). Therefore, the myths of the First World War which are used within Britain should not be simplistically considered as submissively accepted by the public, but rather chosen for specific reasons. This is not a pursuit or acceptance of a relativist stance, whereby any interpretation of the past has validity, regardless of the evidence which it employs; it is an acknowledgement that the 'myths and memories' have real purpose for the society which uses them (see Dening 1988: 100). In examining the 'myths we live by', Samuel (1989: xxvii) suggested that 'in dealing with the figures of national myth, one is confronted not by realities which became fictions, but rather by fictions which by dint of their popularity, became realities in their own right'. This is where facts and dates in themselves are unimportant, but gain greater meaning when considered alongside what these facts and dates mean for the people who use them; the choices they make about the past, the stories they wish to tell about themselves. Whilst this popular memory is of course informed by the representations offered through popular culture, echoing Marx's (1968: 16) observation that histories are made by individuals but not under the circumstances of their choosing; the choices made by individuals with these cultural forms nevertheless remains a significant area of study,

the manner in which individuals have appropriated these cultural materials to fashion their own memories and histories (Wertsch 2002). This 'selection' remains unaddressed within the context of the memory of the First World War within Britain, with military historians particularly quick to dismiss the popular memory as regrettable 'myths', without regarding the processes involved in the production of the popular perceptions of the past. By assessing the function of these myths regarding the Great War, another aspect of the cultural heritage of the conflict in Britain can be assessed. Myths provide an intangible aspect of the war's cultural heritage and their usage as frames demonstrates the place and utility of the Great War within contemporary society.

Britain, the Great War and the 'Lost Generation'

One of the most enduring myths of the conflict is that of the 'lost generation'. The belief that the war of 1914–1918 saw the substantial loss of many of the young men who died on the battlefields is one which permeates the popular perceptions of the conflict across Britain (see Pound 1964, Wohl 1979). The death toll of over 750,000 British combatants who served in the armed forces is often used to validate this perception. Wartime fatalities were such that few areas across Britain were spared the loss of a father, a brother, a son or a friend (see Winter 1977, 1986). Such a widespread sense of loss contributed to a perception that the war had succeeded in significantly reducing the male population within Britain. Indeed, Lord Lansdowne, a member of Prime Minister Herbert Asquith's War Cabinet issued a memorandum in 1916 that reflected these concerns, declaring that the war was 'slowly but surely killing off the best of the male population of these islands' (quoted in Asquith 1928: 165). However, in the immediate post-war era, the idea of a 'lost generation' emerged with the specific sense that it was the young men of the upper classes, Britain's 'brightest and best', who had been cut down in their prime on the fields of France, Flanders, Gallipoli, Italy, Mesopotamia and Salonika. This assessment was heightened by the economic and politically uncertain world in the interwar period. In his social study of post-war Britain, George Greenwood asserted that all these problems stemmed from the loss of the 'best men' at the front:

> They were of the stock of men with high desires that come from fresh brains and who have the energy to apply them, the elements that count for most in the world's affairs. It is no mere coincidence that our almost intolerable weight of social, industrial and economic problems follows upon the sudden abstraction from and the very partial restoration to the life of its nation of its noblest, bravest and most unselfish youth (Greenwood 1922: 138).

Indeed, Vera Brittain (1893–1970), who lost a brother and her fiancé in the conflict, was convinced that 'the finest flowers of English manhood had been

plucked from a whole generation' (Brittain 1933: 610). With this sense of loss of a 'golden generation' the blame and responsibility was levelled at those in authority who were seen to have sent soldiers off to fight in the war. The words of one of those members of the lost generation of this *Belle Époque*, Wilfred Owen, aptly summarised the case against those who told 'children' of the glory of war; 'My friend, you would not tell with such high zest, To children ardent for some desperate glory, The old Lie' (Owen 1965: 52). Such indictments were levelled against not just the politicians and the General Staff of the British Army, they were used to criticise an entire older generation which had seemingly neglected its responsibilities towards the nation's youth. Rudyard Kipling, who was an energetic member of the War Propaganda Bureau during the conflict and who lost a son at Loos in 1915, affirmed this condemnation in his *Epitaphs of the War*, published in 1919; 'If any question why we died, Tell them, because our fathers lied' (Kipling 1940: 390). Responsibility for the deaths of those serving and suffering on the battlefields was, therefore, paramount in this discussion. This notion of the 'lost generation' developed in the interwar period and after 1945 to encompass all of those who died in service during the Great War. Indeed, the literary scholar, Paul Fussell remarked in 1975 that the war had been 'catastrophic' for Britain as a 'whole generation was destroyed' (Fussell 1975: 337). Similarly, Samuel Hynes echoed these sentiments in his assessment of the war:

> ... innocent young men, their heads full of high abstractions like Honour, Glory, and England, went off to war to make the world safe for democracy. They were slaughtered in stupid battles planned by stupid generals. Those who survived were shocked, disillusioned and embittered by their war experiences (Hynes 1990: x).

The accuracy of the 'lost generation' has been doubted by scholars as Britain's level of fatalities has been compared with other combatant nations (see Winter 1986). In fact, whilst France and Germany each saw over a million individuals perish in the Great War there is no corresponding discourse of a 'lost generation'. Although the idea of the 'lost generation' remains current, this particular concept of the war in Britain has been analysed as a post-war literary concoction. In this assessment, during the 1920s and 1930s novels and memoirs of the conflict provided a misleading impression of a group of young men from the higher levels of society who had been sacrificed on the altar of nationalism. Whilst members of the upper-classes, many of whom served as officers, suffered a higher proportional rate of fatalities, this concept that the majority of a generation were lost has been shown to be inaccurate. In his detailed study of the post-demographics, Winter (1977; 1986) has highlighted that the loss of those who died in the war did not adversely impact upon Britain's population levels. The myth of a 'lost generation' within Britain has therefore been 'debunked' from a historical perspective (see DeGroot 1999). However, the sense that the war resulted in the loss of a whole age group has taken on

notes: Bib.

especial significance within the communities across Britain. Within its popular usage, the 'lost generation' is part of the heritage of the Great War as it is used to allude to the present through the past (after Neal 1989: 6). To speak of the 'lost generation' conjures perceptions of loss, suffering, neglect, responsibility and blame. It is a powerful frame through which to view contemporary issues as it eludes to a critique of authority, a denunciation of power and an identification *alludes?* with victimhood (after Alexander 2001: 2). As such, it is part of the intangible heritage of the 1914–1918 conflict and its presence within political, media and public discourse evidences the way in which the Great War is brought to bear on the present. The accusation that the actions of authorities, which are either negligent or callous, have resulted in a 'lost generation' is one which seeks to highlight blame and responsibility.

Across Britain, the assessment that the war resulted in an absence of the 'brightest and best' is current within national and regional political, media and public discourse. Indeed, the 'lost generation' is not a myth in these circumstances, but an evident, tragic presence within society. Perhaps this perception is evidenced in the choice of this myth as the title for the 2005 season of television programmes broadcast in Britain on Channel 4. The *Lost Generation* schedule consisted of documentaries focusing on the Battle of the Somme and the array of war memorials constructed in Britain in the post-war era in response to the vast scale of death which occurred on the battlefields. Its stated aim was to turn 'those long lists of names of the fallen back into real people' (Channel 4 2005). Certainly, even within the highest levels of government, the belief that the war acted to extinguish an entire section of society can be located. For example, in 2010 during the discussions over the form of the commemoration of the centenary of the war in the House of Commons, Members of Parliament regularly rehearsed the sentiment in their discussions.

> As my hon. Friends the Members for Folkestone and Hythe and for New Forest East (Dr Lewis) have pointed out, it was not the war to end all wars, but its scale robbed this country of a generation of young men (HC Deb, 8 July 2010a, c630).

The existence of the 'lost generation' who fought in the conflict is thereby imbued with the value of 'truth'; it is an accepted and widely acknowledged myth which has become reality in its own right. In this manner, media reports can refer to the 'lost generation' without accusations of inaccuracy. Indeed, during Remembrance Sunday or Armistice Day there is a marked tendency to utilise this term. For example, see 'Armistice Day services pay tribute to lost generation' (Meikle 2009: 3), or, 'Take Your Place to Remember Lost Generation' (Anon 2009d: 7):

> Her Majesty, along with the Duke of Edinburgh, senior politicians and military top brass joined 2,000 guests to remember the sacrifices made by the "Lost Generation" of the Great War (Larcombe 2011).

> By 1918 a third of British men who were aged 19–22 at the start of the war were
> dead. In Scotland the proportion was even higher and thousands of women in the
> prime of their lives realised that they would never marry or raise families. Truly
> this was a lost generation (Anon 2006d: 4).

In this respect the remembrance of the Great War focuses entirely upon the 'lost
generation' as the emotive, tragic and poignant sense of loss the concept evokes
a powerful response within the wider media (see Heaven 2011). With the passing
of the last veterans of the conflict from Britain in 2009, there was a greater focus
on the meaning of the 'lost generation' for wider society. In this reflective moment
the necessity for remembrance was evoked so that the 'sacrifices and the suffering'
of the men and women of that era could be recognised. The last veterans were
considered to be the 'spokesmen' of the 'lost generation' and their experience of the
horrors of war were framed as providing an instructional and educational value. For
example, the death of Harry Patch in 2009 was marked by a number of headlines
which corresponded to this sentiment; 'Best tribute to Harry Patch is teaching our
children why they must never forget horrors of Great War' (Roberts 2009), or, 'Lest
we forget ... memorial unveiled to Harry Patch, the Last Tommy' (Dewsbury 2012).
The usage of the term is also highly apparent within a local and regional context,
as communities seek to establish the impact that the deaths of so many from a
particular locale would have had on towns or villages across Britain. To speak of a
'lost generation' within this context is engage with a definite 'truth' of the war as the
long list of names on the local war memorials appear to evidence the absence of an
entire age bracket with its corresponding effect of grief, trauma and bereavement.

> Like many communities, Castleton was deprived of almost an entire generation of
> its youth, killed in the trenches of northern France during the 'war to end all wars'
> (Appleton 2004: 6).

The experience of communities over a 'lost generation' is thereby enacted in the
present as the sense of victimhood and suffering is emphasised for a particular area.
For example, see 'Remembering a lost generation' (Anon 2007d: 5), reported in the
Jarrow and Hebburn Gazzette, or, 'The Lost Generation' (Taylor 2006), reported in
the *Newcastle Evening Chronicle*. Through this process, local individuals from this
'lost generation' are permeated with a sense of place and identity:

> Jack Garbutt wasn't a hero – except in the sense that all the young men who fought
> in the trenches in the First World War were heroes. He was an ordinary working
> lad from Bilsdale, in the North York Moors (Lewis 2008: 16).

This vaunted and honourable position held by the 'lost generation' thereby serves
as a reminder of the 'debt' or 'obligation' of remembrance. This operates both for
localities but also for individual families. For example, the author Alan Bennett
remarked in his memoirs upon his Uncle Clarence, a member of the 'lost generation',

that it was always 'the undisputed nobility of his character' which was asserted in family discussions (Bennett 2003: 31). The journalist Ian Hislop also asserted this respectable place of the 'lost generation' within society: 'the more I learn about the lost generation of the First World War the more I realise that the odd act of memory is not much to ask from a fortunate generation like ours' (Hislop 2007). This sense of respect for the suffering of the 'lost generation' is also reiterated within public forums, which debates the research and remembrance of the Great War, where the myth of the absent men and women is not questioned but brought within a wider recognition of the conflict:

> The School are doing a Battlefield trip shortly and I am doing short biographies of the old boys who are buried/remembered at location they will visit, so the present generation can pay their respects to the lost generation (Great War Forum 2011).

> Like all the chums, and many others besides, my sense of reverence, gratitude, and awe for this lost generation has been with me since I was a child (Great War Forum 2009).

> To the Men & Women who fell, our lost generation who gave their lives for us, you will Never be forgotten. God bless you and rest in peace (The Great War Forum 2010).

As if to evidence this perception of the existence of the 'lost generation', the memorials both within Britain and on the former fields of conflict appear to serve as evidence for this great loss. Indeed, the sea of 'endless headstones' at the major cemeteries or the vast memorials to 'the missing' at Thiepval on the Somme and the Menin Gate near Ieper are taken as demonstrative of the way the conflict cut short the lives of so many from one particular age group (see Figure 5.1). This memorial landscape is viewed as irrefutable evidence of the impact of the war that still resounds in the present day:

> If any reader doubts that, I can only urge him or her to go and see it ... to experience the deep intellectual sophistication of its design and then to stand in the centre, where the complexity of its mass is dissolved and the visitor looks out through vast open arches in all four directions to see the sky over the pastoral landscape, soaked in the blood of a lost generation (Stamp 2006: 33).

> You can almost hear the voices of the Lost Generation: a volunteer army raised from the streets, encouraged to join up with their boyhood friends (Wynne-Jones 2006: 17).

Local memorials in the towns and villages also function in this respect as a means through which the 'lost generation' can be evoked in a contemporary setting. For example, see 'Letters from Bristol's lost generation' (Anon 2008e) as reported in

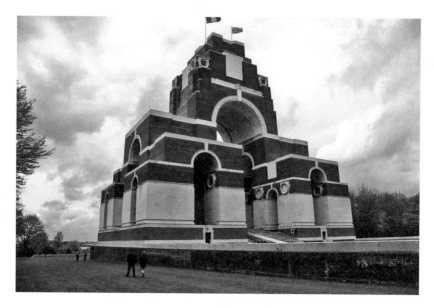

Figure 5.1 Thiepval Memorial, Somme, France

the south-west newspaper, *Western Daily Press*. Considering that the recruitment of soldiers in Britain focused upon both occupational and regional communities to foster morale and commitment, creating such military units as the 'Artists Rifles' as well as the 'Pals Battalions', large-scale fatalities in the field could have a devastating impact upon local areas (see Moorhouse 1992). Under such circumstances, smaller communities could indeed reflect upon the appearance of a 'lost generation' within their midst:

> A generation of young men were lost or injured during the Great War, with every community in Britain affected. Of the 4,252 Shetland servicemen and women who fought, 617 – nearly 15 per cent – lost their lives (Anon 2008f: 6).

However, the presence and prominence of this 'myth' is not derived from the consumption of accessible media images and narratives, the evocation of the 'lost generation' is made as it forms a critical form of discourse within Britain. The accusation that the war created a drastic loss of life amongst the wider body of civilians provides a critical frame of reference to view both the actions of the military and political authorities in the past but also in the present. The 'lost generation' carries an association of victimhood, blame and responsibility, as those who were culpable for inflicting a 'lost generation' upon society are rebuked. The 'myth' of a 'lost generation' of the Great War exists therefore because of its utility to society; it provides a means of mobilisation and identification. Indeed, by asserting that those of the 'lost generation' were treated negligently, persuaded

by the 'old lie' and forgotten by their social and political superiors, a dissonant mode of identity is created within society. This identity focuses on the association with the suffering, victims of the war and the culpability of authorities. The 'lost generation' is therefore equated to a 'cheated', 'fallen' or a 'betrayed' group, where the young were forced off to fight resulting in the deaths of a generation of young men (see Kennedy 2010):

> In the First World War a generation of young men were packed off to be slaughtered at Passchendaele and the Somme on the basis that it was a war to end all wars (Holt 2010).

> There are plenty of words to describe the horrors of the 1939–45 war. But there were none, as far as I could discover, that captured the character of the First World War. So I constructed one from the Greek word ephebos, a young man of fighting age. Ephebicide is the wanton mass slaughter of the young by the old (Monbiot 2008: 17).

This critical use of the 'lost generation', of the application of a dissonant perspective on the events of the Great War is not restricted to the political left. Aspects of right-wing politics across Britain also highlight a sense of 'betrayal' experienced by 'ordinary' citizens during and after the conflict as politicians are criticised for not protecting and honouring the sacrifices made on the battlefields. In this manner, the post-war promise made by the Liberal-Conservative Government, led by David Lloyd George (1863–1945), of a 'land fit for heroes' has become part of the myth of the 'lost' or 'betrayed' generation as it serves an ironic statement of official irresponsibility. Lloyd George stated this aim in a speech in 1918 where he asked his audience, 'What is our task? To make Britain a fit country for heroes to live in' (quoted in Anon 1918: 1). However, the post-1918 economic decline saw the promise of extra housing, jobs and the extension of the social welfare programme evaporate (see Grayling 1987). This historical failure compounds the sense of abandonment that resounds with the term 'lost generation'. To defend British interests and to 'make good' on a pledge to secure a country which is suitable for the sacrifices made on its behalf by its people has become a critique favoured by politicians and private individuals of both the left and the right. To state how the government or officials did not provide nor indeed help its citizens further condemns those who are responsible for the 'lost generation'. For example, contributors to the *Vanguard News Network Forum*, an online 'uncensored forum for Whites' based in Britain, allude to the failure of politicians both past and present through reference to the 'betrayed generation' and the absence of a country which is 'fit for heroes':

> "British jobs for British workers" and "A land fit for heroes" should be the primary campaigns of the BNP (VNN Forum 2010).

Further without being "racist" the BNP could offer to make good on the 1918 "Land fit for heroes to live in pledge" of Lloyd George ... (VNN Forum 2009).

Such allusions are also drawn upon within left-wing politics across Britain as accusations that Britain's working classes were abandoned after the conflict serves to place a questioning and sceptical emphasis on current political and social agendas. For example, in the wake of the economic austerity measures brought in by the Coalition Government after 2010, comparisons were made to the promises made to the British people in the wake of the Great War:

> For four years, from 1914 to 1918, working class men and women made enormous sacrifices in World War One. During this time they were lied to by pro-big business politicians such as Tory Winston Churchill and Liberal David Lloyd George, who said that the war would lead to a land "fit for heroes to live in" (Price 2011: 7).

Indeed, the abandonment of the 'lost generation' and the promise of a 'land fit for heroes' serves as a call for unity within left-wing politics to unite against the perceived abuse of working class interests. For example, see 'History repeats itself in the Khyber Pass' (Hernon 2002). This critical use of the 'myths' of the Great War demonstrates the reasons for the longevity and persistence of ideas such as the 'lost generation' despite the lamentations of historians: their utility. The historical myths of the conflict of 1914–1918 provide a critical frame through which to make statements about past and present contexts.

The ability to call upon the 'lost generation' to assess situations beyond the context of the First World War is notable. Individuals and communities seek to use the myth as a means of outlining current concerns. As such, these assessments draw upon the issues of blame, responsibility and victimhood which are implied in the analytical usage of the historical myth. Therefore, to ascribe to the notion that contemporary generations are 'lost' or 'forgotten' or 'fallen' demands that there is a figure of blame or a group that is culpable for the situation (after van Dijk 1988). Placing the issue within the framework provided by the myth of the 'lost generation' of the Great War serves to heighten and intensify the suffering or abandonment of an 'at risk' age group (after Fairclough 1995: 28). References to the First World War through this myth can be implicit or explicit, but it nevertheless enables a correlation to be made to demonstrate the failings of authorities to prevent such a tragic loss occurring. In these circumstances, the 'lost generation' has become a frequently used but also a very useful and highly important means to deliver a damning indictment of official neglect. Whilst the term is liberally applied to the experience of the young within war zones or areas which have been adversely altered by natural disasters, within Britain the myth has been mobilised to stress the fault of governments to secure a future or provide a 'land fit for heroes'. For example, in the context of the recession after 2008, the myth has been relied upon as a means of stressing the 'victimisation' of a younger generation across Britain

Table 5.1 Usage of the phrase 'Lost Generation' within *The Guardian* newspaper

Some n years would have helped

Year	Frequency of use
1999	23
2000	20
2001	19
2002	23
2003	17
2004	34
2005	35
2006	33
2007	47
2008	47
2009	98
2010	79
2011	112

Source: *The Guardian* (2012).

as access to resources and employment has been reduced. Indeed, the tag of the 'lost generation' to describe the younger members of society has become almost universal. Indeed, the appearance of the term within *The Guardian* newspaper has doubled as commentators have employed a term that carries powerful associations of neglect and blame (see Table 5.1). Whilst not all articles directly allude to the generation of British youths suffering under the conditions of the recession, its wider usage is representative of the increasing prominence of the term in society. In this manner, the employment of the myth enables an overt or covert assessment of society and its ideals:

> For those not able to afford an education or be lucky to get chosen for an apprenticeship, the label of a "lost generation" is looming (Ridgway 2012: 8).

The economic problems that impacted upon the regions across Britain after 2008 have certainly brought an increasing usage of the 'lost generation' as a definition. Within the political sphere and the wider media, lamentations of a 'lost generation' have abounded with a corresponding accusatory tone levelled at those in power who are held to be responsible for such a situation. See, for example, 'Fears of lost generation as youth unemployment hits record (Inman 2011: 13), or, 'Youth unemployment crisis warning: A lost generation blighted by debt, depression and self-loathing' (Barrow 2011: 8) and 'Fears over lost generation of unemployed young Scots' (Harrison 2012: 5). The myth is reused in these contexts to stress the status of an age group as 'victims' of the economic downturn but also of the actions

and policies of the authorities. Whilst the links between the war of 1914–1918 and the experiences of the current youth of Britain remain unstated in certain uses, direct associations are made by some commentators to frame contemporary issues with the past conflict in a tactical use of the heritage of the Great War:

> But still, like some demented general in the bloodbath of the First World War, they press on, hurling men, women, children and the social fabric over the top to be shredded by murderous machine-gun fire. Perhaps in years to come they'll concoct an equivalent of the poppy to mark another fallen generation. The hypocrites and hirelings can wear it ever larger – maybe chrysanthemums would suit them (Galloway 2011b).

The myth of the 'lost generation' is thereby directly mobilised to bring to light the official culpability for this failing. Therefore, this myth of the Great War is shown to have a high degree of cultural capital within contemporary contexts. It serves as a frame through which current issues can be dissected and analysed to provide a critical and at times dissident perspective on the actions of officials. In this manner, the myth of the 'lost generation' is a significant part of the heritage of the Great War as it forms a direct way in which the past is activated and brought to bear on the present. The status of the 1914–1918 conflict within Britain as a subversive topic is also demonstrated in the uses of this particular historical myth. Whilst elements from both the left and the right can be seen to draw upon the 'lost generation' in an attempt to further their own agendas, they do so because of the place of the Great War as a piece of critical heritage, one which demands appraisal of the structures and actions of authority (after Brown 2001). What is enacted through this usage of the heritage of the Great War is a bulwark against the abuse of power; the conflict is sought out as a means of ensuring governments fulfil their assumed obligations towards the body politic and to not neglect their responsibilities for the care and provision of their citizens.

Lions led by Donkeys: The Suffering Soldier and the Incompetent Officers

Perhaps one of the most familiar aspects of the First World War which is a 'truth' known by individuals and communities throughout Britain is that it was a military failure (see Corrigan 2003, Griffith 1994). The General Staff of the British Army are assessed as being tactically inept, geared towards cavalry rather than mechanised warfare and unaware of the situations encountered on the ground by front line troops (see Terraine 1980). This perception of the inadequacy or even the incompetence of the General Staff during the conflict is a well-rehearsed aspect of the 'popular memory' of the Great War (see Bond 2002: 15). Indeed, historians who seek to revise this understanding of the war have considered this particular aspect to be the most enduring (Sheffield 2002: 8). Whilst overt criticism of the actions of the military authorities during the First World War was not readily

forthcoming during the conflict itself, a number of individuals did make pleas for an end to the suffering of soldiers on the front lines. Most notably, Siegfried Sassoon in *A Solder's Declaration* published in 1917, spoke 'on behalf of those who are suffering now' (Sassoon 1937: 481).

In the post-war era, a number of memoirs of politicians and veterans sought to indict the Generals of the British Army for their decisions which were thought to have led to the high death tolls during the conflict. The principal target in these denunciations was Earl Haig (1861–1928), Field Marshal of the British Army from 1915 and one of the chief architects of the British Imperial and the Entente's military engagements on the field of battle. Chief among Earl Haig's detractors was the wartime Prime Minister Lloyd George who damned the actions of both Haig and others in the General Staff for the deaths of thousands:

> Millions of the picked young men of the nation were placed at their disposal. More than half of these millions were either killed or wounded, too often in the prosecution of doubtful plans or mishandled enterprises. Generals demanded more millions not only to fill up gaps thus caused but to increase further the numbers under their direction (Lloyd George 1936: 2033).

Similarly critical depictions of the General Staff in the memoirs of Robert Graves and Siegfried Sassoon, as well as assessments by military scholars such as Basil Liddell Hart (1928, 1930, 1934) assisted in the creation of a public impression that the General Staff pursued strategies that were tactically deficient and which resulted in large numbers of fatalities. These accounts also lambasted the politicians for their role in sending men to the 'slaughter' of the Somme, Passchendaele of Gallipoli. Therefore, the perception of a bungling, incompetent military and negligent political class has come to dominate the understanding of the conflict. This is most aptly summarised in the phrase 'lions led by donkeys', which at once established the heroism and victimisation of the ordinary ranks and the asinine nature of their so-called 'betters'. Indeed, the expression has been used so frequently that it almost appears as a catch-all definition of the war itself.

Despite this prominence, those who would seek to revise this understanding of the war have highlighted how the idea of 'lions led by donkeys' and that of the inadequacy of leaders, both political and military, is a historical myth (see Corrigan 2003). In part, this position rests on the outcome of the war, that the British Army was successful in the field (Sheffield 2002, Todman 2005). Proponents of this view also point to the developments both tactical and technological that occurred during the four years of war. In this manner, the General Staff of the British Army are not the inept products of a rigid class-system that promoted on the basis of association and family rather than on ability, but skilled individuals working in difficult circumstances. The notion of the inability or inadequacy of officers is dismissed in these assessments as the product of inaccurate post-war representations borne out of the 'disillusion' experienced by veterans and recorded in their memoirs. The phrase 'lions led by donkeys' is also regarded as an unfortunate historical

inaccuracy, as it supposed origins from a comment made by the German General Erich Ludendorff (1865–1937) have never been verified. In fact, the popular usage of the phrase has often been credited to the work of Alan Clark's (1961) *The Donkeys*. However, despite the debunking of this myth, the notion of official incompetence and the heroism/victimisation of soldiers, which is aptly summarised with the phrase 'lions led by donkeys', is still current across society within Britain. Whilst depictions of the buffoonery of the General Staff is a well-established trope within film and television, most notably within the original stage production of *Oh! What a Lovely War* (Theatre Workshop 1965), which featured a vastly incompetent Field Marshal Haig, as well as the fictional character of General Melchett in the series *Blackadder Goes Forth* (1989), the myth of 'lions led by donkeys' has been maintained within society for its utility. Within political, media and public discourse this 'myth' operates to provide individuals, groups and communities with a means of censoring and critiquing the operation of power. As such, the myth has become an accepted 'truth', a key part of the heritage of the Great War in Britain, as it frames current fears and concerns and enables the present to be outlined by the past.

Such is the prevalence of the myth of 'lions led by donkeys' that it is regularly rehearsed within the political sphere, both in direct relation to the Great War but also to draw attention to a perceived incompetency in authority. The myth serves as a tactical retort to castigate officials for their policies which are presumed to have led to a wholehearted failure. Indeed, politicians in opposition to the government of the day can be seen to regularly employ this accusation of mismanagement for a variety of issues. For example, in a 2006 debate about agricultural reform in the House of Lords, official branches of government were ridiculed by opposing politicians through using the myth. In this debate, far removed from any military discussion, Lord Inglewood (Conservative Peer) stated:

> Sometimes in debates about the shortcomings of the system, we have not put on record the fact that a lot of people have been working very hard to try to administer something that has got completely out of control. Sometimes I am reminded about the troops in the First World War being "lions led by donkeys" (HL Deb, 16 November 2006, c73).

Similarly, the myth was deployed in a debate of 2006 by opposition members within the Scottish Parliament to chastise government officials for their short-sighted decision to maintain nuclear weapons at the naval base of Faslane, located on the west coast of Scotland. John Swinburne (Scottish Senior Citizens Party) called upon the myth to draw allusion to the contemporary incompetence of the authorities:

> After the First World War, people talked about lions led by donkeys. The MOD is the ministry of donkeys – I am talking not about the politicians but about the

civil servants and the military people who drive them on and tell them what to say (SP OR, 28 September 2006, S2M 27972).

The uses of the myth in these circumstances is significant; it not only demonstrates the conversion of 'myth into reality' but evidences how this perception is mobilised to provide context and meaning regarding contemporary concerns by all political elements across Britain. Both sides of the political divide can be seen to rely on this myth as they seek to undermine confidence in the government of the day. In a debate in Parliament regarding the London Metropolitan Police Force and their leadership decisions, Andrew MacKay (Conservative, Bracknell):

> ... referring to the generals in the First World War and the wonderful soldiers in the trenches, because our ordinary police officers risking their lives and well-being on the streets of London daily are "lions led by donkeys". I very much hope that there will be major changes at the top of the Metropolitan police force (HC Deb, 18 December 2008, c1288).

The utility of the myth is that it enables the heritage of the Great War to be deployed to colour and inform current fears. It serves as a means of assessing and critically engaging with authority. As such the myth operates in this political sphere as a response against the incompetency or abuse of power. The outlining of contemporary issues with the 1914–1918 conflict operates as a means to accentuate and embellish, to highlight the connections between the present actions of authorities and an accepted 'truthful' account of official ineptitude in the past. Whilst this utilisation of the heritage of the Great War can be assessed within political discourse, it also features heavily within the wider media. References to the poor planning and tactical naivety during the conflict can be located within newspaper coverage during Remembrance Sunday or in discussion of a particular aspect of the conflict. The myth has an unquestioned place within these accounts as the phrase or the sentiment of 'lions led by donkeys' forms a central part in reporting the war for all political leanings:

> 'Lions led by donkeys,' they were later called – the donkeys being the Establishment of the officer corps which had by now taken over. World War One was a Titanic a day. Those responsible should have been court-martialled and shot for criminal incompetence (Forsyth 2012: 15).

However, whilst explicit references to the war are made with the phrase, it is employed for wide variety of causes within public life beyond that of the Great War itself. For example, the failures of the authorities to provide adequate services for the victims of the terrorist bombing of the 7 July 2005 were highlighted in *The Sun* newspaper through this First World War reference:

> Survivors of the 7/7 bombing atrocities have accused the Government of
> abandoning them. They claim red tape hampered the rescue, saying firefighters
> and paramedics were lions led by donkeys (Moult 2007).

Such is the evocative power of this myth and its malleability that it can also
be applied without any sense of incongruity to issues within the wider public
service as it reveals a particular 'truth' regarding the operation of authority whilst
emphasising the 'victim' status of those who are forced to bear this apparent
ineptitude:

> I sometimes think we have lions led by donkeys in the NHS – too many decisions
> made by too many people who know nothing about the reality of mental health
> (Butler 2009: 21).

Therefore, the myth functions in this media arena in a similar fashion to that of the
political sphere, acting as a means of calling those in power to account but also
focusing on the 'victim status' of those who suffer the effects of a government's or
organisation's indifference. This concentration on the perceived victims is significant
as it provides a highly critical agenda to emerge. This sentiment is expressed
most clearly within left-wing sources in the media, as the frame of 'lions led by
donkeys' is used to expose official hypocrisy, the suffering of the working classes
and the indifference or incompetence of a ruling political elite. Therefore, socialist
commentators draw upon the phrase and the idea to state incredulity towards the
governing elite:

> The old adage that they were lions led by donkeys is accurate. The lions are still
> here, but I'm afraid so are the donkeys (Anon 2012c).

> Truly, the working-class movement in Britain is like the troops in the First World
> War: 'lions led by donkeys' (Taaffe 2009: 8).

Indeed, the theme of incompetent generals and a victimised working class is to be
located so frequently within the left-wing media that it is often criticised as a clichéd
motif of the left's political opinion (see Todman 2005: 203). Whilst revisionist
historians have often cited how this 'myth' of the war has been propounded by
socialist agendas, this fails to recognise the utility of both the expression and the
strength of attitude placed within the idea of 'lions led by donkeys' for both the
left and the right of politics in Britain. Certainly, far from being the preserve of a
left-wing interpretation of history, in keeping with the place of the critical agenda of
the heritage of the Great War, the 'myth' serves as mode of communicating dissent
towards the governing classes from all sides of the political spectrum. This is to
be most clearly noted in the reportage of the wars in Afghanistan from 2001 and
from Iraq from 2003 (after Hoskins and O'Loughlin 2010). As the conflicts in both
these arenas became ever more costly in both human life and public expenditure, the

expressions of mismanagement and incompetence using the frames of reference of the Great War were frequently mobilised (after Wilson 2008a).

From the outset, both the Afghanistan and Iraq campaigns were framed by both left and right elements within the media using the context of the Great War and the assessment of 'lions led by donkeys'. In this mode of representation, for those who were sceptical of official policy, the incompetency of the politicians who led the country into an unnecessary conflict and sent young men and women to die in a foreign war provided a direct correlation with the events of 1914–1918 (see Harman 2008). Indeed, the reporting of the conflicts and their aftermath was frequently implicitly or explicitly framed within the heritage of the Great War. The questioning of the motives for war, the perception of 'lying politicians' and the deaths of a young section of society in combat brought a greater critical focus to the coverage of the war from all sections of the media (see 'Tony Blair "misled" country over Iraq war, parents of dead soldiers tell inquiry' (Adams 2009), or, 'Families of dead soldiers threaten Blair with court' (Norton-Taylor and Watt 2005:7). However, it was with the accusation that the British Government had neglected their troops by providing faulty equipment or not enough equipment, thus placing soldiers' lives at risk, which drew the greatest comparison between the current conflicts and the war of 1914-1918. In these circumstances, the serving soldiers in Iraq and Afghanistan were portrayed as victims of an incompetent authority whilst the tag of 'lions led by donkeys' was rehearsed as both a phrase and a sentiment (see 'Lions led by Donkeys' (Brady 2004b: 21), '10 years of lions led by donkeys' (Galloway 2011c: 8) and 'Lions led by donkeys ... put in pigsties' (Moore 2009). What was significant about this usage is that encompassed sections of the media from both the right and the left as the wider utility of the expression as a means to disrupt and challenge authority was realised:

> Major General Sir Evelyn Webb-Carter invoked the phrase often used to describe the failures of the First World War to brand the past decade's policy in Iraq and Afghanistan as one of betrayal (Jeeves 2008: 10).

> That powerful phrase 'lions led by donkeys' – the German view of British troops in World War I – keeps springing to mind when studying Afghanistan (Alexander 2012: 12).

The censoring of authority through the framework provided by the Great War is a tactic which is drawn upon by all aspects of society and this usage thereby confirms the way in which this particular aspect of the heritage of the First World War operates across Britain. Rather than merely being a tool of left-wing politics to foster class dissent within society, the claim of 'lions led by donkeys' and the myth of official incompetence leading to the suffering of others is one which is utilised for a variety of groups. Despite the differences of agendas, the function and utility of the myth remains the same; to examine and critique structure of authority and to place them accountable for the body politic. In this role, the heritage of the

Great War operates as a significant aspect of contemporary society across Britain. It serves as a rebuke against overwhelming power and requires that the structures of democratic governance are questioned and assessed.

The now familiar retort that the politicians and generals of the First World War were 'butchers and bunglers', or that soldiers were 'lions led by donkeys', which is so often derided as a 'myth' by revisionist historians, therefore, constitutes a vital part in the functioning of society. This is the cultural heritage of the Great War in Britain, a collection of viewpoints, perspectives, images and phrases that serve as a means to critically frame contemporary issues with the events of 1914–1918. The phrase 'lions led by donkeys' is a direct challenge to authority, an appeal for the recognition of the impact of authority on the lives of 'ordinary' men and women. It is, therefore, perhaps unsurprising that it was of direct relevance in the consideration of critiques against the wars in Iraq and Afghanistan at a local and at a national level:

> What a senseless waste of more lives than will mean. And apart from the deaths hundreds of young men and women will return home from the battlefields physically and mentally maimed for life. And after all the years in Afghanistan force will have achieved nothing. Lions led by donkeys spring to mind! (Anon 2012d: 9).

This part of the historical myths of the Great War is not the preserve of the left or the right; rather it is an aspect of the heritage of the conflict in Britain which is mobilised to demonstrate opinion and challenge authority.

Mud, Blood, Rats, Gas and Disillusion: The Great War as the 'worst war'

A presumed certainty when considering the events of the Great War, especially those of the Western Front in France and Flanders, is that the conditions which were faced by troops were one of unmitigated suffering (see Todman 2005). The 'mud, blood, rats and gas' perception of the war as the worst conflict ever experienced is deeply ingrained within the heritage of the First World War across Britain (after Bond 2002, Corrigan 2003). The war of 1914–1918 assumes the role of the exemplum of the horrors of unrestrained, industrialised war. This constitutes another 'myth' of the conflict; that it was unparalleled in its ferocity and devastation and those who saw service at the front were marked by this 'baptism of fire' as distinct and different (see Bracco 1993). This perception was reinforced in the 1930s, as writers influenced by the war poets and especially Siegfried Sassoon and Wilfred Owen, but too young to have fought in the conflict, contemplated their experience of 'missing out' (after Tate 1998: 8–10). Literary figures such as George Orwell (1903–1950), W.H. Auden (1907–1973), Christopher Isherwood (1904–1986) and Graham Greene (1904–1991), all remarked on this peculiar character of their interwar generation which valorised

those who had served in the Great War. Orwell (2000: 537) recalled how he felt a little 'less of a man' for having not seen action, whilst Greene (1980: 37) stated the profound sense of under-achievement which he and his peers experienced on hearing stories of the previous generation's endeavours. This contributed to a sense that Britain's sacrifices during the First World War were pre-eminent; that young Britons had fought in the most horrendous, unimaginable conditions and the nation had suffered incomparably for their loss (Dawson 1990, 1994). Terraine (1980: 122) described this aspect of the understanding of the Great War as leading to the impression that the conflict constitutes a 'private British sorrow'. Indeed, this understanding constitutes another 'myth' of the First World War across Britain, a sense of unparalleled suffering in a brutal, unsurpassable conflict.

This perception of the war has been challenged by historians over the last two decades as they seek to alter the perception of the conflict as a 'tragic waste'. These revisionist works highlight the eventual victory of the British Army in the field, the wide variety of experiences within the armed forces and the impact of the war on the whole world not just within Britain. Within these accounts, historians have highlighted the nature of the war as a global conflagration and one where Britain was a smaller partner in the military alliance of the Entente (see Morrow 2008). Indeed, the losses experienced by Britain were substantially less than those of France, Russia, Austria-Hungary or Germany, who lost over a million military personnel each during the war. In fact, the total death toll of combatants in the conflict numbers over ten million, whilst civilian deaths which occurred as a direct consequence of military action and occupation total over six million. These statistics, combined with the effects of the Spanish Influenza, which spread across the world killing nearly twenty million people immediately after the cessation of hostilities, could place the losses of Britain and its experiences in the conflict into a far wider perspective (Bond 1991). The focus on the battlefields of the Western Front is also disputed by revisionist historians as they highlight how the conflict was not solely confined to northern France and Flanders, but fighting occurred across Europe, the Middle East and East Africa. Indeed, the bitter fighting in the Italian Alps between Italian and Austrian-Hungarian soldiers who faced extreme environmental and material privations would appear to represent the very worst aspect of the conflict (see Thompson 2008). However, despite this evidence to the contrary, the primacy of the horrors experienced by British soldiers on the Western Front is affirmed across society. The reason for this seemingly myopic viewpoint is usually assumed to be the product of an insular and inaccurate media portrayal that focuses upon the 'British experience' of the 1914–1918 war (Badsey 2001, 2002, 2009). Rather than dismissing this as another ahistorical 'myth', the utility of viewing the war as 'the very worst' is considered as a means of promoting and elevating ideas and values.

Although criticised as historically inaccurate, the representation of the First World War as an industrialised Armageddon can be located across popular, media and political discourse (see Korte 2001). Indeed, acknowledgements of the

'mud, blood, rats and gas' faced by soldiers is a common occurrence in both the media and political spheres during commemorations and also debates regarding the events of the Great War (Wilson 2008a). For example, in a discussion of the proposed development of an airport in the Somme Department in France in 2002, members of the Northern Ireland Assembly recalled the conditions of the battlefields as one of 'unimaginable horror', a maelstrom of almost unspeakable suffering. Fraser Agnew (Ulster Unionist Party, Belfast North) drew upon this established imagery:

> As a result, those soldiers, weakened by war, underfed and undernourished, sank to their knees in the mud and fell to the ground face down. Many of them drowned in a sea of mud ... (NIA OR, 22 January 2002, 27-01).

This representation serves a distinct purpose, whilst emphasising the victimisation of the troops as discussed in Chapter 3, it also preserves the war as unique and different, a vital means of maintaining the critical nature of the heritage of the conflict (after Žižek 2002: 272). The affirmation of the conflict's 'disastrous' nature can, therefore, be located within political discourse as its status as the 'worst war' ensures its utility as a means of framing contemporary issues. The necessity for stating the 'horrors of the First World War' is therefore bound to the way in which the heritage of the conflict is mobilised in the present:

> 9/11 has become, at least for now, the twenty-first century's defining moment, but no one who grew up in the twentieth century can escape the numinous power of 11/11, Remembrance Day and its incredible iconography. 9/11 is a *Dies Irae*, but 11/11 is an entire requiem (McCrum 2002: 23).

Within this myth, the battlefields of the Great War provide a typesite, a place where the excesses of warfare in general, its cruelty, its barbarity and its futility are realised. The trenches of the Western Front thereby acquire an epistolary nature, stating the dangers of conflict generally and its inhumanity. Indeed, such is the repetition of the 'horror' of the trenches that it might be regarded as a truism. See, 'Boy, 12, was youngest British soldier in First World War' (Henry 2009), or, 'The flesh of the men and horses was mixed up ...' (Coles 2010: 8). This was perhaps confirmed with the statement issued by Prince William, Duke of Cambridge in his capacity as Patron of the Imperial War Museum Foundation which referred to the 'horrors' of a war 'which was a terrible chapter in our history' (see Prince of Wales 2010). Regardless of the frequency in which the Great War is referred to as demonstrating the 'horror' and the 'futility' of war, its status as the prime example of modernised warfare is reaffirmed in this usage. This is significant as the place of the heritage of the Great War as a medium of critical expression towards power and authority is provided through its acknowledgement within Britain as the 'worst war'. For example, see 'Why these deaths hit home as hard as the Somme',

the journalist Robert Fisk's (2009b) assessment of the recent conflicts in Iraq and Afghanistan:

> In its savagery, scale and sheer waste of human life, World War I is still fascinating, thought-provoking stuff (Collett 2008: 13).

> Diaries written by men at the front have revealed the true horror of the slaughter faced by North-East servicemen in the Belgian trenches (Anon 2003c: 8).

Indeed, the 'slaughter' or the 'horror' of the trenches, the perversity of the mass death that occurred on the battlefields of the First World War, is the point from which dissident or critical perspectives emerge. Because of the scale of loss, its presumed place as the 'worst' example of conflict the war is utilised as a frame through which to criticise, condemn and campaign. For example, the decision taken by a Labour Government to send troops to participate in the military engagement in Iraq in 2003 was placed within a critical context by leftist elements using the 1914–1918 conflict to assess the ability of the party to speak for the working classes. In 2003, the *Socialist Worker* compared the modern-day military operations, supported by a Labour Government, with the 'hell' of the Western Front, also supported by some Labour Parliamentarians:

> Labour leaders went on to urge workers from Britain to slaughter workers from Germany in the hell of the trenches (Anon 2003d: 13).

However, the place of the Great War as the example above all others of the 'horrors' of conflict is not a subject reserved for left-wing critique. Broader political ideas also draw upon the 1914–1918 heritage as a means of demonstrating or encouraging critical viewpoints. For example, in 2008, a report in the conservative newspaper, the *Daily Telegraph*, regarding a school trip to the Western Front battlefields, used the 'myths' to critique the policies of the Labour Government that had led the country to war in Iraq and Afghanistan:

> They spent the coach trip home debating the rights and wrongs of the slaughter in the trenches and of the wars in Iraq and Afghanistan that some of them have brothers and cousins fighting in (Meo 2008: 21).

In this manner, the referencing of the 'mud, blood, rats and gas' myth of the First World War, of the conflict as unremitting 'hell on earth', serves as a means through which the place of the conflict cannot be discredited (after Scarry 1985: 9). The heritage of the war, located within this historical myth, is therefore one of a 'lesson', comparable to a religious instruction or morality tale. Framing the conflict as supreme example of the folly and revulsion of modern warfare elevates the conflict to an incontestable status (after Nora 1989: 10–12). The

Great War therefore provokes questions regarding the scale of death, decision-making and the structures of power that led to the participation in the conflict:

> Why did a Western world that was beginning, for the first time, to respect and value individuals, pour them into its new mincing machine of military-industrial power? Why did an educated population stand for it? (Lichfield 2006).

This is certainly not a contemporary phenomenon, previous generations have also sought to rely on this heritage of the First World War to demonstrate political points and to critique authority, gaining validity from the perception of the 1914–1918 conflict as the most abominable slaughter experienced (after Ashplant et al. 2000). For example, in 1972, to combat rising inflation, the British Conservative Government introduced pay and price freezes across society, an increasingly desperate strategy which had also been employed by the previous Labour Government. Despite the lack of immediate correspondence with military affairs, it was through this myth that this political response was likened to the events of the First World War. Christopher Tugendhat (Conservative, London and Westminster) stated that:

> ... when one hears people talking about previous freezes one is reminded of the military strategists of the First World War, those gentlemen whose troops were permanently stuck in the mud, who constantly reverted to the big set-piece battles of the Somme and so on, who gained a few yards but then quickly lost the ground which had been taken (HC Deb 7 November 1972 c. 823).

The almost obligatory reference to the 'mud' of the battlefields also reinforces the perception of the atrocious conditions of the war which was wrought upon the combatants. The 'sea of mud' in which soldiers lost their lives is cast as a nightmarish arena in which the horrors of industrialised war are relayed repeatedly within the contemporary media (see 'Royal tribute to Passchendaele dead' (Anon 2007e), or, 'We go tomorrow' (Bostridge 2006). The 'mud' and 'blood' is also a feature of popular representations of the conflict, which emphasises the apocryphal status of the First World War as the 'worst war'. For example, references can be found in the British heavy metal band Motörhead's (1991) song *1916*; 'And I lay in the mud / And the guts and the blood'. Similarly, the band Iron Maiden (2003) also referenced this aspect of the war in their song *Passchendaele*; 'drowned in mud, no more tears, surely a war no one can win'.

Associated with this myth of the war is another interpretation of history that the horrendous conditions at the front resulted in the widespread disillusionment of the soldiers (see Eksteins 1989, Fussell 1975, Hynes 1991). Within this myth, troops endured the privations of the conflict heroically and stoically but the consequence of this endurance was an alienation from society. Historians have debated the accuracy of this assessment, regarding the lack of mutiny or

dissent within the British Army as evidence of a civilian army which was largely supportive of the war aims and the pursuit of victory (see Gregory 2008). The origins of the 'disillusionment' school of thought are considered to emanate from the literature of the 1920s and 1930s, when an educated officer class, observing the economic and political troubles of the interwar period, looked back to their wartime experiences with a degree of cynicism (see Montague 1922). Fussell (1975) described this as the advent of an 'ironic age' where such concepts of 'patriotism', 'sacrifice' and 'glory' became crudely synonymous with the mass death that occurred on the battlefields. However, historians have been quick to point to the memoirs and diaries of veterans of all social classes which highlight the experience of wartime not as a steady process of disenchantment but one which left a favourable impression (see Edmonds 1929). Despite these efforts, it is the alienated soldier suffering in the trenches, rejecting the highfalutin ideals of a political and military elite, which remains an integral myth of the Great War across British society.

The deployment of this myth can be noted in the coverage of the death of Harry Patch, the last 'Tommy' who promoted a personal anti-war sentiment, as the horrors of war and the rejection of violence was reiterated in the context of the involvement of the British Army's continuing engagement in several theatres of war:

> How strange it is to be marking the death of Harry Patch, the last straggler of
> the First World War, in the same week that we see yet another sad procession
> of coffins come home from Afghanistan (Hitchens 2009: 23).

Indeed, the example of the last veteran was taken as a means of critiquing the involvement of the British Army in Afghanistan and Iraq by some sections of the media. For example, see 'Had we listened to Harry Patch, we would not still be in Helmand', (Riddell 2009). The employment of this aspect of the heritage of the conflict can be seen within left-wing or socialist interpretations as it is activated to refute the presumed ideals of the bourgeois nation-state:

> It is appropriate that the last survivor of the First World War should have been
> someone who used his longevity to speak of the horror and pointlessness of
> that war ... Patch deserves recognition and respect as someone from whom
> it elicited a human understanding rather than nationalist or militarist hatreds
> (Robinson 2009).

The 'disillusion' suffered in the trenches, therefore, serves as a rallying point as it indicates the failures of authority and the rejection of the limitations of democratic government (after Brown 2001). As such, it provides another aspect of the critical, anti-democratic heritage of the First World War as it challenges policies and values of administrations.

Conclusions

The 'myths' of the First World War have become the object of ridicule and incredulity amongst revisionist historians as these scholars seek to alter the presumed 'incorrect' perception of the conflict within Britain (see Gregory 2008). The way in which society seemingly clings to the 'debunked' myths and memory is frequently presumed to result from the misrepresentation of the war through the media and a vapid consumption of these products by an incredulous public (after Badsey 2002). This approach obscures the nature and use of myths within society. Far from being misapprehensions, the myths 'that society lives by' form essential means of communicating attitudes and perspectives (see Samuel 1989). Myths in this respect are part of a cultural heritage, demonstrating how the past is used to frame and outline issues in the present (after Neal 1989: 6). Myths operate to provide an understanding or a context to contemporary situations in order to draw attention to issues and to structure responses. With regard to the Great War, the myths of the 'lost generation', of 'lions led by donkeys' or of 'mud, blood, rats and gas', constitute a significant part of the heritage of the conflict in Britain. The myths serve as a means of activating ideas and mobilising opinion as part of the critical legacy of the 1914–1918 war. The myths enable an oppositional viewpoint towards authority and governance, critiquing the operation of power and right, both politically and militarily within Britain. Such criticism does not belong solely to one political agenda or another, rather the uses of this heritage of the Great War are mobilised by politicians, the media and the wider public of varying political hues and values. What is common within these utilisations of the 'myths' of the war is its ability to call current structures of authority into account, to limit or rebuke the excesses of power and to demand alterations within society. As such, the anti-democratic nature of the heritage of the Great War is affirmed; with the legacy of the conflict serving as a barricade and protection against the operation of power.

Chapter 6

Museums, Memorials and Memory – Remembering the Great War

The intangible heritage of the Great War provides frameworks through which society can talk about, imagine, consider and utilise the events of 1914–1918 as a means of commentating on the past but also current issues. Alongside this legacy of the conflict are the tangible effects, the museums and memorials that commemorate and represent the Great War to contemporary populations (see Gregory 1994, Kavanagh 1994, King 1998). The memorials to the war are a feature of cities, towns and villages across Britain (see Boorman 1988). The names of 'the fallen' generation are a notable part of the urban landscape and as such they form a significant part of the heritage of the conflict (Moriarty 1999). Memorials and monuments have been the object of a great degree of study, particularly over the last three decades, as a greater interest in social and cultural history of the war has emerged (see Bushaway 1992, Heffernan 1995, Moriarty 2007, Winter 1992). However, these studies have taken as their subject the origins and development of local and national war memorials, rather than the contemporary perspectives or indeed the more recent memorials to the dead of the war. Such assessments neglect the ways in which these materials structure attitudes and ideas in the present regarding the war and serve as frames of reference for contemporary populations (after Iles 2008a). Similarly, the museums that represent the war, displaying the artefacts and documents of the conflict and the personal stories of those at the front and those at home, have also been extensively examined on a range of issues, from their ability to communicate the violence of the conflict to the social and political issues that enabled their development (see Kavanagh 1988, 1994, Whitmarsh 2010). However, the absence of a contemporary perspective is also noticeable in this field, as the ways in which museums structure exhibition content and organise perspectives for visitors is also apparent in its absence (after C. Winter 2009, 2012). How present-day visitors use these materials, both in the museum but also through online exhibitions and digital archives, to outline values and associations concerning the past and the present, is, therefore, the object of concern within this chapter. Associated with both these concerns is the manner in which the war is remembered, at a local, regional and national level, as a means of establishing moral, social and political identities. This can be observed through the current memorialisation of the 'Pals Battalions', military units who were recruited from neighbouring areas or local professional groups in the early stages of the war to engender morale within the army. Combined, these areas of study reveal the ways in which the heritage of the Great War is constructed through tangible means to address current agendas and concerns.

The wider study of memorials and museums, and the ways in which they structure or frame aspects of the past, remains a major area of inquiry within heritage studies, history and archaeology (See Moore and Whelan 2007, Williams 2003, Young 1993). These assessments have demonstrated how the material environment provides a means to remember through; it acts as an instrument to alter ideas and perceptions through a process of 'mediated action' (Wertsch 2002). Individuals and groups, therefore, use these objects or cultural forms in an active manner, within the context of social and political issues, which possesses implications for identity and the recognition of others. These cultural forms, whilst possibly representing particular narratives regarding the past, provide frames in which societies themselves forge alternative, dissonant or indeed affirming narratives (Wertsch 2002). The uses of these objects as a means of outlining the present, drawing associations and implications for social, cultural and political identities is particularly significant in the study of the heritage of the Great War in Britain. Since the cessation of hostilities these objects, museums and memorials, have been used to both communicate the ideals and values which were associated with the war; of dedication, sacrifice and duty to the nation, the principles propounded by both the government and regional authorities, to the waste and futility of conflict, as associated with pacifist and anti-war campaigners (see Bushaway 1992, Heffernan 1995). In this manner, their ability to be used within a process of 'mediated action' is quite apparent, as they comment on issues and interests that are pertinent both for the past and the present. By examining how the museum and memorials frame and structure the memory of the Great War and how these outlines are mobilised in the present, this chapter will assess how museum exhibitions and displays, both national and regional, both virtual and real, represent the war to their audiences and how in turn these are used by audiences (after Lang et al. 2006).

Museums: The Display of War

The museuological representation of the Great War in Britain has a detailed history which is rarely acknowledged (see Kavanagh 1988, 1994). Beginning with the Imperial War Museum, founded in 1917 with the express aim of preserving the sacrifice of the soldiers of the army of the British Empire, the war has been relayed to the public through a variety of guises (see Kavanagh 1994). After the ending of the conflict, the Imperial War Museum was joined by a variety of local, regional and regimental museums which also sought to collect and display objects to maintain the memory of the war in the public's consciousness. Whilst, these institutions have been accompanied by other museums and galleries from the Armistice to the present and the means of representing the war have been updated and altered in line with shifting concerns and alterations within society, the thesis to protect or safeguard the events of the 1914–1918 conflict remains constant (Kavanagh 1994: 10–12). These institutions thereby place themselves within the traditional museum context of the purveyor of education to the public for their betterment and

for the good of wider society (see Bennett 1995, Walsh 1992, Witcomb 2003). The museum rendering of the war to the public, therefore, mirrors many of the concerns and issues surrounding exhibition politics and practice, not just with regard to the display of objects of war and the circumstances of mass death, but with regard to the role of the museum within society (see Knell et al. 2007, Macdonald 1998). Therefore, by examining the content of exhibitions and the perspectives provided by institutions across Britain with displays of the conflict, the manner in which the heritage of the conflict is used in the present can be observed. Indeed, the place of online and actual exhibitions regarding the war can be examined as evidence of how the war is placed and perceived within contemporary society, as visitors become 'witnesses' to the effects of the conflict in the past and the present. The perspective of the 'witness' has already been explored in Chapter 4, through the commemorative actions and events in Britain. However, it is also developed within contemporary museum displays and exhibitions. Indeed, the museological display of the conflict prepares visitors as 'witnesses' to the war, but as witnesses the testimony taken from these displays can be used for a variety of purposes (after Williams 2007, 2011).

The construction of the 'witness' perspective within museums in Britain that depict the Great War can be noted in a range of exhibitions, from the national institutions to the regional museums, libraries and archives. This mode of viewing the war is created through the arrangement of objects, spaces and texts within a display space (after Macleod 2005). Whilst institutions vary in size and the extent of their collections, this common viewpoint of 'witnessing' the war is noticeable across many of these institutions in Britain (Espley 2008). This perspective can be identified in the predominance of the recreated 'trench' system, used in institutions as a means to display artefacts and inform visitors about the costs of war both at the front and at home (see Walsh 1992: 92). In these examples, recreated trenches are used as a space through which visitors can move through and engage with the history of the conflict. As such, visitors are placed within the context of the witness, they are asked to observe the events of the conflict and bear the 'truth' of the war in the present (after Williams 2007). Such a perspective orientates the visitor within a particular moral, political and social viewpoint, as it requires individuals to 'carry the burden' of memory. The most notable example of this usage of space and objects is the Imperial War Museum's recreated trench scene known as the *Trench Experience* which details the sights, smells and sounds of the Western Front as a British Army raiding party prepare to launch their mission (Foster 1990). Launched in 1989, the exhibition provides a walk through the trenches, where visitors can observe the materials, contexts and sights of the battlefields. The exhibit was intended to emphasise the 'reality' of the war, to remind visitors of the conditions experienced by soldiers:

> Everyone who goes through the trench comes out with a better understanding
> of what it must have been like to live and to fight in such appalling conditions
> (Borg 1991: 6).

The scenes of war are replete with Tommies sharing cigarettes, large 'trench rats' and observation posts with periscopes where the enemy lines can be viewed in the distance. The exhibition, therefore, immerses the visitor in the representation of the war, a representation that specifically does not engage with the poignancy of the conflict or the recognition of victims. However, despite the historical accuracy and the determination to remain apolitical, the exhibition nevertheless provides visitors with the role of the witness, asking individuals to observe the conditions of the war and assume the responsibility for holding this event in the present. In this manner, 'the trenches' serve as a useful educational device, their malleability as a route or experiential space enables the institution to instruct audiences in their duty to remember. The *Trench Experience*, therefore, fulfils the original detail of the Imperial War Museum to protect the memory of the sacrifice of those who died in the conflict (Kavanagh 1994: 5–6). This objective is enabled by using the 'trenches' in this respect, rather than mobilising the 'view from the trenches', a potentially dissonant perspective, the 'witness' perspective provides a degree of malleability within its political message (see Williams 2007: 8–10). To be a 'witness' can carry a normative role, as observed with the commemorative actions associated with Armistice Day, where a common expression of values and ideals is required, however, it also provides individuals with a moral and ethical stance as it ensures that witnesses are responsible for the carrying of the past into the present and testifying as it its impact (see Booth 1996: 16).

This mode of 'witnessing' the Great War within contemporary museums can be identified in other exhibitions and displays. In the National Army Museum (2012), located in Chelsea, London, a permanent exhibition features a variety of displays of the conflict, including a reconstructed dug-out. Within this structure, visitors can observe the material environment of the battlefields of the Western Front, with the cramped confines of the wooden bunker sheltering men from the maelstrom of war, demonstrating the conditions of the conflict. The perspective of the witness is reinforced in this manner as visitors are placed as 'eyewitnesses' to the conflict through replicas of the trench system. The Royal Engineers Museum in Chatham, Kent, also uses an immersive 'trench experience' display, to instruct visitors in the every-day life of engineers or 'sappers' on the front. Similar reconstructions abound within local and regional museums across Britain. For example, the Museum of Lancashire in Preston reopened in November 2011 with the display *Lancashire at War*. The display consisted of a long stretch of communication trench, with details of fire-steps, gas alarms and original artefacts; with a fully immersive experience, visitors can experience the sights, sounds and smells of the Western Front (see Figure 6.1). The exhibition detailed the lives and experiences of the soldiers from Lancashire, as visitors are required to observe the events of the war and their effects on individuals both at the front and at home. The same usage of reconstructed trench systems can be found at the Museum of Liverpool Life, where the *City Soldiers* gallery houses objects of the war, audio-visual displays of the front and uniforms of the troops, all within a section of reconstructed trench. Once again, the material environment of the front is provided to visitors

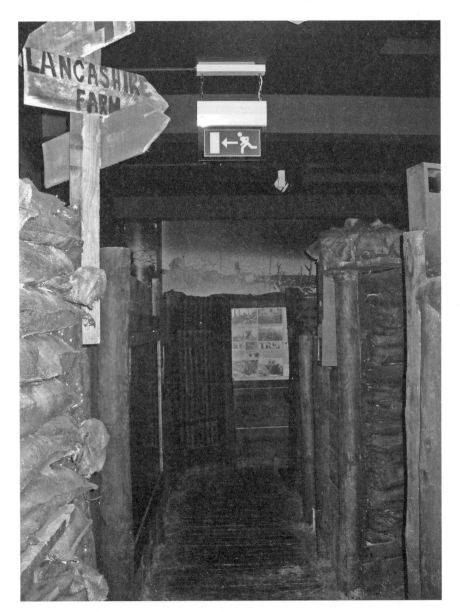

Figure 6.1 Recreated trench at the Museum of Lancashire, Preston

as evidence to witness and to then hold these truths as a means of preserving the events of the conflict in the present.

The Tank Museum in Bovington, Dorset, is perhaps one of the best examples of this usage of reconstructed trench systems to instruct visitors in the necessity of

maintaining the memory of the sacrifice of the soldiers. The 'Trench Experience' is a detailed exhibition using the trench structure that leads visitors through the life of the soldier from recruitment in Britain, through the reserve lines in France and Belgium, to going 'over the top' into no man's land to attack the German trenches; thereby detailing the life of the ordinary infantryman. Such an experiential route places the visitor as an observer, an onlooker to the events that are displayed before them as a means of emphasising the occurrence of the war, to demonstrate its significance. In this manner, the 'evidence' is presented to the witness, who is then required to hold these truths to be undeniable (after Booth 1996: 27, William 2007: 15). Similar arrangements of spaces and objects can be observed in the regimental museums across Britain. The Black Watch Regimental Museum in Perth uses a recreated trench scene, complete with sound effects of shell fire, machine guns and the voices of soldiers, to display objects of the war used by soldiers from the Black Watch. The Manchester Regiment Museum, in Ashton-under-Lyne, also uses a mock-up of the trench system to display the conditions of war for soldiers in the 'Manchesters' and allows visitors a chance to see how troops experienced the conflict. The Border Regiment and King's Own Royal Border Regiment Museum in Carlisle uses the trench structure to allow visitors to walk through the war landscape and experience the material surroundings of the conflict.

Recreations of trenches appear to be common within regimental museums, as the same model is also employed in Stirling, within the Argyll and Sutherland Highlanders Regimental Museum. As in other institutions, a 'realistic' reconstruction of the trenches is provided for visitors at the Highlanders museum to understand the precarious nature of life on the battlefield and the difficult conditions on the Western Front. In Derby, the 9th/12th Royal Lancers and Derbyshire Yeomanry Museum also uses a 'small slice' of trenches, with audio-visual effects, to detail the experiences of the Lancers in northern France and Belgium during the Great War. Recreated trench scenes are not just to be found within the confines of the museum, for example, the Staffordshire Regiment Museum in Lichfield built their own trench system in the grounds of the museum. The trench measures over a hundred metres and was named the Coltman Trench, after Corporal William Coltman, a highly decorated stretcher-bearer of the regiment. The trench itself was constructed in the late 1990s to serve as a memorial to Corporal Coltman and all of the soldiers of Staffordshire who served in that war. Indeed, the features of the trench, the fire-step, the dug-out and the look-out post are also named after soldiers from the regiment who were awarded the Victoria Cross. The structure provides school groups and organised parties with the opportunity to walk through the surroundings that would have been familiar to troops from the Staffordshire Regiment. Coltman Trench is also used for 'living history' groups as a place for re-enactment activities and hosts a 'Carols in the Trenches' event during Christmas time. However, the objective of the structure is for the public's benefit and the maintenance of the memory of the war:

The primary purpose of the Coltman Trench is as an educational facility, providing visitors with some idea of the conditions soldiers lived and fought in during the First World War (Staffordshire Regiment Museum 2012).

Whilst not all regimental museums use the 'trench experience' to place their visitors as witnesses, some do use the trench structure itself within their exhibition space. The King's Own Royal Regiment Museum in Lancaster uses the physical space of the trenches to guide visitors through the experience of the Regiment during the Great War. Display cases, models and objects are placed within darkened timber frames and gas lamps hang from the corners to recreate the trench atmosphere as visitors move through the display space. The Cheshire Military Museum also utilises their exhibition space in a similar manner. In their display entitled *World War I and Remembrance*, the main feature of the room is a reconstructed, 'typical' trench system which contains personal items and captured weapons from what is termed 'The Great War for Civilisation'. The structure is intended to educate and reform by placing visitors into the material environment of the war landscape and allowing individuals to engage with its physicality:

> The trench is 8ft deep and only wide enough to allow a person to pass along it behind the firers. Have a look through the home made periscope to see what 'no man's land' looked like. Take a peep at an officer having a camp bath (Cheshire Military Museum 2012).

Again, the exhibition space uses this experience to demonstrate the significance of remembering the service and sacrifice of soldiers. By representing the trenches and war landscape, museums emphasise the responsibility of witnessing:

> Leaving the trench is an area dedicated to remembrance. Stop to consider the sacrifice involved to give us who are still here a new chance. Over 8000 men from the Cheshire Regiment were killed in the Great War and another 715 in World War II, a very different kind of war (Cheshire Military Museum 2012).

The frequency in which the trench recreations feature in museum exhibitions is therefore highly noticeable (see Table 6.1). Certainly the usage of this structure may stem from the utility of the trenches as a 'walk-way' a convenient form of space for exhibitions to detail the history of the war. The trenches and dug-outs are highly amenable to this usage as they can easily be incorporated into an institution and form a expedient means for displays and objects to be arranged. However, the dominance of 'the trenches' as a means of representing the war in museums across Britain also reveals the wider cultural value of the perspective of the 'witness'. In this way, museums as repositories of the nation's history, act to preserve the 'sacrifice' of the soldiers of the war, by casting visitors as witnesses, asking them to bear responsibility for remembering the conflict in the present (after William 2007: 24).

Table: 6.1 Museums with First World War trench displays

Location	Museum	Display
Ashton-under-Lyne, Manchester	Manchester Regiment Museum	Reconstruction of a First World War trench
Bovington, Dorset	Tank Museum	Trench display
Carlisle	Border Regiment & King's Own Royal Border Regiment Museum	Replica of a Great War trench
Derby	9th/12th Royal Lancers and Derbyshire Yeomanry Museum	Section of a trench of the Western Front
Lichfield	Staffordshire Regiment Museum	Recreated section of a First World War trench
London	Imperial War Museum	Recreated trench experience
London	National Army Museum	Recreated trench display
London	Royal Engineers Museum	Display of 'trench life' and the underground war
Liverpool	Museum of Liverpool Life	Recreated trench display
Preston	Museum of the King's Royal Hussars in Lancashire	Recreated trench scene
Stirling	Argyll & Sutherland Highlanders Regimental Museum	Realistic model of a trench scene

The use of reconstructions and replicas within exhibitions and displays is a highly contested subject within museology. The issue of replication, authenticity and engagement are significant debates regarding this mode of representing the past (see Walsh 1992). However, within the context of histories which are deemed 'traumatic', such as those concerning war, genocide, enslavement and repression, reconstructions of scenes of death or victimisation are particularly problematic (see Crane 1997). Within these representations, the mock-ups and models, allowing visitors to experience the material, sensuous and sometimes psychological settings have also garnered attention for their ability to build empathetic, active and imaginative links with the past (see Landsberg 1997: 63–5). These reconstructions demonstrate the position of the 'witness', as museums require visitors to act as 'eyewitnesses', on occasion participating in re-enactments, in order that they observe and then carry the burden of memory (see Prosisea 2009: 351–2). Such a perspective provides a particular frame for visitors to understand the Great War and therefore constitutes a significant aspect of the heritage of the conflict. However, as already discussed, the 'witness' perspective can serve to reaffirm established ideas and norms. The manner in which reconstructions of trenches and dugouts serve to state the strength and forbearance of the troops indicates this nature of the 'witness' (see Espley 2008). After this fashion, visitors are called upon to observe the same features of the war reinforcing the state-sanctioned values of commemoration of service and sacrifice:

Underlying the promise of existential communion, and despite the appeal to diverse audiences, the epistemological conviction remains strong – in museums as elsewhere – that ultimately there is one truth and that a single (and well controlled) stimulus will recall it ... Even as we stand side by side, simultaneously undergoing our separate experiences shaped by a museum environment, we are prompted to carry away the judgement of a same and publicly acknowledged reality (Hein 2000: 80).

Recreations and models, therefore, could indeed offer visitors a means to access the past in an engaging fashion encouraging an emotive and imaginative link with the events of 1914–1918. Nevertheless, these representations could also encourage a passive connection with the Great War, as the frame of the witness perspective, provided by institutions displaying model trenches or dug-outs, reinforces established notions of remembrance. This is certainly noticeable in the *Trench Experience*, an initiative in Woking, Surrey, to build an open-air museum including a substantial section of reconstructed trench. The site will be presented to educate and inform, visitors are witnesses and are sought to maintain the 'truths' of the conflict:

> The Trench Experience does not try to glorify war but is dedicated to
> commemorate and celebrate the memory of the millions of men and women who
> fought and died. Away from the fighting it will show how troops took rest and
> relaxed in the estaminets (makeshift cafe/bar) some of these men kept journals,
> wrote books, poetry and music (The Trench Experience 2012).

(handwritten note: (Still not open Spring '15))

The witness perspective does not assume a passive stance of the visitor; rather, that the reconstructions of the trenches and dugouts of the Western Front battlefields in museums insist upon a particular framework of understanding (after Garton Smith 1999). Within this structure, visitors are required to actively engage with the displays, but this engagement procures no overt testimony, only a requirement that an observation should be made. The 'truth' of the 'sacrifice' of soldiers and those at the home front is provided, but the exhibitions featuring reconstructions do not demand that this truth is stated or used in the present (see Booth 1996: 14). Witnessing, in this respect has a moral duty, to ensure that remembrance is maintained, but it is curtailed in its ability to draw further on the perspective provided.

In contrast to this passivity, the overt role of the witness perspective as a frame of reference can be noted in the online exhibitions and digital archives in Britain which enable visitors to engage with the historical materials of the conflict (after Marty 2007, 2008). A number of institutions within Britain have constructed online exhibitions or social media sites through which a degree of interaction is provided (after Williams 2009: 237). On these sites, individuals are able to upload and share wartime family photographs, images of objects or comments and feedback on items which are presented online to visitors. An example of this work can be

identified with the IWM's *Faces of the First World War* which was constructed as a site for online public engagement with the conflict. From the 11 November 2011, on every weekday until the hundredth anniversary of the outbreak of the war in August 2014, the institution has pledged to upload photographs of the British and Commonwealth men and women who served in the war onto the image-sharing website Flickr:

> The photos were collected by IWM between 1917 and 1920. All of them tell a story. Those shown in them fought – and often died – for Britain and the Commonwealth during the First World War (Faces of the First World War 2011).

In this manner, the images are part of the hegemonic structure of the museum, organised and portrayed by the institution as a means of educating and informing the wider public for society's betterment. However, the initiative marks a new departure for the IWM as it provides a means by which the public can engage and contribute to the artefacts presented to them. Visitors to the website are asked to 'get involved' by contributing pieces of information about those men and women to tell the stories of people's lives who witnessed the world's first industrialised war:

> Use any means you can – online newspapers, museums, libraries and archives – to build up more of a picture about those in the photographs. Add what you find out to the Flickr site and help to remember the people behind the faces, a century on from the war they fought in (Faces of the First World War 2011).

Through this initiative, visitors to the site become active witnesses, contributing their own evidence and in part testifying in their comments as to the effect of the war on the past and the present. The online materials ensure that individuals are not confined to the framework provided within the environs of the museum. Indeed, placing the materials on Flickr, which functions as an image and video sharing site, but also a social networking community, offers an alternative medium through which witness testimonies can be made. Rather than witnessing the war as a common event, ratifying the ideals of the state, individuals serve as witnesses for personal, family and community histories as the comments left on the website reflect a wider engagement with the history of the war:

> My Great Grandad (sic) and his four brothers all went away to this war ... only one survived. To see all these faces, really brings it home that our family wasn't the only one, even though I know they weren't ... if that makes sense? (Anon 2011i).

> What a great project and so worthwhile. My grandfather (Private Arthur Gee) was one of the "lucky" ones even though he was shot he survived the war(s), and i'm (sic) sure with many "horror" stories, He served with the Royal Berkshire

Regiment at the Somme. Being from an ex Military family I salute all past, present and future service men and women. Thank you (Anon 2011j).

My Great Great Grandfather was in Gallipoli, he survived but was wounded, he was sent home. Just after the start of the Battle of the Somme he was sent out in reserve, he went missing during the battle of thiepval (sic) – missing in action. We believe his body lies near a row of apple trees at Mouquet Farm. His son my Great Grandfather never knew his father (Anon 2011k).

Visitors to this online resource use the photographs of the war to demonstrate their connections to the conflict. Indeed, stories of engagement abound in the comments offered by visitors to the website; these are not offered as dispassionate observers but as active 'witnesses' to the trauma of the conflict. In this manner, the style used by the audience of *Faces of the First World War* is one of intimate engagement with what was a global conflict (after Berger 1972: 71). The images can therefore be considered as a 'punctum', an object which pierces the viewer and which is entirely dependent on the individual experience, one which is distinct and removed from the 'studium', the culturally and politically normative response towards the object (after Barthes 1984). The witnesses to these images do not verify the common values of sacrifice and service but acknowledge how the conflict is felt and experienced in the present. Witnessing the conflict through online resources removes the war from the past and recreates it as a lived, contingent trauma. Therefore, witnesses to the conflict are able to testify as to the relevance of the war in the present:

> These photos are so important they are not only of people who died, but of social history of how we live in that period. Although it is sad to see the number of people who died defending this country and our freedom have we moved foreward (sic) yet because we are still at war today. I just hope that peace can be brought about soon (Anon 2011l).

The witness perspective acquires an active role in these circumstances as visitors are able to draw wider associations from the evidence that they are asked to observe. Such was the response of the public to the *Faces of the First World War* website that a separate area was provided on Flickr for individuals and communities to upload their own images of those who witnessed the conflict at home or on the battlefield as well as the places and objects that were experienced during the conflict. Without direct associations with Britain or the wider Commonwealth through the IWM's material, this Flickr group, entitled *Your Faces of the First World War*, is able to engage with a witness perspective that crosses national boundaries as images of German, American, Indian, French and Russian civilians and soldiers are uploaded. Over 1,000 images have been shared through this group providing a forum to explore alternative associations with the war and building a public, comparative history which acknowledges a shared sense of trauma. This is also mirrored in

the main group area of *Faces of the First World War*, where individuals provide information on the images uploaded by the IWM. The details shared by members of the public range from detailed genealogical data to photographs of the houses, streets and towns from which the servicemen and women lived and worked. The format also provides a means through which critical or dissonant testimonies can emerge which directly question the war as well as the issues of present society. For example, the image of Private Albert Jones who died aged 19 in 1918 whilst serving on the Western Front elicited responses which detailed the family and community history but also questioned the ability of current generations to face the same experiences:

> So sad that so many young lads died for what?? the bloody idiots and hooligans that live today. God bless lads and hope you have peace where you are (Anon 2011m).

Similarly, the comments left for the image of Private Thwaite Williamson, who was killed in France in 1917 aged 41, provoked responses which were highly critical of official wartime actions:

> What a waste of a generation. It just shows what happens when we rely too much on political leaders. The same problems exist today, greed and selfish interests still prevail ... (Anon 2011n)

This IWM Flickr website followed an earlier initiative which also provided online visitors with the perspective of the 'witness' which was used to affirm but also to challenge established values. In 2008, the University of Oxford began the online project *The Great War Archive*, which was part of the *First World War Poetry Digital Archive* and funded by the Joint Information Systems Committee (JISC), and sought contributions to develop a digital collection of material relating to the Great War. Members of the public were encouraged to submit scanned photographs, images of objects or transcripts of letters, diaries or memoirs relating to the war from Britain but also abroad during March to June of 2008. Contributions were accepted online but the project also ran a series of open days at libraries and museums throughout Britain where materials could be brought in to be recorded. These materials were then presented as a free resource for the public's use which was launched in November 2008 containing over 6,500 items. The project's emphasis was on asserting the value of personal and family history and the contribution of the public in 'remembering' and 'understanding' the First World War. In this way the role of the public as 'witnesses' to the past was reaffirmed:

> Both those who died and those who lived through the war left evidence of their experience, items collected included diaries, photographs, official documents, and even audio interviews with veterans. However insignificant, each of these

items has a part to play in helping todays (sic) generation to understand what war meant to ordinary people: the soldiers, their families and the workers back in Britain who kept the country going (The Great War Archive 2008).

The objects offered by members of the public were chosen specifically because 'their family's history mattered to them' (The Great War Archive 2008). As observers to the war, contemporary visitors to this online repository can testify to their personal engagement with the war through offering their own evidence to the war's effect. Medals, letters, diaries and the ephemeral objects of everyday life are recorded in this way; items have, therefore, been included within the archive because their personal value has ensured their preservation rather than an assumed value in telling a wider story. The witness perspective is through this means activated in this digital initiative as visitors are asked to testify their experiences. Similar programmes of online engagement can be examined in the European-wide initiative organised by *Europeana*, the digital access group, named *Europeana 1914–1918* which sought to collect personal material of the Great War era from the public in Germany, Britain, Ireland, Slovenia, Luxembourg and Denmark from 2010 onwards:

> Do you have pictures, letters, postcards, souvenirs or other items from 1914–1918 relating to World War One? Do you have a story or anecdote to tell about those involved or affected? Please add it to the online story collection so the world can know about it (Europeana 2010).

The project coordinated online submissions but also ran open days for individuals to share their stories and artefacts regarding the war. Individuals were elevated in this way to the position of witnesses whose testimony matters in the comprehension of the conflict and its effect:

> You can add your story to Europeana 1914–1918 by using the online collection form on this website. You simply type in some information about your contribution, saying what it is (a postcard sent from XX, a diary, etc) and add any story that you want to share (for example about the person in the photograph, how you got it, what you know about the object) (Europeana 2010).

The content of these archives has been used to develop an online exhibition which also validates the contemporary testimonies of witnesses to the conflict through personal objects or associations. The exhibition, entitled *Untold Stories of the First World War*, was launched in 2012 and draws upon the extensive data of the *Europeana 1914–1918* project. Whilst linked by six thematic structures, the online exhibition utilises the stories of the objects, their owners and their descendants to consider the effect of the war on 'ordinary men and women'. Objects, photographs and texts are displayed with details of the individuals who owned them as well as the meanings for those who inherited them. What is significant in these accounts

is not the requirement of the witness to observe the sacrifice and endeavour of the troops, but an acknowledgement of the suffering of individuals, both mental and physical, and the sense of trauma that the war still evokes in the present (see Wilson 2009). In these 'witness statements', contributors provide their response to the war based on the evidence they provide to the digital archives. For example, for one item, a memoir and photographs of a British soldier, donated by his daughter, recalled a historical trauma experienced both in the past but also in contemporary life:

> Dad was a wonderful man, she said. But looking back I think the war must have haunted him a lot, especially when you read his account. My mother used to encourage him to write down his experiences and this seemed to have a calming influence (Anon 2012e).

Similarly, with regard to an interview with a British veteran of the conflict, aged just 19 when he signed up to fight in the war, the trauma of the war for one so young is considered by a friend who had conducted the interview as a present concern:

> The thing that struck me about Billy was his dry sense of humour. He must've seen some terrible sights during the war, yet I am sure his ability to laugh helped carry him through (Anon 2012f).

These testimonies indicate the nature of the witness perspective with regard to the First World War in Britain. The frame of the witness enables a variety of responses to the conflict to emerge in the present. Within the traditional museum format the witness perspective serves to affirm the values inherent in the remembrance of the war dead, to preserve the idea of the sacrifice of troops for the security and safety of the nation. The reconstructed trenches and dug-outs which appear so prominently within national, local and regimental museums enable visitors to act as 'eye-witnesses'. As an observer of events, individuals are required to take responsibility to maintain the duty to commemorate the war dead. However, no further testimony is required from this engagement with the past. Witnesses to the models, reconstructions and re-enactments in museums provide a means to re-establish the understanding that it is 'good' and 'proper' to remember; to commemorate for the sake of commemorating. In this manner, the witness perspective is passive as it requires observation not mobilisation. It places responsibility upon the individual to bear the burden of remembering the events of the Great War but it does not ask for that responsibility to impact upon the present (after Booth 1996: 20). The framework provided by this aspect of the heritage of the Great War could therefore be classed as inert. In contrast to this position, the uses of Web 2.0 technology and social networking have forwarded a highly active example of the witness perspective in relation to online exhibitions and digital archives. Within these structures, individuals are not just required to be witnesses but to testify as to their relation to the war; making statements as to the

personal, family or community connections. These observations are significant as they enable witnesses to express their declaration of the 'truth' of the war. These 'truths' acknowledge the trauma of the conflict, the loss of the war and the criticism of governing structures to prevent the onset of military action and the mass death that accompanied it. Witnessing in this manner provides a highly active role; one which places the individual in relation to both the past and present; to testify from their observations ensures that the evidence they have acknowledged is used to pass judgement on the present. The witness perspective is a highly significant aspect of the cultural heritage of the Great War in Britain as it can establish accepted norms and values but it can also empower individuals with a moral, political and social duty to testify against those norms (after Sandell 2002, Sandell 2007, Sandell and Nightingale 2012).

Memorials and Memory: Pals Battalions

The concern for local heritage has recently developed into a separate area of inquiry within the wider field of heritage studies (see Dicks 2000a, Smith and Waterton 2009, 2010, Schofield and Szymanski 2011, Waterton and Watson 2010). Scholars have focused on how a sense of heritage within a local area is defined through the attribution of meanings and values onto a particular site or upon a particular cultural practice (Crooke 2005, 2007, 2010). Notions of tangible and intangible heritage are employed in these studies as the manner in which local heritage constitutes a 'sense of place' for a community is assessed (see Ashworth and Graham 2005). These analyses demonstrate how local heritage reflects the aspirations of groups, offering a means of projecting ideas about themselves and their attachment to their local environment (after Dicks 2000b). This active construction of a 'sense of place' has been examined as a reaction to globalisation, *ie social capital* post-industrial decline, political hegemony and a means of expressing dissonant voices (see Schofield and Szymanski 2011). Whilst these studies enable an approach of affirming the significance of local heritage, analysts have also critiqued the tendency towards romanticised notions of the past (after Wright 1985). This has highlighted how definitions of 'local' and 'community' that are employed by scholars often obscure issues of exclusion, difference, ethnicity and politics that are present in the construction of local heritage (see Smith and Waterton 2010). Therefore, the study of 'local heritage', or how communities create a means of engagement with the past, provides a point of analysis for identity, governance and place that details the social and political components of memory and history within a locale (Howard 2003: 5–7). As memory and the act of remembering is taken as an active engagement and as a mode of expression, local heritage forms a key point in examining how communities represent themselves within wider cultural and political frameworks.

The local commemoration of the Great War in contemporary Britain certainly reflects these issues. The significance of this regional remembrance has its basis in

the way in which the British Army was structured during the conflict. The army can be considered to have possessed three stages during the war which responds to how manpower was organised to respond to the increasing demands of the war effort (see Beckett and Simpson 1985, Grieves 1988). These three stages of Regular, Volunteer and Conscript also possessed significant local connections. Whilst the Regular Army was constituted by Regiments with strong local attachments, one of the features of the war in August 1914 was the call to colours to local men who were offered the chance to serve alongside their friends, their work colleagues and townsmen (see Simkins 1988). These were the so-called 'Pals Battalions' which were initiated by Lord Kitchener and pioneered by Lord Derby in Liverpool to promote citizens to volunteer and ensure a degree of 'camaraderie' within new recruits (Maddock and Holmes 2008).

This method of recruitment drew upon the considerable degree of both civic pride and labour identification within Edwardian Britain as industrialisation had created a highly urbanised and socially stratified society (Silbey 2005). The recruitment of local battalions also utilised the significant internal economic migration within Britain since the mid-nineteenth century which had resulted in Scottish, Welsh and Irish workers within the major industrial centres who maintained links and associations with their home countries (Glass and Taylor 1976). Working class and middle class professionals, therefore, flocked to the colours to 'do their bit' and represent their locality, their occupation and their area's commitment to the cause (see Connelly 2006). Groups such as the Grimsby Chums, the Tyneside Irish, the Glasgow Pals, the Swansea Pals and the Manchester Pals were formed and were incorporated into the British Army (Bilton 1999, Lewis 2004). These battalions, which numbered around 1000 men in total, were trained and sent to the theatres of operation. Due to these practical delays, many of these Pals Battalions were only available for deployment by the spring of 1916. Pals Battalions were, therefore, used substantially in the Battle of the Somme (1916) where together with the other troops of the British Army they sustained heavy losses as over 18,000 men were killed and nearly 39,000 men were injured on the first day of the battle alone (Brown 1999).

The impact of these deaths upon the local communities was substantial as the engagement of Pals Battalions in costly operations would result in local areas losing large swathes of their young male population (see Macdonald 1983). After the conflict, local memorials, statues, tablets and plaques were erected in villages, towns and cities across Britain where families of the bereaved could bear witness to the service and sacrifice of their loved one, whilst communities could honour the commitment of their fellow citizens (Connelly 2002). Studies of these memorial schemes have detailed how funds were raised, designs were chosen and how events were organised around these sites which made them part of a community (Gaffney 1998). Alongside these assessments, scholars have also noted the iconography and social meanings of the memorials for groups and communities as a means of political and cultural expression. In this respect, the memorials are assessed as reflective of the values and ideals of post-war society as constructs of gender,

identity and representation were communicated through the memorials (Boorman 1988). For example, Gaffney (1998) highlighted how post-war Wales responded to the deaths of thousands of countrymen with a series of memorials in local areas which relied upon a complex set of values to serve as a memorial for the dead, a solace for the bereaved and as a statement of the area's character.

This post-war remembrance is significant, as it reveals the values and identities that communities built through the history of the war. It can also assist in illuminating the recent rise in new memorials to the Pals Battalions and local units that served in the Great War. Over the last two decades a rise in interest in the history of the Pals Battalions has created an extensive literature (see Stedman 1993, Turner 1992). Local historical studies of these battalions have provided a new means of assessing the war from a regional perspective as they detail both the background and experiences of those who enlisted as well as the context of their area and the aspects of life on the home front during the conflict. This burgeoning interest in the Pals Battalions and local links to the Great War can be observed to have been initiated during the early 1980s. The Pals Battalions featured in a number of novels and plays and served as a means of political expression. This is most notable with Whelan's 1982 play *Accrington Pals*, a dramatic work that contrasted the home front with the battlefields as the men and women of the Lancashire town endured the privations of the war (see Whelan 2011). The play's depiction of a community shattered by the effect of a duplicitous government, an incompetent military and the horrors of modern warfare played against the policies of first Thatcher Government (1979–1983). Similarly, McGuinness's (1986) drama, *Observe the Sons of Ulster Marching Towards the Somme*, also provided an indictment of government and military policies that resulted in the deaths of thousands from a locality whilst exploring the contemporary meaning of the Battle of the Somme for the community in Ulster.

In the last few years the movement to commemorate the efforts of the Pals Battalions and local regiments in Britain who served during the Great War has moved beyond the detailed historical analyses of their period of service. A growing trend can be identified in the memorialisation of Pals Battalions as local communities seek to stress their attachment to the events of the First World War. Honouring the local Pals Battalion in this manner serves as a means for a community to identify with their location and create a 'sense of place' within their local environment (after Schofield and Szymanski 2011). Indeed, in the context of the hundredth anniversaries of the war, the desire to reiterate the memory of the Pals Battalion is evident in a series of local initiatives throughout the country. Over the last decade, drives to raise funds for new memorials, art projects and community schemes for commemorating Pals Battalions have been highly prominent. For example, the Lancashire market town of Chorley dedicated its memorial to the Chorley Pals in February 2010; an occasion marked by a large crowd in the town's Flat Iron Market (see Figure 6.2). This memorial of a poised soldier on a stone plinth which lists the names of the dead and the places where they served is obviously

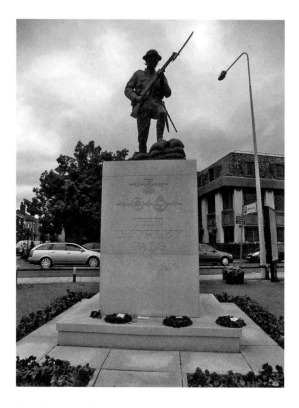

Figure 6.2 Chorley Pals Memorial, Flat Iron Market, Chorley, Lancashire

reminiscent of the immediate post-war memorials erected across Britain. It was dedicated to acknowledge the contribution of the 222 local men to the better known Accrington Pals of the East Lancashire Regiment that sustained heavy losses on the first day of the Battle of the Somme. What is distinctive about the memorial is that the town already possessed a memorial to the service of citizens. In 1924, the local estate park, Astley Hall, was donated by the Tatton family to the Borough of Chorley as a memorial to all the men from the region who fought and died in the Great War. Within the estate house, a small memorial room to 'the fallen' from 1914 to 1918 was constructed containing an illuminated scroll listing the original members of the Chorley Pals. Therefore, although the new memorial evokes the past through its style, the memorial is certainly an object of use in the present and representative of contemporary concerns. Since its inauguration, the new memorial has featured in Remembrance Day parades and was the focus of attention during a ceremony to mark the anniversary of the Battle of the Somme in July 2011. Therefore, the memorial was explicitly constructed to highlight the links between past and present, to demonstrate a sense of pride and ownership of the Chorley Pals:

At the start of the appeal back in February 2007, we looked to make the dream of a memorial to the Chorley Pals a reality – on the 28th February 2010 that dream will be finally realised. The memorial will take pride of place in the town, proudly overlooking the 'Flat Iron' market – a place well known to all the Pals back in 1914 (Chorley Pals Memorial 2010)

This connection and identification is formed through the sense of victimhood associated with the losses of the Great War. Indeed, the fund-raising and reporting of the memorial within the local media whilst the project was in its initial planning stages and after its subsequent erection reflects this association with suffering:

Dozens of soldiers from Chorley were among the thousands killed during the first hours of the battle (Anon 2012g: 3).

In the first 30 minutes of the 1916 battle, dozens of Chorley men were killed and many more injured as they were ordered to go 'over the top' in Northern France (Gee 2011: 5).

The identification with this historic suffering enables communities to promote their place and significance in the present (see Alexander 2012: 26–7). In the case of Chorley, it has been used as a means to establish local pride and identification as local citizens were encouraged to both donate to the campaign but also to 'pay their respects' to the sacrifice of fellow citizens. Indeed, the moral compunction of commemoration was confirmed by the local Labour Member of Parliament, Lindsay Hoyle, who supported the campaign for the memorial to be erected, stating that the lack of a 'proper' memorial to the soldiers was an 'injustice' that had to be 'put right'. In this manner, the memorial serves as an exercise of values and ideals:

The majority of the Chorley Pals never returned. The fact that no memorial to these brave men has ever been erected is an injustice I want to see put right (Lindsey Hoyle quoted in Anon 2007f: 6).

The 'witness perspective' is also evoked in these circumstances, requiring residents to realise their role as bearers of memory. In this way, normative values can be seen to be asserted as the campaign for the memorial was frequently placed within a wider context of support and concern for current, serving soldiers in the British Army from the area. Witnessing the sacrifice of those in the past through the Chorley memorial, therefore, is associated with support for troops in the present day. With military operations in the first decade of the twenty-first century in Iraq and Afghanistan and with government cutbacks to defence budgets meaning the disappearance of historic regiments, the association between the soldiers of the Great War and current soldiers is made distinct through reference to the 'Chorley Pals' (see 'Pride of Lancashire' (Anon 2005c: 9)). This can also be observed in the

nearby town of Accrington with the erection of a memorial tablet to the Accrington Pals in 2004. The memorial was erected to mark the granting of the freedom of the borough to the Queen's Lancashire Regiment in 2002, however, it draws allusions to the Great War and notions of sacrifice and service, by framing the dedication to the 'pals':

> THIS MONUMENT IS DEDICATED TO
> THE EAST LANCASHIRE REGIMENT IN
> MEMORY OF ALL RANKS WHO SERVED AND DIED
> IN ALL WARS, PARTICULARLY THOSE OF THE
> 11TH (SERVICE) BATTALION (ACCRINGTON)
> OTHERWISE KNOWN AS
> THE ACCRINGTON PALS

Similar memorial schemes for Pals Battalions are planned or recently erected in several other locations within Britain such as Preston, Liverpool, Glasgow and Manchester through commemorative tablets, plaques and memorials. In Preston, Lancashire, the Preston Pals Memorial tablet was dedicated in July 2012 to mark the service and sacrifice of the local men from 'D' Company the 7th Battalion of the Loyal North Lancashire Regiment in the Great War. The tablet, placed at the city's railway station, where the troops embarked upon their journey, was intended to honour the memory of the city's 'forgotten heroes'. As such, issues of pride and identification are evident in this commemoration, as the city seeks to demonstrate its association to the events of the Great War. A volunteer organisation composed of local historians campaigned and raised funds for the Cumbrian slate memorial which is inscribed to the 'Pals' 'who served their country with honour and sacrifice in the Great War 1914–1918'. In the reporting of the memorial within the local media, the commemoration has served to remind residents of the victimhood of their forebears, who were 'massacred' during an 'offensive'. Indeed, the 'poignant' history of the Pals is rehearsed within the coverage of the memorial:

> Yesterday a memorial was unveiled at Preston Station close to where, 98 years ago, more than 200 of the tragic Pals kissed their families goodbye for the final time (Anon 2012h: 7).

> ... they thought it would be a quick trip abroad ... But 200 members ... known as the Preston Pals, lost their lives in the deadly trenches (Anon 2012i: 6).

These modern memorials to the Pals Battalions are not just located within Britain, several structures have been erected in France and Belgium to mark the service of local men from Britain in the Great War. In 1998 a black granite memorial stone was placed near the battlefields of Serre on the Somme, France, to commemorate the lives lost from the 'Barnsley Pals'. Erected seven years after the death of the last veteran, the memorial was raised through public subscription (see Figure 6.3). In

Figure 6.3　Memorial to the Barnsley Pals, Serre, Somme, France

2006, in Bus-lès-Artois, France, a memorial consisting of trees, shrubs and a block of Portland stone, the same used in the CWGC cemeteries, was unveiled by civic leaders from Leeds to mark the part of the Leeds Pals in the Great War. The memorial was inaugurated on the ninetieth anniversary of the Battle of the Somme where the majority of the Pals died on the first day. The inscription reads, 'We remember with pride the soldiers of the Leeds Pals and Leeds Rifles'. Whilst reaffirming the points of pride in the association between the Pals and the modern city of Leeds, the media reporting of the event also stressed the victimisation of soldiers:

> The Pals were a middle-class battalion and their heavy losses robbed Leeds of a generation of businessmen and other professionals. They included a journalist from the Yorkshire Evening Post, Lance Grocock, and the son of the Vicar of Leeds, the Rev Samuel Bickersteth (Ginley 2006: 14).

Leeds City Councillor, Mark Harris, also remarked that the memorial to the Leeds Pals offered a fitting means to re-establish pride in the city after the London Underground bombings of July 2007, which were committed by Leeds residents:

> In the week of 7/7 anniversary when are thinking about the most recent tragedy to hit Leeds, and the way the city has overcome it, it is appropriate we remember the greatest tragedy to hit the city which was the almost total annihilation of the Leeds battalion (Edwards 2006: 8).

The social significance of this aspect of commemoration can be considered in the emotionally-loaded image of 'mates' from the same region volunteering together, serving together and dying together. The connection with the historic suffering of the troops from this area enables a validation of the city's identity and character. With these examples of the Preston Pals and the Leeds Pals the association with trauma and suffering is evident. The emotive nature of the position of the memorial at the point of embarkation or the site of their victimisation as well as the direct reference to the 'poignancy' of the story of the Pals is demonstrative of association with the victimhood of others (after Alexander 2001: 5, Novick 2001: 224). Through this exercise a connection with a regional identity is established. Such connections are formed through the memorial structures, as they frame an understanding of the conflict for present generations (after Wertsch 2002: 5). Contemporary populations draw upon these frames of reference to understand present conditions and values. However, this utilisation of the heritage of the Great War through the Pals Battalions is not only evoked through monuments and memorials. The commemorative activities such as services, marches and silences also reinforce this sense of identity (see Connerton 1989: 8–10). For example, ceremonies in Bradford to mark the anniversary of the Battle of the Somme in 2011 were accompanied by an invocation for citizens of Bradford to remember those who fell on the first day of the battle as part of their civic identity:

> I think July 1 seems to register with all Bradfordians ... I don't know if I lost anybody in the Somme but just the feeling you could have done strikes a chord. It has been a moving tribute. It is part of Bradford's past (Bradley 2011: 3).

The contemporary significance of the Pals Battalion from Bradford is also demonstrated in the construction of a memorial tablet in 2000 to those from the area who served in the war. The tablet, located behind the post-war cenotaph in the city centre, has been incorporated into the memorial services which are conducted to mark both the Armistice and the Battle of the Somme (see 'Sacrifices of the Bradford Pals remembered' (Winrow 2012: 3)). The inscription of the tablet reaffirms the sense of place and evocation of identity which is common within other recent memorials to the Pals Battalions across Britain:

TO THE MEMORY OF
THE SOLDIERS OF THE
BRADFORD PALS
AND THE OTHER SERVICEMEN OF
WEST YORKSHIRE
WHO SERVED IN THE GREAT WAR 1914–18
AND LO, A MIGHTY ARMY CAME OUT OF THE NORTH

This process of identification is also certainly evident with the reporting of the excavation of a mass grave of British soldiers from Le Point du Jour, near Arras, in June 2001. In the grave were the remains of members of the 10th Battalion of the Lincolnshire Regiment, known as the Grimsby Chums. Their bodies had been arranged carefully by their comrades, placed side by side, despite some of their number sustaining significant injuries and mutilation from shrapnel fire (see Boura 1998). Media coverage of the event emphasised this care and attention provided for their dead comrades as indicative of the 'true' meaning of the war, of significant bonds forged through shared wartime experiences and local connections. In this respect, the Grimsby Chums served to create a sense of identity and local pride for contemporary society. For example, one comment left on the pages of the local newspaper *Grimsby Telegraph* reporting on new archaeological work at the site of La Boiselle where the 'Chums' sustained heavy losses during the Battle of the Somme stated:

> The memory of the Grimsby Chums should make us all stand a little taller and work a little harder. That strange feeling my friends, is pride. God Bless them, we will never forget their sacrifice (Anon 2011o).

The pride and identification that emerges through the commemoration of the Pals Battalions can also be source of a dissonant political identity, as this example of historic 'sacrifice' is shown to highlight the deficiencies in contemporary society (Neal 1989: 5). Indeed, the usage of the Pals Battalions as a frame to examine current contexts provides a significant example of the application of the heritage of the Great War. The Pals Battalions provide an exemplum of service and sacrifice through which the present can be critically assessed. To examine these sentiments, the comments left on website forums and online news sites with regard to the Pals Battalions can be considered and identified as a distinct discourse (after van Dijk 1988). For example, with regard to an exhibition held at the local Haworth Art Gallery on the Accrington Pals in 2010, visitors considered how the Pals compared to present-day society:

> It is a tremendous opportunity to look upon the people who 'gave their today, for our tomorrows'. I have often said, that if there was a war on the same scale today, most of the young men of today, would go back to their mother country to avoid the fighting. Not able to take their black BMWs to the barracks, that is (Anon 2010d).

> In WW1 and WW2, Britain was a fairly homogeneous nation. We had our rivalries, Yorks v Lancs, English v Scots, Northerners v Cockneys, etc, but when we were threatened, we were all British. Could this happen today? (Anon 2010e).

The implications of this sentiment is that the Pals represented a 'lost generation', who were cruelly cut down, but whose service provides an example of what is absent within contemporary society across Britain. The references to Britain as a 'homogeneous nation' and 'back to their mother country' also suggests a critical approach to the development of a multicultural society over the course of the twentieth century. The heritage of the Great War is mobilised in these instances to demonstrate a reaction against perceived problems within society. Measuring contemporary society against this benchmark enables a critical anti-democratic discourse to emerge, as present-day groups can censure authorities for their abandonment of the 'values' which the Pals Battalions are perceived to represent (after Brown 2001: 5). A rather clear example of this was the appropriation of the title 'Preston Pals' by an activist in March 2008 for a right-wing political party with the purpose of promoting an anti-Islam leafleting campaign in Preston. When this case arrived at court in June 2010, the reasoning for the moniker was debated by the prosecuting council:

> They (the Preston Pals) have got nothing whatsoever to do with the BNP and nothing whatsoever to do with the hatred of Islam. Why that name was being used is not really known ... (Magill 2010: 7).

Whilst the barrister in question was not able to understand the linkage between the activist and the Great War, it is likely that the connection relies upon the sense of pride and critical capacity which is drawn from the conflict of 1914–1918. The Pals Battalions serve as a 'lesson from history', from which the current generation draws associations and allusions to critique the present. The Pals Battalions are a significant aspect of the cultural heritage of the Great War in Britain because they are mobilised by present generations to evoke a sense of pride, morality but also an identity. This identification can be exclusory, criticising current society for its apparent failings when measured against the generation of the Pals Battalions, but this serves to highlight how the heritage of the conflict constitutes an anti-democratic discourse (see Brown 2001). In this manner, using the Pals Battalions as a frame of reference provides a means of assessing society, its governance, its values and its objectives.

Modern Memory of the Great War in Britain

The frames used to evoke the Great War across contemporary British enables the conflict to be mobilised in the present. The ability of the war to be evoked within society to alter or to comment on its ideals is one which is rarely considered within discussions of the memory of the First World War (see Bond 2002). Whilst different social contexts are viewed as interpreting the conflict in different ways, this is often negatively viewed as a movement away from the 'history' of the war (Sheffield 2002: 8). However, whilst the 'history' of the conflict has been interpreted and

reworked since the Armistice, indeed, often dramatically, as scholars debunk theories and ideas regarding the pursuit of the war, such malleability in the heritage of the conflict is criticised as a failing (after Todman 2005: 3–5). Indeed, the shifts in focus and concern in what is derided as the 'myths and memory' of the war is considered symptomatic of a far weaker evidence base (see Badsey 2002). Nevertheless, the workings of the cultural heritage of the Great War demonstrate a responsive and significant area of study. To demonstrate this value, its operation can be observed within the seminal work of Paul Fussell (1975), *The Great War and Modern Memory*. Within this highly regarded research, the war was considered to have created an ironic attitude within Britain, as expressed by literary and artistic forms that rejected the highfalutin values of patriotism, endeavour and sacrifice. Critics of this work have suggested that Fussell's thesis is derived from only a selection of certain types of evidence from a well-educated officer class (see Smith 2001). What this assessment fails to acknowledge is that the usage of irony as a means of framing the understanding of the war has value in itself. This frame of reference, which existed during the conflict, as evidenced from the laconic Bruce Bainsfather (1887-1959) cartoons and the wartime 'trench newspapers' such as the *Wipers Times*, has been evoked as a means of understanding and outlining the war for current society. It functions as a means of utilising the conflict to promote particular ideas in the present. This irony is not a product of modernity, rather a modern means of remembering the Great War. S. *Fussell was wrong*

In this manner, one can perceive how a modern means of remembering the conflict in the present constitutes an active engagement with the history of the 1914–1918 conflict. Using irony as a means of framing the Great War for contemporary society is a way in which individuals, groups and communities can challenge historical issues and present-day concerns. The focus on attempts at revising the 'popular memory' of the conflict has obscured a discussion as to why this apparently 'inaccurate' representation of the war dominates understanding across British society. To comprehend the contemporary status of the conflict, the role of trauma within the cultural heritage of the Great War in Britain requires consideration. Recent assessments of the wars, genocides and dictatorships that dominated the twentieth century have revealed the presence of trauma, both in the generation that experienced the events but also in proceeding generations (Antze and Lambek 1996, Eyerman 2001). This residual trauma affects descendant communities through the memorialisation of the event, the manner in which the event shaped and continues to shape attitudes and identities and through the presence of the trauma in cultural responses, such as film, television and fiction (Alexander 2001, 2012). The cultural heritage of the 1914–1918 conflict in Britain, which saw the loss of over 700,000 individuals, should therefore be regarded not as the product of some vapid consumption of media, but as a response to a historical trauma (Wilson 2009). In such circumstances, the trauma of the past experienced by societies in the present can best be described through Freud's (2003: 203) discussion of melancholia. This assessment highlighted how melancholia manifests itself as a focus on an object or event by the subject which

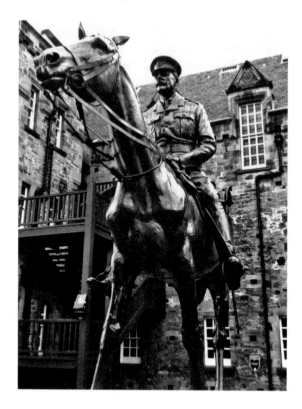

**Figure 6.4 Equestrian statue of Field Marshal Douglas Haig, Edinburgh
 Castle**

creates a restless or disturbed state as the subject fails to overcome the sense of
loss regarding the past. What is required in these circumstances is not a refusal or
denial of this focus but an engagement which acknowledges this loss not as past
but as felt in the present. Roth (1995: 187), in his assessment of the Holocaust, has
applied this discussion beyond the individual toward society at large and regards
this sense of trauma in history as one in which subsequent generations return to a
past they cannot comprehend. To engage with this trauma and not dismiss it, Roth
(1995) suggests a practice of engagement in the 'service of the present' involving
the analysis of the way societies have reacted to events, sympathising with the
manner in which events are remembered and enabling a suitable discourse of the
events to emerge which mirrors this sentiment.

 With regard to the Great War in Britain, the sense of trauma evoked through the
cultural heritage of the conflict is evident. Through language and imagery, the war
is brought to bear on the present. The past is evoked in these circumstances as a felt
and current trauma. The war is certainly not over in this effect as individuals still
find themselves 'in the trenches' or 'in no man's land'. This ensures that the war is

brought into the present, that it still evokes concern, outrage and emotion within current generations. This response can be observed in the controversy surrounding the relocation of the statue of Earl Haig within Edinburgh Castle in 2011 (see Figure 6.3). The statue of the Field Marshal, who above all others bears association with the tactics of the Great War which saw the deaths of thousands of servicemen, was removed to enable new seating to be constructed at the Castle Esplanade. Known colloquially as the 'Butcher of the Somme', Earl Haig's place within the cultural heritage of the Great War serves as a means to mobilise opposition and debate. The relocation and renovation of the statue was accompanied by fierce debate on the merits of commemorating Earl Haig:

> Field Marshall Sir Douglas Haig remained unmoved in the face of a barrage of criticism over the loss of hundreds of thousands of troops in the First World War – and for more than 85 years his statue has stood proudly atop Edinburgh Castle's esplanade (Anon 2009e).

This mirrors debates elsewhere as to the propriety of commemorating the military elite of the First World War, who are widely perceived to be 'butchers and bunglers'. Indeed, debates as to the place of Haig as someone deserving commemoration were raised during the eightieth anniversary of the Armistice in 1998. The *Daily Express* newspaper used the occasion to question the place of the General's equestrian statue within the heart of government in Whitehall with a front page editorial:

> No-one will ever question the heroism and self-sacrifice of those magnificent doomed men. But today *The Express* calls into question Earl Haig's right to symbolise their loss (Anon 1998: 1).

What is distinct about these debates is not the questioning of the place of the Earl Haig in the remembrance of the war, but the manner in which the trauma of the thousands who were killed in the conflict is remarked upon as a present-day concern. This is distinct aspect of the intangible cultural heritage of the conflict, the ability to narrative the conflict as a current issue (Wilson 2009). Rather than ascribing the war with the value of history, as 'past', the conflict is evoked as 'present', as a trauma that is experienced and engaged with in the present (after Eyerman 2001: 5–6). The ability to narrate the conflict in such a manner is significant as it allows contemporary groups to mobilise the war for effect. Therefore, the sense of outrage, anger and emotion that accompanies public, political and media discourse of the war is an identifiable part of the cultural heritage of the Great War as it evidences a means of using and working with this history to motivate current concerns. For example, the scale of death during the conflict, rather than being cast as 'part of history' is narrated as part of the present, impacting and shaping issues within contemporary society. Comments on blogs and forums evidence this sense of loss and tragedy, but they do so as a critical voice in the present. For example:

What would Scotland be like if the best of its young men had not died in a senseless imperial war? (Anon 2011p).

I am a member of the SNP. I am not in any way motivated by hatred of England; I lived there for most of my life, and I have a lot of family and friends who still live there. What does motivate me is that, as long as Scotland is part of the Union, we will always find ourselves being called on to send our young people to fight and die in unnecessary wars. This is still going on right now (Anon 2011q).

The sense of trauma pervades these responses as contributors evoke the past as a perceived and experienced event for contemporary society (after Alexander 2001: 5). Framing the Great War as a current concern, therefore, enables a variety of agendas and values to be expressed. This constitutes the dissonant, anti-democratic presence of the 1914–1918 conflict across society within Britain. History is, therefore, not a closed-off, completed exercise, but a story which is offered for retelling and understanding as the trauma of the past is acknowledged and engaged with (after Samuel 1994: 5–6). This is certainly evident in the *Shot at Dawn* campaign to pardon executed soldiers. Indeed, it can also be observed in the erection of a statue in the National Arboretum in Staffordshire to commemorate those servicemen of the British Army sentenced to death during the war. The statue, entitled *Blindfolded and Alone*, was unveiled in 2001 and features a blindfolded soldier tied to a wooden stake seemingly ready to face the firing squad. The sculpture is inspired by the story of 17-year-old Private Herbert Burden, on whose likeness the memorial is modelled. Burden, who lied about his age to enlist in the armed forces, was shot for desertion in 1915. Around the statue, a semi-circle of stakes follow the seating pattern of a Greek theatre to symbolise the tragedy of the 306 British and Commonwealth servicemen who were executed during the First World War. The reporting of the memorial's unveiling was accompanied by a rehearsal of outrage, pain and trauma for the deaths of both those executed and those who were sent to fight by an indifferent or openly hostile officer class:

In many cases, even when senior officers recommended mercy, Field Marshal Haig, the commander-in-chief of the British forces, authorised executions. There was a prevailing feeling that examples needed to be made (Sengupta 2001: 14).

It stands in an amphitheatre of wooden stakes, like execution posts, each bearing the name of an executed soldier, at the National Memorial Arboretum, in Alrewas, near Lichfield, Staffordshire. Private Burden panicked at the battle of Ypres and was shot for desertion (Ezard 2001: 7).

The inauguration of the memorial provided an opportunity for individuals, groups and communities to revisit the trauma of the events of 1914–1918. This return to the trauma of the past is frequently dismissed by critics of the 'popular memory'

of the war as an exercise in historically flawed, mawkish voyeurism (see Corns and Hughes-Wilson 2002). This is to grossly misunderstand the utility of such an exercise in the present as an activation of the cultural heritage of the Great War. The insistence on the historical accuracy in the reportage of the war has become the central critique of revisionist historians seeking to re-assess the popular memory of the conflict (Corrigan 2003: 8). Indeed, the value of the intangible heritage of the conflict, in its expressions, images and allusions is denigrated in this respect because it does not report a 'correct' interpretation of the war (after Bond 2002: 5). However, the place of the cultural heritage of the Great War does not require the recreation of the event in its entirety; neither does it require the level of accuracy demanded by critics of the popular memory of the war. This 'truthful' vision, if it is indeed possible, is unnecessary as it is the point of trauma which is essential to the evocation of the conflict within society:

> The point is not to remember the past trauma as exactly as possible: such "documentation" is a priori false, it transforms the trauma into a neutral, objective fact, whereas the essence of the trauma is precisely that it is too horrible to be remembered, to be integrated into our symbolic universe (Žižek 2002: 272).

In this manner, the utility of evoking the trauma of the war within contemporary society can be observed. Historians have lamented this continued repetition of the 'myths' of the war within contemporary society, on occasion even reiterating the fact that the First World War 'is over' to dissuade the public from relying on 'false' images and ideas about the conflict (see Becker and Audoin-Rousseau 2002: 3). Nevertheless, the continued evocation of the conflict possesses a function for society as by preserving the trauma, ensuring that it does not pass into a neutral, dispassionate history, it operates as a point of coalescence for groups and individuals but also as a critical frame of reference upon contemporary issues. The trauma functions as a continuing statement upon issues of authority, responsibility and blame. This insistence upon the past is not a nostalgic trap, condemning those who rely upon it to outdated and irrelevant references. Rather, rehearsing the trauma within society ensures that it remains current, relevant and applicable to the social, political and cultural contexts within contemporary Britain (see Wilson 2009).

The recent movement to preserve and rededicate existing monuments and memorials to the war dead can be seen as symptomatic of the desire to maintain the sites of trauma, to preserve this frame of critical discourse for the present. Indeed, ensuring that the memorials and the memory of the war are maintained for 'the next generation' acquires a strong utilitarian association, as the presence of these artefacts facilitates the use of the heritage of the conflict as a vehicle for anti-democratic sentiment. This can be observed in the 2005 campaign to repair and rededicate a memorial to the Leeds Pals which had fallen victim to time and weather erosion. The reporting of the issue focused on the 'sacrifice' of soldiers for the city and the need to keep the memory of this service 'alive'. For example, see 'Campaign victory

over fading of the fallen' (Lazenby 2005: 9), or, 'Man's campaign to save memorial lasted as long as the Great War' (Lavery 2006: 8). Similarly, in Accrington the need to 'save' the late nineteenth century St John's Church, where members of the Pals attended a service before embarking for the front and where the Pals Chapel is located, itself only built in 1992, prompted a vigorous campaign in 2007 within the local press and amongst the town's politicians to ensure that the site continues to evoke the memory of the Accrington Pals:

> The closure threat aroused a storm of protest from our readers who deluged our letters pages with pleas for a way to be found to save the Pals Chapel, the town's major memorial to the gallant men who gave their lives at the Battle of the Somme during the First World War ... *Accrington Observer* Editor, Mervyn Kay – "The story of the heroic Pals is so deeply imbedded in our collective psyche that it would be a crying shame if it was allowed to close without a fight" (Anon 2007g).

The campaign was also often couched in the 'war discourse', making full use of the phrases, expressions and allusions to the conflict, thereby linking the present with the past event and evoking the sense of trauma associated with the war (see 'One last push to reach target by Xmas' (Anon 2008g: 8)). This maintenance of the trauma of the war is not limited to a particular political ideology or perspective. Indeed, elements of both the left and right of politics within Britain draw upon the sense of trauma but for differing agendas. This can be observed in the 'Lest we Forget' campaign in 2012 led by the conservative newspaper the *Daily Telegraph* to save 'our' war memorials'. In this initiative, the war memorials of the Great War were regarded as important for a national identity, something that 'we' should value as part of 'our' heritage. As emblematic of national, British unity the memorials of the Great War were valued by the campaign as a significant resource. However, it is through a lingering sense of trauma that this narrative is evoked:

> They were erected as permanent reminders of those who made the ultimate sacrifice for their country. Yet many of Britain's war memorials appear to have been forgotten (Lusher 2011).

> The last veterans of the Great War have died, but there is a pain of loss which continues from one generation to the next, and we ignore that suffering at our peril (Van Emden 2011: 8).

The trauma of the conflict, therefore, operates as a symbolic resource, enabling groups and communities to activate differing ideas through the same concerns. In this manner, trauma serves as a frame of reference through which the past and the present are viewed. This sense of trauma enables a critical, anti-democratic discourse to emerge as it places into question the ideals and values of current society.

It is within this sense of trauma that the cultural and artistic representation of the war can be understood. Critics of the popular memory of the First World War have often lamented the way in which opinion has been formed through film, television, drama and literature, but this neglects the way in which contemporary audiences use these representations to evoke and maintain the sense of trauma regarding the war in the present (Badsey 2001). In this mode of analysis, television programmes such as *Blackadder Goes Forth*, films such as *Oh! What a Lovely War* (1969) and recent novels such as *Birdsong* (Faulks 1993) do not shape or inform popular opinion, rather they are utilised by individuals and groups across society to perpetuate that sense of trauma (see Wilson 2008a). Whilst the limited narratives, stereotyped characters and piteous scenes that these media representations might possess have been used to demonstrate how the 'mud, blood, rats and gas' image of the war has been continuously repeated within the media, such analyses fail to comprehend why these particular representations find favour within society (after Wertsch 2002). They are valued above others because of what they do for communities, they provide a frame through which that sense of trauma can be reignited. Indeed, in this manner, characters, ideas and values from these representations are brought to bear on the present and examples such as *Blackadder Goes Forth* (1989) has thereby contributed to the wider lexicon and serves as a reference itself for both media and political discourse which is applied in a variety of contexts:

> The problem for today's politicians is that, unlike the generals on the western front they have to be elected. It looks a bit like the episode of *Blackadder Goes Forth* in which Edmund says of the latest big push: Haig is about to make another gargantuan effort to move his drinks cabinet six inches closer to Berlin. (Elliott 2011).

> I feel something of a fraud, writing a diary in wartime when I am as far away from the front as *Blackadder*'s General Melchett was (Mair 2003).

> I am grateful to the Hon. Member for Mid-Norfolk for drawing attention to *Oh! What a Lovely War* and *Blackadder Goes Forth*. That satire really made an impact on people of my generation, because we could see not only the futility of war, but the stupidity of those who were responsible for such actions. As my Hon. Friend the Member for Portsmouth, South said, not all officers led from the front. Of course, there were many brave officers, but there were those who did not get stuck in as the men at the front did (HC Deb, 18 January 2006, c258).

Alongside these well-studied examples of the cultural representations of the conflict, contemporary cultural and artistic responses can be understood in a similar perspective. Across the country, interest groups, theatre companies, schools and youth organisations regularly engage in projects that draw upon the trauma of the conflict. For example, in 2007 the *East Lancashire on Film* project, initiated to

screen important films of the region to the public, showed footage of the Accrington Pals departing the town in 1915 at the Accrington Local Library in an event which promised to bring 'history back to life' (Thacker 2007: 8). Similarly, in 2006 local newspapers reported how pupils at local schools in Accrington were working on a joint project to make 'comfort boxes', mimicking the wartime packages sent to soldiers at the front by families and friends. This act of mimesis provided a powerful means to connect pupils to the trauma of the war, experienced both at the front and behind the lines. One teacher remarked that:

> ... many of the pupils will have had ancestors who were affected by the war. They may have seen objects at home relating to it but never put it in context before. This project will help bring it alive for them (Anon 2006e: 6).

The recreation events, performed by professional and volunteer groups, that take place across Britain, which feature volunteers carrying out 'trench duties' whilst wearing 'authentic' uniforms and carrying replica equipment provide another means for this trauma to be evoked. Indeed, one of the more prominent recreation societies, the Great War Society, state this as their specific aim:

> We ... exist to further the memory of the soldiers of the Great War as the last Veterans inevitably pass away and what happened between 1914 to 1918 becomes merely another dusty history lesson to the children of today (Great War Society 2012).

The recreation of the conflict thereby serves as a poignant means in which to engage with the past as it asks members of public to bear witness to the trauma of the conflict as they observe the portrayal of individuals who are seemingly already doomed to take their place amongst 'the fallen' (after Dyer 1994). An event organised near Barnsley, Yorkshire, in 2008, provided just such a platform as organisers recreated the training for members of the 13th and 14th Battalions of the York and Lancaster Regiment, otherwise known as the Barnsley Pals:

> Many of them would travel to the front in northern France and never return, but yesterday a group of dedicated historians recreated the scene as it would have been before the Pals went abroad (Anon 2008h: 12).

Drama companies also rely on this trauma to provide arresting and emotive accounts of wartime life in plays and productions. For example, from 2008, *Holding Hands at Passchendaele* (2011), written by Irish playwright Martin Lynch, was toured across Britain. The drama depicted the story of an Irish soldier forced to guard a London-born soldier who had been accused of cowardice. The play focuses on the development of the relationship between the two men, as they recount personal experiences from the front and from home. However, this friendship is tempered by the poignancy of the fact that both men face uncertain

futures and possibly death which heightens the pathos of their situation. The audience see both men trapped by the social and political confines of the period where they are forced to capitulate to the military authorities in the continued pursuit of the war. Whilst the drama repeats a number of motifs and is reminiscent of the stage play *Hamp* (Wilson 1966), its demonstration of the trauma of war provides its audiences with a means to access the cultural and symbolic capital of the heritage of the Great War. The cultural and artistic responses to the conflict can, therefore, be assessed as part of the cultural heritage of the conflict. However, they do not form a structuring device in themselves through which audiences vapidly consume the representations they are provided with (after Fish 1980: 12). Rather, these depictions of the conflict find favour because of what they do for the individuals, groups and communities who witness them (see Samuel 1994: 5). These representations provide a means through which the trauma of the war can be brought to the present. They are mobilised as frames by their audiences through which comment and critique can be passed on the present (Wertsch 2002: 5). The almost ceaseless depiction of the Great War on screen and in novels provides audiences with a path to the historical trauma of the conflict, a trauma which can still be evoked within contemporary society.

Conclusions

The museums, memorials and the modern memory of the Great War in Britain provide a means of assessing the cultural heritage of the conflict. Each of these areas demonstrates how the conflict is reproduced, disseminated and utilised by various groups across society for particular agendas. As a frame of reference, museum exhibitions and displays ensure visitors partake of a particular 'vision' of the conflict, as witnesses to the past they are cast as moral observers and required to carry the burden of memory in the present (after Williams 2007). However, this remembrance is purely symbolic, visitors are required not to draw upon this act of witnessing to testify against the conflict or the authorities that led to its continuation. Instead, visitors are asked to hold onto the memory for the sake of remembering. This can be directly contrasted with the experience of visitors to online exhibitions and archives. Within these forums, visitors are provided with the means to pass comment and reflect upon the material present. Indeed, within some formats, visitors can actively participate in the collection, storage and interpretation of the Great War through providing their or their families' artefacts and accounts. This approach can be seen to be mirrored in the manner in which local interest groups draw upon the history of the Pals Battalions in their area. The Pals Battalions provide a means for stressing local identification and engagement, as the efforts of individuals from a local community are offered as an exemplum for contemporary society. In this approach, the Pals Battalions are viewed as emblematic of a *belle epoch*, a golden age of service, sacrifice and dedication. This identification with a glorious past does lead in some circumstance to the

appearance of an exclusory identity which disbars those who are not connected with the formative event which constitutes a local or national consciousness (after Alexander 2001: 7). However, what can certainly be discerned within this approach is the nature of the cultural heritage of the Great War in Britain as a critical and anti-democratic discourse (after Brown 2001). Indeed, the ability to use the Pals Battalions as a lesson above all others or to evoke the slogans 'fit for heroes' or 'home by Christmas' ensures that this aspect of the past is used to bring a greater focus on the present. The existence of this aspect of the cultural heritage of the war ensures that current members of the government, local authorities or any figure in a position of power can be assessed on this basis of responsibility and blame (Alexander 2012: 35). This serves to provide a final examination of why this traumatic history is still rehearsed within contemporary society (Wilson 2009). The identification of the trauma of the event has been dismissed by revisionist historians seeking to critique the popular perception of the conflict. In this interpretation, a sense of trauma regarding the past is viewed as a modern phenomenon without relevance to the events experienced by individuals at the time. This misunderstands the nature of historical trauma, as scholars have demonstrated its capacity to constitute a symbolic resource for contemporary societies (Edkins 2003). Framing the war as a 'traumatic event' thereby again enables its preservation as a mode of critical discourse. The trauma of the conflict is evoked through a variety of mediums, within political and media representation to the recreation societies and campaigners seeking to 'preserve' the memory of the war for the next generation. Therefore, in 'saving' the memorials and monuments for posterity, the tangible artefacts preserve the intangible sense of trauma which enables contemporary society to frame the present in the context of the past.

Chapter 7

Conclusions

The Great War still possesses a tremendous, evocative power across British society; it is capable of conjuring powerful, emotive images and ideas that resonate in the present. Such is the intensity of feeling that the mere mention of 'the trenches' elicits, a number of commentators have considered how the war appears so immediate, even after the last few remaining veterans of the conflict have passed on (after Dyer 1994). There are some who consider the presence of the war within current society as an inevitable product of the mass death witnessed on the battlefields of the Western Front, Gallipoli, Italy, Salonika as well as the theatres of war in Africa, the Middle East, the Atlantic and the North Sea (see Holmes 1998: 8–10). In total, over 700,000 individuals from Britain lost their lives during the conflict, a figure which bears no testament to the countless others who suffered bereavement and grief at the loss of a loved one. The chronological distance from this trauma has often been stated by revisionist historians, keen to promote a 'factual' account of the conflict, as a reason to disavow the 'emotive' accounts of the war that reflect the words of the war poet Wilfred Owen (1965: 52), 'the pity of war, the pity war distilled'. However, despite the efforts to provide a rendering of the conflict which is beyond the 'veil of sentimentality', the popular perception of the conflict as a futile endeavour, wrought by national self-interest and perpetuated by an incompetent political and military elite that resulted in the needless deaths of hundreds of thousands of people is still dominant across Britain (after Sheffield 2002: 12). Contrary to the opinions of those who seek to disrupt this notion, the public understanding of the conflict is not derived from the media representations of the war (contra Todman 2005). It is created and recreated by those who seek to establish its relevance in the present. This mobilisation of the conflict to serve current contexts is enabled by the cultural heritage of the Great War, the material and ethereal artefacts that stem from the conflict which are brought to bear upon contemporary society.

The Dissonance of the Cultural Heritage of the Great War

It is this intangible heritage, specifically through the uses of phrases, imagery, perspectives, metaphor, allusion and direct reference, which has been the focus of concern in this analysis. Through the study of this use of heritage, this study has highlighted how the Great War is mobilised by individuals, communities and groups across Britain to pass comment on the present, to validate ideas in the present and to activate identity in the present. This intangible heritage of the conflict in

Britain has been largely neglected in the assessment of the 'popular memory' of the war. The monuments, memorials, dramas, novels, television programmes and the historiography of the war have elicited more debate than the manner in which the war functions for society within Britain (see Todman 2005; Bond 2002). These studies have concentrated on locating the origin point of the 'myths and memory' of the conflict, to stress the fabricated, 'ahistorical' nature of the 'mud, blood, rats and gas' perception of the war in Britain (Corrigan 2003: 6). Indeed, scholars have focused entirely on this 'invention of tradition', rather than locating the motivations for framing and referencing contemporary issues through the cultural heritage of the First World War. Such an approach prevents a due consideration of why the conflict, which was fought at the outset of the twentieth century, provides context and meaning for contemporary society across the regions and nations within Britain. This assessment is necessary as it reveals the values, ideals and beliefs that drive the maintenance of the memory of the war. What can be discerned from an examination of how and why the heritage of the Great War is utilised is a demonstration of how heritage functions within a critical capacity. As Smith (2004) has demonstrated, 'heritage' is frequently packaged by national governments and global organisations as an object of inherent value which possesses a reassuring quality that establishes normative values. However, Smith (2006) challenges this 'inert' understanding of 'heritage' by demonstrating its capacity to possesses a dissonant quality, as subaltern histories serve as a means to disrupt hegemonic structures, challenge established values and provide alternative frameworks in which to understand the past and the present. It is in this context that the cultural heritage of the Great War can be comprehended, as various groups and agendas draw upon the 1914–1918 war as a critical mode of discourse in the present.

Through this assessment, the cultural heritage of the Great War can be observed as a vehicle for anti-democratic sentiment. This application of heritage is not restricted to a particular political ideology. Indeed, elements of both the left and right of the political agenda within Britain utilise the heritage of the conflict to forward their viewpoint and to critique present modes of governance. The cultural heritage of the Great War serves as a frame of reference through which direct assessments of current society can be made. The notion of anti-democracy employed here does not entail a direct attack on the institutions of democracy, rather a critique of the institutions that pertain to hold democratic values. This mode of thinking follows the work of Wendy Brown (2001: 122), who postulates on the need for democratic institutions to possess an anti-democratic critique to serve as a bulwark against lapses in principle, the abuse of power and the descent into what de Tocqueville (1875: 262) termed 'the tyranny of the majority'. In Brown's (1995; 2001) assessment, traumatic events from the past can perform a vital function within society by insisting upon their recognition as a failure of democracy. The place of unresolved past injustices, either perceived or experienced, is one which haunts and restrains the contemporary political landscape by acting as an exemplum, a challenge to the operation of power within society (Alexander 2001, 2012). The corresponding identity politics based upon victimhood are also

assessed by Brown (1995). In this manner, association with a past group who are considered to have been 'victims' or experienced suffering provides a critique of power relations when it is directed at the institutions of accountability (Brown 1995: 70). It is in this assessment that the function of the cultural heritage of the Great War can be understood, as its presence within society across Britain operates to disrupt, challenge and demand accountability from authorities. In a period of decentralised politics and liberal-democratic consensus in Britain as in other western democracies, the presence of this dissonant heritage operates as a significant function for society.

This usage of the heritage of the Great War can be directly witnessed in the framing of the wars in Iraq and Afghanistan with reference to the conflict of 1914–1918. The use of references, allusions and phrases from the First World War to describe or to critique the pursuit of the conflict in both theatres of war formed a means to disrupt the operation of the war. In this manner, references to a war which was fought without reason or concocted from national self-interest, a war which seemingly had no definite conclusion and resulted in the mutilation and death of members of a young generation possessed a distinct emotive and evocative power within society. The dissonant function of the cultural heritage of the Great War, therefore, provides a means to heighten current contexts by drawing association and allusions with an event which constitutes an acknowledged trauma (after Eyerman 2001: 12). It is employed to critique the operation of authorities as it demands an acknowledgement that the same processes that led to the deaths of hundreds and thousands is being pursued within contemporary contexts. However, whilst the heritage of the Great War is employed to critique contemporary military operations, it is also mobilised in a far wider context to draw attention to the failures or incompetency of authorities. In this manner, individuals can be 'in the trenches' over reforms to health services, education or policing. It is within this critical, anti-democratic context that the heritage of the 1914–1918 conflict is employed to demonstrate against the perceived abuse of power in the present.

Despite or perhaps because of this potential to demand accountability and responsibility from authorities, the heritage of the Great War in Britain has also been frequently mobilised to cement normative and hegemonic concepts. Appeals to national consensus, traditional values and self-sacrifice underlie this utilisation of heritage, mirroring the post-war commemorative schemes that sought to establish the memory of the war as one of service to 'King and Country' (see Bushaway 1992). In this manner, the dissonant nature of the heritage of the conflict is neutralised, rendered without political association as the significance of 'witnessing' the service and sacrifice of others is cast as important in itself. What this demonstrates is the malleability of the cultural heritage of the Great War, its ability to be mobilised by varying groups for very different agendas. Nevertheless, it is in this fluidity that the reformative capacity of the heritage of the conflict can be observed most clearly. Certainly, what is apparent from an assessment of the cultural heritage of the Great War is that this critical capacity to demand redress and responsibility from governing structures is used by all political ideologies across society. Elements of

both the left and the right draw upon the heritage of the Great War to further their agendas. Whilst left-leaning and socialist perspectives use the conflict to argue against class oppression or nationalistic agendas in the present, conservative and right-wing elements consider the war as a lesson in official neglect and abandonment of 'traditional' virtues and values. Whilst the objectives differ in these uses of heritage, the means do not: the heritage of the Great War is mobilised as a critical, anti-democratic presence for contemporary society.

The Utility of the Cultural Heritage of the Great War

Within this capacity of the cultural heritage of the conflict we can discern the reason for the continuing fascination with a war that is now frequently regarded as having passed beyond 'living memory' with the deaths of the remaining veterans. The First World War maintains its unique place across British society because it possesses a utility for those individuals, groups and societies who use it (after Samuel 1989, 1994). Framing contemporary concerns with the phrases, images and perspectives of the 1914–1918 conflict provides a powerful means of demonstrating ideas and forwarding identities. This usage of heritage is also undertaken within a critical context, as to claim to be 'in the trenches', left in 'no man's land' or facing individuals with 'entrenched' viewpoints immediately associates with a sense of victimhood, suffering and responsibility. It places the individual who uses these allusions within a particular and communicable context that draws upon the social, cultural and political capital associated with the misery and torment of soldiers during the Great War (after Scarry 1985). Similarly, the activation of specific images from the war, such as the trenches or no man's land is a direct use of the cultural heritage of the Great War to demonstrate issues of power, politics and identity in the present. What is evident from the study of the heritage of the conflict is this utilitarian aspect; for a conflict that is now regarded as having moved beyond 'living memory', the war is curiously still alive in the manner in which it is evoked across British society.

It is this aspect of the cultural heritage that ensures that the war retains its status as a continuing trauma and why attempts at revising the 'popular memory' of the conflict have failed even by the admission of some historians (sees Sheffield 2002). Due to its utility, its ability to be mobilised for contemporary concerns, the trauma of the conflict must be maintained. The Great War still evokes great emotion, poignancy and pity because its function within society is to serve as a site of trauma (after Alexander 2001: 7). To render this event into 'history' would be to deprive it of its contemporary significance and its relevance for modern society (after Roth 1995). Therefore, the pain and trauma of the conflict is maintained as a modern phenomenon (Wilson 2009). This can be observed in the continuing interest with the Pals Battalions and the interest in providing new memorials to 'keep alive' the memory of those who joined up, trained, served and died together. By continuing this memory for the community, the trauma of the event is held

and can, therefore, be evoked to establish aspects of identity for that locality. In assuming that the media representations of the conflict have ensured that the war is recalled through the image of the pitiable soldiers suffering heroically and stoically in the trenches the critics of the popular memory of the conflict have misunderstood the uses of the heritage of the Great War. The media representations of the war do not depict the event as a trauma, the war is perceived by aspects of society as a trauma because it fulfils a function for those groups and serves as the basis for identity and claims for validity and recognition.

It is within this utility that the heritage of the Great War can be observed to provide society in Britain with a range of identities within the present. These can be summarised into three areas:

- Political identity – The heritage of the Great War possesses a strong radical agenda purporting to take the view of the working classes or the disenfranchised, which seeks to criticise authority, challenge the orders of the political class and places itself within an anti-war tradition.
- Social identity – The heritage of the Great War forms a social agenda in its association of camaraderie, its connection with the 'Pals Battalions' and its use as a unifying device across different communities in Britain.
- Ethical identity – The heritage of the Great War constitutes an ethical stance through its relation with the 'suffering' of the soldiers in the trenches as it constructs identification with a historical 'trauma' and builds a sympathetic link to the past.

Through the uses of the cultural heritage of the Great War, individuals and groups utilise and form themselves through these identities. This can most emphatically seen with the Shot at Dawn campaign which cast itself as possessing an ethical or moral concern, but it can also be observed with the framing of the twenty-first-century wars in Iraq and Afghanistan through reference to the First World War, as concern for the suffering of the troops is expressed. Whilst these identities have been explored within this investigation, as the cultural heritage of the war has been utilised to serve political, social and ethical agenda, the limitations of this heritage must be acknowledged. Certainly, the cultural heritage of the war in Britain focuses upon a particular image of a male, white, combatant in the trenches of the Western Front. The role of women, children, non-combatant men, African and Asian men and the significance of the home front and battlefields elsewhere in Europe, Africa and the Middle East would appear to condemn this heritage as at best inadequate and at worst wilfully deficient. The cultural heritage of the war could, therefore, appear to be the product of a narrow sense of nationalism and ingrained misogyny across British society. However, this criticism of the cultural heritage of the war discounts the value of its place within wider society and assumes that absences within its construction are indicative of society's failings. Rather, the ability of the cultural heritage of the conflict to critically assess society does not demonstrate exclusivity; it exists as a device which can be drawn upon by

wider society regardless of ethnicity, gender or class. The cultural heritage of the war, as an exemplum or lesson of responsibility, critique of authority, empathetic understanding and the way in which power is abused considers themes which are apparent and of concern to various groups within society.

The Frames of the Cultural Heritage of the Great War

Throughout this analysis, the usage of 'frame analysis' as a means of assessing the uses of the cultural heritage of the Great War has been forwarded. By applying this approach, this assessment has demonstrated how the intangible heritage of the First World War is used to outline and structure issues and debates in the present. The issue of 'framing the past' in the present has been explored in the wider context of heritage studies as a means of analysing the manner in which history is presented and consumed by visitors to heritage sites and within the wider media (see Johnson 1999b; Pearce 1998). However, other studies have also drawn upon similar concepts to examine how heritage is structured, framed and experienced through discourse, imagery and perspective (see Smith 2006; Waterton 2010; Waterton and Watson 2011). Following on from these works, frame analysis is employed within this study, not as a means to understand how the present structures the past, but how the past is mobilised to structure and frame the present. Through frame analysis, another means of assessing the uses of heritage can be considered, where 'heritage' is not considered a passive source of material or cultural capital to be drawn upon by groups and organisations in the present, rather 'heritage' possesses an active agenda which constrains and challenges the present (Harvey 2001). In this respect the understanding of 'frame analysis' within this assessment is underscored by the philosophy of critical realism (Bhaskar 1978, 1979, 1986, 1991). Within this understanding, the 'past', 'heritage' or 'history' has a definite, irrefutable reality; however, the comprehension of this reality is historically and socially constructed in the present (after Smith 2006). Contemporary society possesses a transitive knowledge of past events, but that transitive knowledge is constituted by the conditions of the present:

> ... the intransitive objects of knowledge are in general invariant to our knowledge of them; they are the real things and structures, mechanisms and processes, events and possibilities of the world (Bhaskar 1978: 22).

Bhaskar (1978) thereby provides an alternative to Foucault's (1975) 'genealogy' or 'archaeology' which postulates systems of thought and knowledge, structured by discourse, image and language, which govern the consciousness of individuals and limit a set of possibilities of engagement. It also rejects the notion that events are purely a discursive formation, constructed in retrospect by a society that remakes the past in the guise of itself (after Derrida 1976). Within Bhaskar's (1978) conception, the past events constitute a definite reality which current society

attempts to understand and possess. This does not denigrate either the formative events themselves or the later attempts to comprehend them, it demonstrates that the comprehension of the past, or notions of heritage, are constituted in the present by current agendas but base themselves on a reality which will always be unknowable.

It is in this respect, that the application of 'frame analysis' to heritage studies is able to consider the contribution of Raphael Samuel (1989, 1994). Samuel's insistence on the production of history as the work of a wider social basis demonstrates the applicability of 'frame analysis' within the critical study of heritage. Samuel (1994: 8) stated that 'history is a social form of knowledge; the work, in any given instance of a thousand different hands'. Therefore, the variety of ways of 'seeing' the past through the frames or 'lenses' of religion, class, gender, politics or personal history evidence a requirement for an understanding of the structures present within the public apprehension and use of heritage (see Graham and Howard 2008, Howard 2003):

> The validity of a particular lens may also be situationally determined rather than a constant while the interpretations will vary depending on the situation of the observer in time and space. Thus, it is meaning that gives value, either cultural or financial, to heritage and explains why certain artefacts, traditions and memories have been selected from the near infinity of the past (Graham and Howard 2008: 2).

Within this assessment, the manner in which individuals, groups and communities place the present in the context of the past is dependent on their perspective, their background and their own personal agenda. As Hall (1997: 61) has stated, 'it is us – in society, within human culture – who make things mean, who signify. Meanings, consequently, will always change, from one culture or period to another'. Within frame analysis, these structures are active constituents of knowledge, providing their viewer with a particular stance both on the past but also with regard to the present. Rather than limiting the study of the frames of heritage to how individuals, groups and communities correspond to history, these frames of reference can be shown to have a definite effect upon the contemporary political, social and cultural landscape (see Smith et al. 2010; Ashworth and Graham 2005). Therefore, frame analysis constitutes a valuable tool for studies of heritage as it enables scholars to assess both the 'construction of perception' as well as the 'object of perception' (after Goffman 1974: 3). Within frame analysis, the significance of study is located in the ways in which structures of knowledge outline ideas, values and perceptions within society. This is not merely an acceptance of relativism, but an acknowledgement that the interpretation of a reality is dependent upon the context of the individual:

> Framing is a process whereby communicators, consciously or unconsciously, act to construct a point of view that encourages the facts of a given situation to be

interpreted by others in a particular manner. Frames operate in four key ways: they define problems, diagnose causes, make moral judgments, and suggest remedies. Frames are often found within a narrative account of an issue or event, and are generally the central organising idea (Kuypers 2006: 8).

Whilst the employment of frame analysis as a medium in which to examine the role of heritage within contemporary life can assist in the development of interpretations as to how views on the past are mobilised and activated in and for the present, it does present particular methodological problems. Indeed, the wider methodological issue that besets frame analysis is the manner in which those frames are identified and delineated (see Maher 2001). However, within this assessment, the work of Fairclough (1995) is of particular use as it is through the definition of discourses, both verbal and non-verbal that the specific frames used to mobilise the heritage of the Great War can be located. Fairclough (1995) forwards the use of critical discourse analysis as a means of understanding the structures used within the social, political and media spheres. These structures are identified through repetition and similarity and demonstrate the existence of relations of power, domination and resistance (Fairclough 2001). Therefore, the frames through which heritage is perceived and activated as a critical engagement with the past and the present can be examined in a similar fashion. In the context of this study, the cultural heritage of the Great War can be identified within the use and presence of phrases, expressions, imagery and perspectives across a variety of media within contemporary British society.

It is through these frames that individuals, groups and societies place value, association and meaning on the present. The outlining of current issues with past events demonstrates the ways in which the cultural heritage of the Great War forms a significant element within society across modern Britain. In this way, an event which occurred at the beginning of the twentieth century, which concerned individuals who have now passed away and which was fought for reasons now largely unfathomable for contemporary society is brought to bear on current contexts and is found to be meaningful and relevant. Therefore, the cultural heritage of the Great War can be identified as possessing a structural, dissonant and potentially transformative effect for those who utilise it. The way in which the past is used to outline the present, to evoke arguments, ideas and agendas demonstrates the critical capacity of heritage studies to identify and define the uses of history for society (see R. Harrison 2012). This critical agenda within heritage studies has emerged as a means to move beyond issues of mere classification and conservation but to radically engage with why societies choose to remember their pasts in particular ways and how that remembrance shapes and informs the present (see Graham and Howard 2008; Smith et al. 2012; Waterton and Watson 2011). As the events of 1914–1918 recede further into the past and generations become increasingly chronologically distant from the First World War, it will be through the critical study of the tangible and intangible legacies of the war that the conflict's place within society can be assessed. Whilst the cultural heritage of the conflict

can be examined as fluid, altering with the concerns and desires of the current societal contexts, the value and utility of the Great War will endure because of its function for groups and communities. In this manner, every generation across Britain will possess the opportunity to return to 'the trenches', to locate meaning, relevance and understanding for its contemporary fears and desires. In this respect, the Great War is not over.

Bibliography

Adam-Smith, P. 1978. *The Anzacs*. Melbourne: Nelson Press.

Adams, S. 2009. Tony Blair 'misled' country over Iraq war, parents of dead soldiers tell inquiry. *Daily Telegraph* [Online 14 October]. Available at: http://www.telegraph.co.uk/news/uknews/defence/6318079/Tony-Blair-misled-country-over-Iraq-war-parents-of-dead-soldiers-tell-inquiry.html [accessed 14 October 2009].

Alba, C. 1999 Pardon at Last for Scots Shot at Dawn. *Daily Record*, 27 October, 12.

Aldington, R. 1929. *Death of a Hero*. London: Chatto and Windus.

Alexander, A. 2012. What will U.S. warlords lead us into next? *Daily Mail*, 29 May, 12.

Alexander, J.C. 2001. Toward a Theory of Cultural Trauma, in *Cultural trauma theory and applications*, edited by J. Alexander, R. Eyerman, B. Giesen, N. Smelser and P. Sztompka. Berkeley, CA: University of California Press, 1–31.

Allardyce, J. 1999. Pardon Great War deserters urge MSPs. *The Times*, 12 November, 6.

Ammer, C. 1989. *Fighting Words: From War, Rebellion, and Other Combative Capers*. New York: Paragon.

Anderson, B. 1983. *Imagined Communities: Reflections on the Origin and Spread of Nationalism*. London: Verso.

Anon 1918. What is our task? To make Britain a fit country for heroes to live in. *The Times*, 25 November.

Anon, 1998. Why do we let this man cast a shadow over our war dead? *Daily Express*, 6 November, 1.

Anon, 2002a. Proud to be British. *Daily Post*, 18 March, 16.

Anon, 2002b. March plan to win pardons. *Bradford Telegraph and Argus*, 9 November, 11.

Anon, 2003a. Truth and the trenches. *The Scotsman*, 6 September, 19.

Anon, 2003b. War of attrition: Labour's discontents grow as the war against Iraq proceeds. *The Economist*, 3 April, 17.

Anon, 2003c. Diaries reveal what life was like in the trenches. *The Journal*, 11 November, 8.

Anon, 2003d. Never on our side. *Socialist Worker: Issue 1844*, 29 March, 13.

Anon, 2004a. Military families against the war. *Socialist Worker*, 20 November, 4.

Anon, 2004b. Progress in fight for shot-at-dawn pardons. *The Journal*, 29 March, 5.

Anon, 2004c. Gallipoli: town to honour the heroes. *Bury Times*, 22 April, 6.

Anon, 2005a. War veteran recalls Christmas truce. *Evening Telegraph and Post*, 7 November, 12.

Anon, 2005b. Town prepares to salute Gallipoli heroes. *Bury Times*, 23 April, 5.

Anon, 2005c. Pride of Lancashire. *Lancashire Evening Press*, 18 April, 9.

Anon, 2006a. The war over pity. *The Economist*, 17 August, 23.

Anon, 2006b. Pardons in sight for Great War soldiers shot at dawn. *The Scotsman*, 16 August, 4.

Anon, 2006c. My uncle was shot at dawn for simply following orders. *Northern Echo*, 21 June, 7.

Anon, 2006d. In July 1916 eager recruits faced their first major battle. *The Scotsman*, 11 November, 4.

Anon, 2006e. Pupils bring the First World War back to life. *Accrington Observer*, 30 June, 6.

Anon, 2007a. Second strike announced as civil service row escalates. *Daily Mail* [Online 23 April]. Available at: http://www.dailymail.co.uk/news/article-450100/ Second-strike-announced-civil-service-row-escalates.html [accessed 25 April 2009].

Anon, 2007b. Barrage of criticism for Hewitt. *Daily Express*. [Online 23 May]. Available at: http://www.express.co.uk/news/uk/7774/Barrage-of-criticism-for-Hewitt [accessed 25 May 2007].

Anon, 2007c. Call time on Blair. *Morning Star* [Online 17 January]. Available at: http://www.morningstaronline.co.uk/index.php/news/content/view/full/40316 [accessed 18 March 2008]

Anon, 2007d. Remembering a lost generation. *Jarrow and Hebburn Gazette*, 8 November, 5.

Anon, 2007e. Royal tribute to Passchendaele dead. *Metro*, 12 July, 5.

Anon, 2007f. Time to honour brave pals. *Leyland Guardian*, 22 February, 6.

Anon, 2007g. Observer launches appeal to save Pals Chapel. *Accrington Observer* [Online 19 October]. Available at: http://www.accringtonobserver.co.uk/ news/local-news/observer-launches-appeal-to-save-pals-1269288 [accessed 19 October].

Anon, 2008a. Creditors left in no-man's land over bust NHS Foundation Trusts. *Daily Mail* [Online 27 December]. Available at http://www.dailymail.co.uk/ money/article-1102163/Creditors-left-mans-land-bust-NHS-Foundation-Trusts. html [accessed 1 January 2009].

Anon, 2008b. Prince Harry in Taliban Gun Battle. *Daily Telegraph* [Online 28 February]. Available at: http://www.telegraph.co.uk/news/uknews/1580113/ Prince-Harry-in-Taliban-gun-battle.html [accessed 25 March 2008].

Anon, 2008c. Ministers' pensions rise despite credit crunch. Morning Star [Online 30 December]. Available at: http://www.morningstaronline.co.uk/news/content/ view/full/70043 [accessed 24 September 2010].

Anon, 2008d. The Christmas Miracle. *The Guardian*, 10 November, 19.

Anon, 2008e. Letters from Bristol's lost generation. *Western Daily Press*, 11 November, 9.

Anon, 2008f. Commemorating the Great War. *Shetland Times*, 14 November, 6.

Anon, 2008g. One last push to reach target by Xmas. *Accrington Observer*, 21 November, 8.

Anon, 2008h. Re-enactment revives memories of the Great War trenches. *Yorkshire Post*, 12 May, 12.

Anon, 2009a. 150 soldiers claim £6m for suffering 'cold injury' on duty, *The Scotsman* [Online 16 June]. Available at: http://www.scotsman.com/news/uk/150-soldiers-claim-163-6mfor-suffering-cold-injury-on-duty-1-1042603 [accessed 4 July 2009].

Anon, 2009b. Afghanistan battle like First World War. *The Telegraph*, 4 January, 7.

Anon, 2009c. Warwickshire soldier's account of Christmas truce in the trenches. *Kenilworth Weekly News*, 9 April, 8.

Anon, 2009d. Take Your Place to Remember Lost Generation; Service at Abbey to Pay Tribute to Heroes. *Evening Post*, September 24, 7.

Anon, 2009e. After 85 years, Haig's statue finally retreats inside Edinburgh Castle. *The Scotsman* [Online 16 June]. Available at: http://www.scotsman.com/news/scottish-news/top-stories/after-85-years-haig-s-statue-finally-retreats-inside-edinburgh-castle-1-1042602 [accessed 20 August 2009].

Anon, 2010a. Shell-shocked Afghanistan war veteran. *Daily Mail* [Online 26 October]. Available at: http://www.dailymail.co.uk/news/article-1323854/I-wont-lie-going-hurt-Chilling-words-shell-shocked-Afghanistan-war-veteran-stabbed-girlfriend-stomach.html [accessed 5 November 2010].

Anon, 2010b. The Labour election, the rich. Socialist Worker [Online 28 September]. Available at: http://www.socialistworker.co.uk/art.php?id=22577 [accessed 2 October 2010].

Anon, 2010c. North East falls silent for Armistice Day. *The Journal*, 12 November, 3.

Anon, 2010d. Comments: Preview - Our dear pals and the Great War exhibition in Accrington. *Lancashire Telegraph* [Online 11 July]. Available at: http://www.lancashiretelegraph.co.uk/leisure/whats_on/exhibitions/8262000.Preview_Our_Dear_Pals_and_the_Great_War_Exhibition_in_Accrington/[accessed 13 September 2010].

Anon, 2010e. Comments: Preview – Our dear pals and the Great War exhibition in Accrington. *Lancashire Telegraph* [Online 11 July]. Available at: http://www.lancashiretelegraph.co.uk/leisure/whats_on/exhibitions/8262000.Preview_Our_Dear_Pals_and_the_Great_War_Exhibition_in_Accrington/[accessed 13 September 2010].

Anon, 2011a. Stray dogs, abandoned cows ... and the rice farmers who refuse to go: The only living things left in Japan's nuclear no-man's land. *Daily Mail* [Online 30 March]. Available at: http://www.dailymail.co.uk/news/article-1371103/Japan-nuclear-crisis-Fukushima-mans-land-rice-farmers-refuse-go.html [accessed 5 April 2011].

Anon, 2011b. Riots in England: The Fire This Time. *The Economist* [Online 13 August]. Available at: http://www.economist.com/node/21525945 [accessed 2 September 2011].

Anon, 2011c. News from the PM's bunker. Morning Star [Online 23 August] Available at: http://www.morningstaronline.co.uk/news/content/view/full/108619 [accessed on 22 July 2012].

Anon, 2011d. Remembrance Sunday: Amazing story of 'shot at dawn' soldier, the luckiest Tommy alive. *Daily Mirror* [Online 13 November] Available at: http://www.mirror.co.uk/news/uk-news/remembrance-sunday-amazing-story-of-shot-91195 [accessed 22 November 2011].

Anon, 2011e. The amazing football truce. *Lancashire Evening Post*, 23 December, 9.

Anon, 2011f. Poppy-burning Muslims plan new 'Hell for Heroes' demonstration on November 11. *Daily Mail* [Online 31 October]. Available at: http://www.dailymail.co.uk/news/article-2055365/Poppy-burning-Muslims-plan-new-hell-heroes-demonstration-November-11.html [accessed 19 November 2011].

Anon, 2011g. Scotland remembers the fallen on Armistice Day. *The Scotsman* [Online 12 November]. Available at: http://www.scotsman.com/news/scottish-news/top-stories/scotland-remembers-the-fallen-on-armistice-day-1-1961242 [accessed 16 November 2011].

Anon, 2011h. Voice From the Back. *Socialist Standard, 1288: December Issue*, 24.

Anon, 2011i. Comments: Faces of the First World War [Online 11 November]. Available at: http://www.flickr.com/photos/imperialwarmuseum/sets/721576279105 30369/comments/[accessed 12 June 2012].

Anon, 2011j. Comments: Faces of the First World War [Online 11 November]. Available at: http://www.flickr.com/photos/imperialwarmuseum/sets/721576279105 30369/comments [accessed 12 June 2012].

Anon, 2011k. Comments: Faces of the First World War [Online 11 November]. Available at: http://www.flickr.com/photos/imperialwarmuseum/sets/721576279105 30369/comments/[accessed 12 June 2012].

Anon, 2011l. Comments: Faces of the First World War [Online 11 November]. Available at: http://www.flickr.com/photos/imperialwarmuseum/sets/721576279105 30369/comments/[accessed 12 June 2012].

Anon 2011m. Comments: Faces of the First World War [Online 11 November]. Available at: http://www.flickr.com/photos/imperialwarmuseum/sets/721576279105 30369/comments/[accessed 12 June 2012].

Anon, 2011n. Comments: Faces of the First World War [Online 11 November]. Available at: http://www.flickr.com/photos/imperialwarmuseum/sets/721576279105 30369/comments/[accessed 12 June 2012].

Anon, 2011o. Unearthing the true extent of the Chums' sacrifice. Grimsby Telegraph [Online 13 June]. Available at: http://www.thisisgrimsby.co.uk/Unearthing-true-extent-Chums-8217-sacrifice/story-12759840-detail/story.html [accessed 15 July 2011].

Anon, 2011p. Comments: Family's ultimate sacrifice for King and Country. *The Scotsman* [Online 26 August]. Available at: http://www.scotsman.com/the-scotsman/scotland/family-s-ultimate-sacrifice-for-king-and-country-1-1814698 [accessed 14 September 2011].

Anon, 2011q. Comments: Family's ultimate sacrifice for King and Country. *The Scotsman* [Online 26 August]. Available at: http://www.scotsman. com/the-scotsman/scotland/family-s-ultimate-sacrifice-for-king-and-country-1-1814698 [accessed 14 September 2011].

Anon, 2012a. In the Trenches: Fighting Racism Online. *Gizmodo* [Online 27 January]. Available at: http://www.gizmodo.co.uk/2012/01/fighting-online-racism/[accessed: 25 June 2012].

Anon, 2012b. Prince Harry in Afghanistan: the radio operator known only as Widow Six Seven. *Daily Telegraph* [Online 9 February]. Available at: http://www.telegraph.co.uk/news/uknews/theroyalfamily/9069593/Prince-Harry-in-Afghanistan-the-radio-operator-known-only-as-Widow-Six-Seven.html [accessed 23 February 2012].

Anon, 2012c. Same donkeys are running Britain into the ground. *Morning Star* [Online 6 July 2012]. Available at: http://www.morningstaronline.co.uk/news/content/view/full/1210 88 [accessed 7 July 2012].

Anon, 2012d. Time to bring our lions home. *Mid Devon Gazette*, March 13, 9.

Anon, 2012e. *Untold Stories of the First World War. Europeana 1914–1918* [Online 18 November]. Available at: http://exhibitions.europeana.eu/exhibits/show/europeana-1914-1918-en/the-unexpected/saved-after-two-painful-days [accessed 5 May 2012].

Anon, 2012f. *Untold Stories of the First World War. Europeana 1914–1918* [Online 18 November]. Available at: http://exhibitions.europeana.eu/exhibits/show/europeana-1914-1918-en/the-unexpected/teenager-turns-medic [accessed 5 May 2012].

Anon, 2012g. Remembrance ceremony for Chorley Pals. *Chorley Citizen*, 30 June, 3.

Anon, 2012h. City remembers tragic heroes. *Lancashire Evening Press*, 23 July, 7.

Anon, 2012i. Station to be troops' memorial. *Lancashire Evening Press*, 12 June, 6.

Antze, P. and Lambek, M. (eds) 1996. *Tense Past: Cultural Essays in Trauma and Memory*. New York: Routledge.

Appleton, D. 2004. War's lost generation remembered forever. *Rochdale Observer*, 29 December, 6.

Arbuthnot, F. 2007. The prince goes to Iraq. *Morning Star* [Online 5 March]. Available at: http://www.morningstaronline.co.uk/news/content/view/full/42348 [accessed on 23 July 2007].

Arnold, J., Davies, K. and Ditchfield, S. (eds) 1998. *History and Heritage: Consuming the Past in Contemporary Culture*. Shaftsbury: Donhead Publishing.

Arthur, M. 2007. *The Faces of World War I: The Great War in Words and Pictures*. London: Cassell.

Ashcroft, A. 2011. Today, Remembrance Day, let us recall the bravery of the fallen. *Conservative Home* [Online 11 November] Available at: http://conservativehome.blogs.com/platform/2011/11/lord-ashcroft-today-

remembrance-day-let-us-recall-the-bravery-of-the-fallen.html [accessed 25 May 2012].

Ashplant, T.G., Dawson, G. and Roper, M. (eds) 2000. *The Politics of War Memory and Commemoration, Routledge Studies in Memory and Narrative.* London: Routledge.

Ashworth, G.J., Graham, B. and Tunbridge, J.E. 2007. *Pluralising pasts. Heritage, identity and place in multicultural societies.* London: Pluto Press.

Ashworth, G.J. and Graham, B. 2005. Senses of Places, Senses of Times and Heritage, in G.J. Ashworth and B. Graham (eds) *Senses of Places: Senses of Time.* Aldershot: Ashgate, 3–14.

Ashworth, T. 1980. *Trench Warfare, 1914–1918: The Live and Let Live System.* New York: Holmes & Meier.

Asquith, H. 1928. *Memories and Reflections, Vol. II, 1852–1927.* London: Cassell.

Austin, M. 2008. Wilfred Owen's sad bugles still call. *Daily Mirror,* 20 July, 8.

Badsey, S. 2001. Blackadder Goes Forth and the "two Western Fronts" debate, in *The Historian, Television and Television History,* edited by G. Roberts and P.M. Taylor. Luton: University of Luton Press, 113–25.

Badsey, S. 2002. The Great War Since The Great War. *Historical Journal of Film, Radio and Television,* 22(1), 7–19.

Badsey, S. 2009. *The British Army in battle and its image 1914–1918.* London: Continuum.

Bagley, R. 2004. Black Watch 'back for Christmas'. *Morning Star* [Online 21 October]. Available at: http://www.morningstaronline.co.uk/index.php/news/content/view/full/4511 [accessed 2 December 2011].

Bal, M., Crewe, J.V. and Spitzer, L. (eds) 1999. *Acts of Memory: Cultural Recall in the Present.* Hanover, NH: University Press of New England.

Baldwin, S. 1928. *A Revelation and a Comfort: Impression of the Cemeteries. War Graves of the Empire.* London: The Times, 3.

Banks, M. and Morphy, H. (eds) 1999. *Rethinking Visual Anthropology.* New Haven and London: Yale University Press.

Banks, T. 2012. A very dirty war: British soldiers shot dead by enemy troops waving the white flag and Argentinean prisoners bayoneted in cold blood. An ex-Para tells of the horrors of the Falklands. *Daily Mail* [Online 2 March] Available at http://www.dailymail.co.uk/news/article-2109429/A-dirty-war-British-soldiers-shot-dead-enemy-troops-waving-white-flag-Argentinian-prisoners-bayoneted-cold-blood-An-ex-Para-tells-horrors-Falklands.html [accessed 3 March 2012].

Barber, H. 2012. Remembrance Service for the Yorkshire Regiment, Halifax Minster [Online 11 March]. Available at: http://www.halifaxminster.org.uk/index. php/sermons/134-service-of-remembrance [accessed 22 June 2012].

Barker, P. 1991. *Regeneration.* London: Penguin.

Barrett, F. 1993. Poignancy without pomp and poppies. *Independent,* 3 November, 7.

Barrow, B. 2011. Youth unemployment crisis warning: A 'lost generation' blighted by debt, depression and self-loathing. *Daily Mail* [Online 17 November]. Available at: http://www.dailymail.co.uk/news/article-2062493/ Lost-generation-blighted-unemployment-risk-debt-depression-self-loathing-warn-experts.html [accessed 22 November 2011].

Barthes, R. 1984. *Camera Lucida*. London: Fontana.

Basketter, S. 2010. Poppies help our rulers forget. *Socialist Worker*, 16 November, 5.

Becker, A. and Audoin-Rouzeau, S. 2002. *14–18: Understanding the Great War*. New York: Hill and Wang.

Beckett, I.F.W. 2001. *The Great War: 1914–1918*. Harlow: Pearson Education.

Beckett, I.F.W. and Simpson, K. 1985. *A Nation in Arms: a social study of the British Army in the First World War*. Manchester: Manchester University Press.

Beckett, I.F.W. 2006. *Home front, 1914–1918: how Britain survived the Great War*. London: National Archives.

Beckford-Ball, J. 2009. Veterans' mental health is being neglected. *Nursing Times* [Online 20 January]. Available at: http://www.nursingtimes.net/ veterans-mental-health-is-being-neglected/1970668.article# [accessed 25 February 2009].

Benammar, E. 2011. Great Britain Men "shell-shocked" by Spain defeat and now face struggle to qualify for Champions Trophy 2012. *Daily Telegraph* [Online 6 December]. Available at: http://www.telegraph.co.uk/sport/ olympics/hockey/8938562/Great-Britain-Men-shell-shocked-by-Spain-defeat-and-now-face-struggle-to-qualify-for-Champions-Trophy-2012.html [accessed 15 January 2012].

Bennett, A. 2003. *Writing Home*. London, Faber and Faber.

Bennett, T. 1995. *The Birth of the Museum: History, Theory, Politics*. London: Routledge.

Benton, T. (ed.) 2010. *Understanding Heritage and Memory*. Manchester: Manchester University.

Berger, J. 1972. *Ways of Seeing*. London: BBC Books.

Bet-El, I. 1999. *Conscripts: Lost Legions of the Great War*. Stroud: Sutton.

Beresford, D. 2006. At least 63 dead in Iraq after roadside bombings and suicide attack. *The Guardian*, 2 August, 5.

Bergonzi, B. 1965. *Heroes' Twilight: A Study of the Literature of the Great War*. London: Constable.

Bergonzi, B 1999. *War Poets and Other Subjects*. Aldershot: Ashgate.

Bernard-Donals, M. and Glejzer, R. (eds) 2003. *Witnessing the Disaster: Essays in Representation and the Holocaust*. Madison: University of Wisconsin.

Bevins, A. 1998. Civil servants block pardons for First World War deserters. *Independent*, 17 March, 12.

Bhaskar, R. 1978. *A Realist Theory of Science*. Brighton: Harvester Press.

Bhaskar, R. 1979. *The Possibility of Naturalism*. Brighton: Harvester Press.

Bhaskar, R. 1986. *Scientific Realism and Human Emancipation*. London: Verso.

Bhaskar, R. 1991. *Philosophy and the Idea of Freedom*. Oxford: Blackwell.

Bilton, D. 1999. *Hull Pals: 10th, 11th, 12th and 13th (Service) Battalions of the East Yorkshire Regiment - A History of the 92nd Infantry Brigade, 31st Division, 1914–19*, Barnsley: Wharncliffe Books.

Bilton, D. 2003. *The home front in the Great War: aspects of the conflict 1914–1918*. Barnsley: Leo Cooper.

Binyon, L. 1922. *Selected Poems of Laurence Binyon*. New York: Macmillan.

Black History for Schools, 2001. Black Footballers [Online]. Available at http://www.black history4schools.com/20century/blackfootballers.pdf [accessed 21 February 2010].

Blackadder Goes Forth (dir. Richard Boden, 1989).

Blair, T. 1997. *New Britain: my vision of a young country*. London: Westview Press.

Blighty Blog, 2012. *The Economist* [Online 13 September 2011]. Available at: http://www. economist.com/blogs/blighty [accessed 17 January 2012].

Blighty Channel, 2012. Best in Britain: Blighty TV [Online 17 February]. Available at: http://uktv.co.uk/blighty/homepage/sid/5009 [accessed 17 January 2012].

Blomfield, R. 1932. *Memoirs of an Architect*. London: Macmillan.

Bloomfield, 2006. Belfast Forum [Online 16 August]. Available at: http://www.belfastforum.co.uk/index.php?topic=847.0 [accessed on 17 November 2007].

Blower, N. 2011. *Shell Shock: The Diary of Tommy Atkins*. Eastbourne: Firestep Publishing.

Blunden, E. 1930. *Undertones of War*. London: Cobden and Sanderson.

BNP, 2009. Henry Allingham [Online 7 August]. Available at: http://bnp.org.uk/tag/henryallingham/[accessed 22 August 2009].

BNP, 2011. Protect the Poppy Campaign [Online 3 November]. Available at: www.bnp.org.uk/news/national/protect-poppy [accessed 12 November 2011].

BNP, 2012. We Demand Our Referendum Now [Online 19 September]. Available at: www.bnp.org.uk/news/we-demand-our-referendum-now [accessed 22 September 2012].

Bolton Council, 2009. *Report Title: Private James Smith*. Bolton Council, Director of Legal and Democratic Services.

Bond, B. 1991. Introduction, in *The First World War and British Military History*, edited by Brian Bond. Oxford: Oxford University Press, 1–12.

Bond, B. 2002. *The Unquiet Western Front*. Cambridge: Cambridge.

Boorman, D. 1988 *At the Going Down of the Sun: British First World War Memorials*. Ebor Press: York.

Booth, A. 2006. *Postcards from the Trenches: Negotiating the Spaces Between Modernism and the First World War*. Oxford: Oxford University Press.

Booth, W.J. 2006. *Communities of Memory: On Witness, Identity, and Justice*. Ithaca, New York: Cornell University Press.

Borg, A. 1991. New Developments at the Imperial War Museum. *Interpretation Journal*, 47, 6–7.

Bostridge, M. 2006. We go tomorrow. *The Guardian: Culture Section*, 1 July, 4.

Boura, F. 1998. Une tombe de soldats à Saint-Remy-la-calonne, in *14–18: aujourd'hui. Today. Heute. no.2, l'archéologie et al Grande Guerre*, edited by A. Schnapp. Péronne: Historial de la Grande Guerre, 70–83.

Bourke, J. 1996. *Dismembering the Male*. London: Reaktion Books.

Bourke, J. 1999. *An Intimate History of Killing: Face-to-Face Killing in Twentieth Century Warfare*. London: Granta.

Bourke, J. 2000. Effeminacy, Ethnicity and the End of Trauma: the Sufferings of 'Shell-Shocked' Men in Great Britain and Ireland, 1914–39. *Journal of Contemporary History*, 35, 57–69.

Bourne, J.M. 1989. *British Society and the Great War 1914–1918*. London: Edward Arnold.

Bowcott, O. 2003. British troops come under missile barrage. *The Guardian*, 1 April, 8.

Bower, T. 2004. A pilgrimage to the killing fields. *The Evening Standard*, 30 July, 13.

Bracco, R.M. 1993. *Merchants of Hope: British Middlebrow Writers and the First World War*, 1919–1939. Providence RI and Oxford: Berg.

Bradley, K. 2011. People of all ages stop to recall the sacrifice of soldiers in First World War at Bradford Pals' Memorial. *Bradford Telegraph and Argus*, 4 July, 3.

Brady, B. 2004a. UK to pardon executed Irish troops. *Scotland on Sunday*, 21 March, 12.

Brady, B. 2004b. Lions led by donkeys. *Scotland on Sunday*, 25 January, 22.

Brady, B. 2006. Tory blow to campaign for war pardons. *Scotland on Sunday*, 10 September, 8.

Breen, S. 2002. Maskey plans to honour Somme victims. *Irish Times*, 27 June, 13.

Brenan, V. 2006. Posthumous Pardons for Border Soldiers. *News and Star*, 17 August, 4.

Bright, M. 2002. West Indians who shared trench hell. *The Observer*, 10 November, 17.

Bright, M. 2008. No credible alternative. *New Statesman*, 2 October, 10.

Brittain, V. 1933. *Testament of Youth: an autobiographical study of the years 1900–1925*. London: Macmillan.

Brooke, R. 1920. *The Collected Poems of Rupert Brooke*. New York: John Lane.

Brooks, C. 2012. Cheltenham Festival 2012: this meeting is a war of attrition on many fronts. *Daily Telegraph* [Online 11 March]. Available at: http://www.telegraph.co.uk/sport/horseracing/cheltenham-festival/9137105/Cheltenham-Festival-2012-this-meeting-is-a-war-of-attrition-on-many-fronts.html [accessed 23 March 2012].

Brophy, J. 1929. *The Soldier's War: A Prose Anthology*. London and Toronto: J.M. Dent.

Brown, D. 1999 Blair in no man's land. *The Guardian*, 14 October, 27.

Brown, G. 2006. *Moving Britain Forward: Selected Speeches, 1997–2006*. London: Bloomsbury Publishing.

Brown, K. 2007. 'Our Father Organization': The Cult of the Somme and the Unionist 'Golden Age' in Modern Ulster Loyalist Commemoration. *The Round Table*, 96, 707–23.

Brown, K. and MacGinty R. 2003. Public Attitudes toward Partisan and Neutral Symbols in Post-Agreement Northern Ireland. *Identities: Global Studies in Culture and Power*, 10, 83–108.

Brown, M. 1999. *The Imperial War Museum Book of the Somme*. London: Imperial War Museum.

Brown, M. 2007. The Fallen, the Front and the Finding: Archaeology, Human Remains and the Great War. *Archaeological Review from Cambridge*, 22(2), 53–68.

Brown, M. and Seaton, S. 1984. *Christmas Truce: The Western Front, December 1914*. London: Imperial War Museum.

Brown, W. 1995. *States of Injury: Power and Freedom in Late Modernity*. Princeton: Princeton University Press.

Brown, W. 2001. *Politics out of History*. Princeton: Princeton University Press.

Buitenhuis, P. 1989. *The Great War of Words: Literature as Propaganda 1914–18 and After*. London: Batsford.

Burchill, J. 2010. So the prince of hypocrites is going on tour. Lucky I'm away. *Belfast Telegraph*, 19 August, 25.

Burke, G. 2007 *Black Watch*. London: Faber and Faber.

Burnham, A. 2010 Speech to the Labour Party Conference. *Labour Party* [Online 28 September 2010] Available at: http://www2.labour.org.uk/andy-burnhams-speech-to-labour-party-conference [accessed 13 October 2011].

Bushaway, B. 1992. Name upon Name: The Great War and Remembrance, in *Myths of the English*, edited by R. Porter. Cambridge: Polity, 136–67.

Bushe, A. 2002. Pardon for Patrick. *Sunday Mirror*, 27 October, 23.

Butler, P. 2009. NHS mental health: lions are led by donkeys. *The Guardian*, 7 October, 21.

Callan, P. and Murray, D. 2011. Should it be compulsory to wear a poppy? *Daily Express* [Online 9 November]. Available at: http://www.express.co.uk/comment/expresscomment/282565/Should-it-be-compulsory-to-wear-a-poppy [accessed 25 November 2011].

Callinicos, A. 2006. The politics of the new rank and file. *Socialist Worker*, 25 March, 14.

Callow, S. 2003. *Being an actor*. London: Vintage.

Carter, P. 2010. Fewer staff, wards shut, services cut ... protecting frontline NHS, ConDem-style, *Daily Mirror*, 12 November, 4.

Cave, N. 1996. *Arras: Vimy Ridge*. Barnsley: Pen and Sword/Leo Cooper.

Chambers, R. 1984. *Story and Situation: Narrative Seduction and the Power of Fiction*. St. Pauls: University of Minnesota Press.

Channel 4, 2005. *Lost Generation* [Online November 12]. Available at: http://www.channel4.com/history/microsites/L/lostgeneration [accessed 16 March 2006].

Cheshire Military Museum, 2012. World War 1 and Remembrance. [Online]. Available at: http://www.cheshiremilitarymuseum.co.uk/[accessed 14 May 2012].

Chorley Pals Memorial, 2010. The Campaign [Online 18 January]. Available at: http://www.chorleypalsmemorial.org.uk/about-us/the-campaign/[accessed 23 February 2010].

Chrisafis, A. 2004. Pardon plea for Irish volunteers shot in trenches. *The Guardian*, 12 November, 4.

Chulov, M. 2012. Syria uprising is now a battle to the death. *The Guardian*, 9 February, 3.

Churchill, W.S. 1974. *Winston Churchill: His Complete Speeches 1897–1963, Vol. III: 1914–1922*. New York and London: Chelsea House.

Clarke, A. 1961. *The Donkeys*. London: Hutchison.

Cockburn, P. 2005. Iraq is a bloody no man's land. America has failed to win the war. But has it lost it? *Independent*, 15 May, 22.

Cohrs, P.O. 2006. *Peace after World War I: America, Britain, and the Stabilisation of Europe, 1919–1932*. Cambridge: Cambridge University Press.

Cole, D. 2011. Norfolk police constable talks of his London riots experience. *Norfolk Evening News* [Online 21 August]. Available at: http://www.eveningnews24.co.uk/news/norfolk_police_constable_talks_of_his_london_riots_experience_1_1000134 [accessed 22 October 2011].

Coles, J. 2010. The flesh of the men and horses was mixed up. *The Sun*, 22 October, 9.

Connelly, M. 2002. *The Great War, Memory and Ritual: Commemoration in the City and East London, 1916–1939*. Woodbridge: Boydell.

Collett, V. 2008. My Grandfather's Great War relives the horror of the trenches. *Metro*, 15 October, 13.

Connerton, P. 1989. *How Societies Remember*. Cambridge: Cambridge University Press.

Coppard, G. 2003. *With a Machine Gun to Cambrai*. London: Papermac.

Corbyn, J. 2009. From denial to harsh reality. *Morning Star* [Online 29 July]. Available at: http://www.morningstaronline.co.uk/news/content/view/full/78629 [accessed 13 June 2010].

Corbyn, J. 2012. Tragic lesson wasted on the war hawks. *Morning Star* [Online 7 March]. Available at: http://www.morningstaronline.co.uk/news/content/view/full/116299 [accessed 8 March 2012].

Corns, C.M. and Hughes-Wilson, J. 2002. *Blindfolded and Alone: British Military Executions in the Great War*. London: Cassell.

Corrigan, G. 2003. *Mud, Blood and Poppycock*. London: Cassell.

Cosgrove, D.E. 1993. *The Palladian Landscape: Geographical Change and its Cultural Representations in Sixteenth Century Italy*. Leicester: Leicester University Press.

Coulter, J. 2012. The living and the dead both have key roles to play. *Tribune Magazine*, 6 May, 12.

Cowan, M. 2006. Shot WWI troops may get pardons. *Birmingham Mail*, 16 August, 15.

Crane, S.A. 1997. Memory, distortion, and history in the museum. *History and Theory* 36(4), 44–63.

Crawford, S. 2010. Remember Scots serving abroad this Christmas. *Caledonian Mercury* [Online 23 December] Available at http://caledonianmercury. com/2010/12/23/remember-scots-serving-abroad-this-christmas/0012812 [accessed 22 December 2011].

Crerar, P. 2004. Families pour scorn on Black Watch vow. *Daily Record*, 21 October, 4.

Croall, J. 1997. The spirit of Devil's Wood. *Times Educational Supplement*, 17 January, 9.

Crooke, E. 2005. Community heritage and place making in Northern Ireland, in *Ireland's Heritages: Critical Perspective on Memory and Identity*, edited by M. McCarthy. Aldershot: Ashgate, 223–34.

Crooke, E. 2007. Museums, Communities and the politics of heritage in Northern Ireland, in *The politics of heritage: The legacies of race*, edited by J. Littler and R. Naidoo. London: Routledge, 69–81.

Crooke, E. 2010. Heritage and Community Engagement: Collaboration or Contestation? *International Journal of Heritage Studies*, 16(1–2), 16–29.

Crowson, M. 2011. Leicester Tigers' players need to stick hands up when club is in trenches. *Leicester Mercury*, 29 November, 27.

Cubitt, G. 2009. *History and Memory*. Manchester: Manchester University Press.

Dalton, A. 2010. Duo aiming to end trench warfare of capital tramworks. *The Scotsman*, 15 November, 8.

Danchev, A. 1991. Bunking and Debunking: The Controversies of the 1960s, in *The First World War and British Military History*, edited by B. Bond. Oxford: Oxford University Press, 263–88.

Darrow, H. 2000. *French Women and the First World War: War Stories of the Home Front*. Oxford: Berg.

Das, S. (ed.) 2011. *Race, Empire and First World War Writing*. Cambridge: Cambridge University Press.

Dawson, G. 1990. Playing at War: An Autobiographical Approach to Boyhood Fantasy and Masculinity. *Oral History*, 18, 44–53.

Dawson, G. 1994. *Soldier Heroes: British Adventure, Empire and the Imagining of Masculinities*. London and New York: Routledge.

Days of Hope (dir. K. Loach, 1975).

D'Ancona, M. 2010. Budget 2010: David Cameron prepares for 48-hour trench warfare. *Daily Telegraph*, 20 March, 16.

Deathwatch (dir. M.J. Bassett, 2002).

de Groot, J. 2009. *Consuming History: Historians and Heritage in Contemporary Culture*. London: Routledge.

de Tocqueville, A. 1875. *Democracy in America, Vol. 1*. London: Longmans, Green and Co.

DeGroot, G.J. 1996. *Blighty: British Society in the Era of the Great War*. London and New York: Longman.

DeGroot, G.J. 2009. A Lost Generation? The Impact of the First World War. *Modern History Review*, 11(1), 18–21.

DeMarco, N. and Radway, R. 1995. *Twentieth Century World*. Cheltenham: Stanley Thomas.

Dening, G. 1988. *History's Anthropology: The Death of William Gooch*. New York: University Press of America.

Derrida, J. 1976. *Of Grammatology*. Baltimore: John Hopkins University Press.

Derrida, J. 1989. *Memoires: for Paul de Man*. New York: Columbia University Press.

Devine, T. 2006. *The Scottish Nation 1700 to 2007*. London: Penguin.

Dewsbury, R. 2012. Lest we forget ... memorial unveiled to Harry Patch, the Last Tommy. *Daily Mail* [Online 7 May]. Available at: http://www.dailymail.co.uk/news/article-2140666/Harry-Patch-memorial-unveiled-Britains-WWI-survivor.html [accessed 2 June 2012].

Dicks, B. 2000a. *Heritage, Place and Community*. Cardiff: University of Wales Press.

Dicks, B. 2000b. Encoding and Decoding the People Circuits of Communication at a Local Heritage Museum. *European Journal of Communication*, 15(1), 61–78.

Diffley, J. 2004. North boy soldier shooting revealed. *Evening Chronicle*, 14 June, 7.

Don Kiddick, 2006. Sheffield Forum [Online 15 August] Available at: http://www.sheffieldforum.co.uk/showthread.php?t=134824&highlight=pardon+soldiers [accessed 17 November 2007.

Donald, G. 2008. *Sticklers, Sideburns & Bikinis: The Military Origins of Everyday Words and Phrases*. Oxford: Osprey Publishing.

Donovan, P. 2009. Getting the wrong end of the stick. *Morning Star* [Online 20 August]. Available at: http://www.morningstaronline.co.uk/index.php/news/content/view/full/79580 [accessed 22 August 2009].

Douglas, D. 2006. Plan to pardon soldiers shot at dawn welcomed. *Belfast Telegraph*, 17 August, 4.

Downton Abbey (dir. Julian Fellowes, 2011).

Duffy, C.A. 2011a. *The Christmas Truce*. London: Picador.

Duffy, C.A. 2011b. *The Bees*. London: Picador.

Dungan, M. 1995. *Irish voices from the Great War*. Dublin: Portland.

Dungan, M. 1997. *They shall grow not old: Irish soldiers and the Great War*. Dublin: Portland.

Dunn, S. and Fraser, T.G. 1996. *Europe and Ethnicity: World War I and Contemporary Ethnic Conflict*. New York: Routledge.

Dyer, G. 1994. *The Missing of the Somme*. London: Phoenix Press.

Editorial, 2009. Romancing the past. *The Guardian*, 1 August, 23.

Editor's Viewpoint, 2010. Time to cast off the blinkers. *Belfast Telegraph*, 5 May, 22.

Edkins, J. 2003. *Trauma and the Memory of Politics*. Cambridge: Cambridge University Press.

Edmonds, C. 1929. *A Subaltern's War*. London: Peter Davies.

Edmonds, Brigadier-General J.E. 1922. *Military Operations: France and Belgium, 1914*. London: Macmillan and Co.

Edwards, R. 2006. Courage of Leeds Pals remembered. *Yorkshire Evening Post*, 30 June, 8.

Eksteins, M. 1989. *Rites of Spring: The Great War and the Birth of the Modern Age*. Boston: Houghton Mifflin Company.

Elliot, J. 1964. *The Battlefields of Fifty Years Ago*. Dunmow and Maldon: May and Brett Ltd.

Elliott, L. 2011. European Debt Crisis. *The Guardian* [Online 23 October]. Available at: http://www.guardian.co.uk/business/economics-blog/2011/oct/23/european-debt-crisis-uk-economic-growth?INTCMP=SRCH [accessed 26 October 2011].

Ellis, J. 1989. *Eye-Deep in Hell: Trench Warfare in World War I*. Baltimore: The Johns Hopkins University Press.

Elton, B. 2005. *The First Casualty*. London: Bantam Press.

Erskine, T. 2008. *Embedded Cosmopolitanism: Duties to Strangers and Enemies in a World of Dislocated Communities*. Oxford: Oxford University Press.

Erwin, M. 2009. Silence falls on Armistice Day. *Metro*, 12 November, 2.

Espley, R. 2008. How much of an 'experience' do we want the public to receive?: Trench reconstruction and popular images of the Great War, in *British Popular Culture and the First World War*, edited by J. Meyer. Leiden: Brill, 325–50.

Europeana, 2010. Homepage [Online 11 November]. Available at: http://www.europeana1914-1918.eu [accessed 12 May 2012]/

Eyerman, R. 2001. *Cultural Trauma: Slavery and the Formation of African American Identity*. Cambridge: Cambridge University Press.

Ezard, J. 2001. Memorial to soldiers shot as cowards. *The Guardian*, 22 June, 7.

Faces of the First World War, 2011. Homepage [Online 11 November]. Available at: http://www.flickr.com/photos/imperialwarmuseum/sets/7215762791053 0369/ [accessed 11 October 2012].

Fairclough, N. 1995. *Critical discourse analysis: The critical study of language*. London: Longman.

Fairclough, N. 2001. *Language and Power*. London: Longman

Falls, C. 1930. *War Books: A Critical Guide*. London: Peter Davis.

Farndale, N. 2007. Pilgrimage to Passchendaele, a killing field haunted by family memories. *Sunday Telegraph* [Online 28 July]. Available: http://www.telegraph.co.uk/news/uknews/1558790/Pilgrimage-to-Passchendaele-a-killing-field-haunted-by-family-memories.html. [accessed 3 October 2009].

Faulkner, N. 2008. Armistice day, remembrance and the 'glorious war'. *Socialist Worker* [Online 15 November 2008]. Available at: http://www.socialistworker.co.uk/issue.php? id=445 [accessed 22 November 2008.

Faulks, S. 1993. *Birdsong*. London: Vintage.

Featherstone, S. 1995. *War Poetry: An Introductory Reader*. London: Routledge.

Feld, S. and Basso, H. 1996. Introduction, in S. Feld and H. Basso (eds) *Senses of Place*. New Mexico: School of American Research Press, 3–11.

Felsted, A. 2011. Shifting shops from no man's land. *Financial Times* [Online 24 May 2011]. Available at: http://www.ft.com/cms/s/0/80801fb2-863d-11e0-9e2c-00144feabdc0.html [accessed October 24 2011].

Fentress, J. and Wickham, C. 1992. *Social Memory, New Perspectives on the Past.* Cambridge, MA: Blackwell.

Fish, S. 1980. *Is There a Text in This Class? The Authority of Interpretive Communities.* Cambridge, MA: Harvard University Press.

Fisk, R. 2009a. In Ypres I suddenly realised what this war has been about. *Independent*, 26 December, 5.

Fisk, R. 2009b. Why these deaths hit home as hard as the Somme. *Independent*, 18 August, 19.

Fitzgerald, M. 2004. Lord mayor leads fight to pardon shot soldiers Thousands urged to sign City Hall petition. *Belfast Telegraph*, 22 April, 3.

Fleming, S. 2009. Humiliation for UK as our credit rating is threatened. *Daily Mail* [Online 22 May]. Available at: http://www.dailymail.co.uk/news/article-1184688/Humiliation-UK-credit-rating-threatened.html [accessed 12 June 2009].

Forsyth, F. 2012. The Establishment, 100 years of never saying sorry. *Daily Express*, 18 April, 15.

Foster, M. 2012. Fireball victim of panic over fuel. *Northern Echo*, 31 March, 2.

Foster, R. 1990. Not a black and white issue. *The Museums Journal*, 90(10), 20–21.

Foucault, M. 1975. *Archaeology of Knowledge.* New York: Pantheon Books.

Foucault, M. 1980. *Power/Knowledge: Selected Interviews and Other Writings 1972–1977.* London: Harvester.

Fox, F. 1922. *King's pilgrimage.* London : Hodder and Stoughton.

Fox, R. 2009. This was a shambolic misadventure and we must learn from it, *London Evening Standard*, 30 April, 22.

Freeman, M.E. 1999. *Poets and Pals of Picardy: A Somme Weekend.* Barnsley: Pen and Sword/Leo Cooper.

French, D. 1988. The Meaning of Attrition, 1914–1916. *The English Historical Review* 103(407), 385–405.

Freud, S. 1939. *Moses and Monotheism.* New York: Alfred A. Knopf.

Freud, S. 2003. *An outline of psychoanalysis.* London: Penguin.

Friends School, 2012. *WW1 Battlefields Trip* [Online]. Available at: http://www.friends.org.uk/ww1-battlefields-trip/[accessed 13 June 2012].

Fussell, P. 1975. *The Great War and Modern Memory.* Oxford: Oxford University Press.

Gaffney, A. 1998. *Aftermath: Remembering the Great War in Wales.* Cardiff: University of *Wales* Press.

Galloway, G. 2004. *Mea culpa*, that's what we want. *The Guardian*, 2 June, 23.

Galloway, G. 2008. Interview on Talksport Radio. 26 December.

Galloway, G. 2011a. The ultimate futility and barbarism of war. *Morning Star* [Online 10 June] Available at: http://www.morningstaronline.co.uk/index.php/news/content/view/full/105758 [accessed 14 June 2012].

Galloway, G. 2011b. This crisis is a time to demand the impossible. *Morning Star* [Online 11 November]. Available at: http://www.morningstaronline.co.uk/news/content/view/full/11185 5 [accessed 15 November 2011].

Galloway, G. 2011c. 10 years of lions led by donkeys. *Daily Record*, 13 June, 8.

Garai, R. 2009. No Man's Land. *The Guardian* [Online 19 March] Available at: http://www.guardian.co.uk/commentisfree/2009/mar/19/iraq-syria-refugees?INTCMP=SRCH [accessed 23 November 2012].

Gardner, B. 1964. *Up the line to death: the war poets 1914–1918: an anthology*. London: Eyre Methuen.

Garton Smith, J. 1999. Learning from popular culture: Interpretation, visitors and critique. *International Journal of Heritage Studies*, 5(3–4), 135–48.

Gee, C. 2011. Chorley marks Somme 95th anniversary at Pals' memorial. *Chorley Citizen*, 1 July, 5.

George V, King of the United Kingdom, the British Dominions and Emperor of India. 1919. First November 11 Commemoration. *The Times*, 7 November, 1.

Gergen, K. J. 2005. Narrative, moral identity, and historical consciousness: A social constructionist account, in *Narrative, identity and historical consciousness*, edited by J. Straub. New York: Berg, 120–39.

German, L. 2009. Remembering Dissent. *Socialist Review* [Online 12 December]. Available at: http://www.socialistreview.org.uk/article.php?article number=11052 [accessed 14 January 2010].

German, L. 2011. How the Cenotaph and red poppies became symbols of war. *Stop the War Coalition* [Online 4 November]. Available at: http://stopwar.org.uk/index.php/united-kingdom/904-how-the-cenotaph-and-red-poppies-became-symbols-of-war [accessed 15 August 2012].

Gibson, C. 2001. Sex and Soldiering in France and Flanders: The British Expeditionary Force along the Western Front, 1914–1919. *The International History Review* 23(3), 535–79.

Gibson, C. 2003. The British Army, French Farmers and the War on the Western Front 1914–1918. *Past and Present* 180, 175–239.

Gilbertson, D. 2012. Britain's police are at war with the people. *The Guardian*, 1 April, 3.

Gilbey, R. 2010. Robert Harris: I used to love politics. Not now. *The Guardian: Culture Section*, 3 April, 5.

Gill, A. 2006. *Burnley in the Great War* [Online]. Available at: http://www.burnleyinthegreat war.info/[accessed 12 February 2010].

Ginley, J. 2006. Brave Pals who sang before battle slaughter. *Yorkshire Post*, 1 July, 14.

Gitlin, T. 1980. *The Whole World Is Watching: Mass Media in the Making and Unmaking of the New Left*. Berkeley, CA: University of California Press.

Glass, D.V. and Taylor, P.A.M. (eds) 1976. *Population and emigration in 19th century Britain*. Dublin: Irish University Press.

Goffman, E. 1974. *Frame Analysis: an essay on the organisation of experience*. New York: Harper and Row.

Gough, P. 1993. *The Empty Battlefield: Painters and the First World War. Imperial War Museum Review*, 8. London: Imperial War Museum/Leo Cooper.

Gough, P. 2010a. *A Terrible Beauty: British Artists in the First World War.* Bristol: Sansom and Company.

Gough, P. 2010b. The Living, The Dead and the Imagery of Emptiness and Re-appearance on the battlefields of the Western Front, in *Deathscapes: Spaces for Death, Dying, Mourning and Remembrance*, edited by A. Maddrell and J.D. Sidaway. Aldershot: Ashgate, 263–82.

Gouriévidis, L. 2010. *The Dynamics of Heritage: History, Memory and the Highland Clearances*. Farnham: Ashgate.

Graham, B. 2004. The Past in the Present: The Shaping of Identity in Loyalist Ulster. *Terrorism and Political Violence*, 16(3), 483–500.

Graham, B., Ashworth, G. and Tunbridge, J.E. 2000. *A Geography of Heritage: Power, Culture and Economy*. London: Arnold.

Graham, B. and Howard, P. 2008. Introduction: Heritage and Identity, in *The Ashgate Research Companion to Heritage and Identity*, edited by B. Graham and P. Howard. Ashgate: Aldershot, 1–18.

Graham, B. and Shirlow, P. 2002. The Battle of the Somme in Ulster memory and identity. *Political Geography*, 21(7), 881–904.

Graham, D. 1984. *The Truth of War*. Manchester: Carcanet Press.

Graves, R. 1929. *Goodbye To All That*. London: J.M. Dent.

Grayling, A.C. 2001. The last word on Remembrance. *The Guardian*, 9 November, 21.

Grayling, C. 1987. *A land fit for heroes: British life after the Great War*. London: Buchan and Enright.

Grayson, R.S. 2010. The Place of the First World War in Contemporary Irish Republicanism in Northern Ireland. *Irish Political Studies*, 25(3), 325–45.

Grayzel, S.R. 1999. *Women's Identities at War: Gender, Motherhood, and Politics in Britain and France during the First World War*. Chapel Hill: University of North Carolina Press.

Great War Forum, 2006. Buried where they fall – or at home [Online 31 May]. Available at: http://1914–1918.invisionzone.com/forums/index.php?showtopic=53406 [accessed 20 May 2012]

Great War Forum, 2007a. My Boy Jack [Online 5 November]. Available at: http://19141918.invisionzone.com/forums/index.php?showtopic=85399&st=100 [accessed 20 May 2012].

Great War Forum, 2007b. Everyone has a special day – here's mine [Online 2 May]. Available at: http://1914-1918.invisionzone.com/forums/index.php?showtopic=74586 [accessed 20 May 2012].

Great War Forum, 2008. 91 Years Ago – We will remember them [Online 1 June]. Available at: http://1914-1918.invisionzone.com/forums/index.php?showtopic=99297 [accessed 20 May 2012].

Great War Forum, 2009. Dulce Et Decorum Est or the Old Lie [Online 11 November]. Available at: http://19141918.invisionzone.com/forums/index.php?showtopic =136676 [accessed 20 May 2012].

Great War Forum, 2010. 11 Nov 10 [Online 11 November]. Available at: http://19141918.invisionzone.com/forums/index.php?showtopic=155598 (accessed 20 May 2012].

Great War Forum, 2011. 1st/28th London Regt (Artist's Rifles) [Online 18 March]. Available at: http://1914-1918.invisionzone.com/forums/index.php?showtopic =161416 [accessed 20 May 2012].

Great War Society, 2012. Homepage [Online 17 May]. Available at: http://www. thegreatwarsociety.com/[accessed 20 June 2012].

Greek, S. 2012. Parents left in 'no-man's land' at Hertford school expansion decision. *Hertfordshire Mercury* [Online 17 March]. Available at: http://www. hertfordshiremercury.co.uk/Hertfordshire/Parents-left-in-no-mans-land-at-Hertford-school-expansion-decision-16032012.htm [accessed 15 June 2012].

Green, A. 2003. *Writing the Great War: Sir James Edmonds and the Official Histories 1915–1948*. London, Portland: Frank Cass.

Green, J. 2006. *Cassell's Dictionary of Slang*. Second Edition. London: Cassell.

Greenberg, A. 1989. Lutyens's cenotaph. *Journal of the Society of Architectural Historians*, 48, 523.

Greene, G. 1980. *Ways of Escape*. London: Bodley Head.

Greenwood, G.A. 1922. *England To-Day: a social study of our time*. London: George Allen and Unwin.

Gregory, A. 1994. *The Silence of Memory: Armistice Day, 1919–1946*. Oxford: Berg.

Gregory, A. 2008. *The Last Great War: British Society and the First World War*. Cambridge: Cambridge University Press.

Grenfell, J. 1917. Into Battle, in *In the Day of Battle: Poems of the Great War*, edited by C.E. Holman. Toronto: William Briggs, 166–7.

Grice, A. 2012. Lansley heckled while PM rules out concessions to critics of Bill. *Independent*, 21 February, 5.

Grieves, K. 1988. *The Politics of Manpower, 1914–18*. Manchester: Manchester University Press.

Grieves, K. 1991. Early Historical Responses to the Great War: Fortescue, Conan Doyle and Buchan, in *The First World War and British Military History*, edited by B. Bond. Oxford: Oxford University Press, 15–39.

Griffin, B., Hayden, B., Wood, T., Lukowiak, K., Polley, N. and Pratt, S. 2010. Soldiers Say Remember the Futility of War on Poppy Day. *Independent*, 3 November, 1.

Griffith, G. 2005. Blinkered vision. *Morning Star* [Online 7 February]. Available at: http://www.morningstaronline.co.uk/news/content/view/full/9523 [accessed 12 September 2008].

Griffith, P. 2004. *Battle Tactics of the Western Front: The British Army's Art of Attack, 1916–18*. New Haven, CT: Yale University Press.

Grundlingh, A. 1987. *Fighting their own war: South African Blacks and the First World War*. Johannesburg: Raven Press.

Guoqi, X. 2005. *China and the Great War: China's pursuit of a new national identity and internationalisation*. Cambridge: Cambridge University Press.

Gurney, I. 1996. Strange Hells, in *The Penguin Book of First World War Poetry*, edited by J. Silkin. London: Penguin, 214.

Habermas, J. 1987. *The Philosophical Discourse of Modernity*. Cambridge: Polity Press.

Haig, Field Marshal D. 1919. Preface, in *Sir Douglas Haig's Despatches*, edited by J.H. Boraston. London and Toronto: J.M. Dent and Sons, v–vii.

Halifax, S. 2010. Over by Christmas: British popular opinion and the short war in 1914. *First World War Studies*, 1(2), 103–21.

Hall, J. 2009. Postcards from No Man's Land: The desertion of Britain's high street. *Daily Telegraph*, 17 January, 23.

Hall, S. (ed.) 1997. *Representation: Cultural Representations and Signifying Practices*. London: Sage/Open University.

Hallahan, K. 1999. Seven Models of Framing: Implication for Public Relations. *Journal of Public Relations Research*, 11(3), 205–42.

Hammond, P. 2003. Tin hats on everyone – we're going over the top. *Guidelines in Practice* 6(7) [Online]. Available at: http://www.eguidelines.co.uk/eguidelinesmain/gip/out_of_hours/hammond_july03.htm [accessed: 14 July 2012].

Hanna, E. 2007. *Reality-experiential history documentaries: the Trench (BBC, 2002) and Britain's modern memory of the First World War. Historical Journal of Film Radio and Television*, 27(4), 531–48.

Hanna, E. 2009. *The Great War on the Small Screen: Representing the First World War in Contemporary Britain*. Edinburgh: Edinburgh University Press.

Hanretty, R. 2011. Anthem from Doomed Youth. *Herald Scotland* [Online 9 December]. Available at: http://www.heraldscotland.com/x/x/anthem-from-doomed-youth.2011121326 [accessed 12 January 2010].

Hansen, A. 2008. Fabio Capello will get caught in no-man's-land. *Daily Telegraph*, 17 March, 28.

Harding, M. 1977. *Christmas 1914*. Phillips Music.

Harding, T. 2006. Home by Christmas? Make that 2010 at least. *Daily Telegraph*, 23 May, 15.

Harman, C. 2008. The state of imperialism. *Socialist Review* [Online 1 March]. Available at: http://www.socialistreview.org.uk/article.php?articlenumber=10306 [accessed 12 March 2008].

Harris, J. 1962. *Covenant with Death*. London: Hutchinson.

Harris, R. 2002. The Trench isn't history: it's just pornography. *Daily Telegraph*, 12 March, 19.

Harrison, J. 2012. Fears over lost generation of unemployed young Scots. *The Herald*, 20 June, 5.

Harrison, R. 2012. *Heritage: Critical Approaches*. London: Routledge.

Hartnett, D. 1999. *Brother to Dragons*. London: Vintage.

Harvey, D.C. 2001. *Heritage Pasts and Heritage Presents: Temporality, Meaning and the Scope of Heritage Studies*. *International Journal of Heritage Studies*, 7(4), 319–38.

Harvey, P.J. 2011. *Hanging in the Wire*. Island Records.

Hastings, M. 2011. A nation divided: Britain is no longer split by class. Instead the social chasm is between taxpayers and the public sector. *Daily Mail*, 2 April, 27.

Hattersley, R. 2010. Poppy Fascists? *Daily Mail*, 5 November, 21.

Heaven, W. 2011. Remembrance Sunday will not fade away. *Catholic Herald*, 18 November, 12.

Heffernan. M. 1995. For Ever England: the Western Front and the politics of remembrance in Britain. *Ecumene*, 2(3), 293–323.

Heidegger, M. 1962. *Being and Time*. Oxford: Blackwell.

Hein, H.S. 2000. *The Museum in Transition: A Philosophical Perspective*. Washington: Smithsonian Institute Press.

Help For Heroes, 2012. Homepage. Available at: http://www.helpforheroes.org.uk [accessed 12 June 2012].

Henig, R. 1989. *Origins of the First World War*. London: Routledge.

Hennessey, T. 1998. *Dividing Ireland: World War I and Partition*. London: Routledge.

Henry, J. 2009. Boy, 12, was 'youngest British soldier in First World War'. *Daily Mail* [Online 31 October]. Available at: http://www.telegraph.co.uk/news/newstopics/onthefrontline/6472805/Boy-12-was-youngest-British-soldier-in-First-World-War.html [accessed 23 November 2009].

Hernon, I. 2012. History repeats itself in the Khyber Pass. *Morning Star* [Online 20 June]. Available at: http://www.morningstaronline.co.uk/news/content/view/full/120424 [accessed 26 May 2012].

Hewison, R. 1987. *The heritage industry: Britain in a climate of decline*. London: Methuen.

Hickley, M. 2006. Soldier awarded posthumous pardon to have name added to WW1 memorial. *Daily Mail* [Online 26 December]. Available at: http://www.dailymail.co.uk/news/article-424864/Soldier-awarded-posthumous-pardon-added-WW1-memorial.html#ixzz1uPWDVwuj [accessed 22 May 2011].

Hickley, M. 2008. From his bunker on the edge of no man's land, Harry opens fire on the Taliban, *Daily Mail*, 29 February, 6.

Higonnet, M.R. 1993. Women in the Forbidden Zone: War, Women and Death, in *Death and Representation*, edited by S. Webster-Goodwin and E. Bronfen. Baltimore and London: The John Hopkins University Press, 192–209.

Higonnet, M.R., Jenson, J., Michel, S. and Weitz, M. 1987. Introduction, in *Behind the Lines: Gender and the Two World Wars*. New Haven, London: Yale University Press, 1–17.

Hirsch, M. and Spitzer, L. 2009. The Witness in the Archive: Holocaust Studies/ Memory Studies. *Memory Studies*, 2(2), 151–70.

Hislop, I. 2007. Foreword. *Craven's Part in the Great War* [Online 6 November]. Available at: http://www.cpgw.org.uk/[accessed 12 May 2008].

Hitchens, P. 2008. Like Haig on the Somme, we'll bleed to death in Afghanistan. *Daily Mail*, 1 December, 24.

Hitchens, P. 2009. Harry Patch didn't go to war so Plodder Bob could give the orders. *Daily Mail*, 4 August, 23.

Hitchens, P. 2010. Another big push, another procession of coffins ... another unwinnable war. *Daily Mail*, 23 February, 21.

Hobsbawm, E. and Ranger, T. (eds) 1983. *The Invention of Tradition*. Cambridge: Cambridge University Press.

Hodgkin, K. and Radstone, S. 2003. *Contested Pasts: The Politics of Memory*. New Brunswick: Transaction Publishers.

Hoffenberg, P.H. 2001. Landscape, Memory and the Australian War Experience 1915–1918. *Journal of Contemporary History* 36(1), 111–31.

Hoggart, S. 2003a. Armies gather to go over the top on top-up fees. *The Guardian*, 5 December, 2.

Hoggart, S. 2003b. PM goes over the top and survives skirmish in no man's land. *The Guardian*, 19 March, 2.

Holden, W. 1998. *Shell Shock: The Psychological Impact of War*. London: Macmillan.

Holmes, R. 1998. *The Western Front*. London: BBC Books.

Holt, M. 2010. Justifying the Unjustifiable. *Morning Star* [Online 16 November]. Available at: http://www.morningstaronline.co.uk/news/content/view/full/331 [17 November 2010].

Holtam, N.R. 2008. Remembrance Sunday [Online 9 November]. Available at: http://www. smitf.org/uploadpdfs/sermon/November%209%2008%20RC. pdf [accessed 13 November 2011].

Holt's Tours, 2012. *It's a Long Way to Tipperary* [Online]. Available at: http:// www.holts.co.uk/2011/09-2012tipperary.html [accessed 12 June 2012].

Hopkins, K. 2009. Recession over by Christmas, says CBI. *The Guardian* [Online 23 September] Available at: http://www.guardian.co.uk/business/2009/sep/23/ cbi-forecast-recession-over [accessed November 12 2011].

Horsfall, J. and Cave, N. 1996. *Serre (Somme)*. London: Leo Cooper.

Hoskins, A. and O'Loughlin, B. 2010. *War and Media: The Emergence of Diffused War*. Cambridge: Polity Press.

House of Commons Hansard Parliamentary Debates, 1972. *Economic Situation*. 7 November, vol. 845 c. 823–958.

House of Commons Hansard Parliamentary Debates, 1986. *Second Day's Debate: Defence*. 1 July, vol. 100 c. 855–930.

House of Commons Hansard Parliamentary Debates, 1993. *Early Day Motion, 1618: Wilfred Owen*. 15 March, Session 1992–1993.

House of Commons Hansard Parliamentary Debates, 1995. *Early Day Motion, 1077: Anniversary of the Battle of the Somme.* 1 July, Session 1995–1996.

House of Commons Hansard Parliamentary Debates, 1996. *Pardons Executed Soldiers.* 9 May, vol. 277 c. 468–77.

House of Commons Hansard Parliamentary Debates, 1996. *Prevention and Suppression of Terrorism.* 14 March, vol. 273 c. 1124–72.

House of Commons Hansard Parliamentary Debates, 1996. *Savings, Amendments and Repeals: Northern Ireland (Emergency Provisions) Bill.* 19 February, vol. 272 c. 84–108.

House of Commons Hansard Parliamentary Debates, 1998. *Pardons for Executed Soldiers.* 24 July, vol. 316 c.1372–86.

House of Commons Hansard Parliamentary Debates, 2000. *War Graves Commission.* 26 October, vol. 355 c. 487–94.

House of Commons Hansard Parliamentary Debates, 2002. *War Graves.* 14 January, vol. 378 c.6–7.

House of Commons Hansard Parliamentary Debates, 2004. *Engagements: Oral Answers to Questions.* 20 October, vol. 312 c.882–90.

House of Commons Hansard Parliamentary Debates, 2005. *Defence in the United Kingdom.* 17 November, vol. 325 c.1135–1210

House of Commons Hansard Parliamentary Debates, 2006a. *Executed Soldiers.* 18 January, vol. 216 c.241–63WH.

House of Commons Hansard Parliamentary Debates, 2006b. *Armed Forces Bill.* 7 November, vol. 257 c.766–96.

House of Commons Hansard Parliamentary Debates, 2008. *Christmas Adjournment: Bill Presented.* 18 December, vol. 331 c.1263–91.

House of Commons Hansard Parliamentary Debates, 2009. *Engagements: Oral Answers to Questions.* 11 November, vol. 367 c.240–50.

House of Commons Hansard Parliamentary Debate, 2010a. *Foreign Affairs and Defence.* 26 May, vol. 249 c.174–273.

House of Commons Hansard Parliamentary Debate, 2010b. *First World War Commemoration.* 8 July, vol. 211 c. 630–38.

House of Commons Hansard Parliamentary Debates, 2011a. *Armed Forces Personnel.* 10 November, vol. 375 c. 468–548.

House of Commons Hansard Parliamentary Debates, 2011b. *Armed Forces Bill.* 10 January, vol. 180 c. 46–121.

House of Commons Hansard Parliamentary Debates, 2012a. *Assisted Suicide Debate.* 27 March 2012, vol. 278 c. 1373–1439.

House of Commons Hansard Parliamentary Debates, 2012. *Backbench Debates: Uncorrected Transcript.* 17 April, 1–38.

House of Lords Hansard Debates, 2006. *Debates on the Address.* 16 November, c. 20–100.

House of Lords Hansard Debates, 2008. *Counter-Terrorism Bill.* 8 July, c. 632–740.

House of Lords Hansard Debates, 2011. *Great War: Centenary Commemoration.* 22 March, c. 594–96.

Howard, P. 2003. *Heritage: Management, Interpretation, Identity.* London Continuum Publishing.

Howard, T. and Stokes, J. (eds) 1996. *Acts of War: The Representation of Military conflict on the British Stage and Television since 1945.* Aldershot: Scholar Press.

Howe, G.D. 2002. *Race, war and nationalism: a social history of West Indians in the First World War.* Kingston/Oxford: Ian Randle/James Currey.

Hughes-Wilson, J. 2008. Pardons for All. *The RUSI Journal*, 151(5), 56–9.

Hurst, P. 2007. *Scots Commander Leads Charge Against Taliban*, Daily Record, 17 December, 12.

Hutchison, G.S. 1935. *Pilgrimage.* London: Rich and Cowan.

Hynes, S. 1991. *A War Imagined: The First World War and English Culture.* London: Bodley Head.

Hynes, S. 1998. *The Soldiers' Tale: Bearing Witness to Modern War.* London: Pimlico.

Iles, J. 2008a. Encounters in the Fields - Tourism to the Battlefields of the Western Front. *Journal of Tourism and Cultural Change*, 6 (2), 138–54.

Iles, J. 2008b. In Remembrance: The Flanders Poppy. *Mortality*, 13(3), 201–21.

Iles, J. 2011. Going on Holiday to Imagine War: The Western Front Battlefields as Sites of Commemoration and Contestation, in *Great Expectations: Imagination and Anticipation in Tourism*, edited by D. Theodossopoulos & J. Skinner, Oxford: Berg, 155–73.

Inglis, K.S. 1993. Entombing Unknown Soldiers: From London and Paris to Bagdad. *History and Memory*, 5(2), 7–31.

Inman, P. 2011. Fears of 'lost generation' as youth unemployment hits record. *The Guardian*, 19 January, 13.

Iron Maiden, 2003. *Passchendaele.* EMI.

Jaber, H. and Amoore, M. 2012. Last-ditch bid to save journalists. *The Sunday Times*, 26 February, 4.

Jackson, L. 2011. Review: *Journey's End*, at Belgrade Theatre, Coventry, *Birmingham Post*, October 28, 21.

Jarman, N. 1997. *Material Conflicts: Parades and Visual Displays in Northern Ireland.* Oxford: Berg.

Jeeves, P. 2012. Major General Sir Evelyn Webb-Carter believes British soldiers are like lions being led by donkeys. *Daily Express*, 8 March, 10.

Jenkins, K. 1999. *Why History? Ethics and Postmodernity.* London: Routledge.

Jenkins, S. 2008. The errors of Iraq are being repeated - and magnified. *The Guardian*, 18 November, 22.

Johnson, H.C. 1994. *Breakthrough! Tactics, Technology, and the Search for Victory on the Western Front in World War I.* Novato, CA: Presidio.

Johnson, N.C. 1999a. The Spectacle of Memory: Ireland's remembrance of the Great War, 1919. *Journal of Historical Geography*, 25(1), 36–56.

Johnson, N.C. 1999b. Framing the past: time, space and the politics of heritage tourism in Ireland. *Political Geography*, 18, 187–207.

Johnson, N.C 2003. *Ireland, the Great War and the Geography of Remembrance*. Cambridge: Cambridge University Press.

Jones, D. 1937. *In Parenthesis*. London: Faber and Faber.

Jones, G. 2004 You'll be home by Christmas, Blair tells Black Watch. *Daily Telegraph* [Online 21 October] Available at: http://www.telegraph.co.uk/news/worldnews/middleeast/iraq/147 4669/Youll-be-home-by-Christmas-Blair-tells-Black-Watch.html [accessed 28 November 2011].

Jones, H., O'Brien, J., and Schmidt-Supprian, C. (eds) 2008. *Untold War: New Perspectives in First World War Studies*. Leiden: Brill Academic Publishers.

Jung, C.G. 1964. *Man and his Symbols*. London: Aldus Books.

Kandel, V. 2006. Pardon for soldier shot for cowardice. *Northwich Guardian*, 30 August, 5.

Kavanagh, G. 1988. Museum as Memorial: The Origins of the Imperial War Museum. *Journal of Contemporary History*, 23(1), 77–97.

Kavanagh, G. 1994. *Museums and the First World War: a social history*. Leicester: Leicester University Press.

Keegan, J. 1998. *The First World War*. London: Verso.

Kennedy, D. 2010. A Cenotaph history. *Morning Star* [Online 19 December]. Available at: http://www.morningstaronline.co.uk/content/view/full/99009 [accessed 21 December 2010].

Kennedy, M. 2008. Ninety years on, victims of a futile massacre exhumed from the mud. *The Guardian*, 3 June, 5.

King, A. 1998. *Memorials of the Great War in Britain: The Symbolism and Politics of Remembrance*. Oxford: Berg.

Kipling, R. 1940. *Rudyard Kipling's Verse: Definitive Edition*. London: Hodder and Stoughton.

Kirk, T. 2010. Labour leader 'shell shocked' by Harrow Council win. *Harrow Times*, 7 May, 4.

Knell, S.J., MacLeod, S. and Watson, S. (eds) 2007. *Museum revolutions: How museums change and are changed*. London and New York: Routledge.

Korte, B. 2001. The Grandfathers' War: Re-imagining World War One in British Novels and Films of the 1990s, in *Retrovisions: Reinventing the past in film and fiction*, edited by D. Cartmell, I.Q. Hunter, and I. Whelhan. London and Sterling: Pluto Press, 120–31.

Kramer, A. 2007 *Dynamic of Destruction. Culture and Mass Killing in the First World War*. Oxford: Oxford University Press.

Kuypers, J.A. 2006. *Bush's war: media bias and justifications for war in a terrorist age*. New York: Rowman & Littlefield.

LaCapra, D. 1998. *History and memory after Auschwitz*. Ithaca, NY: Cornell University Press.

Laffin, J. 1959. *Digger: The Legend of the Australian Soldier*. Melbourne: Macmillan.

Laffin, J. 1997. *British Butchers and Bunglers*. Stroud: Sutton.

Landsberg, A. 1997. America, the Holocaust, and the Mass Culture of Memory: Toward a Radical Politics of Empathy. *New German Critique*, 71, 63–86.

Lang, C., Reeve, J. and Woollard, V. (eds) 2006. *The Responsive Museum: Working With Audiences in the Twenty-first Century*. Aldershot: Ashgate.

Laquer, T.W. 1994. Memory and Naming in the Great War, in *Commemorations: The Politics of National Identity*, edited by J.R. Gillis. Princeton: Princeton University Press, 150–67.

Larcombe, D. 2011. Our silent thanks to the fallen. *The Sun* [Online 12 November]. Available at: http://www.thesun.co.uk/sol/homepage/news/campaigns/our_boys/2724598/Queen-leads-Armistice-Day-ceremony-for-World-War-1-veterans.html [accessed 12 November 2011].

Lavery, C. 2009. Frontline firefight as troops face down attack in Afghanistan. *Daily Record*, February 1, 7.

Lavery, M. 2006. Man's campaign to save memorial lasted as long as the Great War. *Yorkshire Evening Press*, 17 June, 8.

Lawson, M. 2002. The Battle for Ratings. *The Guardian*, 11 March, 19.

Lazenby, P. 2005. Campaign victory over fading of the fallen. *Yorkshire Evening Press*, 19 August, 9.

Leach, B. 2009. Armistice Day: the Queen and Duke of Edinburgh lead tributes to fallen soldiers. *Daily Telegraph* [Online 12 November]. Available at: http://www.telegraph.co.uk/news/newstopics/onthefrontline/6543163/Armistice-Day-the-Queen-and-Duke-of-Edinburgh-lead-tributes-to-fallen-soldiers.html [accessed 13 November 2009].

Leed, E.J. 1979. *No Man's Land: Combat and Identity in World War One*. Cambridge: Cambridge University Press.

Leese, P. 2002 *Shell Shock: Traumatic Neurosis and the British Soldiers of the First World War*. Basingstoke: Palgrave.

Leggewie, C. 2008. A Tour of the Battleground: The Seven Circles of Pan-European Memory. *Social Research*, 75(1), 217–34.

Leonard, J. 1997. Facing the finger of scorn: veterans' memories of Ireland after the Great War, in *War and Memory in the Twentieth Century*, edited by M. Evans and K. Lunn. Oxford: Berg, 59–72.

Lévi-Strauss, C. 1978. *Myth and Meaning*. Toronto: University of Toronto Press.

Levinas, E. 1998. *On Thinking-of-the-Other*. London: The Athlone Press.

Lewie, J. 1980. *Stop the Cavalry*. Stiff Records.

Lewis, B. 2004. *Swansea Pals*. Barnsley: Leo Cooper/Pen and Sword.

Lewis, S. 2008. Symbol of our lost generation. *York Evening Press*, 18 March, 16.

Lichfield, J. 2003. Discovered in the mud: The intact battlefield of Passchendaele and a grim harvest of bones. *Independent*, 11 November, 5.

Lichfield, J. 2006. The Battle of the Somme. *Independent* [Online 30 June]. Available at: http://www.independent.co.uk/news/world/europe/the-battle-of-the-somme-406120.html [accessed 30 July 2006].

Lichfield, J. 2009. Images rescued from dump reveal black British 'Tommy' at the Somme. *Independent*, 23 May, 8.

Liddell Hart, B.H. 1928. *Reputations*. London: John Murray.

Liddell Hart, B.H. 1930. *The Real War*. London: Faber and Faber.

Liddell Hart, B.H. 1934. *A History of the World War 1914–1918*. London: Faber and Faber.

Lister, K. 2007. First World War hero speaks out. *The Sun*, 3 August, 7.

Littler, J. and Naidoo, R. (eds) 2005. *The Politics of Heritage: the Legacies of Race*. London: Routledge.

Lloyd, D.W. 1998. *Battlefield Tourism: Pilgrimage and the Commemoration of the Great War in Britain, Australia and Canada 1919–1939*. Oxford and New York: Berg.

Lloyd George, D. 1936. *War Memoirs of David Lloyd George, Vol. VI*. London: Little and Brown.

Longworth, P. 1967. *The Unending Vigil. A History of the Commonwealth War Graves Commission*. London: Constable.

Lowe, S. and McArthur, A. 2011. *Blighty: The Quest for Britishness, Britain, Britons, Britishness and the British*. London: Little Brown.

Lowenthal, D. 1985. *The Past is a Foreign Country*. Cambridge: Cambridge University Press.

Lowenthal, D. 1989. Nostalgia Tells It Like It Wasn't, in *The Imagined Past: History and Nostalgia*, edited by C. Shaw and M. Chase. Manchester: Manchester University Press, 18–32.

Lowenthal, D. 1998. *The Heritage Crusade and the Spoils of History*. Cambridge: Cambridge University Press.

Lucy, G. 2011. Recalling bravery of heroic Somme troops. *Belfast Newsletter*, 1 July, 8.

Lusher, A. 2011. Save our war memorials campaign launched. *Daily Telegraph* [Online 6 November]. Available at: http://www.telegraph.co.uk/news/uknews/defence/8872178/Save-our-war-memorials-campaign-launched.html [accessed 12 November 2011].

Lutyens, E. 1917. Letter to Fabian Ware. *Commonwealth War Graves Commission*. (WG files 18): Cat No. 133 - Box: 1137.

Lynch, J. 1997. *Silent Night Christmas 1915*. Dolphin Records.

Lynch, M. 2008. *Holding Hands at Passchendale*. London: White Bear Theatre.

Lyon, R. 2004. Black Watch Home By Christmas. *International Marxist Tendency* [Online 26 November 2004] Available at: http://www.marxist.com/iraq-black-watch261104.htm [accessed 13 December 2011].

Lyons, J. 2007. Luck Eddie: How I dodged Taliban bullets. *Daily Record*, 9 January, 17.

McAllion, J. 2007. Shattered Scottish left. *Morning Star* [Online 26 September] Available at: http://www.morningstaronline.co.uk/news/content/view/full/50970 [accessed September 28 2011].

MacAskill, E. and White, M. 2000. Potential for panic inside Blair's bunker. *The Guardian*, 19 July, 21.

McCartney, H. 2005. *Citizen Soldiers The Liverpool Territorials in the First World War.* Cambridge: Cambridge University Press.

McCartney, P. 1983. *Pipes of Peace*. Parlophone/EMI.

McCrae, J. 1919. *In Flanders fields: and other poems*. New York: The Knickerbocker Press.

McCrum, R. 2002. They shall not grow old. *The Observer*, 10 November, 23.

Macdonald, L. 1978. *They Called it Passchendaele: The story of Ypres and of the men who fought in it.* London: Macmillan.

Macdonald, L. 1980. *The Roses of No-Man's Land*. London: Macmillan.

Macdonald, L. 1983. *Somme*. London: Papermac.

Macdonald, L. 1987. *1914: The Dawn of Hope*. London: Joseph.

Macdonald, L. 1998. *To The Last Man: Spring 1918*. London: Viking.

Macdonald, L. and Seaton, S. 1991 *1914–1918: Voices and Images of the Great War*. London: Penguin.

Macdonald, S. 1997. *Reimagining Culture: Histories, Identities and Gaelic Resistance*. Oxford: Berg.

Macdonald, S. 1998. Exhibitions of power and powers of exhibition, *The Politics of Display: Museums, Science, Culture*, edited by S.Macdonald. London and New York: Routledge, 1–24.

Macdonald, S. 2009. *Difficult Heritage: Dealing with the Nazi Past in Nuremberg and Beyond*. London, New York: Routledge.

McGregor, E. and Boorman, C. 2003 *Long Way Round: Chasing Shadows Across the World*. London: Atria.

McGuinness, F. 1986. *Observe the Sons of Ulster Marching towards the Somme*. London: Faber.

Macintyre, G. 2004. It's time to pardon victims of class war. *Sunday Sun*, 25 April, 8.

McKay, P. 2010. Don't let our fallen be casualties in this PR war. *Daily Mail* [Online 13 December]. Available at: http://www.dailymail.co.uk/debate/article-1338114/ Wootton-Bassett-processions-Dont-let-fallen-soldiers-PR-war-casualties.html [accessed 15 December 2010].

MacLachlan, M. 2012. Why Ypres matters more than Bannockburn for the independence. *Caledonian Mercury* [Online 16 April] Available at: http:// caledonianmercury.com/2012/04/16/opinion-why-ypres-matters-more-than-bannockburn-for-the-independence-vote/0032258 [accessed 21 July 2012].

Macleod, J. 2010. By Scottish hands, with Scottish money, on Scottish soil: The Scottish National War Memorial and National Identity. *Journal of British Studies*, 49(1), 73–96.

MacLeod, S. (ed.) 2005. *Reshaping Museum Space: Architecture, Design, Exhibitions*. London: Routledge.

McManamon, F.P. 1999. Cultural Resource Management in Contemporary Society: Perspectives on Managing and Presenting the Past, One World Archaeological Series, No. 33. London: Routledge.

McManus, M. 2011. Poppies and Pedagogy: learning from the 'Great War'. *Citizenship, Social and Economics Education*, 10(1), 27–36.

McNab, A. 2008. The battle that never ends. *Daily Telegraph*, 22 November, 18.

McNeill, W.H. 1986. Mythistory, or Truth, Myth, History, and Historians. *The American Historical Review*, 91(1), 1–10.

McVeigh, T. 2009. Police over the top at climate camp. *The Observer*, 1 March, 15.

Maddock, G. and Holmes, R. 2008. *Liverpool Pals: 17th, 18th, 19th, 20th (Service) Battalions the King's (Liverpool Regiment)*. Barnsley: Pen and Sword.

Magill, P. 2010. BNP activist 'delivered anti-Islam leaflets' in Barnoldswick. *Lancashire Telegraph*, 16 June, 7.

Maher, T.M. 2001. Framing: An Emerging Paradigm or a Phase of Agenda Setting, in *Framing Public Life: Perspectives on Media and our Understanding of the Social World*, edited by S.D. Reese, O.H. Gandy and A.E. Grant. Mahwah, NJ: Lawrence Erlbaum Associates, 83–94.

Mair, E. 2003. It's a dirty business. *The Guardian* [Online 25 March]. Available: http://www.guardian.co.uk/media/2003/mar/26/tvandradio.radio?INTCMP=SRCH [accessed 4 April 2009].

Major, J. 1999. *John Major: the autobiography*. London: Harper Collins.

Mallinson, A. 2012. Army redundancies are the result of politicians trying to peddle the lie that you can do more with less. *Daily Mail* [Online 13 June]. Available at: http://www.dailymail.co.uk/debate/article-2158642/Army-redundancies-result-politicians-trying-peddle-lie-less.html [accessed 15 June].

Mallinson, H. 2005. Landing on the beaches from Hell. *Bury Times*, 19 August, 3.

Manning, F. 1936. *Her Privates We*. London: Peter Davies.

Marshall, D. 2004. Making sense of remembrance. *Social and Cultural Geography*, 5(1), 37–54.

Martin, A. 2007. Back in Blighty, the pedalo hero who fooled the French. *Daily Mail* [Online 1 October]. Available at: http://www.dailymail.co.uk/news/article-484901/Back-Blighty-pedalo-hero-fooled-French.html [accessed 5 October 2007].

Martin, I. 2012. Number 10 gets into full-blown bunker-mentality mode. *Daily Telegraph* [Online 5 April]. Available at: http://blogs.telegraph.co.uk/news/iainmartin1/100149505/number-10-gets-into-full-blown-bunker-mentality-mode [accessed 5 May 2012].

Marty, P. 2007. Museum websites and museum visitors: Before and after the museum visit. *Museum Management and Curatorship*. 22(4), 337–60.

Marty, P. 2008. Museum websites and museum visitors: digital museum resources and their use. *Museum Management and Curatorship*, 23(1), 81–99.

Marwick, A. 1965. *The Deluge: British Society and the First World War*. Macmillan: London.

Marx, K. 1968. *The Eighteenth Brumaire of Louis Bonaparte*. Moscow: Foreign Languages Publishing House.

Mason, R. 2012. June, 75, stands up to Andrew Lansley's NHS reforms. *Daily Telegraph* [Online 20 February]. Available at: http://www.telegraph.co.uk/ health/healthnews/9094407/June-75-stands-up-to-Andrew-Lansleys-NHS-reforms.html [accessed 25 February 2012].

Meacher, M. 2011. Like the Somme, it's not just the brutality of Osborne's budget, it's the futility. *Left Futures* [Online 1 December]. Available at: http://www. leftfutures.org/2011/12/like-the-somme-it%E2%80%99s-not-just-the-brutality-of-osborne%E2%80%99s-budget-it%E2%80%99s-the-futility/[accessed 29 April 2012].

Meikle, J. 2009. Armistice Day services pay tribute to lost generation. *The Guardian*, 12 November, 3.

Meo, N. 2008. Pupils from inner city visit site of slaughter on Somme. *Daily Telegraph*, 1 November, 21.

Messinger, G.S. 1992. *British Propaganda and the State in the First World War*. Manchester and New York: Manchester University Press.

Middlebrook, M. 1971. *The First Day on the Somme*. Harmondsworth: Penguin.

Miller, B. 2008. Will this generation learn from WWI? *Morning Star* [Online 28 November]. Available at: http://www.morningstaronline.co.uk/news/content/view/full/68809 [accessed 13 December 2008].

Mills, A.J., Godfrey, F. and Scott, B. 1916. *Take Me Back To Dear Old Blighty*. Star Music.

Milne, S. and Gow, D. 2000. Brown runs into a barrage of criticism from unions. *The Guardian*, 13 September, 1.

Ministry of Defence 2002. *We Were There* [Online]. Available at: http://mod.uk/ wewerethere/files/introduction.html [accessed 24 March 2003].

Mitchell-Innes, C. 2011. Remembrance Sunday, Salisbury Cathedral [Online 13 November]. Available at: http://www.salisburycathedral.co.uk/services. sermons.php?id=415 [accessed 18 March 2012].

Monaghan, G. 2009. Anthem for doomed youth. *The Sunday Times*, 28 June, 19.

Monbiot, G. 2008. Lest we forget: the generals chose to kill their sons rather than their policies. *The Guardian*, 11 November, 17.

Montague, C.E. 1922. *Disenchantment*. London: Chatto and Windus.

Moore, J. 2009. Lions led by donkeys ... put in pigsties. *The Sun* [Online 10 March]. Available at: http://www.thesun.co.uk/sol/homepage/news/2290863/ Lions-led-by-donkeys-put-in-pigsties-Jane-Moore.html [accessed 15 March 2009].

Moore, N. and Whelan, Y. (eds) 2007. *Heritage, Memory and the Politics of Identity: New Perspectives on the Cultural Landscape*. Aldershot: Ashgate.

Moorhouse, G. 1992. *Hell's Foundations: A Town, Its Myths, and Gallipoli*. London: Hodder and Stoughton.

Morgan, T. 2007. Gallipoli dead remembered in solemn service. *Bury Times*, 23 April, 6.

Moriarty, C. 1999. The Material Culture of Great War Remembrance. *Journal of Contemporary History*, 34(4), 653–62.

Moriarty, C. 2007. Private Grief and Public Remembrance, in *War and Memory in the Twentieth Century*, edited by M. Evans and K. Lunn. Oxford: Berg, 125–42.

Morris, M. 1997. Gardens forever England: landscape identity and the First World War British cemeteries on the Western front. *Ecumene*, 4(4), 410–34.

Morrow, J.H. 2004. *The Great War: An Imperial History*. London and New York: Routledge.

Morz, A. 2009. Leader: Anthem for doomed youth. *Times Higher Education Supplement*, 20 August, 15.

Mosse, G.L. 1990. *Fallen Soldiers: Reshaping the memory of the World War*. Oxford: Oxford University Press.

Motörhead, 1991. *1916*. WTG.

Moult, J. 2007. 7/7 survivors' lone battle. *The Sun* [Online 3 August]. Available at: http://www.thesun.co.uk/sol/homepage/news/42431/77-survivors-lone-battle.html [accessed 12 October 2010].

Mulford, S. 1999. Please Give Me Another Chance: Young Soldier's Letter Begging The Army To Spare His Life. *Daily Record*, 28 October, 9.

Murray, A. 2009. Clegg needs to find a way out of No Man's Land. *Spectator*, 19 September, 32.

Murray, D., Demetriou, D. and Lydall, R. 2002. If more strikes are ordered it will turn into a war of attrition. *Daily Mail* [Online 2 October] Available at: http://www.dailymail.co.uk/news/article-140922/Tube-bullies-halttrains.html#ixzz1tdUrpsgF [accessed 13 January 2012].

Nairn, T. 1977. *The Break-Up of Britain. Crisis and Neo-Nationalism*. London: New Left Books.

National Army Museum, 2012. Homepage [Online]. Available at: www.nam.ac.uk/[accessed 12 May 2012].

Neal, A.G. 1998. *National Trauma and Collective Memory: Major Events in the American Century*. New York: M.E. Sharpe.

Neil, B. 2005. Shot at Dawn but Dad was a Victim not a Coward. *Daily Mirror*, 29 October, 8.

Nelson, B. 2009. A helping hand for shell-shocked vets, *Northern Echo*, 30 October, 8.

Newall, V. 1976. Armistice Day: Folk Tradition in an English Festival of Remembrance. *Folklore*, 87(2), 226–9.

NHS, 2008. Post-Traumatic Stress Disorder. [Online 13 July]. Available at: http://www.nhs.uk/Conditions/Post-traumatic-stress-disorder/Pages/Introduction.aspx [accessed 12 May 2012].

Nichol, S. 2011. Tyneside falls silent for Remembrance Sunday. *Evening Chronicle*, 14 November, 3.

Nietzsche, F. 1968. *The Will to Power*. New York: Vintage Books.

Niland, L. 2011. Christmas Truce, 1914. The Guardian [Online 23 December] Available at: http://www.guardian.co.uk/theguardian/from-the-archive-

blog/2011/dec/23/from-the-archive-blog-christmas-truce-1914 [accessed 28 June 2011].

Nora, P. 1989. Between Memory and History: Les Lieux de Mémoire. *Representations*, 26, 7–25.

Northamptonshire Black History Association, 2007. Walter Tull. *NBHA* 5(4), 5.

Northern Ireland Assembly, 2010. *Location of Public Sector Jobs*. 25 January.

Northern Ireland Assembly Official Record, 2002. *Chaulnes Area*. 22 January, Northern Ireland Assembly, 2010. *Seventieth Anniversary of the Death of Lord Craigavon*. 22 November.

Norton-Taylor, R. 2006a. Executed WW1 soldiers to be given pardons. *The Guardian*, 16 August, 5.

Norton-Taylor, R. 2006b. Haig's son opposes first world war pardons, *The Guardian*, 5 September, 12.

Norton-Taylor, R. and Watt, N. 2005. Families of dead soldiers threaten Blair with court. *The Guardian*, 4 May, 7.

Novick, P. 2001. *The Holocaust in Collective Memory*. London: Bloomsbury.

OED, 2002. *Oxford English Dictionary*. Oxford: Oxford University Press.

Oh! What a Lovely War (dir. R. Attenborough, 1969).

Oldham, P. 1998. *Messines Ridge (Ypres)*. Barnsley: Pen and Sword: Leo Cooper.

O'Neill, D. 2009. War to End All Wars was just the start of many more. *South Wales Echo*, 11 November, 21.

O'Neill, D. 2011. Politicians send more to war while they wear poppies. *South Wales Echo*, 9 November, 19.

Onions, J. 1990. *English Fiction and Drama of the Great War, 1918–1939*. New York: St. Martin's Press.

Oram, G. 1998. *Worthless Men: Race, eugenics and the death penalty in the British Army during the First World War*. London: Francis Boutle.

Orwell, G. 2000. *My Country, Right or Left*. Jaffrey, NH: David R. Godine.

Owen, W. 1965. *The Collected Poems of Wilfred Owen*. Chatto and Windus: New York.

Pardon for Soldiers of the Great War Bill 2006. London: HMSO.

Parfitt, G. 1988. *Fiction of the First World War: A Study*. London and Boston: Faber and Faber.

Parris, M. 2006. A Clever Trick: Say Sorry, Condemn the Past and Look Good, with No Cost, *The Times*, 26 August, 21.

Partridge, E. 1966. *Origins: a short etymological dictionary of modern English*. London: Kegan Paul.

Pascoe-Watson, G. 2009. Darling: Slump 'over by Xmas'. *The Sun* [Online 20 April]. Available at: http://www.thesun.co.uk/sol/homepage/news/money/2385273/Alistair-Darling-Slump-over-by-Xmas.html [accessed 25 April 2009].

Pearce, S. 1998. The construction and analysis of the cultural heritage: Some thoughts. *International Journal of Heritage Studies*, 4(1), 1–9.

Pelling, R. 2012. Why Blighty breeds a better class of bounder. *Daily Telegraph* [Online 28 February]. Available at: http://www.telegraph.co.uk/culture/9111195/ Why-Blighty-breeds-a-better-class-of-bounder.html [accessed 3 March 2012].

Pennell, C. 2012. *A Kingdom United: Popular Responses to the Outbreak of the First World War in Britain and Ireland*. Oxford: Oxford University Press.

Penny, L. 2010. Poppy Day is the opium of the people. *New Statesman* [Online 7 November]. Available at: http://www.newstatesman.com/blogs/laurie-penny/2010/11/british-war-poppy-carnage [accessed 13 August 2011].

Perryman, M. 2008. *Imagined Nation: England after Britain*. London: Lawrence and Wishart.

Perryman, M. (ed.) 2009. *Breaking up Britain: four nations after a union*. London: Lawrence and Wishart.

Peterkind, T. 2012. Alex Salmond marches out into political no man's land. *The Scotsman*, 11 January, 8.

Pickles, R. 2011. Diary of returning expat: back in Blighty. *Daily Telegraph* [Online 13 May 2011] Available at: http://www.telegraph.co.uk/expat/expatlife/8511558/ Diary-of-returning-expat-back-in-Blighty.html [accessed June 14 2012].

Pike, B. 2008. Going over the top in the 'climate war'. *Spiked* [Online 24 September]. Available at: http://www.spiked-online.com/index.php/site/article/5753/ [accessed 25 May 2012].

Pilger, J. 2003. As the world protests against war, we hear again the lies of old. *New Statesman*, 17 February, 12.

Pink, S. 2006. *The Future of Visual Anthropology: Engaging the Senses*. London: Routledge.

Pinter, H. 1975. *No Man's Land*. London: Karnac Books.

Pound, R. 1964. *The Lost Generation*. London: Constable.

PPU 2012a. Christmas Truce [Online 12 December 2007]. Available at: http://www. ppu.org.uk/remembrance/xmas/xmas.html [accessed 20 October 2011].

PPU 2012b. Two Famous Poems from the First World War [Online 9 June 2007]. Available at: http://www.ppu.org.uk/poppy/new/tx_fallen1.html [accessed 20 October 2011].

Preston, P. 2003. How many bodybags can we take? *The Guardian*, 31 March, 22.

Preston, P. 2011. Remembrance day: The lessons of war are too easily forgotten. *The Guardian*, 13 November, 15.

Price, A. 2011. A warning for the workers' movement. *The Socialist*, 667, 20 April, 7.

Price, J. 2008. The Devonshires hold this trench, they hold it still: cultural landscapes of sacrifice and the problem of the sacred ground of the Great War, 1914-1918, in *Landscapes of Clearance: Anthropological and Archaeological Perspectives*, edited by A. Smith and A. Gazin-Schwartz. Walnut Creek: Left Coast Press, 180–89.

Prince of Wales, 2010. Prince William to become Patron of the Imperial War Museum Foundation's First World War Centenary Appeal [Online 9 December]. Available at: http://www.princeofwales.gov.uk/mediacentre/

pressreleases/prince_william_to_become_patron_of_the_imperial_war_
museum_f_122973838.html [accessed 12 May 2012].

Priory, J. 2011. School Children Must Learn the Meaning of the Poppy. *Daily Telegraph*, 11 November, 17.

Proctor, T.M. 2010. *Civilians in a World at War, 1914–1918*. New York: New York University Press.

Prosisea, T.O. 2009. Prejudiced, historical witness, and responsible: Collective memory and liminality in the Beit Hashoah museum of tolerance. *Communication Quarterly*, 51(3), 351–66.

Pulteney, W. 1925. *The Immortal Salient: An Historical Record and Complete Guide for Pilgrims to Ypres*. London: John Murray.

Purseigle, P. 2005. Introduction: Warfare and Belligerence: Approaches to the First World War, *Warfare and Belligerence: Perspectives in First World War Studies*, edited by in P. Purseigle. Leiden, Boston: Brill, 1–37.

Purseigle, P. and Macleod, J. (eds) (2004) *Uncovered Fields: Perspectives in First World War Studies*. Leiden, Boston: Brill, 1–23.

Putkowski, J. and Sykes, J. 1989. *Shot at Dawn*. Barnsley: Wharncliffe Publishing.

Qureshi, Y. 2009. At long last, a salute to hero. *Manchester Evening News*. 26 February, 8.

Radnedge, A. 2011. Nurses warn of 40,000 job cuts. *Metro* [Online 10 April] Available at: http://www.metro.co.uk/news/860488-nurses-warn-of-40-000-job-cuts#ixzz1u7v37oUF [accessed 12 November 2011].

Radstone, S. and Hodgkin, K. 2005. *Memory Cultures: Memory, Subjectivity, and Recognition*. New Brunswick: Transaction Publishers

Radstone, S. and Schwarz, B. (eds) 2010. *Memory. Histories, Theories, Debates*. New York: Fordham University Press.

Ralston, G. 2007. Caley Thistle Leave Hearts Shell-Shocked. *Daily Record*, 24 December, 32.

Reece, D. 2009. Dear old Blighty's truly world class. *Daily Telegraph*, 8 October, 22.

Reeves, N. 1983. Film Propaganda and its Audience: The Example of Britain's Official Films during the First World War. *Journal of Contemporary History*, 18(3), 463–94.

Reeves, N. 1986. *Official British Film Propaganda during the First World War*. London: Croom Helm.

Reeves, N. 1997. Cinema, Spectatorship and propaganda: Battle of the Somme (1916) and its contemporary audience. *Historical Journal of Film, Radio and Television*, 17(1), 5–28.

Reeves, N. 1999. Official British Film Propaganda, in *The First World War and Popular Cinema 1914 to the Present*, edited by M. Paris. Edinburgh: Edinburgh University Press, 27–50.

Reid, F. 2009. *Broken Men: Shell Shock, Treatment and Recovery in Britain, 1914–1930*. London: Continuum.

Remarque, E.M. 1929. *All Quiet on the Western Front*. London: Putnams.

Ricoeur, P. 2004. *Memory, History, Forgetting*. Chicago: The University of Chicago Press.

Riddell, M. 2006. The soldier's song has become a lament. *The Observer*, 5 February, 32.

Riddell, M. 2009. Afghanistan: Our troops are giving their lives to safeguard a rigged election. *Daily Telegraph*, 13 July, 21.

Riddell, M. 2009b. Had we listened to Harry Patch, we would not still be in Helmand. *Daily Mail* [Online 27 July]. Available at: http://www.telegraph. co.uk/comment/columnists/maryriddell/5919886/Had-we-listened-to-Harry-Patch-we-would-not-still-be-in-Helmand.html [accessed 3 August 2009].

Ridgway, T. 2012. What future for the 'lost generation'? *The Argus*, 6 January, 8.

Rifkin, J. 2009. *The empathic civilisation*. New York: Jeremy P. Tarcher/Penguin.

Riordan, J. 2009. Afghan war jingoism. *Morning Star* [Online 16 July 2009] Available at: http://www.morningstaronline.co.uk/index.php/news/content/ view/full/78095 [accessed 20 August 2010].

Rivers, W.H. 1918. The Repression of War Experience. *Proceedings of the Royal Society of Medicine* 11, 1–20.

Robbins, S. 2005. *British generalship on the Western Front 1914–18: defeat into victory*. Abingdon: Frank Cass.

Roberts, A. 2009. Best tribute to Harry Patch is teaching our children why they must never forget horrors of Great War. *Daily Mirror*, 27 July, 7.

Roberts, B. 2007. 1,000 troops back for Xmas. *Daily Mirror*, 3 October, 22.

Robertson, I. 2012. *Heritage from Below*. Aldershot: Ashgate.

Robinson, B. 2009. Harry Patch: a human understanding. *Workers Liberty* [Online 29 August]. Available at: http://www.workersliberty.org/story/2009/08/29/ harry-patch-human-understanding [accessed on 3 September 2009].

Robinson, H. 2002. Remembering War in the Midst of Conflict: First World War Commemorations in the Northern Irish Troubles. *20th Century British History*, 21(1), 80–101.

Robson, R. 2005. Slaughter on the Somme. *Workers Liberty* [Online 19 November]. Available at: http://www.workersliberty.org/node/5261 [accessed 22 June 2010].

Rogers, G. 2006. A pardon, 90 years on. *South Wales Echo*, 17 August, 6.

Rolston, B. 1991. *Politics and Painting: Murals and Conflict in Northern Ireland*. Rutherford: Fairleigh Dickinson University Press.

Royal British Legion, 2012. We Will Remember Them. Available at: http://www. britishlegion.org.uk/remembrance/we-will-remember-them/keeping-their-memory-alive/[accessed 12 June 2012].

Rootschat, 2007. Christmas Truce [Online 13 December] Available at: http://www. rootschat. com/forum/index.php/topic,273465.0.html [accessed 12 September 2011].

Rorty, R. 1989. *Philosophy and the Mirror of Nature*. Princeton: Princeton University Press.

Roth, M. 1995. *The ironist's cage: Memory, trauma and the construction of history.* New York: Columbia University Press.

Routledge, P. 2011. Brass hats enlist in David Cameron's army. *Daily Mirror,* 7 October, 12.

Rudkin, A. 2011. Left in Limbo. *Oldham Chronicle,* 26 October, 6.

Ruggles, D.F. and Silverman, H. (eds) 2009. *Intangible Heritage Embodied.* New York: Springer.

Russell, I. (ed.) 2006. *Images, Representations and Heritage: Moving beyond Modern Approaches to Archaeology.* New York: Springer.

Sadgrove, M. 2006. *Sermon: On Remembrance Sunday,* Durham Cathedral [Online 12 November]. Available at: http://www.durhamcathedral.co.uk/ schedule/sermons/100 [accessed 12 July 2009].

Samuel, R. 1989. Introduction: the figures of national myth, in *Patriotism: The Making and Unmaking of British National Identity, Volume III National Fictions,* edited by R. Samuel. London and New York: Routledge, xi–xxix.

Samuel, R. 1994. *Theatres of Memory.* London: Verso.

Sandell, R. (ed.) 2002. *Museums, Society, Inequality.* London: Routledge.

Sandell, R. 2007. *Museums, Prejudice and the Reframing of Difference.* London: Routledge.

Sandell, R. and Nightingale, E. (eds) 2012. *Museums, Equality and Social Justice.* London: Routledge.

Sanderson, T. 2012. Why are Remembrance Day ceremonies Christian? Why aren't they inclusive? [Online 23 May]. Available at: http://www.secularism.org. uk/uploads/terry-sanderson-address-to-nss-members-and-msps-at-holyrood-parliament-on-23-may-2012.pdf [accessed 28 June 2012].

Sassoon, S. 1918. *Counter-attack, and Other Poems.* New York: E.P. Dutton.

Sassoon, S. 1937. *The Complete Memoirs of George Sherston.* London: Faber and Faber.

Sassoon, S. 1983. *The War Poems.* London: Faber.

Saunders, A. 2012. *Reinventing warfare 1914–18: novel munitions and tactics of trench warfare.* London and New York: Continuum.

Saunders, N.J. 2001. Matter and memory in the landscapes of conflict: The Western Front 1914–1999, in *Contested Landscapes: movement, exile and place,* edited by B. Bender and M. Viner. Oxford: Berg, 37–54.

Saunders, N.J. 2002. Excavating memories: archaeology and the Great War, 1914–2001. *Antiquity,* 76, 101–8.

Saunders, N.J. 2007. *Killing Time: Archaeology and the First World War.* Sutton: Stroud.

Scarry, E. 1985. *The Body in Pain.* Oxford: Oxford University Press.

Scheufele, D.A. 1999. Framing as a Theory of Media Effects. *Journal of Communication,* 49(4), 103–22.

Schofield, J. and Szymanski, R. 2011. Sense of Place in a Changing World, in *Local Heritage, Global Context: Cultural Perspectives on Sense of Place,* edited by J. Schofield and R. Szymanski. Farnham: Ashgate, 1–12.

Schoony, 2011. *Boy Soldiers*. February 2011 to March 2011. Peace of Plinth, London.

Scottish Government, 2007. Tribute to Scots Soldiers at Passchendaele [Online 24 August]. Available at: http://www.scotland.gov.uk/News/Releases/2007/08/24115256 [accessed 12 October 2007].

Scottish Parliament Official Record. 1999. *Pardon for Executed Soldiers*. 11 November, S1M-223.

Scottish Parliament Official Record. 2005. *Scotland's Veterans*. 12 May, S2M 2794.

Scottish Parliament Official Record, 2006. *Trident*. 21 December, S2M 27972

Scottish Parliament Official Record. 2007. *Ninetieth Anniversary of the Battle of Passchendaele*. 31 January, S2M-5290.

Scottish Parliament Official Record. 2008. *Lest We Forget*. 3 November, Motion S3M-02810.

Seanad Éireann. 2006. *Shot at Dawn Campaign: Statements*. 28 March, v.183.

Segal, R.A. 1999. *Theorizing About Myth*. Boston, MA: University of Massachusetts Press.

Sengupta, K. 2001. Tragic statue for the Great War's executed soldiers. *Independent*, 22 June, 14.

Shaw, C. and Chase, M. (eds) 1989. *The Imagined Past: History and Nostalgia*. Manchester: Manchester University Press.

Sheffield, G. 2002. *Forgotten Victory, The First World War – Myths and Realities*. London: Review.

Sherriff, R.C. 1929. *Journey's End*. London: Faber and Faber.

Siddle, J. 2010. A Formby Conservative councillor was said to be "shell-shocked" after being axed by her own party. *Formby Times*, 20 October, 5.

Siefring, J. (ed.) 2005. *The Oxford Dictionary of Idioms*. Oxford: Oxford University Press.

Silbey, D. 2005. *The British Working Class and Enthusiasm for War, 1914–1916*. Abingdon: Frank Cass.

Silkin, J. (ed.) 1996. *The Penguin Book of First World War Poetry*. London: Penguin.

Silverman, D.P. 1982. *Reconstructing Europe after the Great War*. Cambridge, MA: Harvard University Press.

Simkins, P. 1988. *Kitchener's army: the raising of the new armies, 1914–16*. Manchester: Manchester University Press.

Simkins, P. 1991. Everyman at War: Recent Interpretations of the Front Line Experience', in *The First World War and British Military History*, edited by B. Bond. Oxford: Oxford University Press, 263–88.

Simpson, A. 2007. Truce in the trenches: let's meet for cigars. *Daily Telegraph* [Online 26 December]. Available at: http://www.telegraph.co.uk/news/worldnews/1573711/Truce-in-the-trenches-lets-meet-for-cigars.html [accessed 15 October 2010].

Simpson, J. 2009. *News from no man's land: reporting the world*. London: Pan.

Sinn Féin, 2008. Belfast Mayor Outlines Approach to Somme Commemoration [Online 19 June] Available at: http://www.sinnfein.ie/contents/13005 [accessed 25 September 2010].

Smith, H. 2010. Muslim protesters burn poppy at Armistice Day silence for war dead. *Metro*, 22 November, 3.

Smith, J. 2004 Black Watch Home by Christmas, promises Blair. *Independent* [Online 20 October] Available at: http://www.independent.co.uk/news/uk/politics/black-watch-home-by-christmas-promises-blair-6159630.html [accessed 25 November 2011].

Smith, L. 2004. *Archaeological Theory and the Politics of Cultural Heritage*. London and New York: Routledge.

Smith, L. 2006. *Uses of Heritage*. London: Routledge.

Smith, L. 2009. Deference and humility: The social values of the country house, in *Valuing Historic Environments*, edited by L. Gibson and J. Pendlebury. Farnham: Ashgate, 33–50.

Smith, L. and Akagawa, N. 2009. *Intangible Heritage*. London, New York: Routledge.

Smith, L. and Waterton, E. 2009. *Heritage, Communities and Archaeology*. London: Duckworth.

Smith, L, Shackel, P.A. and Campbell, G. (eds) 2010. *Heritage, Labour and the Working Classes*. London: Routledge.

Smith, L. Waterton, E. and Watson, S. (eds) 2012. *The Cultural Moment in Tourism*. London: Routledge.

Smith, L.V. 2001. Paul Fussell's The Great War and Modern Memory: Twenty-Five Years Later. *History and Theory*, 40, 241–60.

Smith, M. 2010. In praise of … Dulce Et Decorum Est. *The Herald*, 1 October, 21.

Sørensen, M.S. and Carman, J. 2009. *Heritage Studies: Methods and Approaches*. London and New York: Routledge.

Sorlin, P. 1999. Cinema and the Memory of the Great War, in *The First World War and Popular Cinema 1914 to the Present*, edited by M. Paris. Edinburgh: Edinburgh University Press, 5–26.

South Belfast Friends of the Somme Association, 2012. [Online] Available at: http://www.belfastsomme.com/[accessed 12 January 2012].

Spackman, A. 1994. A losing battle in the trenches – Residents have no control over construction work on their doorsteps. *Independent: Life and Style*, 18 June, 4.

Spagnoly, T. 1999. Introduction, in *Poets and Pals of Picardy: A Somme Weekend*, edited by in M.E. Freeman. Barnsley: Pen and Sword/Leo Cooper, ix–x.

Spagnoly, T. and Smith, T. 1995. *Salient Points: Cameos of the Western Front Ypres Sector 1914–1918*. Barnsley: Pen and Sword/Leo Cooper.

Speller, E. 2010. Firing Squads: Cruel Fate of the 'Cowards'. *Daily Express* [Online 24 February]. Available at: http://www.express.co.uk/posts/view/160138/Firing-squads-Cruel-fate-of-the-cowards [accessed 2 March 2010].

Spencer, N. 2009. Can we climb out of the trenches? *The Guardian*, 30 December, 25.

Spencer, W. 2008. *First World War Army Service Records: A guide for family historians*. London: The National Archives.

Staffordshire Regimental Museum, 2012. The Coltman Trench [Online]. Available at: http://staffordshireregimentmuseum.com/trench.html [accessed 14 May 2012].

Stallworthy, J. 1993. *Wilfred Owen*. Oxford: Oxford University Press.

Stamp, G. 2006. *Memorial to the Missing of the Somme*. London: Profile Books.

Starkey, J. and Wheeler, V. 2007. We WILL remember them. *The Sun*, 4 August, 4.

Starrett, I. 2000. Pressure is on to pardon soldiers executed at dawn. *The News Letter*, 1 June, 5.

Stedman, M. 1993. *Salford Pals: A History of the 15th, 16th, 19th and 20th Battalions Lancashire Fusiliers 1914–1919*. London: Leo Cooper.

Stedman, M. 1995. *Thiepval (Somme)*. London, Pen and Sword/Leo Cooper.

Steel, M. 2009. Why should I be pressured into wearing a poppy? *Independent*, 4 November, 18.

Steele, J. 2006. Horrors of closet civil war played out in no man's land. *The Guardian*, 6 December, 5.

Sternberg, C. 2002. The Tripod in the Trenches, Media Memories of the First World War in *War and the Cultural Construction of Identities in Britain*, edited by B. Korte and R. Schneider, Amsterdam: Kluwer, 201–33.

Stewart, W. 2012. "Shell-shocked" LAs about to get another surprise. *Times Educational Supplement*, 20 April, 4.

Strachan, H. 2005. *The First World War*. London: Penguin.

Sturken, M. 1997. *Tangled Memories: The Vietnam War, the AIDS Epidemic, and the Politics of Remembering*. Berkeley: University of California Press.

Sweeney, J. 1999. Day trip to hell gives young a lesson in war's folly. *The Observer*, 6 November, 8.

Swindler, A. 1995. Cultural Power and Social Movements, in *Social Movements and Culture*, edited by H. Johnston and B. Klandermans. Minneapolis: University of Minnesota Press, 25–40.

Taaffe, P. 2009. Preparing for the showdown. *Socialism Today*, Issue 132, 8–9.

Tate, T. 1998. *Modernism, History, and the First World War*. Manchester and New York: Manchester University Press.

Taylor, A.J.P. 1963. *The First World War: An Illustrated History*. London: Penguin.

Taylor, H.A. 1928. *Good-bye to the battlefields*. London: S. Paul.

Taylor, P. 2006. The lost generation. *Newcastle Evening Chronicle*, 12 May, 6.

Tempest, M. 2004. Blair: Black Watch home for Christmas. *The Guardian* [Online 20 October]. Available at: http://www.guardian.co.uk/politics/2004/oct/20/iraq.iraq [accessed 20 November 2011].

Terraine, J. 1980. *The Smoke and the Fire: Myths and Anti-Myths of War 1861–1945*. London: Sidgwick and Jackson.

Thacker, S. 2007. Viewers get rare chance to see Pals go off to war. *Accrington Observer*, 2 November, 8.

The Farm, 1990. *All Together Now*. Sony Records.

The First World War (dir. Marcus Kiggell, 2003).

The Great War (dir. Tony Essex, 1964).

The Great War Archive, 2008. [Online 12 June]. Available at: http://www.oucs. ox.ac.uk/ww1lit/gwa/[accessed 28 June 2012].

The Monocled Mutineer (dir. Jim O'Brien).

The Trench (dir. William Boyd, 1999).

The Trench (dir. Dominic Ozanne, 2002).

The Times, 1928. *War Graves of the Empire, reprinted from the special number of The Times*. London: The Times Publishing Company.

The Trench Experience, 2012. Homepage [Online]. Available at: http://www. thetrenchexperience.com/[accessed 13 June 2012].

Theatre Workshop, 1965. *Oh! What a Lovely War*. London: Methuen.

Timewatch: The Last Day of World War I (dir. by J.H. Fisher, 2008).

Thomas, L. 2010. Anti-war poem by Wilfred Owen is a favourite with David Cameron. (Wonder what Tony Blair's would have been ...). *Daily Mail*, 28 September, 15.

Thompson, M. 2008. *The White War: Life and Death on the Italian Front 1915–1919*. London: Faber and Faber.

Thomson, A. 1994. *Anzac Memories: Living with the Legend*. Oxford: Oxford University Press.

Todman, D. 2002. The Reception of The Great War in the 1960s. *Historical Journal of Film, Radio and Television*, 22(1), 29–36.

Todman, D. 2005. *The Great War: Myth and Memory*. London: Hambledon.

Tootal, S. 2009. My friend Tug and the scandal of our shell-shocked soldiers. *Independent*, 20 October, 15.

Timmins, N. 2011. Lansley faces rough ride over NHS reform. *Financial Times*, 13 February, 5.

Trudell, M. 1997. *Prelude to Revolution: Class Consciousness and the First World War*. International Socialism 76, 67–107.

Tuan, Y. 1977. *Space and Place: The Perspective of Experience*. London: Edward Arnold.

Tucker, S.C. 1998. *The Great War 1914–18*. Bloomington: Indiana University Press.

Tunbridge, J.E. and Ashworth, G. 1996. *Dissonant Heritage: The Management of the Past as a Resource in Conflict*. New York: Wiley.

Turley, J. 2011. Patriotism and pyromania. *Weekly Worker*, 10 November, 12.

Turner, J. (ed.) 1988. *Britain and the First World War*. London: Unwin Hyman.

Turner, W. 1992 *The Accrington Pals: 11th (Service) Battalion, Accrington, East Lancashire Regiment*. Lancashire: Lancashire County Books.

Tyson, A. 2008. Crafting emotional comfort: interpreting the painful past at living history museums in the new economy. *Museum and Society*, 6(3), 246–62.

Ulster Defence Association, 2007. *Remembrance Day Statement*. 11 November 2007.

Ulster Nation, 2007. The Somme [Online] Available at: http://www.ulsternation.org. uk/somme.htm [accessed 22 June 2010].

United Artists, 2009. *We will remember them*. Zoom Music.

Van Bergen, L. 2009. *Before my helpless sight: suffering, dying and medicine on the Western Front, 1914–1918*. Farnham: Ashgate.
van Dijk, T.A. 1988. *News as Discourse*. Hillsdale, NJ: Erlbaum.
van Dijk, T. 1991. *Racism and the Press*. New York and London. Routledge.
van Emden, R. 2011. Why war memorials matter. *Daily Telegraph*, 30 October, 8.
van Emden, R. and Humphries, S. 2004. *All Quiet on the Home Front: An Oral History of Life in Britain During the First World War*. London: Headline.
Vance, J.F. 1998. *Death so Noble: Memory, Meaning and the First World War*. Vancouver: University of British Columbia Press.
Vasili, P. 1996. Walter Tull. 1888–1918: Soldier, Footballer, Black. *Race and Class*, 38(2), 51–69.
VNN Forum, 2009. British Jobs for British Workers [Online 19 September]. Available at: http://www.vnnforum.com/archive/index.php/t-116515.html [accessed 12 May 2012].
VNN Forum, 2010. Great New Poster [Online 9 February]. Available at: http://www. vnn forum.com/archive/index.php/t-107334.html [accessed 12 May 2012].
Walker, B. 2000. *Past and present: history, identity and politics in Ireland*. Belfast: Institute of Irish Studies.
Walker, B. 2007. Ancient enmities and modern conflict: history and politics in Northern Ireland. *Nationalism and Ethnic Politics*, 13(1), 103–28.
Walker, M. 2011. Miracle of the Christmas Truce game reconnects with a new generation. *Daily Mail*, 4 December, 11.
Walsh, K. 1992. *The Representation of the Past: Museums and Heritage in the Post-Modern World*. London: Routledge.
War Office, 1922. *Statistics of the Military Effort of the British Empire during the Great War*. London: HMSO.
Ward, L. and Watt, N. 2002. Rebels lay down barrage of criticism. *The Guardian*, 26 November, 3.
Ward, P. 2011. Remembrance Day: Scots across the country pay tribute to the fallen. *Daily Record*, 12 November, 2.
Ward, S. 2012. War of attrition in Southampton. *Solidarity*, 28 March, 11.
Ware, F. 1928. Introduction. *Ninth Annual Report of the IWGC*. London: HMSO, 3–5.
Ware, F. 1937. *The Immortal Heritage*. Cambridge: Cambridge University Press.
Warner, E. 2000. Hunkered in the bunker. *The Guardian*, 30 September, 4.
Waterton, E. 2010. *Politics, Policy and the Discourses of Heritage*. Hampshire: Palgrave Macmillan.
Waterton, E. and Smith, L. 2009. *The envy of the world? Intangible heritage in England*, in *Intangible Heritage* edited by N. Akagawa and L. Smith. New York: Routledge, 289–302.
Waterton, E. and Watson, S. (eds) 2010 *Cultural Heritage and Representation: Perspectives on Visuality and the Past*. Aldershot: Ashgate.
Waterton, E. and Watson S. (eds) 2011. *Heritage and Community Development: Collaboration or Contestation?* London: Routledge.

Watson, J.S.K. 1997. Khaki Girls, VADs, and Tommy's Sisters: Gender and Class in First World War Britain. *International History Review*, 19(1), 32–51.

Watson, J.S.K. 2000. The Paradox of Working Heroines: Conflict Over the Changing Social Order in Wartime Britain, 1914–1918, in *World War I and the Cultures of Modernity*, edited by M. Mays and D. Mackaman. Jackson: University Press of Mississippi, 81–103.

Watson, J.S.K. 2002. Wars in the Wars: The Social Construction of Medical Work in First World War Britain. *Journal of British Studies*, 41(4), 484–510.

Watson, J.S.K. 2004. *Fighting Different Wars: Experience, Memory, and the First World War*. Cambridge: Cambridge University Press.

Watt, C. and Williams, M. 2011. Military Cross winner attacked partner after mental breakdown. *The Herald*, 19 January, 7.

Weiss, M. 2012. The Syrian rebels' war of attrition. Daily Telegraph [Online 30 January]. Available at: http://blogs.telegraph.co.uk/news/michaelweiss/100133520/the-syrian-rebels-war-of-attrition/[accessed 15 February 2012].

Weintraub, S. 2002. *Silent Night: The Story of the World War I Christmas*. New York: Plume.

Wertsch, J.V. 2002. *Voices of Collective Remembering*. Cambridge: Cambridge University Press.

West, C. (ed.) 2010. *Understanding Heritage in Practice, Understanding Global Heritage*. Manchester and New York: Manchester University Press.

Whealan, P. 2011. *Accrington Pals*. London: Methuen.

Wheatcroft, G. 2001. No, it was not a lovely war. *The Observer*, 1 July, 32.

White, M. 2001. Surely Somme mistake as battle-weary troops hold their ground. *Health Services Journal* [Online 31 May]. Available at: http://www.hsj.co.uk/news/surely-somme-mistake-as-battle-weary-troops-hold-their-ground/24307.article [accessed 5 May 2011].

Whitmarsh, W. 2001. We Will Remember Them: Memory and Commemoration in War Museums. *Journal of Conservations and Museum Studies*, 7. Available at: http://jcms-journal.com/index.php/jcms/article/view/21/21 [accessed 13 October 2008].

Wight, J. 2010. The ugly reality of Remembrance Sunday. *Socialist Unity* [Online 14 November]. Available at: http://www.socialistunity.com/the-ugly-reality-of-remembrance-sunday/[accessed 21 November 2010].

Williams, D. 2009. *Media, Memory, and the First World War.* Montreal and Kingston: McGill-Queen's University Press.

Williams, H. (ed.) 2003. *Archaeologies of Remembrance: Death and Memory in Past Societies*. New York: Kluwer.

Williams, J. 2008. *Modernity, the Media and the Military: The Creation of National Mythologies on the Western Front 1914–1918*. London: Routledge.

Williams, P. 2007. *Memorial Museums: The Global Rush to Commemorate Atrocities*. Oxford: Berg.

Williams, P. 2011. Memorial Museums and the Objectification of Suffering, in *The Routledge Companion to Museum Ethics*, edited by Janet C.C. Marstine. London and New York: Routledge, 220–35.

Williams, R. 2009. A sermon at a Service to mark the Passing of the World War One Generation [Online 11 November]. Available: http://www.archbishopof canterbury.org/articles.php/857/a-sermon-at-a-service-to-mark-the-passing-of-the-world-war-one-generation [accessed 12 December 2009].

Wilson, J. 1966. *Hamp: a drama*. London: Samuel French.

Wilson, J.M. 2007. *Isaac Rosenberg: The Making of a Great War Poet: A New Life*. London: Weidenfeld and Nicholson

Wilson, R. 2007. Archaeology on the Western Front: the archaeology of popular myths. *Public Archaeology* 6(4), 227–41.

Wilson, R. 2008a. The Trenches in British Popular Memory. *InterCulture* 5(2), 109–18.

Wilson, R. 2008b. Strange Hells: a new agenda on the Western Front. *Historical Research*, 81(211), 150–66.

Wilson, R. 2009. Memory and Trauma: Narrating the Western Front, 1914–1918. *Rethinking History*, 13(2), 251–68.

Wilson, R. 2010. The Popular Memory of the Western Front: Archaeology and European Heritage, in *Cultural Heritage and Representation: Perspectives on Visuality and the Past*, edited by E. Waterton and S. Watson. Aldershot: Ashgate, 75–90.

Wilson, R. 2011. Tommifying the Western Front. *Historical Geography*, 37(3), 338–47.

Wilson, R. 2012. Landscapes of the Western Front: materiality during the Great War. London and New York: Routledge.

Winegard, T.C. 2012. *Indigenous Peoples of the British Dominions and the First World War*. Cambridge: Cambridge University Press.

Winn, J.A. 2008. *The Poetry of War*. Cambridge: Cambridge University Press.

Winrow, J. 2012. Sacrifices of the Bradford Pals remembered. *Bradford Telegraph and Argus*, 14 June, 3.

Winter, A. 2012. *Memory: Fragments of a Modern History*. Chicago: The University of Chicago Press.

Winter C. 2009. Tourism, social memory and the Great War. *Annals of Tourism Research*, 36(4), 607–26.

Winter, C. 2012. Commemoration of the Great War on the Somme: exploring personal connections. *Journal of Tourism and Cultural Change* 1, 1–16.

Winter, J.M. 1977. Britain's 'Lost Generation' of the First World War. *Population Studies*, 31(3), 449–66.

Winter, J.M. 1986. *The Great War and the British People*. London: Macmillan.

Winter, J.M. 1992. *Sites of Memory, Sites of Mourning: the Great War in European Cultural History*. Cambridge: Cambridge University Press.

Winter, J.M. 2006. *Remembering War: The Great War between Memory and History in the Twentieth Century*. New Haven: Yale University Press.

Witcomb, A. 2003. *Re-Imagining the Museum: beyond the mausoleum.* London and New York: Routledge.

Wohl, R. 1979. *The Generation of 1914.* Cambridge, MA: Harvard University Press.

Wolff, L. 1959. *In Flanders Fields: The 1917 Campaign.* London: Longmans.

Woods, E. 2008. Sermon For Harvest Festival, Sherborne Abbey [Online 28 September]. Available at: http://www.sherborneabbey.com/sermons/viewsermon.php?ID=135 [accessed 29 October 2009].

Wright, P. 1985. *On Living in an Old Country: The National Past in Contemporary Britain.* London: Verso.

Wrigley, C. (ed.) 2000. *The First World War and the International Economy.* Cheltenham: Edward Elgar.

Wyllie, S. 2011. Teachers shell-shocked at school closure news. *Lynn News* [Online 1 April] Available at: http://www.lynnnews.co.uk/community/teachers_shell_shocked_at_school_closure_news_1_2555850# [accessed 12 April 2012].

Wynne-Jones, R. 2006. Return to the Somme. *Daily Mirror*, 1 July, 17.

Yerushalmi, Y. 1983. *Zakhor: Jewish History and Jewish Memory.* Seattle: University of Washington State.

Young, J. 1993. *The Texture of Memory: Holocaust Memorials and Meaning.* New Haven and London: Yale University Press.

Ziemann, B. 2011. *War Experiences in Rural Germany: 1914–1923.* Oxford: Berg.

Žižek, S. 2002. *For They Know Not What They Do: Enjoyment As a Political Factor.* London: Verso.

Index